Modern Architec[...]

02

Oxford History of Art

Alan Colquhoun was born in 1921 and studied architecture in Edinburgh and London. He was in partnership with J. H. Miller from 1961 until 1988. He is currently Professor Emeritus in the School of Architecture at Princeton University. His other publications include *Essays in Architecture: Modern Architecture and Historical Change* and *Modernity and the Classical Tradition: Architectural Essays 1980–1987*.

Oxford History of Art

Titles in the Oxford History of Art series are up-to-date, fully illustrated introductions to a wide variety of subjects written by leading experts in their field. They will appear regularly, building into an interlocking and comprehensive series. In the list below, published titles appear in bold.

Modern Architecture

Alan Colquhoun

OXFORD

UNIVERSITY PRESS

OXFORD

UNIVERSITY PRESS

Great Clarendon Street, Oxford OX2 6DP

Oxford New York

Athens Auckland Bangkok Bogotá Buenos Aires Cape Town
Chennai Dar es Salaam Delhi Florence Hong Kong Istanbul Karachi
Kolkata Kuala Lumpur Madrid Melbourne Mexico City Mumbai
Nairobi Paris São Paulo Shanghai Singapore Taipei Tokyo Toronto Warsaw

and associated companies in Berlin Ibadan

Oxford is a registered trade mark of Oxford University Press
in the UK and in certain other countries

0-19-284226-9

10 9 8 7 6 5 4 3 2 1

British Library Cataloguing in Publication Data
Data available

Library of Congress Cataloging in Publication Data
Data available

ISBN 0-19-284226-9

Picture research by Elisabeth Agate
Typesetting and production management by
The Running Head Limited, Cambridge, www.therunninghead.com
Printed in Hong Kong on acid-free paper by C&C Offset Printing Co. Ltd

Contents

Acknowledgements

Many people have—knowingly or unknowingly—contributed to the making of this book. But, for reading and commenting upon various chapters I am particularly indebted to Jean-Louis Cohen, Esther Da Costa Meyer, Hubert Damisch, Hal Foster, Jacques Gubler, Robert Gutman, Michael J. Lewis, Sarah Linford, Steven A. Mansbach, Arno Mayer, Guy Nordensen, Antoine Picon, and Mark Wigley. I owe a special debt of gratitude to Mary McLeod, who read and offered valuable advice on the entire manuscript, and to John Farnham and Can Bilsel for their help, both practical and intellectual, at crucial moments in its preparation. I would also like to thank my editors at Oxford University Press, Simon Mason and Katherine Reeve, for their advice and encouragement. Last but not least, I would like to thank Frances Chen and her staff in the library of the Princeton University School of Architecture, for their unfailing kindness and help.

During the preparation of the book I received a generous scholarship from the Simon Guggenheim Foundation and a Senior Samuel H. Kress Fellowship at the Center for the Study of the Visual Arts, the National Gallery, Washington, DC, both of which I gratefully acknowledge.

Introduction

The term 'modern architecture' is ambiguous. It can be understood to refer to all buildings of the modern period regardless of their ideological basis, or it can be understood more specifically as an architecture conscious of its own modernity and striving for change. It is in the latter sense that it has generally been defined in histories of contemporary architecture, and the present book follows this tradition. Already in the early nineteenth century, there was wide dissatisfaction with eclecticism among architects, historians, and critics. This well-documented attitude justifies a history of modern architecture concerned primarily with reformist, 'avant-garde' tendencies, rather than one that attempts to deal with the whole of architectural production as if it operated within a non-ideological, neutral field.

It is in the space between the idealist utopias of the historical avant-gardes and the resistances, complexities, and pluralities of capitalist culture that this book seeks to situate itself. Though not attempting to be in any way encyclopedic, the narrative follows an overall chronological sequence, and tries to be, perhaps, less certain in its outcome and less triumphalist than those of most previous histories of modernism. The book consists of a number of essays that can be read either as self-contained narratives or as part of a larger whole, each dealing with a cluster of related themes reflecting an important moment in the confrontation of architecture with the external conditions of modernity. If it is still largely a history of the masters, that is because that was the nature of modernism itself, despite its many claims to anonymity.

A word on terminology: I use—more or less interchangeably—the terms 'modern architecture', 'Modernism', 'the avant-garde', to mean the progressive movements of the 1910s and 1920s as a whole. I also occasionally use the term 'historical avant-garde', which has the effect of historicizing the movement and distinguishing it from contemporary practice. I do not follow Peter Bürger (*Theory of the Avant-Garde*, 1984), who, in the context of Dada photomontage, distinguishes between an avant-garde that sought to change the status of art within the relations of production and a Modernism that sought only to change its forms. That these two polar positions can be applied to architecture is undeniable. But the line between them is hard to define,

and even the work of the Left Constructivists and Marxists like Hannes Meyer does not, in my opinion, escape aestheticism. This is hardly surprising, since, before it could be separated from the classical–academic theory of the arts, aesthetics had first to become an autonomous category. Apart from the general terms mentioned above—which are useful precisely because of their semantic vagueness—other terms are used, either to define well-attested sub-movements, such as Futurism, Constructivism, De Stijl, L'Esprit Nouveau, and the Neue Sachlichkeit (New Objectivity), or migratory tendencies within the overall phenomenon of modernism, such as organicism, neoclassicism, Expressionism, functionalism, and rationalism. I have tried to explain what I mean by these slippery terms in the appropriate chapters.

From a certain perspective, general terms such as 'modernism' can also be applied to Art Nouveau—as, indeed, the temporal span of this book implies. To try to avoid such ambiguities would be to make unsustainable claims for logic. Art Nouveau was both the end and the beginning of an era, and its achievements as well as its limitations were the result of this Janus-like perspective.

Many aspects of Modernist theory still seem valid today. But much in it belongs to the realm of myth, and is impossible to accept at face value. The myth itself has now become history, and demands critical interpretation. One of the main ideas motivating the protagonists of the Modern Movement was the Hegelian notion that the study of history made it possible to predict its future course. But it is scarcely possible any longer to believe—as the Modernist architects appear to have believed—that the architect is a kind of seer, uniquely gifted with the power of discerning the spirit of the age and its symbolic forms. Such a belief was predicated on the possibility of projecting the conditions of the past onto the present. For progressive-minded architects of the nineteenth century and their twentieth-century successors, it seemed essential to create a unified architectural style that would reflect its age, just as previous styles had reflected theirs. This meant the rejection of an academic tradition that had degenerated into eclecticism, imprisoned in a history that had come to an end and whose forms could only be endlessly recycled. It did not imply a rejection of tradition as such. The architecture of the future would return to the *true* tradition, in which, it was believed, a harmonious and organic unity had existed between all the cultural phenomena of each age. In the great historical periods artists had not been free to choose the style in which they worked. Their mental and creative horizons had been circumscribed by a range of forms that constituted their entire universe. The artist came into a world already formed. The study of history seemed to reveal that these periods constituted indivisible totalities. On the one hand, there were elements unique to each period; on the other, the organic unity that bound these elements together was itself a universal. The new age

must exhibit the cultural totality characteristic of all historical periods.

The question was never asked how a cultural totality, which by definition had depended on an involuntary collective will, could now be achieved voluntarily by a number of individuals. Nor did it ever seem to have occurred to those who held this view that what separated the past from the present might be precisely the absence of this inferred organic unity. According to the model of the organic unity of culture, the task of the architect was first to uncover and then create the unique forms of the age. But the possibility of such an architecture depended on a definition of modernity that filtered out the very factors that differentiated it most strongly from earlier traditions: capitalism and industrialization. William Morris, the founder of the Arts and Crafts movement, had rejected both capitalism and machine production, a position that was at least consistent. But the theorists of the German Werkbund, while they rejected capitalism, wanted to retain industrialization. They condemned what they saw as the materialistic values of both Marxism and Western liberal democracy, but sought an alternative that would combine the benefits of modern technology with a return to the pre-industrial community values that capitalism was in the process of destroying. The Modern Movement was both an act of resistance to social modernity and an enthusiastic acceptance of an open technological future. It longed for a world of territorial and social fixity, while at the same time embracing, incompatibly, an economy and technology in flux. It shared this belief in a mythical 'third way' between capitalism and communism with the Fascist movements of the 1930s, and though it would be completely wrong to brand it with the crimes of Fascism, it is surely no accident that the period of its greatest intensity coincided with the anti-democratic, totalitarian political movements that were such a dominant feature of the first half of the twentieth century.

The conclusion would seem inescapable that the cultural unity and shared artistic standards—whether deriving from folk or from aristocratic traditions—demanded by the modern movement from its inception were increasingly out of step with the political and economic realities of the twentieth century. Based on an idealist and teleological conception of history, modernist theory seems radically to have misread the very *Zeitgeist* it had itself invoked, ignoring the complex and indeterminate nature of modern capitalism, with its dispersal of power and its constant state of movement.

The revolution of modernism—partly voluntary, partly involuntary—has irrevocably changed the course of architecture. But in the process it has itself become transformed. Its totalizing ambitions can no longer be sustained. Yet, the adventure of the Modern Movement is still capable of acting as an inspiration for a present whose ideals are so much less clearly defined. It is the aim of this book to sharpen our image of that adventure.

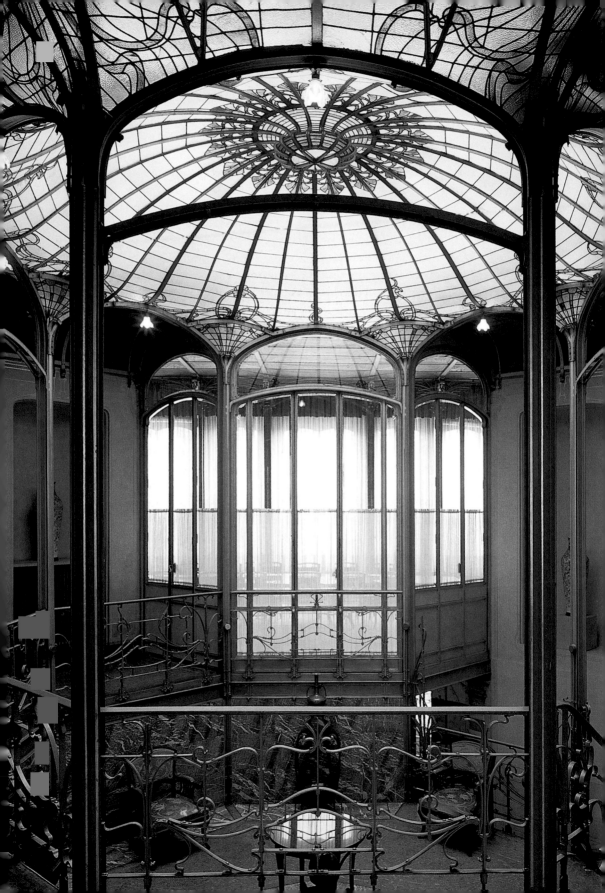

Art Nouveau 1890–1910

1

In 1892 the short-lived but vigorous Art Nouveau movement was launched in Belgium and quickly spread, first to France and then to the rest of Europe. Its inspiration came from the English Arts and Crafts movement and developments in wrought iron technology, particularly as interpreted by the French architect and theorist, Eugène Viollet-le-Duc (1814–79). The movement was closely associated with the rise of a new industrial bourgeoisie on the one hand and, on the other, with the many movements for political independence in *fin-de-siècle* Europe. It spread rapidly by means of journals such as *The Studio*, which included high-quality, mass-produced images, made possible by the new printing techniques of offset lithography and photolithography which came into commercial use in the 1880s and 1890s.

Art Nouveau was the first systematic attempt to replace the classical system of architecture and the decorative arts that had been handed down from the seventeenth century and was enshrined in the teaching of the Beaux-Arts academies. The new movement abandoned the post-Renaissance convention of realism, drawing inspiration from styles outside the classical canon—from Japan, from the Middle Ages, and even from Rococo. Though it lasted barely 15 years, many of its precepts were incorporated into the avant-garde movements that followed.

Like all progressive movements of the late nineteenth and early twentieth centuries, Art Nouveau was caught in an inherent dilemma—how to preserve the historical values of art under conditions of industrial capitalism. The Industrial Revolution had radically altered both the individual and the collective conditions of artistic production. In the face of this situation Art Nouveau artists and architects reacted in a way that would become typical of later avant-gardes: they leapt over recent history to a remote and idealized past in order to find an art that could be historically justified and yet be absolutely new.

Although Art Nouveau was preceded and profoundly influenced by the Arts and Crafts movement, the two continued in parallel, each modifying the other. In Austria, and to some extent in England, there was a fusion of the two movements. In Germany the influence of the

1 Victor Horta
View within the octagonal stair hall, Hôtel Van Eetvelde, 1895, Brussels
The real structure is masked by a thin membrane of iron and coloured glass. The space is lit from the roof.

Arts and Crafts proved the stronger of the two, leading to the Deutscher Werkbund and the alliance between industry and the decorative arts.

Antecedents

The reform of the industrial arts

Art Nouveau was the outcome of a transformation in the industrial, or decorative, arts that had been initiated in England and France earlier in the nineteenth century. As early as 1835 a parliamentary commission had been set up in England to study the problem of the decline in artistic quality of machine-made objects and the consequent damage to the export market. In 1851 a Great Exhibition of Industry of all Nations was organized in London, following a similar but abortive project in France. (France had led the way in industrial exhibitions but these had been exclusively national.) The Great Exhibition was a huge commercial and political success, but it confirmed the low quality of decorative products not only in England but in all the industrial countries, compared to those of the East. This realization prompted a succession of initiatives both in England and France . In England, the Victoria and Albert Museum and the Department of Practical Art were founded in 1852, and a spate of books on the decorative arts appeared, including the influential *Grammar of Ornament* (1856) by Owen Jones (1809–74). In France, the Comité central des beaux-arts appliqués à l'industrie was founded (also in 1852), followed by the Union centrale des beaux-arts appliqués à l'ndustrie (1864), which later became the Union centrale des arts décoratifs.

Though originating from the same concerns, these institutional reforms resulted in a different development in each country. In England, after the government initiatives of the 1830s, the reform of the arts became a private affair, dominated by a single individual, the artist and poet William Morris (1834–96). For Morris, as for the philosopher-critic John Ruskin (1819–1900), the reform of the industrial arts was impossible under the present conditions of industrial capitalism by which the artist was alienated from the product of his labour. In 1861, he set up the firm of Morris, Marshall, and Faulkner to create a context for artists to relearn the various crafts under conditions as near as possible to those of the medieval guilds. Morris's initiative was followed up by others, creating what was to become known as the Arts and Crafts movement.

The situation in France was different. First there was a politically influential art establishment, based on the Academy, fundamentally conservative, but aware of the need for reform and eager to promote it.[1] Secondly, the abolition of the guilds during the French Revolution had

not destroyed artisanal traditions in France as thoroughly as the Industrial Revolution had those of England. When they began experimenting with new techniques and forms in the 1870s, artists and craftsmen working in the decorative arts such as Eugène Rousseau (1827–91), Felix Bracquemond (1833–1914), and Emile Gallé (1846–1904) were able to build upon existing craft traditions. The ultimate model for both English and French artists was the medieval guild, but in France this model was combined with the more recent domestic tradition of Rococo.

Viollet-le-Duc and structural rationalism

The Arts and Crafts movement and its off-shoot, the English 'free-style' house were to have a considerable influence on the development of Art Nouveau. But there was another influence at work as well—the use of iron as an expressive architectural medium. The role of iron in architecture had been central to the debates between traditionalist and progressive–positivist architects in France throughout the nineteenth century. The debate was stimulated by the projects of the Saint-Simonian engineers and entrepreneurs who were largely responsible for laying down the French technical infrastructure in the 1840s and 1850s, and by discussions in the progressive magazine *Revue de l'Architecture* under the editorship of César-Denis Daly (1811–93). But it was chiefly through the theories and designs of Viollet-le-Duc that iron became associated with the reform of the decorative arts, and that an idealist decorative movement became grafted onto the positivist structural tradition.

The career of Viollet-le-Duc had been devoted to the distillation of the rational and vitalistic core of Gothic architecture, which he saw as the only true basis for a modern architecture. The main precepts Viollet bequeathed to the Art Nouveau movement were: the exposure of the armature of a building as a visually logical system; the spatial organization of its parts according to function rather than to rules of symmetry and proportion; the importance of materials and their properties as generators of form; the concept of organic form, deriving from the Romantic movement; and the study of vernacular domestic architecture.

Through two of his many books, *Entretiens sur l'Architecture* (*Lectures on Architecture*) and the *Dictionnaire Raisonné de l'Architecture Française* (*Dictionary of French Architecture*), Viollet-le-Duc became the rallying point for all those opposed to the Beaux-Arts. This was true not only in France, where 'alternative ateliers' were set up (though these were soon reabsorbed into the Beaux-Arts system),[2] but also elsewhere in Europe and in North America. His influence on the Art Nouveau movement came from both his theory and his designs.

Symbolism

Most historians[3] agree that important changes took place in the intellectual climate of Western Europe in the last two decades of the nineteenth century. The century had been dominated by a belief in progress made possible by science and technology, a belief that found its philosophical formulation in the movement known as Positivism founded by Auguste Comte (1798–1857). In literature and art it was Naturalism that corresponded most closely to the prevailing Positivist frame of mind. But by the 1880s belief in Positivism had begun to erode, together with the faith in liberal politics that had supported it. Several political events no doubt contributed to this phenomenon, including the terrible European economic depression that began in 1873.

In France, the home of Positivism, the change of intellectual climate was especially noticeable, and it was accompanied by a significant increase in the influence of German philosophy. In literature, the Symbolist movement led the attack. The Symbolists held that art should not imitate appearances but should reveal an essential underlying reality. This idea had been anticipated by Baudelaire, whose poem *Correspondences* (which incorporated Emanuel Swedenborg's theory of synaesthesia, though probably unknowingly), gives voice to the idea that the arts are intimately related to each other at a profound level: 'like long echoes which from afar become confused . . . Perfumes, colours, and sounds respond to each other.' In describing the movement, the Belgian Symbolist poet Emile Verhaeren compared German to French thought, to the detriment of the latter: 'In Naturalism [is found] the French philosophy of the Comtes and the Littrés; in [Symbolism] the German philosophy of Kant and Fichte . . . In the latter, the fact and the world become a mere pretext for the idea; they are treated as appearance, condemned to incessant variability, appearing ultimately as dreams in our mind.'[4] The Symbolists did not reject the natural sciences, but looked on science as the verification of subjective states of mind. As one contributor (probably Verhaeren) to the Symbolist journal *L'Art Moderne* said: 'Since the methods that were formerly instinctive have become scientific . . . a change has been produced in the personality of artists.'[5]

Art Nouveau in Belgium and France

Underlying formal principles

The characteristic motif of Art Nouveau is a flowing plant-like form of the kind first found in English book illustration and French ceramic

work of the 1870s and 1880s [**2**].[6] Common to these proto-Art Nouveau works was the principle that in ornament the imitation of nature should be subordinated to the organization of the plane surface. In his book *Du dessin et de la couleur* (*Drawing and Colour*), published in 1885, the ceramicist Felix Bracquemond defined the new concept in the following terms: 'Ornament does not necessarily copy nature even when it borrows from her . . . Its infidelity to her . . . [is] due to the fact that it is solely concerned with embellishing surfaces, that it depends on the materials it has to adorn, on the forms it has to follow without altering them.'[7]

In Art Nouveau, this 'functional' dependency of ornament led to a paradoxical reversal. Instead of merely obeying the form of the object, ornament began to merge with the object, animating it with new life. This had two effects: first, the object became thought of as a single organic entity rather than as an aggregation of separate parts, as in the classical tradition; second, ornament was no longer thought of as 'space filling', and a dialogue was set up between two positive values—ornament and empty space. The discovery of what might be called 'spatial silence'—probably mainly derived from Japanese prints—was one of Art Nouveau's chief contributions to modern Western aesthetics.

In this redefinition, the accepted boundary between ornament and form became blurred. The classical attitude had been that ornament was a supplementary form of beauty. It was the German archaeologist Karl Bötticher (1806–89) who first suggested that ornament (*Kunstform*) was organically related to the underlying substance of the object, giving the inert mechanical structure (*Kernform*) the semblance of organic life—an idea later used by Gottfried Semper (1803–79) in his book *Der Stil*.[8] Though Art Nouveau was obviously not the direct result

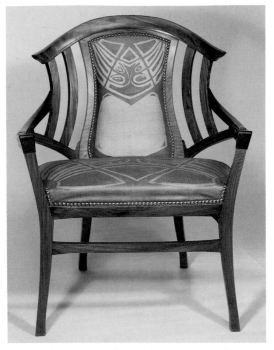

of this theory, which was developed in the context of Greek antiquity, it seems to be derived from the same nexus of ideas. The ornament on a chair by Henry van de Velde (1863–1957) not only completes the structure, the two become indistinguishable, the product of an artistic will striving for total symbolic expression [3]. In his book *Formules de la Beauté Architectonique Moderne* (*Principles of Modern Architectonic Beauty*) of 1917, Van de Velde described this fusion of subjective and objective, of ornament and structure, in the following terms:

Ornament completes form, of which it is the extension, and we recognize the meaning and justification of ornament in its function. This function consists in 'structuring' the form and not in adorning it . . . The relations between the 'structural and dynamographic' ornament and the form or surfaces must be so intimate that the ornament will seem to have determined the form.[9]

In their desire to extend these principles beyond the isolated object, Art Nouveau designers became preoccupied with the design of whole interiors. In many rooms and ensembles individual pieces of furniture tended to lose their identity and become absorbed into a larger spatial and plastic unity [4].

Brussels

Art Nouveau first emerged in Belgium, within the ambience of a politicized and anarchist Symbolist movement in close touch with the Parti Ouvrier Belge (POB, founded 1885). The leaders of the POB—

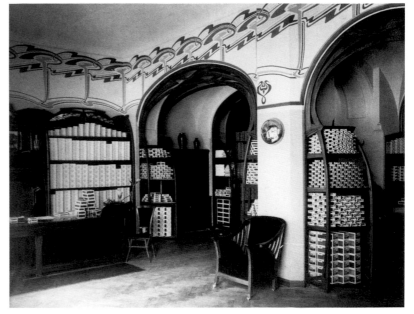

for example, the lawyers Emile Vandervelde and Jules Destrée—had intimate ties with the literary and artistic avant-garde. An educational programme of cultural events was organized by the Section d'Art of the POB's Maison du Peuple (for example, Emile Verhaeren's play *Les Aubes* received its first performance there in 1897). Influenced by William Morris, the Belgian Symbolist journal *L'Art Moderne*, founded in 1885 by Octave Maus and Edmund Picard, increasingly advocated the application of art to daily life.

In 1892, Willy Finch (1854–1936) and Henry van de Velde, members of the painters' group Les XX, inaugurated a decorative art movement based on the English Arts and Crafts Society. A year later the salon of Les XX devoted two rooms to the decorative arts, which were thereby associated with the fine arts rather than the industrial arts. Les XX was superseded by Libre Esthétique in 1894. At the group's first salon, Van de Velde delivered a series of lectures which were published under the title *Déblaiement d'Art* (*The Purification of Art*) and established him as the ideologue of the movement. In these lectures Van de Velde followed Morris in defining art as the expression of joy in work, but unlike Morris he recognized the necessity of machine production—a contradiction that he was never able to resolve.

Influential as these lectures were in spreading the movement and providing it with a theoretical apparatus, two other figures were of greater importance in establishing its formal language. The first of these, the Liège-based architect and furniture designer Gustave Serrurier-Bovy (1858–1910), had been the first to introduce the work of the Arts and Crafts movement into Belgium. He exhibited two rooms in the 1894 and 1895 Libre Esthétique salons, a 'Cabinet de Travail' and a

'Chambre d'Artisan', both characterized by a simplicity and sobriety similar to the Arts and Crafts movement. Serrurier-Bovy's work represents a distinct thread in Belgian Art Nouveau which idealized vernacular building and advocated a simple rural lifestyle.[10]

The second figure was Victor Horta (1861–1947) whose background differed from that of both Van de Velde and Serrurier. After receiving a Beaux-Arts architectural training, Horta spent over ten years working in a neoclassical style, slightly modified by Viollet-le-Duc's constructional rationalism. But in 1893—already in his thirties—he designed a private house of startling originality for Emile Tassel, professor of descriptive geometry at the Université Libre of Brussels and a fellow freemason. This was the first in a series of houses that he built for members of the Belgian professional elite, in which he combined Viollet-le-Duc's principle of exposed metal structure with ornamental motifs derived from the French and English decorative arts.

The hôtels Tassel, Solvay, and Van Eetvelde [1 (see page 12), 5], all

(see page 12)

5 Victor Horta

First-floor plan, Hôtel Van Eetvelde, 1895, Brussels
This floor is dominated by the octagonal stair hall, through which the occupants must pass when moving from one reception room to another.

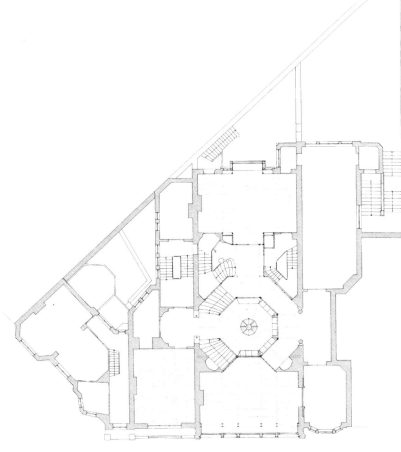

Drawing by David Dernie

designed between 1892 and 1895, present an ingenious range of solutions to typical narrow Brussels sites. In each, the plan was divided from front to back into three sections, the central section containing a top-lit staircase which became the visual and social hub of the house. In each, the *piano nobile* consisted of a suite of reception rooms and conservatories with a spatial fluidity that was accentuated by extensive use of glass and mirror, somewhat recalling the theatre foyers built in Brussels in the 1880s by Alban Chambon (1847–1928).[11] The houses were intended for social display. In his memoirs Horta described the Hôtel Solvay as 'a dwelling like any other . . . but with an interior characterized by an exposed metal structure and a series of glass screens giving an extended perspective . . . for evening receptions'.[12] But this description gives no idea of the sensuous and intimate language in which this social function was embodied, spreading a veil over the 'architectural-real', dissolving structure into ornament. An imaginary world—half mineral, half vegetal—is created, with an air of unreality enhanced by the timeless, subaqueous light filtering down from the roof.

Horta's most important public building was the new Maison du Peuple in Brussels of 1896–9 (demolished 1965). He received this commission through his domestic clients, whose social milieu and socialist ideals he shared. As in the houses, the Beaux-Arts symmetry of the plan is carefully undermined by asymmetrical programmatic elements. The façade, though it appears to be a smooth undulating skin following an irregular site boundary, is in fact a classical composition arranged round a shallow *exhedra*. Nonetheless, because of its continuous glazing (and in spite of its allusion to the heavily glazed Flemish Renaissance buildings to be found in Brussels) it must have had a shocking effect when it was built.

If architecture was a passion for Horta, for Van de Velde (who was trained as a painter) it was more the logical culmination of the 'household of the arts' (the phrase is Rumohr's).[13] Starting from 1896, he exhibited a number of interiors at the Libre Esthétique salon, influenced by Serrurier's rooms. In 1895 he built a house called 'Bloemenwerf' for his family, in Uccle, a suburb of Brussels, in which he set out to create a domestic environment where daily life could be infused with art—he even designed his wife's clothes. This house was a prototype for the villas built in the Utopian artists' colonies that sprang up, mostly in the German-speaking countries, around 1900. It represents a sort of suburban Bohemianism very different from the elegant urban lifestyle catered for by Horta.

Paris and Nancy

The Art Nouveau movement in France was closely related to that of Belgium, though it lacked the Belgian movement's socialist

connotations. The term 'Art Nouveau' had been in circulation in Belgium since the 1870s, but it took on a new lease of life when, in 1895, the German connoisseur and art dealer Siegfried (Samuel) Bing opened a gallery in Paris called L'Art Nouveau, for which Van de Velde designed three rooms.

In France it was Héctor Guimard (1867–1942), just as in Belgium it had been Horta, who integrated the new decorative principles into a coherent architectural style. Guimard was not closely associated either with Bing or with the decorative arts institutions in Paris, but his allegiance to Viollet-le-Duc was even stronger than that of Horta. Two early works, the School of Sacré Cœur in Paris (1895) and the Maison

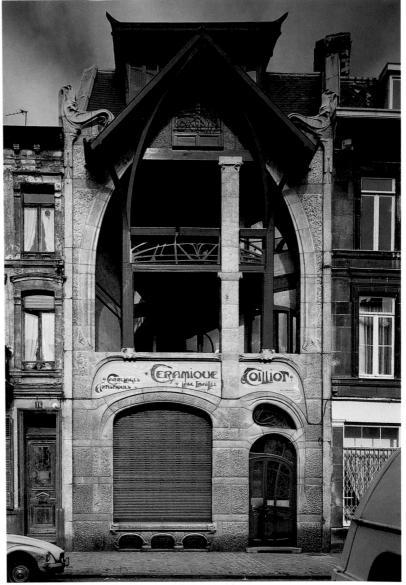

6 Héctor Guimard
Maison Coilliot, 1897, Lille
This house appears to be a paraphrase of one of the illustrations in Viollet-le-Duc's *Dictionnaire Raisonné*.

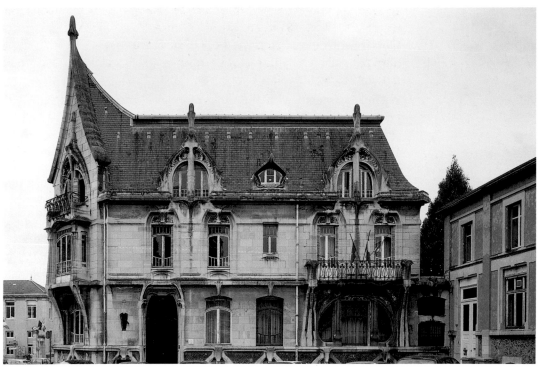

Coilliot in Lille (1897) [6], were based on illustrations in Viollet's *Entretiens* and the *Dictionnaire*. After seeing Horta's houses in Brussels, Guimard was so impressed that he revised the drawings for his first large-scale work, the apartment building Castel Béranger in Paris (1894–98), reworking the stone mouldings and metal details with curvilinear and plastic forms. In the interior of the Humbert de Romans concert hall (1898, demolished 1905), and in the well-known entrances to the Paris Métro, Guimard carried the analogy between metal structure and plant form further than anything found in Horta's work.

The leading figure in the School of Nancy was the glass-worker and ceramicist Emile Gallé. His work was based on a craft tradition with its roots in French Rococo—his father, a ceramicist, having rediscovered the ceramic moulds used by the Lorraine craftsmen of the eighteenth century. It was, however, highly innovative, deliberately playing on the neurasthenic and 'decadent' aspects of the Symbolist tradition.

The architecture of the Nancy School has a distinctly 'literary' flavour. Two houses built in 1903, one by Emile André (1871–1933) and the other by Lucien Weissenburger (1860-1928) [7], are suggestive of castles in a medieval romance. The slightly earlier house for the ceramicist Louis Marjorelle by Henri Sauvage (1873–1932), is less dependent on literary associations, more abstract and formal, with solid stone walls gradually dissolving into a light, transparent superstructure.

Dutch Art Nouveau and the work of H. P. Berlage

The Dutch Art Nouveau movement was split between two opposed groups, the first inspired by the curvilinear Belgian movement, the second associated with the more rationalist circle of J. H. Cuypers (1827–1921) and the Amsterdam group Architectura et Amicitia. This group's members included H. P. Berlage (1856–1934), K. P. C. Bazel (1896–1923), W. Kromhaut (1864–1940), and J. L. M. Lauweriks (1864–1932), and their affinities lay more with Viollet-le-Duc and the Arts and Crafts movement than with Belgian and French Art Nouveau, of which they were critical.[14]

After 1890, structural and rationalist tendencies became pronounced in the work of Hendrick Petrus Berlage. In both the Diamond Workers' Building in Amsterdam (1899–1900) and the Amsterdam Stock Exchange (1897–1903), Berlage reduced his earlier eclecticism to an astylar neo-Romanesque in which basic volumes are articulated and structural materials exposed, with Art Nouveau ornament used sparingly to emphasize structural junctions. Compared to Horta's Maison du Peuple—also a significant public building—the Exchange, with its calm, expansive brick surfaces, reinforces rather than subverts the traditional fabric of the Amsterdam with its solid burgher-like values.

In Berlage's private houses we find the same qualities. The plan of the Villa Henny in the Hague (1898), like many Arts and Crafts and Art Nouveau houses, is organized round a central top-lit hall. But, unlike the evanescent metal structure surrounding the central hall of Horta's Hôtel Van Eetvelde, Berlage's hall is defined by a brick arcade [8], with groin vaults in the spirit of Viollet-le-Duc. The furniture, with its structural rigour, anticipates that of De Stijl and the Constructivists.

Modernisme in Barcelona

The first signs of Modernisme—as Art Nouveau was called in Catalan—seem to pre-date the Belgian movement by several years and the Catalan movement appears to have been inspired independently by the publications of Viollet-le-Duc and the Arts and Crafts movement. Modernisme was more closely related to the nineteenth-century eclectic tradition than was the Art Nouveau of France and Belgium. In 1888 Lluís Domènech i Montaner (1850–1923), the most important architect of early Modernisme, published an article entitled 'En busca de una arquitectura nacional' ('In Search of a National Architecture'), which shows the movement's eclectic intentions: 'Let us apply openly the forms which recent experience and needs impose on us, enriching them and giving them expressive form through the inspiration of

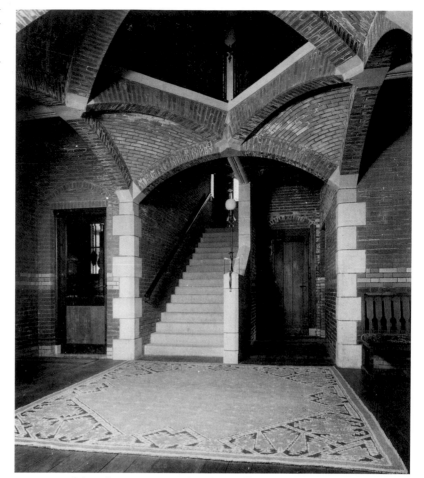

nature and by the ornamental riches offered us by the buildings of every period.'[15]

Barcelona had grown at an even faster rate than Brussels in the second half of the nineteenth century. The new industrial bourgeoisie of Catalonia—men like Eusebio Güell and the Marqués de Comillas—saw Modernisme as an urban symbol of national progress, as did Art Nouveau's patrons in Belgium. But, while in Belgium the movement was associated with an anti-Catholic international socialism, in Catalonia its affiliations were Catholic, nationalist, and politically conservative.

In the early works of the movement, Moorish ('Mudejar') motifs were used to suggest regional identity. This can be seen in the Casa Vicens (1878–85) by Antoni Gaudí i Cornet (1852–1926), and the Bodegas Güell (1888) by Fransesco Berenguer (1866–1914). Both mix historicist 'inventions' with new structural ideas, such as the use of exposed iron beams and catenary vaults (which Gaudí was also to use in the Sagrada Familia).[16]

Catalan Modernisme was dominated by the figure of Gaudí, whose

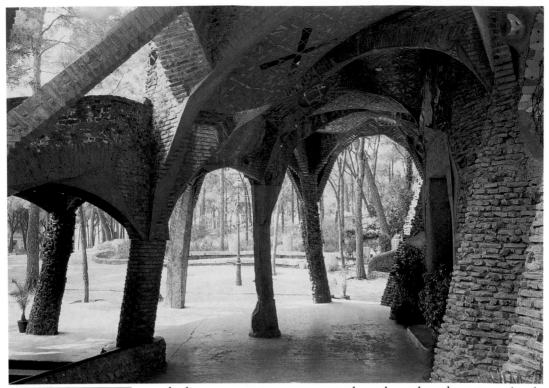

9 Antoni Gaudí
Chapel of the Colonia Güell, 1898–1914, Barcelona
The crypt—the only part of the chapel to be built. This is one of the most mysterious and surreal of Gaudí's buildings. Gothic structure is reinterpreted in terms of a biological structure that has grown incrementally in response to its environment.

work, however protean, seems to have been based on two simple premises: the first, derived from Viollet-le-Duc, was that the study of architecture must start from the mechanical conditions of building; the second was that the imagination of the architect should be free of all stylistic conventions. Gaudí's work is often characterized by a kind of free association in which forms suggestive of animal, vegetal or geological formations appear. In the crypt of the Chapel of the Colonia Güell in Barcelona (1898–1914) [9], the structure imitates the irregular forms of trees or spiders' webs, as if, like them, it has arrived at rational ends unconsciously. In the unfinished church of the Sagrada Familia, also in Barcelona (begun 1883), the façades look as if they have been eroded through millennia or dipped in acid, leaving only the incomprehensible traces of some forgotten language. The deep cultural and personal anxieties that seem to lie behind Gaudí's architecture were to fascinate the Surrealists in the 1930s. At no other time could such an intimate, subjective architecture have become a popular symbol of national identity.

Austria and Germany: from Jugendstil to classicism

Vienna

The concepts that lay behind Symbolism and Art Nouveau were, as we have seen, strongly influenced by German Romanticism and

philosophical Idealism. One of the strongest expressions of this tendency is found in the writings of the Viennese art historian Alois Riegl (1858–1905).[17] According to Riegl, the decorative arts were at the origin of all artistic expression. Art was rooted in indigenous culture, not derived from a universal natural law. This idea meshed closely with the ideas of John Ruskin and William Morris as well as with the aesthetic theories of Felix Bracquemond and Van de Velde, and it stood in stark contrast to the idea (derived from the Enlightenment) that architecture should align itself with progress, science, and the Cartesian spirit.

In the context of the Austro-Hungarian Empire, the conflict between these diametrically opposed concepts was exacerbated by the political struggle between the metropolis, with its liberal and rationalist programme, and ethnic minorities seeking to assert their own identity. For the Slav and Finno-Ugrian-speaking provinces of the empire, the free and unattached style of Art Nouveau became an

10 Otto Wagner

Post Office Savings Bank, 1904–6, Vienna

Detail of main banking hall, showing the use of industrial motifs as metaphors for the abstraction of money in modern capitalism. In the public façade of the same building Wagner used conventional allegorical figures conforming to idealist codes.

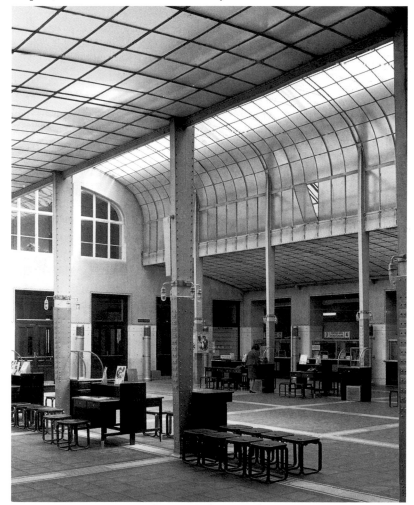

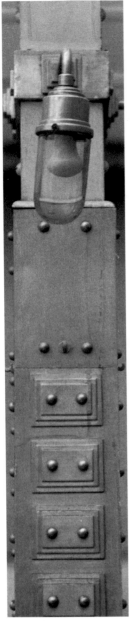

11 Otto Wagner

Post Office Savings Bank, 1904–6, Vienna

This detail of a light fitting shows its industrial metaphors.

emblem of political and cultural freedom,[18] as in Catalonia, Finland, and the Baltic states.

In Austria, the liberal, rationalist spirit was epitomized by the work of Otto Wagner (1841–1918), the most celebrated architect of the time. Wagner stood on the other side of the ideological divide from the urbanist Camillo Sitte (1843–1903), whose internationally influential book, *Der Städtebau nach seinen Künstlerischen Grundstätzen* (*City Building According to its Artistic Principles*) of 1889, had promoted an urban model of irregular, closed spaces, based on the medieval city. For Wagner, on the contrary, the modern city should consist of a regular, open-ended street grid containing new building types such as apartment blocks and department stores.[19] In his buildings, Wagner's rationalism reaches its peak in the Post Office Savings Bank in Vienna (1904–6). It is a rationalism, however, that does not abandon the allegorical language of classicism but extends it. In the bank we find allegorical figurative ornament: but there are also more abstract metaphors, such as the redundant bolt-heads on the façade (the thin marble cladding was in fact mortared to a brick wall). These, like the functional glass and metal banking hall, are both symbols and manifestations of modernity [**10, 11**].

In 1893 Wagner was appointed director of the School of Architecture at the Vienna Academy of Fine Arts where he came into close contact with the younger generation of designers. His two most brilliant students were Joseph Maria Olbrich (1867–1908) and Josef Hoffmann (1870–1956). Wagner employed Olbrich as the chief draftsman on his Stadtbahn (City Railway) project from 1894 to 1898. Due to Olbrich's influence, decorative motifs derived from Jugendstil (as the German Art Nouveau movement was called) began to replace traditional ornament in Wagner's work, though without affecting its underlying rational structure—as shown in the Majolica House apartment building in Vienna (1898).

The early careers of Olbrich and Hoffmann had an almost identical trajectory. They both belonged to the Wiener Sezession (Vienna Secession)—a group that split from the academy in 1897—and both worked with equal facility in architecture and the decorative arts. Olbrich received the commission for the Secession's headquarters in Vienna, and in 1899 the Grand Duke Ernst Ludwig of Hesse appointed him as architect for the artists' colony at Darmstadt. In 1903 Hoffmann—with designer Kolo Moser (1868–1918)—founded the Wiener Werkstätte, a furniture workshop modelled on Charles R. Ashbee's Guild of Handicraft in London, and conceived as a cottage industry.

The Secession marked the introduction of Jugendstil into Austria. But after working in the curvilinear style of high Art Nouveau for about three years, Olbrich and Hoffmann abandoned Van de Velde's dynamic integration of ornament with structure and reverted to a more

12 Joseph Maria Olbrich

A decorated casket, 1901
The neoclassical body of this casket, in the form of a truncated pyramid, is delicately incised and inlaid with stylized ornament. Empty space plays a positive role.

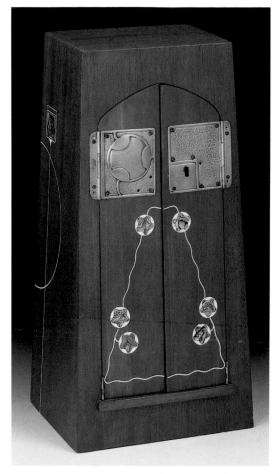

rectilinear organization of planar surfaces and geometrical ornament [**12**]. In this they showed an affinity with both Otto Wagner's classicism and the work of the later Arts and Crafts designers, particularly Charles Rennie Mackintosh (1868–1928), M. H. Baillie Scott (1865–1945), Charles Annesley Voysey (1857–1941), and Charles Robert Ashbee (1863–1942). The artists' houses that Olbrich built at Darmstadt [**13**, **14**] are free variations on the theme of the English 'free-style' house, reminiscent of Scott's work. Hoffmann's Palais Stoclet in Brussels (1905–11) [**15**, **16**], a true *Gesamtkunstwerk* (a 'total work of art'—a concept originating in Richard Wagner's aesthetic theory) with murals by Gustav Klimt and furniture and fittings by the architect, is close to Mackintosh's Hill House (1902–3) and his House for an Art Lover (1900) [**17**].

Over the next five years, the work of both architects took another turn, this time in the direction of classical eclecticism. Olbrich's last house (he died of leukaemia in 1908, aged 41) is in the then newly popular Biedermeier revival style—with a Doric colonnade and a vernacular roof. Hoffmann's brand of Biedermeier is lighter, and is

13 and 14 Joseph Maria Olbrich

Two postcards, issued on the occasion of an exhibition at the Darmstadt artists' colony in 1904, showing a group of Olbrich's houses in the colony dating from between 1901 and 1904—suburban eclecticism raised to the level of artistic frenzy.

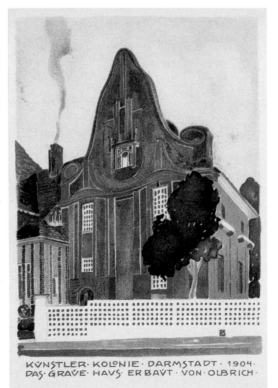

15 Josef Hoffmann (right)

Palais Stoclet, 1905–11, Brussels

The plan of this house—Hoffmann's *chef-d'œuvre*—is clearly derived from that of Mackintosh's House for an Art Lover, but Hoffmann has reorganized the hall so that it bisects the house at mid-point, giving it a Beaux-Arts symmetry. The cut-out quality of the wall planes and the metal trim along their edges make the walls seem paper thin. (This must have been the reason why Le Corbusier reputedly admired this house).

16 Josef Hoffmann (right)

Palais Stoclet, 1905–11, Brussels

This double-height hall is characteristic of free-style, Art Nouveau, and neoclassical houses of the period. The screen of thin, closely spaced columns simultaneously divides and unites the space.

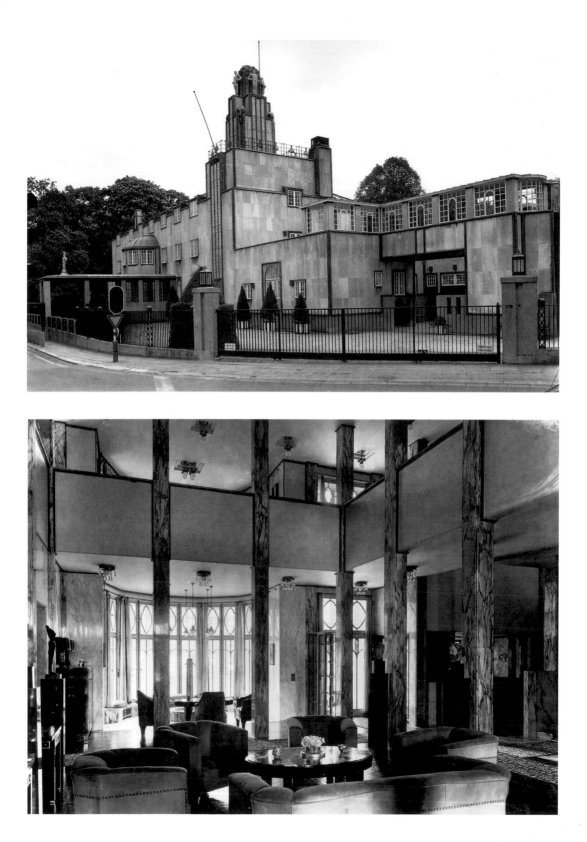

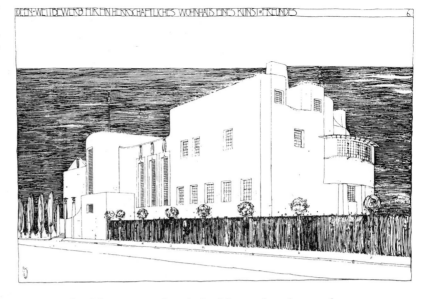

17 Charles Rennie Mackintosh

House for an Art Lover, 1900
This design for a German competition, dating from the period of Mackintosh's maximum popularity in Austria and Germany, was very influential. The house is more plastic than the Palais Stoclet. The austerity of the Scottish vernacular (as opposed to the softness of Voysey's or Baillie Scott's) suggests an emerging Modernist abstraction.

connected with a general trait in his work—the tendency to use a common plastic language for architecture and the decorative arts and to minimize the tectonic effect of gravity. According to a critic of the time, Max Eisler, Hoffmann's later buildings were 'furniture conceived on an architectural scale'.[20]

Munich and Berlin

The centre of the German Jugendstil movement was Munich, where it was launched by the magazine *Jugend* in 1896. The group of designers and architects originally associated with the movement included Hermann Obrist (1863–1927), Auguste Endell (1871–1925), Peter Behrens (1868–1940), Richard Riemerschmid (1868–1957), and Bruno

18 Richard Riemerschmid

Chest, 1905
This chest is typical of the semi-mass-produced furniture designed by Riemerschmid in the first decade of the twentieth century and exhibited in his room ensembles. It is close to some of Adolf Loos's designs, and has the same unpretentious elegance, reflecting both British and Japanese influence.

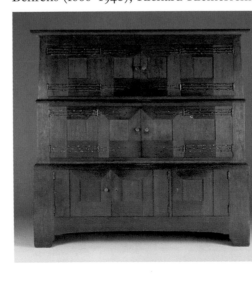

Paul (1874–1968). In 1897, like the Viennese Secessionists, the Munich group soon abandoned Van de Velde's curvilinear style and began to give closer attention to the Arts and Crafts movement. Under the leadership of Riemerschmid and Paul, the Vereinigten Werkstätten für Kunst und Handwerk, founded in 1897, developed a range of semi-mass-produced furniture which was exhibited in the 1899 salon of Libre Esthétique in Brussels. From 1902, Riemerschmid exhibited rooms in which the furniture was simple and robust, with Arts and Crafts and Japanese features [**18**]. After about 1905, the ensembles of Riemerschmid and Bruno Paul—especially the latter—became more classical. The rooms they exhibited at the Munich exhibition of 1908 astonished French interior designers, who admired their elegance and unity—qualities hitherto considered peculiarly French.[21]

The Art Nouveau movement was overtaken by economic and cultural developments. Although it aspired to be a popular movement, its hand-crafted products were only affordable by a wealthy minority and it disintegrated with the decline of a certain set of bourgeois and nationalist fantasies, and with the inexorable rise of machine production and mass society. In the work of the Vienna Secession and in that of Riemerschmid and Paul in Germany, we witness the Art Nouveau movement, with its stress on individuality and originality, being transformed into repeatable forms based on vernacular and classical models.

But the high Art Nouveau movement left a permanent, if submerged, legacy—the concept of an uncoded, dynamic, and instinctual art, based on empathy with nature, for which it was possible to prescribe certain principles but not to lay down any unchanging and normative rules. This concept of an art without codes can be—and often has been—challenged, but its power of survival in the modern world can hardly be questioned.

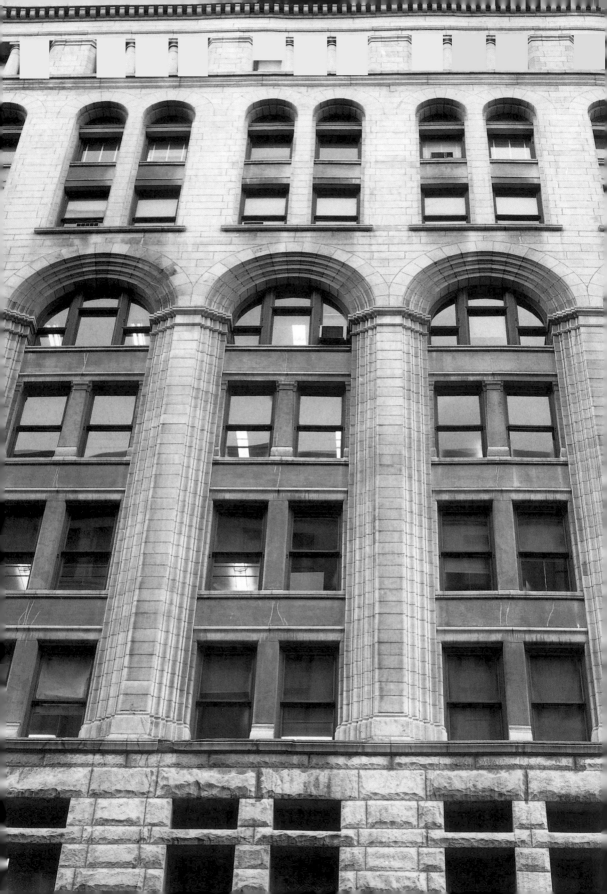

Organicism versus Classicism: Chicago 1890–1910

2

In a lecture entitled 'Modern Architecture', delivered in Schenectady on 9 March 1884, the New York journalist and architectural critic Montgomery Schuyler set out what he saw to be the problem facing American architecture. Schuyler presented his argument in the form of thesis and antithesis. He asserted the need for a universal culture of architecture such as existed in Europe but was lacking in America due to the absence of good models. The Beaux-Arts system, he said, might provide the basis for such a culture, one that would inculcate the qualities of 'sobriety, measure, and discretion', were it not for the fact that it failed to produce an architecture appropriate to modern life. Architecture, he says, is the most reactionary of the arts: 'Whereas in literature the classical rules are used, in architecture they are copied . . . in architecture alone does an archaeological study pass for a work of art . . . It is not the training that I am depreciating, but the resting in the training as not a preparation but an attainment.' He went on to describe a confusion between language and architecture: 'A word is a conventional symbol, whereas a true architectural form is a direct expression of a mechanical fact.'

Schuyler praised American architects, particularly those of Chicago, for attempting to adapt architecture to such technical problems as the elevator and the steel frame, unhampered by too many scruples about stylistic purity. Yet he felt that the problem had not been fully solved. 'The real structure of these towering buildings—the "Chicago construction"—is a structure of steel and baked clay, and when we look for the architectural expression of it, we look in vain.' Such an articulated structure, 'being the ultimate expression of a structural arrangement, cannot be foreseen, and the form . . . comes as a surprise to the author'. Schuyler thus came out in favour of a direct and expressive modern architecture. Yet he never explicitly rejected the Beaux-Arts tradition. Does he think that 'sobriety, measure, and discretion' should be sacrificed on the altar of verisimilitude? That Europe should be rejected? We are not told, and, in spite of his preference for the second alternative, one has the impression that the first has not been completely abandoned.

Schuyler's writings drew attention to a conflict between the

19 Dankmar Adler and Louis Sullivan

The Auditorium Building, 1886–9, Chicago

By combining Richardson's vertical hierarchy with Burnham and Root's elimination of the wall, Adler and Sullivan were able to achieve in this building some measure of balance between classical monumentality and the expression of modern structure.

architect as manipulator of a visual 'language' (classicist) and as exponent of a changing technology (organicist). This can be broken down into a series of further oppositions: collectivism versus individualism; identity (nation) versus difference (region); the normative versus the unique; representation versus expression; the recognizable versus the unexpected.

These oppositions constantly reappeared in the architectural debates of the early twentieth century. But in America, more transparently than in Europe, they tended to be connected with problems of high national policy. It is in Chicago that this tendency manifested itself most dramatically.

The Chicago School

After the fire of 1871 and the subsequent economic depression, Chicago experienced an extraordinary boom in commercial real estate. The architects who flocked to the city to profit from this situation brought with them a strong professional sense of mission. They saw their task as the creation of a new architectural culture, believing that architecture should express regional character and be based on modern techniques. The situation in Chicago seemed to offer the possibility of a new synthesis of technology and aesthetics and of the creation of an architecture that symbolized the energy of the Mid-west.

The term 'Chicago School' was first used in 1908 by Thomas Tallmadge to refer to the group of domestic architects, active between 1893 and 1917, to which both he and Frank Lloyd Wright (1869–1959) belonged. It was not until 1929 that it was also used for the commercial architects of the 1880s and 1890s by the architectural critic Henry Russell Hitchcock (1903–87) in his book *Modern Architecture: Romanticism and Reintegration*. Hitchcock associated both groups of architects with 'pre-modern' Symbolists such as Victor Horta. In the 1940s he made a new distinction between a commercial and a domestic phase of the school. But in contemporary usage, a complete reversal has taken place and 'Chicago School' now generally refers to the commercial architecture of the 1880s and 1890s, while the work of Frank Lloyd Wright and his colleagues is referred to as the 'Prairie School'. This is the terminology that will be adopted here.

The importance of the Chicago School was recognized during the 1920s and 1930s, as the writings of Hitchcock, Fiske Kimball (*American Architecture*, 1928) and Lewis Mumford (*The Brown Decades*, 1931) testify. But it was given a quite new claim to modernity by the Swiss art historian Sigfried Giedion (1888–1968) in *Space, Time and Architecture* (1941), where he presented the Chicago School in Hegelian terms as a stage in the progressive march of history.

In rejecting the Beaux-Arts eclecticism of the East Coast, the

Chicago architects were not rejecting tradition as such. But the tradition they endorsed was vague, pliable, and adaptable to modern conditions. These conditions were both economic and technical. On the one hand, building plots were large and regular, unencumbered with hereditary freehold patterns. On the other, the recently invented electrical elevator and metal skeleton made it possible to build to unprecedented heights, multiplying the financial yield of a given plot. The last restrictions in height were removed when it became possible, due to developments in fireproofing techniques, to support the external walls, as well as the floors, on the steel frame, thus reducing the mass of the wall to that of a thin cladding.[1]

Ever since the mid-eighteenth century French rationalists such as the Jesuit monk and theoretician Abbé Marc-Antoine Laugier had argued for the reduction of mass in buildings and for the expression of a skeleton structure. Armed with this theory, which they had absorbed

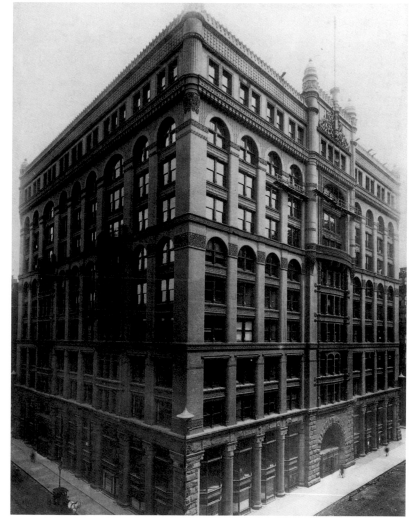

20 Daniel Burnham and John Wellborn Root

The Rookery Building, 1885–6, Chicago

In this early example of a Chicago School office building the hidden skeleton frame is 'expressed' by the windows extending from column to column, but the projecting central feature is a hangover from classical conventions.

from the writings of Viollet-le-Duc, the Chicago architects started from the assumption that window openings should be increased so that they spanned from column to column and provided maximum daylight. But they still felt the need to retain the hierarchies of the classical façade characteristic of the palaces of the Italian quattrocento. This resulted in a compromise in which the masonry cladding took one of two forms: classical pilasters carrying flat architraves; and piers with round arches—the so-called Rundbogenstil which had originated in Germany in the second quarter of the nineteenth century and been brought to America by immigrant German architects.[2] In the earliest solutions, groups of three storeys were superimposed on each other, as can be seen in the Rookery Building (1885–6) [**20**] by Daniel H. Burnham (1845–1912) and John Wellborn Root (1850–91) and in William Le Baron Jenney's Fair Store (1890). Henry Hobson Richardson (1838–86) in the Marshall Field Wholesale Store [**21**] with its external walls of solid masonry, overcame the stacking effect of these solutions by diminishing the width of the openings in successive tiers, and Dankmar Adler (1844–1900) and Louis Sullivan (1856–1924) adapted this idea to a steel-frame structure in their Auditorium Building (1886–9) [**19**, see page 34].

While these experiments and borrowings were taking place, an alternative, more pragmatic approach was also being explored. In the Tacoma Building (1887–9) by William Holabird (1854–1923) and Martin

21 Henry Hobson Richardson
The Marshall Field Wholesale Store, 1885–7, Chicago (demolished)
Here the unpleasant 'stacking' effect of the Rookery Building is overcome by diminishing the width of the openings in the successive layers. But since this building had external walls of solid masonry, the 'Chicago problem' of expressing the frame did not arise.

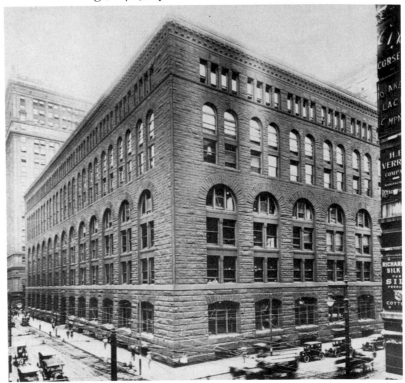

22 Burnham and Co.

The Reliance Building, 1891–4, Chicago

Designed by Charles Atwood, this building has always been seen as proto-Modernist in its lightness and lack of hierarchy. Without striving for the monumental, Atwood achieved a different kind of harmony through the use of materials—it is faced entirely with terracotta tiles—and the subtle handling of the simplest tectonic elements, such as the proportion of the windows and the dimensions of glazing mullions.

Roche (1853–1927), in the Monadnock Building (1884–91, a severe masonry structure, completely without ornament) by Burnham and Root, and in the Reliance Building (1891–4) by Burnham and Co., the floors were not grouped in a hierarchy but expressed as a uniform series, the loss of vertical thrust being compensated for by projecting stacks of bay windows. In the Reliance Building the cladding was of terracotta rather than stone and achieved an effect of extraordinary lightness [**22**].

It was Louis Sullivan's achievement to have synthesized these two antithetical types. If the palace type, as represented by the Auditorium Building, can be said to have had a weakness, it was that it did not reflect the programme, since, in fact, every floor had exactly the same function. The type represented by the Tacoma Building suffered from the opposite fault: the similarity of functions was expressed, but the building, being a mere succession of floors, was lacking in monumental expression. In the Wainwright Building in St. Louis (1890–2) [**23**] Sullivan subsumed the floors under a giant order rising between a strongly emphasized base and attic. At the same time he ignored the column spacing of the 'real' structure, reducing the spacing of the pilasters to the width of a single window. In doing this, he produced a phalanx of verticals that could be read simultaneously as columns and as mullions, as structure and as ornament, one of the effects of which was that the intercolumnation no longer aroused expectations of classical

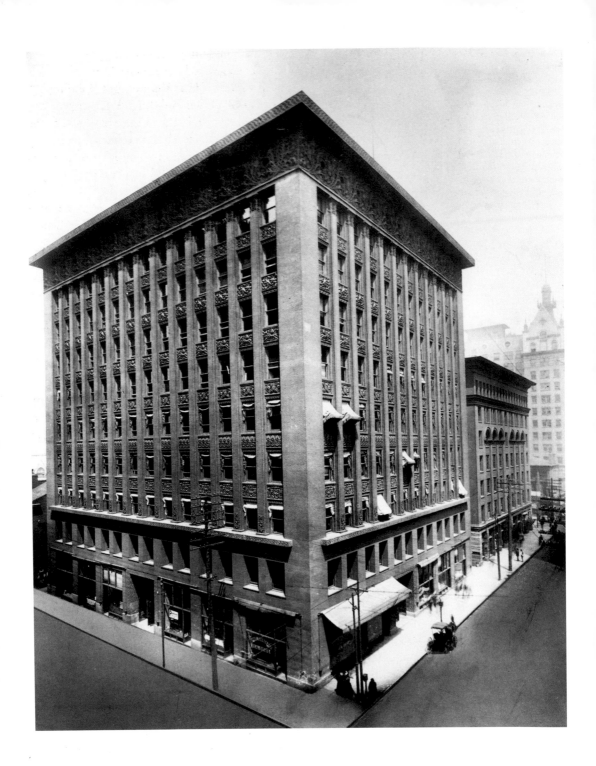

23 Dankmar Adler and Louis Sullivan

The Wainwright Building, 1890–2, St. Louis

The problem that Sullivan solved so brilliantly in the elevations of this building was that of reconciling the monumental classical façade with the 'democratic' repetition inherent in an office building.

proportion. This system was independent of the exact number of floors, though it would certainly not have worked visually in a building of radically different proportions from those of the Wainwright Building.[3]

In his essay entitled 'The Tall Office Building Artistically Considered' (1896), Sullivan claimed that the organization of the Wainwright type of building into three clearly stated layers, with their corresponding functions, was an application of 'organic' principles. In order to judge the validity of this claim, it will be necessary briefly to consider Sullivan's architectural theory, as found in his two books, *Kindergarten Chats* and *The Autobiography of an Idea*. More than any of the other Chicago architects, Sullivan had been influenced by the New England philosophical school of Transcendentalism. This philosophy, whose chief spokesman had been Ralph Waldo Emerson, was largely derived from German Idealism, into which Sullivan had been initiated by his anarchist friend John H. Edelman. The 'organic' idea can be traced back to the Romantic movement of around 1800—particularly to such writers as Schelling and the Schlegel brothers, who believed that the external form of the work of art should, as in plants and animals, be the product of an inner force or essence, rather than being mechanically imposed from without, as they judged to be the case with classicism.[4]

Those architectural theorists who, in their different ways, were heirs to this idea and to the concomitant notion of tectonic expression—such as Karl Friedrich Schinkel, Horatio Greenough, and Viollet-le-Duc—had acknowledged that, when applied to human artefacts, the concept of a 'natural' aesthetic had to be extended to include socially derived normative values.[5] Sullivan ignored this cultural factor and based his argument purely on the analogy between architecture and nature. But in practice he tacitly accepted customary norms. The Wainwright façade was derived from the tradition he so vehemently condemned—the classical–Baroque aesthetic enshrined in Beaux-Arts teaching. In 'correcting' the Chicago architects' mistaken interpretation of this tradition, he was, in fact, returning to the classical principle they had discarded: the need for the façade to have a tripartite hierarchy corresponding to the functional distribution of the interior.

The Wainwright Building can certainly be called a 'solution' to the problem of the Chicago office façade. But its very brilliance brought with it certain problems. The 'impure' solutions of the Chicago School, including Sullivan's own Auditorium Building, had the merit of presenting to the street a complex, contrapuntal texture capable of being read as part of a continuous urban fabric. The Wainwright Building, with its vertical emphasis and strongly marked corner pilasters, isolated itself from its context and became a self-sufficient entity, emphasizing the individuality of the business it both housed and represented. In this, it anticipated later developments in

24 Louis Sullivan

'The High Building Question', 1891

In this drawing, Sullivan attempted another reconciliation, this time between the demands of real estate and those of urban aesthetics. Human scale and a sense of order were maintained by establishing a datum at about eight to ten storeys and allowing random development above it.

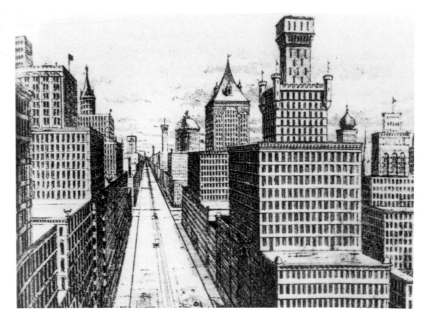

skyscraper design. However, Sullivan showed that he was aware of the danger to urban unity that this kind of solution implied when, in 1891, in the journal *The Graphic*, he sketched a hypothetical street of variegated skyscrapers united by a common cornice line [**24**].

All Sullivan's buildings depend to a greater or lesser extent on ornament, and in his theoretical writings he refers to ornament as an extension of structure. In a body of delicate drawings he developed an ornamental system of arabesques analogous to that of Horta, though denser and less fluid and more independent of the structure. This ornamentation is applied in large bands of terracotta, and contrasted with flat, unornamented surfaces, suggesting the influence of Islamic architecture, and also relating his work to the European Art Nouveau movement.

Sullivan was originally offered a partnership by Adler on the strength of his skill as an ornamentalist and designer of façades. Sullivan believed that the visible expression of a building spiritualized an otherwise inarticulate structure. Adler, on the other hand, thought that the façade merely gave the finishing touches to an organizational and structural concept. This difference of view, whether it shows Adler to have been the better organicist or merely more practical, seems to have given rise to a simmering conflict between the two men, and this is indirectly revealed in a statement made by Adler after the partnership had broken up (due to lack of commissions): 'The architect is not allowed to wait until, seized by an irresistible impulse from within, he gives the world the result of his studies and musings. He is of the world as well as in it.'[6]

Sullivan's catastrophic professional failure a few years after the

dissolution of the partnership was no doubt due to a complicated mixture of psychological, ideological, and economic factors. But already in the 1990s the climate of opinion in Chicago was changing. Architects no longer listened to the Transcendental message they had found so compelling a short time before, nor were they so interested in Sullivan's doctrine of the redemption of a materialistic society through inspired individual creativity. As was soon to be the case in Europe, individualism was giving way to a more nationalistic and collectivist spirit.

The World's Columbian Exposition

The turn towards classicism inaugurated by the Chicago World's Exposition of 1893 was related to a number of contemporary political and economic events in America. The most important of these were the change from *laissez-faire* to monopoly capitalism, the inauguration of the 'open-door' trade policy for a country now ready to take its place on the world stage, and the rise of a collectivist politics both mirroring and challenging the emerging corporatism of industry and finance. In *The Autobiography of an Idea*, Louis Sullivan was to recall these developments: 'During this period [the 1890s] there was well under way the formation of mergers, corporations, and trusts in the industrial world . . . speculation became rampant, credit was leaving terra firma . . . monopoly was in the air.' According to Sullivan, Daniel Burnham was the only architect in Chicago to catch this movement, because, 'in its tendency towards bigness, organization, delegation, and intense commercialism, he sensed the reciprocal workings of his own mind'. These developments were responsible for sounding the death knell of the philosophy of individualism that had inspired the Chicago School and been the basis of Sullivan's theory. Despite his own generalizing and typological propensities, Sullivan resisted the emerging tendency towards collectivism, standardization, and massification that Burnham welcomed so avidly.

Although Chicago was chosen as the site for the World's Fair because it was seen to represent the dynamism of the Mid-west, the fair's promoters were more interested in the creation of a national mythology than a regional one. They were looking for a ready-formed architectural language that could allegorically represent the United States as a unified, culturally mature, imperial power. According to Henry Adams, 'Chicago was the first expression of America thought of as a unity: one must start from there.'[7]

Planning for the World's Fair started in 1890, under the joint direction of Frederick Law Olmsted (1822–1903) (landscape) and Daniel Burnham (buildings). The site chosen was that of Olmsted's unbuilt project for the South Park System. It consisted of two parks—Jackson Park on the lake shore and Washington Park to the west—linked by a

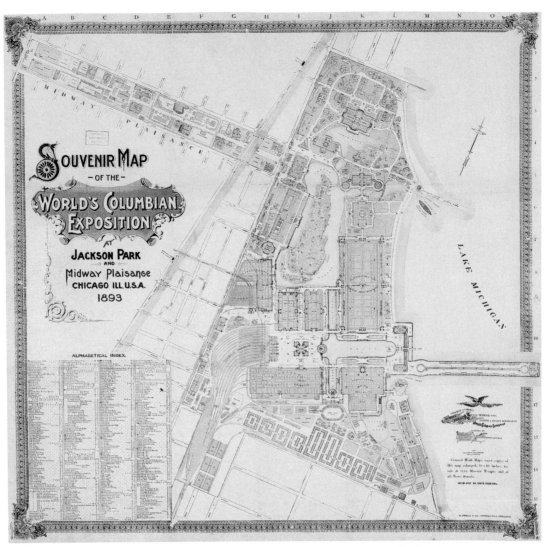

SOUVENIR MAP
- OF THE -
WORLD'S COLUMBIAN
EXPOSITION
AT
JACKSON PARK
AND
Midway Plaisance
CHICAGO ILL. U.S.A.
1893

ALPHABETICAL INDEX.

LAKE MICHIGAN

25 Daniel Burnham and Frederick Law Olmsted

World's Columbian Exposition, 1893, Chicago, plan showing Jackson Park and Midway Pleasance

Note the contrast between the classical regularity of the Court of Honor to the south and the picturesque irregularity of the lake development to the north.

long narrow strip called Midway Pleasance [**25**]. The core of the fair was Jackson Park, where all the American pavilions were sited. Midway Pleasance contained the foreign pavilions and amusements, while Washington Park was laid out as a landscape.

Jackson Park was conceived on Beaux-Arts principles. The Beaux-Arts system had already made inroads on the East coast by the mid-1880s. By ensuring that at least half the architects selected to design the pavilions came from the East the promoters signalled their support for classicism as the style of the fair's architecture.[8] This choice reversed the Chicago School's practice in two ways: it proposed first that groups of buildings should be subjected to total visual control, and second that architecture was a ready-made language rather than the product of individual invention in a world ruled by contingency and change.

Daniel Burnham had no difficulty in adjusting to these ideas.

Unlike Sullivan, he was able to see 'functionalism' as valid for a commercial architecture ruled by cost, and classicism as valid for an architecture representing national power and cosmopolitan culture. This theory of 'character' was shared by the brilliant young Harvard-trained architect Charles B. Atwood (1849–95), who had been hired to take the place of John Root, after Root's sudden death. Atwood was capable of designing the spare 'Gothic' Reliance and Fisher buildings, with their light terracotta facing, at the same time as the florid Baroque triumphal arch for the fair.

The plan of the Jackson Park site was a collaborative exercise in landscape and urban design. The visitor, arriving by boat or train, was immediately presented with the scenic splendour of the 'Court of Honor'—a huge monumental basin surrounded by the most important pavilions [26]. A second group of pavilions, with its axis at right angles to that of the Court of Honor, was more informally disposed round a picturesque lake. The pavilions themselves were huge two-storey sheds faced with classical–Baroque façades, built in lathe and plaster and painted white (hence the name 'White City' often given to the fair). The contrast between a strictly functional 'factory' space and a representative façade followed the international tradition of railway station

26 Daniel Burnham and Frederick Law Olmsted

The Court of Honor (demolished)

Apart from the style of the façades, what was new for Chicago about the Court of Honor was its embodiment of the Baroque concept of a visually unified group of buildings. In his plan for Chicago, Burnham was to combine this idea with the additive city grid.

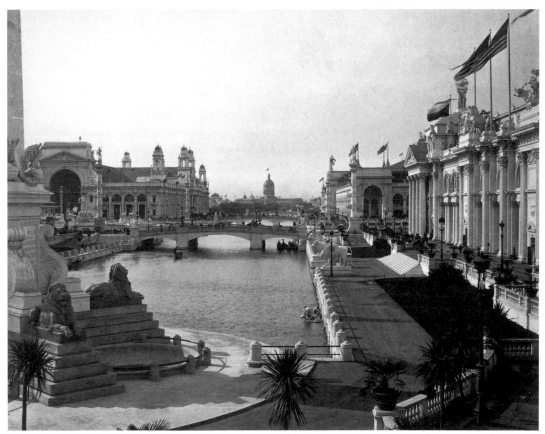

This was one of the many offices built in American cities after about 1910 that conformed to the new classical fashion of the City Beautiful movement.

design, and was to be revived in the 1960s by Louis Kahn at the Salk Institute in La Jolla within a Modernist idiom (see pages 248–54). Until the Paris Exposition of 1889, international exhibitions in Europe had favoured the display of new technologies in their buildings, but the Paris Exposition of 1900 marked a change to something more decorative and popular. The Chicago World's Fair, though it lacked the Art Nouveau aspects of the Paris Exposition and maintained an unremitting *pompier* style, anticipated this approach, differing only in its display of uninhibited kitsch (according to the original plan, authentic gondoliers were to be hired to navigate the basin).

The City Beautiful movement

The World's Fair initiated a wave of classical architecture in America. As the historian Fiske Kimball was to write in 1928: 'The issue whether function should determine form or whether an ideal form might be imposed from without, had been decided for a generation by a sweeping victory for the formal idea.'[9] One of the consequences of the fair was that, after the turn of the century, tall commercial buildings in America began to show increased Beaux-Arts influence. This can be seen in the evolution of Burnham's work. In his Conway Building in Chicago (1912) [27], and in many other examples, he followed Sullivan's clear tripartite division, but ornamented it with a classical syntax, often treating the attic as a classical colonnade, reducing the size of the windows in the middle section of the façade and playing down the expression of structure.

The World's Fair had a great effect on the 'City Beautiful' movement. The movement was triggered by the Senate Park Commission plan for Washington (the 'Macmillan Plan'), which was exhibited in 1902. Both Burnham and Charles McKim (1847–1909) were on the commission, and they were responsible for the design, which envisaged the completion and extension of Pierre Charles L'Enfant's plan of the 1790s. After this Burnham was asked to prepare many city plans, only a few of which—the plan for the centre of Cleveland, for example—were executed. The most spectacular of these was his plan for Chicago, prepared in collaboration with E. H. Bennett (1874–1945) [28].[10] The plan was financed and managed by a group of private citizens, and was the subject of an elaborate public relations campaign. Its most characteristic feature was a network of wide, diagonal avenues superimposed on the existing road grid in the manner of Washington and of Haussmann's Paris. At the centre of this network, there was to be a new city hall of gigantic proportions. Though never executed, the plan was to some extent used as a guide for the future development of the city. One enthusiastic critic, Charles Eliot, called it a representation of 'democratic, enlightened collectivism coming in to repair the

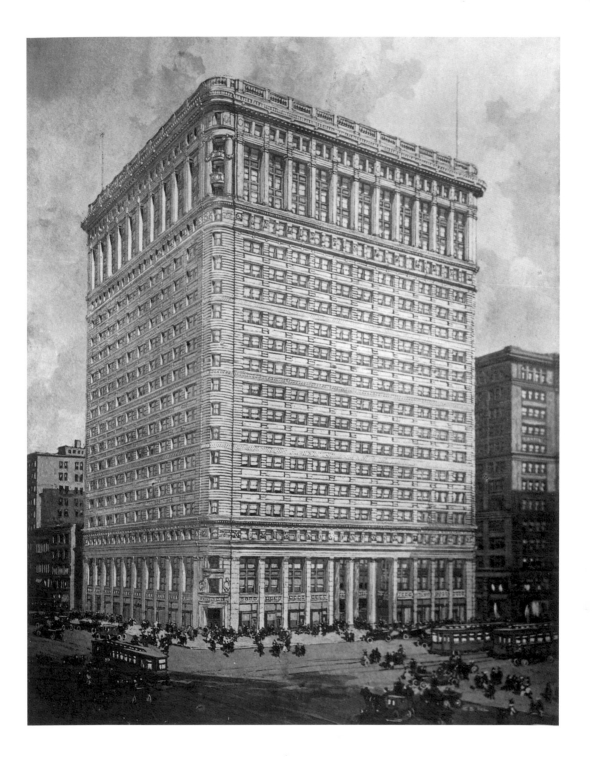

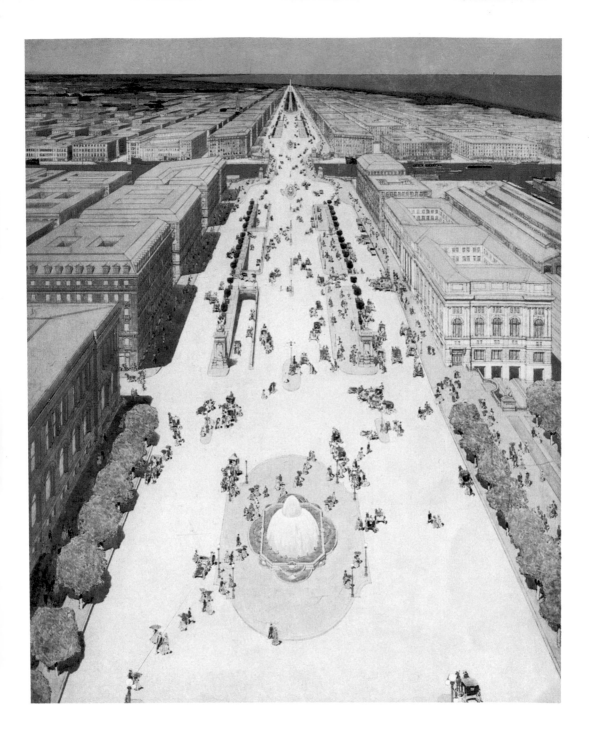

City plan for Chicago, 1909
This beautiful drawing by
Jules Guérin gives a clear
idea of the unprecedented
scale of the architects'
conception. The existence of
technical innovations such as
the underpass at the street
crossing should also be
noted.

damage caused by democratic individualism'.[11] Others criticized the plan because it neglected the problem of mass housing, leaving most of the city in the hands of the speculators.

But in spite of this apparent conflict between two incompatible concepts of city planning, one aesthetic and symbolic and the other social and practical, many social reformers, including the sociologist Charles Zueblin, supported the City Beautiful movement, claiming that the World's Fair had instituted 'scientific planning', stimulated efficient municipal government, and curbed the power of the bosses. It is clear that 'enlightened collectivism', with its rejection of *laissez-faire* and its stress on normative standards, was able to carry both conservative and progressive connotations. In Europe, where there was a simultaneous burst of planning activity, a reconciliation between the aesthetic and the social was consciously attempted. At the London Town Planning conference of 1910, the German planner Joseph Stübben claimed that planners in his own country had been able to combine the 'rational' French with the 'medieval' British traditions. Whether justified or not, this claim was only plausible within the context of the traditional European city. In America, the conceptual and physical split between living and work, the suburb and the city, made such a reconciliation impossible.

Social reform and the home

The reaction of intellectuals against the excesses of uncontrolled capitalism in 1880s America is represented by two Utopian texts: Henry George's *Progress and Poverty* (1880), which proposed the confiscation of all yield from increased land value, and Edward Bellamy's novel *Looking Backward* (1888), which described a future society based on a perfected industrial system, in which there was no longer any space between freedom and total political control (see pages 220–2: 'Systems theory'). A third text—Thorstein Veblen's *Theory of the Leisure Class* (1899)—is of particular interest, not only because Veblen taught at the University of Chicago in the 1890s, but also because his book advanced the theory that there was a conflict in capitalism between the production of money and the production of goods. This theory was to re-emerge in the 1910s in Germany as the rationalization of a position that was in favour of technology but against the market conditions of capitalism.[12]

Chicago was the centre of a vigorous social reform movement which reflected this anti-*laissez-faire* mood. Whereas the Transcendentalists had rejected the city as a corrupting influence, the Chicago reformists saw it as an essential instrument of industrialization, but one that needed to be domesticated. The Department of Social Sciences and Anthropology, which opened in 1892 in the University of

Chicago under the leadership of Albion Small, became an important centre of urban sociology, its wide influence continuing into the 1920s. The department and the institutions connected with it, such as the Department of Household Science at the University of Illinois, focused their attention on the nuclear family and the individual home in the belief that the reform of the domestic environment was the necessary first step in the reform of society as a whole. Thus, the design and equipment of the home became one of the key elements in a radical and wide-ranging social and political agenda.[13]

The problem of the home was addressed at two levels. Hull House, founded by Jane Addams in 1897, and the numerous settlement houses that it helped to set up, worked at the grass-roots level, providing domestic education to immigrant workers living in slum conditions. One of the essential ingredients of this education was training in the crafts, which was organized by the Chicago Arts and Crafts Society, also based at Hull House. Classes and exhibitions in cabinet-making, bookmaking, weaving, and pottery were set up. Some small workshops were founded, but much of the furniture was made by commercial manufacturers, sometimes, but not always, under the supervision of outside designers. The work was promoted by mass-circulation magazines like the *Ladies' Home Journal* and *The House Beautiful* and sold by mail order. Low income groups were targeted, and the furniture was mass produced. In design, it was somewhat heavier and simpler than contemporary Arts and Crafts furniture in England and Germany, tending towards the geometrical forms in the work of Hoffmann and Mackintosh, but without their hand-crafted refinement.

At a more theoretical level, the problem of the modern home was analysed in the department of Social Sciences and the closely affiliated Home Economics group. This nationwide movement had its epicentre in Chicago and one of its leading figures, Marion Talbot, taught at the Department of Social Sciences. The movement was strongly feminist and sought to revolutionize the position of women, both in the home and in society. According to the Home Economics group there was an imperative need to rethink the house in the wake of rapid urbanization and inventions such as the telephone, electric light, and new means of transport. The home should be organized according to Frederick Winslow Taylor's principle of scientific management. The more radical members of the group, like the Marxist Charlotte Perkins Gillman, argued against the nuclear house and advocated the socialization of eating, cleaning, and entertainment in serviced apartment buildings, but generally the group accepted the nuclear house.

In matters of design the Home Economics group followed William Morris in his belief that the house should contain nothing but useful and beautiful objects. But they also believed in mass production and the use of new, smooth materials, invoking the railroad-car buffet and

the laboratory as models for the design of kitchens, and stressing the importance of sunlight, ventilation, and cleanliness. They coined the word 'Euthenics' to describe the science of the controlled environment, a word evidently intended to rhyme with Eugenics. They called for standardization at all levels of design, attaching great importance at the urban level to the design of groups of identical houses—order and repetition being thought to make a harmonious and egalitarian community.[14] In this, their views were not unlike those of the City Beautiful movement, with its preference for classical anonymity in the planning of unified groups.

Frank Lloyd Wright and the Prairie School

The Prairie School was a closely knit group of young Chicago architects continuing to design houses in the organicist tradition under the spiritual leadership of Louis Sullivan, and active between 1896 and 1917. The group included, among others, Robert C. Spencer, Dwight H. Perkins, and Myron Hunt. The group was closely associated with Hull House and the Arts and Crafts Society. Some of the original group later reverted to eclecticism—notably Howard Van Doren Shaw (1869–1926), whose work resembles that of the English architect Edwin Lutyens in its simultaneous allegiance to the Arts and Crafts and to eclectic classicism.[15]

The most brilliant member of the group was Frank Lloyd Wright. He, more than any of the others, was able to forge a personal style that embodied the group's common ambitions. Wright's natural talent was stimulated and guided by the theory of 'pure design', which was the subject of lectures and discussions at the Chicago branch of the Architectural League of America around 1901.[16] This concept was promoted by the architect and teacher Emil Lorch, who had transferred to architecture the geometrical principles of painting and design taught by Arthur Wesley Dow at the Museum of Fine Arts in Boston. According to this theory, there were fundamental ahistorical principles of composition, and these principles should be taught in schools of architecture.[17] This idea was a commonplace of late-nineteenth-century and early-twentieth-century art and architectural theory in Europe in academic as well as avant-garde circles.[18] Although it was antagonistic to eclecticism, its promotion of systematic design theory in architectural schools was probably due to the example of the Beaux-Arts.

Wright's houses show the influence of this theory [**29, 30**]. Their plans are geometrically more rigorous than anything being built in Europe at the time. They also share with the work of Mackintosh, Olbrich, and Hoffmann (see pages 28–9) a geometrical stylization of ornament, but go further in the abstraction of the elements of wall and

roof, which lose their conventional associations and are reduced to a system of intersecting and overlapping planes. The plans of Wright's houses consist of an additive system of simple volumes interlocking with or relating freely to each other in a way that resembles the Arts and Crafts tradition. However, not only is there greater continuity between one space and another than can be found in the English movement, in which the traditional room remains dominant, but the plans exhibit a geometrical order which stems from Beaux-Arts rather than English sources. At the macro scale, the plans tend to develop along the two orthogonal axes, crossing at a central hearth and reaching out into the surrounding landscape, while at the micro scale there are carefully controlled local symmetries and sub-axes, showing the influence of the Beaux-Arts-trained H. H. Richardson. Internally, as in the houses of Voysey, Mackintosh, and Hoffmann, the rooms are unified by low cornices at door-head level. But in Wright's work these have the effect of compressing the vertical dimension, producing a primitive, cave-like sensation [**31**].

The system of ornament consists of dark-stained wood trim, recalling that of Mackintosh and Hoffmann. Electric light and ventilation fittings are absorbed into the general ornamental unity. 'Art' still dominates, but it is now produced by the machine, not by the craftsman, and is totally controlled by the architect working at his drawing-board [**32**]: 'The machine . . . has placed in artist hands the means of idealizing the true nature of wood . . . without waste, within reach of all.'[19]

In fact, Wright came early on to the conclusion that mass production was necessary if good design was to be democratically enjoyed. In 1901 he gave a lecture at Hull House entitled 'The Art and Craft of the Machine' in which he argued that the alienation of the craftsman due to machine production would be outweighed by the artist's ability to create beauty with the machine—an anti-Ruskinian argument that would soon be taken up within the Deutscher Werkbund in its support of machine work as opposed to handwork. This philosophy was completely consistent with Wright's search for universal laws of design, with its privileging of the artist over the craftsman.

Yet Wright's position on industrialization was ultimately ambivalent. It was poised between an endorsement of 'that greatest of machines', as he called the industrial city, and a nostalgic image of the American suburb as a new Arcadia uncontaminated by industrialism. This conflict was reflected in his daily life, divided between his radical friends at Hull House and the suburb of Oak Park where he practised and lived with his young family, and where his neighbours were the practical-minded businessmen who commissioned his houses.[20] This enormously creative and influential phase of Wright's life came to an abrupt end when in 1909, at the age of 42, he abandoned Oak Park,

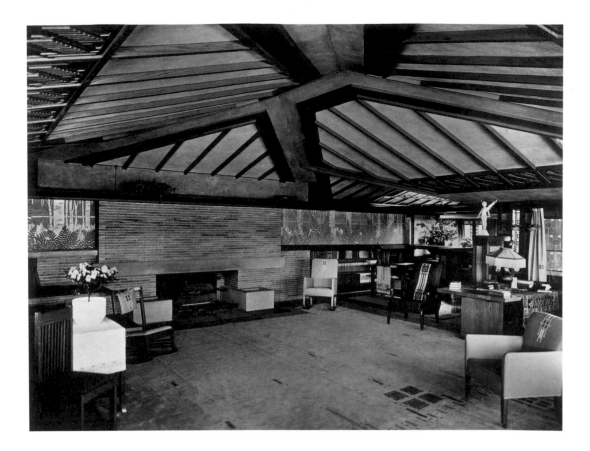

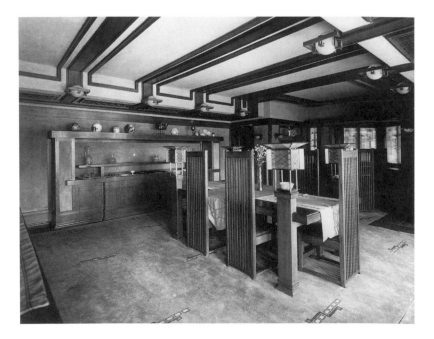

his family and his architectural practice, having concluded that the unity between art and life that he craved was not possible in the suburb.

Montgomery Schuyler, in his anticipation of an American architecture, had been concerned with public and urban buildings, whether they took the form of cultural representation or organic expression. Frank Lloyd Wright, working within the tradition of the Arts and Crafts movement, turned away from such problems to concentrate mostly on the private house, the nuclear family, and the small community. Reviving dreams of the frontier, he sought, more passionately than any of his colleagues, to create a regional Mid-western domestic architecture of rural innocence.

It was the formal skill with which Wright deployed an abstract and astylar architecture that impressed the European avant-garde architects when his work was published in Germany by Wasmuth in 1910, at the moment when they were searching for a formula that would free them from traditional forms. But with this abstraction came an architecture that was primitivist, regionalist, and anti-metropolitan. Through the influence of Frank Lloyd Wright, international Modernism had at least one of its roots in the regional and democratic concerns of the American Mid-west and in the organicist theories of its architects.

Culture and Industry: Germany 1907–14

3

The international reform movement in architecture and the industrial arts was accompanied in Germany by special historical circumstances. In the German-speaking world, a self-image had begun to take shape in the second half of the eighteenth century in opposition to French cultural hegemony and Enlightenment universalism. The consciousness of a specifically German *Kultur*, as distinct from French-derived *Zivilisation*, was reinforced during the Napoleonic wars. The effect of this was to intensify the search for cultural identity, but at the same time to act as a powerful incentive to modernization. Romanticism and Rationalism coexisted, sometimes in mutual reinforcement, sometimes in opposition. Modernization increased its pace after the unification of Germany's many states into the German Empire in 1871. But by the 1890s there was already widespread disappointment with its cultural results, and the beginning of an anti-liberal, anti-positivist backlash. This tendency mirrored similar tendencies in Europe as a whole, but in Germany it brought to the surface a latent ideology of the *Volk*.[1] According to the writer Julius Langbehn (1851–1907) modern civilization, especially that of America, was without roots. In his best-selling book *Rembrandt als Erzieher* (*Rembrandt as Educator*, Leipzig, 1903), he argued for a return to the rooted culture of the German *Volk*, the spirit of which he saw as embodied in the paintings of Rembrandt. The social philosopher Ferdinand Tönnies (1856–1936), in his book *Gemeinschaft und Gesellschaft* (roughly: *Community and Society*, Leipzig, 1887), drew attention to the ancient German forms of association, which were being replaced by modern industrial forms of association or 'companies'.

In fact, the movement for artistic reform in Germany was, from the start, deeply involved in the question of national identity. Those participating in the movement were caught between a desire to return to their pre-industrial roots and an equally strong impulse towards modernization as the necessary condition of competing commercially with the Western nations.

33 Peter Behrens
AEG Turbine Factory, 1908–9, Berlin
The literal use of steel structure in the interior is a complete contrast with the monumental expression of the exterior.

57

The Deutscher Werkbund

At the beginning of the twentieth century in Germany, the chief agent of artistic and cultural reform was the Deutscher Werkbund, which grew out of the German Arts and Crafts (Kunstgewerbe) movement. Many local reform groups had emerged since the onset of the Arts and Crafts movement in the late 1890s, including Alfred Lichtwark's Art Education Movement (1897), Ferdinand Avenarius's Dürerbund (1902), and the Bund Heimatschutz (1904).[2] In addition, a number of workshops modelled on the English guilds had been founded, the most successful of which were the Munich-based Vereinigten Werkstätte (see page 62) and the Dresdner Werkstätte, both of which, unlike their English counterparts, were making semi-mass-produced furniture from their inception.

The Deutscher Werkbund was founded in Munich in 1907 to consolidate these separate initiatives and accelerate the integration of art and industry at a national level. The chief moving spirits behind its foundation were the Christian Socialist politician Friedrich Naumann (1860–1919), the director of the Dresdner Werkstätte Karl Schmidt, and the architect–bureaucrat Hermann Muthesius (1861–1927). Initially 12 architects and 12 companies were invited to join. The architects included Peter Behrens (1868–1940), Theodor Fischer (1862–1938), Josef Hoffmann, Joseph Maria Olbrich, Paul Schultze-Naumburg (1869–1949), and Fritz Schumacher (1869–1947). Most of the companies were manufacturers of domestic furniture and equipment, but two printers, a type founder, and a publisher were also included. All these firms withdrew from the existing conservative and commercially motivated Alliance for German Applied Arts to join the new organization and in so doing committed themselves to working with named architects.

The Werkbund's orientation towards high-quality goods for mass consumption is clear from a speech given by Naumann in 1906: 'Many people do not have the money to hire artists, and, consequently, many products are going to be mass produced; for this great problem, the only solution is to infuse mass-production with meaning and spirit by artistic means.'[3] Speaking at the inaugural meeting of the Werkbund in Munich, Fritz Schumacher, professor of architecture at the Dresden Technische Hochschule and director of a highly successful Arts and Crafts exhibition in Dresden in 1906, stressed the need to bridge the gap between artists and producers that had developed with machine production:

The time has come when Germany should cease to look on the artist as a man who . . . follows his inclination, and rather see him as one of the important powers for the ennobling of work and therefore for the ennobling of the entire

life of the nation, and to make it victorious in the competition among peoples . . . there is in aesthetic power a higher economic value.[4]

Despite this well-defined programme, the membership of the Werkbund represented a wide range of opinion. The organization's main areas of activity were: general propaganda (publishing, exhibitions, congresses); the education of the consumer (lectures, window dressing competitions, and so on); and the reform of product design (for example, persuading industrialists to employ artists).[5]

Form or *Gestalt*

The need to assimilate the machine to the artistic principles of the Arts and Crafts movement entailed a reconceptualization of the role of the artist. Morris's conception of the artist–craftsman as someone physically involved with materials and functions gave way to that of the artist as 'form giver'. The new concept was put forward at the Werkbund congress of 1908 by the sculptor Rudolf Bosselt, and reaffirmed by Muthesius in 1911.[6] Both asserted that, in the design of machine products, 'form' or *Gestalt*[7] should take precedence over function, material, and technique, which had been stressed by the Arts and Crafts and Jugendstil movements. Curiously enough, this idea did not originate in the context of the debate on art and industry, but in the field of aesthetics. It was the product of a century-long history of aesthetic thought, beginning with Immanuel Kant's isolation of art as an autonomous system, and culminating in the theory of 'pure visibility' (*Sichtbarkeit*) propounded by the philosopher of aesthetics Conrad Fiedler.[8]

Muthesius and the notion of type

Closely connected with the idea of *Gestalt* was Muthesius's concept of *Typisierung* (typification)—a word he coined to denote the establishment of standard or typical forms.[9] His argument was the apparently trivial one that mass production entails standardization. But, relying on the ambiguity inherent in the word 'type', Muthesius conflated a pragmatic notion of standardization with the idea of the 'type' as a Platonic universal. Only through typification, he said, 'can architecture recover that universal significance which was characteristic of it in times of harmonious culture'.[10]

Muthesius's concept of a unified culture was an attack on *laissez-faire* capitalism, though not on monopoly capitalism. For him, and for many within the Werkbund who shared his views, the degeneration of modern taste was due not, as Ruskin had thought, to the machine as such, but to the cultural disorder caused by the operation of the market, and the destabilizing effect of fashion. If the middle-man who manipulated the market could be eliminated it would be possible to

recover the direct relationship between producer and consumer and between technique and culture, that had existed in pre-capitalist societies. Muthesius foresaw the emergence of large factories for the production of consumer goods similar to the trusts and cartels that were becoming increasingly characteristic of German heavy industry. These firms, producing goods of standardized artistic quality, would be able to dominate the market and act as the sole arbiters of taste, operating as the modern equivalent of the medieval guilds.[11]

When Muthesius presented his notion of *Typisierung* at the Werkbund congress of 1914 at Cologne it was strongly criticized by a group of artists, architects, and critics which included Van de Velde, Bruno Taut (1880–1938) and Walter Gropius (1883–1969). Van de Velde, though a passionate disciple of William Morris, did not question the need for machine production, nor did he disagree with the notion of a unified culture. But he disagreed with the bureaucratic methods proposed by Muthesius. For him and his supporters, culture could not be created by the imposition of typical forms. High artistic quality depended on the freedom of the individual artist. Fixed types did indeed emerge in all artistic cultures, but they were the end-products of an evolutionary process of artistic development, not its initial condition. Muthesius had simply reversed the order of cause and effect. This celebrated conflict has usually been interpreted as a battle between the avant-garde supporters of a new machine culture and the regressive supporters of an outdated handicraft tradition. The truth is more complex, and to understand the situation it is necessary to disentangle the confusion that reigned at the time as to the status of the 'artist' in the modern industrial arts.

The debate between Van de Velde and Muthesius cannot be seen merely as the conflict between handicraft and the machine (though it was this as well) since the ambiguous figure of the 'artist' appears as chief protagonist on both sides. Both groups believed that, under conditions of machine production, division of labour had separated technique from art and that it was necessary to reintroduce the artist into the production process. They differed, however, in their interpretation of role that the artist would now play. Insofar as he saw the artist as a specialist in 'pure form', divorced from the mechanics of craft (now the domain of the machine), Muthesius's position seems 'progressive', seeking to adapt the artist to the abstract processes of capitalism. But Van de Velde's concept of the evolutionary process of style formation was more compatible with the conditions of market capitalism, and in that sense more 'modern' than Muthesius's bureaucratic model. To what extent Van de Velde, with his strongly held socialist views, grasped the connection between the artistic freedom he was proposing and the marketplace is an intriguing question, but the connection is clearly reflected in the writings of his patron and supporter, Karl Ernst Osthaus.[12]

Originally Muthesius had also held to this concept of the individualistic artist. For example, he had been in favour of the law of 1907 which gave the applied artist the copyright protection that was already enjoyed by the fine artist.[13] But some time between 1907 and 1910 he seems to have moved towards the idea that the artist should not seek originality, but should be the conduit for universal aesthetic laws, a view that was in line with the prevalent neo-Kantian aesthetic philosophy. Muthesius now argued that there was a kinship between the law-like stability and anonymity of the classical and vernacular traditions on the one hand, and the repetitiveness, regularity, and simplicity of machined forms on the other. Machined forms were the modern, historical instance of a universal law. Though this idea did not exclude the artist, it did demand that the personality of the artist should be controlled.[14]

Muthesius sought to implement these ideas by creating an organizational framework within which future artists would have to work, thus reverting to archaic processes similar to those that Karl Friedrich Schinkel had adopted when commissioned to 'normalize' the rural architecture of Prussia a century earlier. In Muthesius, therefore, we see the fusion of two ideologies, the one bureaucratic and nationalistic, the other classicizing and normative. Though it is difficult to say at what level these ideologies are, in fact, connected, they appear to have been inseparable within the context of architectural discourse in the years leading up to the First World War in Germany. It was a combination that took a particularly explosive form in Germany, but it was also present, in differing regional forms, in America, England, and France.

Style and ideology

Another aspect of the battle between Muthesius's concept of type and the spontaneity demanded by Van de Velde must now be addressed. The standardization required by machine production was seen to reconcile modernity with classical humanism. But the demand for the freedom of the artist was also associated with a Nietzschian, Dionysian, anarchistic urge not to try to tame the disorder of modernity but to plunge into its terrifying and nihilistic stream. These different attitudes correspond to two groups of architects. Among the classicizing group, two will be discussed here—Heinrich Tessenow (1876–1950) and Peter Behrens—and their work will be compared to that of the young Walter Gropius, who was poised between the two groups. Discussion of the opposite camp, the Expressionists, belongs to a later chapter.

Heinrich Tessenow

One of Heinrich Tessenow's major concerns was mass housing and the problem of repetition. He studied this issue in the context of the

English Garden City movement, which had had a great influence on the German Arts and Crafts. Most of the leading architects of the day were similarly involved. Behrens, Riemerschmid, Muthesius, as well as Tessenow, designed groups of houses for Karl Schmidt's workers' settlement of Hellerau, just outside Dresden. These architects were influenced by the medieval models advocated by Camillo Sitte (see page 28) and continued by the Garden City movement. But this influence was modified by that of Paul Mebes, whose popular book *Um 1800*, which appeared in 1905, advocated a return to the classical Biedermeier tradition of the early nineteenth century as the last instance of a unified German culture. As we have seen, a similar shift towards the classical occurred in the furniture designed by the Vereinigten Werkstätte (see page 58). This tendency was not restricted to Germany. For example, in the last years of the Arts and Crafts movement in England, there was a similar return to what might be called the 'classical vernacular' of the eighteenth century (commonly known as 'Georgian'), which was seen to represent 'form' and 'proportion' as opposed to 'detail' (though, characteristically, this development was not theorized to the extent that it was in Germany).[15]

Tessenow's housing projects were supported by a social theory that romanticized the petite bourgeoisie as the foundation of traditional German social order, and his fastidious drawings conjure up a lost world of neat Biedermeier innocence. He visualized small towns of between 20,000 and 60,000 inhabitants, with a handicraft industry accommodating a maximum of ten artisans per workshop. Tessenow's rejection of industrial civilization was hardly less extreme than Ruskin's, though his preference for classical forms is very un-Ruskinian [34].

Besides housing, Tessenow built the main 'cultural' building in Hellerau—Jaques Dalcroze's school of eurhythmics (1911–12) [35]. The

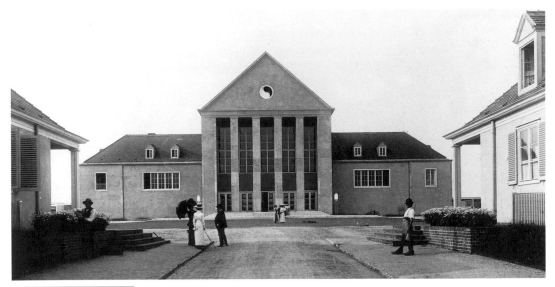

35 Heinrich Tessenow

Dalcroze Institute, 1911–12, Hellerau

Front view, showing the relation between the temple-like auditorium and the side wings. The rather steep pediment illustrates Tessenow's attempt to fuse German and Latin prototypes.

36 Heinrich Tessenow

Dalcroze Institute, 1911–12, Hellerau

This photograph of a dance performance taking place on the stage of the Dalcroze Institute, shows an abstract, rather neo-Grec set by Adolphe Appia. Note the close relationship between the architecture of the set and the formal patterns created by the dancers.

main space in this building was a rectangular auditorium, providing a neutral background for the severely neoclassical stage-sets of the Swiss designer Adolphe Appia [**36**]. Externally, the building itself was neo-classical, though in the final design the residential wings were given a more vernacular, *Heimat*-like appearance, with steep roofs which sit rather incongruously with the Greek portico of the central building. Another aspect of Tessenow's work becomes apparent in the Hellerau school: a quality of abstraction and formal purity that anticipates the work of Mies van der Rohe and corresponds to the Greek spirit of Appia's stage-sets and Dalcroze's choreography.

Peter Behrens

Behrens began as a painter associated with the Munich Secession of 1893. He was a founding member of the Darmstadt artists' colony where in 1901 he built the only house not designed by Olbrich (see page 30). His approach to art and architecture was deeply tinged with the Symbolism that characterized the German secessionist movements. His mystical leanings had already shown themselves when he collaborated in organizing a highly ritualistic inaugural ceremony at the Darmstadt colony with Georg Fuchs, one of the leaders of theatrical reform in Germany. One of the crucial turning points in Behrens's architectural career came during his directorship of the School of Arts and Crafts at Düsseldorf between 1903 and 1907, where he was influenced by the Dutch architect J. L. M. Lauweriks and became interested in the mystical–symbolic implications of geometry.[16] This marked his rejection of Jugendstil in favour of classicism in a move that paralleled the emergence of the idea of *Gestalt* within the Werkbund.

37 Peter Behrens

AEG Pavilion, Shipbuilding Exposition, 1908, Berlin
This octagonal pavilion was a fusion of neo-Grecian and Tuscan proto-Renaissance stylistic elements. Its centralized, baptistery-like plan is often found in German exhibitions before the First World War.

In 1907, outlining the programme of the Düsseldorf School, he wrote: 'The . . . school seeks mediation by going back to the fundamental principles of form, to take root in the artistically spontaneous, in the inner laws of perception, rather than in the mechanical aspects of work.'[17]

From 1905 onwards, Behrens designed a number of buildings in a geometrical Tuscan Romanesque style. These included a crematorium at Hagen (1905) and the Allgemeine Elektricitäts-Gesellschaft (AEG) Pavilion for the Shipbuilding Exposition in Berlin (1908) [37], as well as a series of neoclassical villas such as the Cuno House at Hagen-Eppenhausen (1908–9) and the Wiegand House in Berlin (1911). But the climax of this classical phase of Behrens's career was his design for the huge AEG Turbine Factory in Berlin (1908–9). Behrens was appointed design consultant for the electrical giant in 1907 and was responsible for all AEG's design work, including logos, consumer products, and buildings—a perfect example of Muthesius's ideal of collaboration between the artist and big industry [38]. The Turbine Factory [39], designed in collaboration with the engineer Karl Bernhard, was the first and the most symbolically loaded of a series of industrial buildings that Behrens was to build on AEG's huge Berlin-Maboit site between 1908 and 1912. Behrens's buildings for AEG reflect his faith in the ennobling effect of art on technology. He claimed that the architecture of the machine age should be based on classicism—that in an age of speed the only appropriate buildings would be those with forms as distinct as possible, with quiet, flush surfaces.[18] His critics pointed out that his own buildings reflected

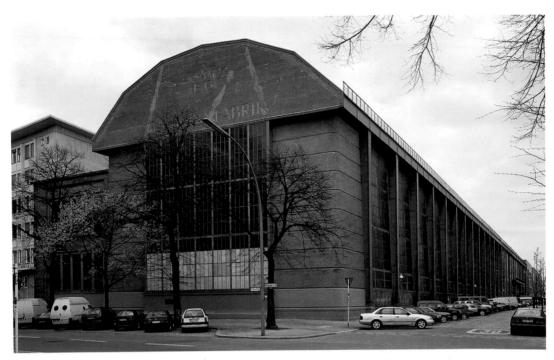

39 Peter Behrens

AEG Turbine Factory, 1908–9, Berlin

This building is striking for its optical effects, including the use of battered walls and solid steel columns diminishing towards their base. The steel columns present their maximum profile when seen in diagonal perspective.

immobility and mass rather than speed,[19] and indeed it seems that Behrens was suggesting a form of resistance to, rather than an acceptance of, the modern metropolis—that metropolis which for the philosopher and sociologist Georg Simmel (1858–1918) was characterized by 'the intensification of nervous stimuli resulting from a rapid and uninterrupted succession of impressions'.[20]

Certainly, another Symbolism than that of the fleeting and ephemeral is at work in the Turbine Factory. Here Behrens set out to spiritualize the power of modern industry in terms of an eternal classicism. The basic metaphor at work is the factory as Greek temple. The corner site makes possible a diagonal approach allowing the observer to view front and side elevations simultaneously, as in the case of the Parthenon. The metaphor is elaborated with great plastic skill. Behrens establishes two simultaneous systems, an outer columnar one, and an inner one of surface. An 'order' of steel stanchions, resting on giant hinges [**40**], takes the place of the temple colonnade, in a direct metonymic displacement. The continuous side glazing, made opaque by a close pattern of glazing bars [**33** (see page 56)], is inclined to the same slope as the inner face of the stanchions, giving a rather Egyptian effect. This is continued in the corner buttresses, their mass further emphasized by deep horizontal striations [**41**]. These buttresses create an effect of classical mass and stability but in fact they are only thin membranes and perform no structural role whatever. Moreover, even their apparent structural role is undermined by the projecting central window, which appears to be supporting the pediment. Because of this

and other discrepancies between appearance and reality the two systems that Behrens tries to synthesize—technical positivism and classical humanism—remain stubbornly separate. Yet, paradoxically, the building has a majestic calm, and is a very effective representation of industrial power.

Walter Gropius and the Fagus Factory

Gropius had worked for Behrens between 1910 and 1911 and had absorbed many of his ideas, but he was 15 years younger—a gap large enough to explain certain ideological differences. For example he was more concerned than Behrens with the social implications of machine production, realizing that it meant the irretrievable separation of artistic conceptualization and the production process, and that the relationship between the craftsman and his own products would henceforth be that of consumer not producer. In an address entitled 'Kunst und Industriebau' given at the Volkwang Museum at Hagen in 1911, Gropius tried to suggest a socially acceptable solution to this problem:

Work must be established in palaces that give the workman, now a slave to industrial labour, not only light, air, and hygiene, but also an indication of the great common idea that drives everything. Only then can the individual submit to the impersonal without losing the joy of working together for that common good previously unattainable by a single individual.[21]

In exchange for being alienated from the end product of their work, workers, as consumers, are offered a transcendental collective experience. This idea, which had been aired a few years earlier by Frank Lloyd Wright (see page 53) was to be given a philosophically more sophisticated formulation by the architect and critic Adolf Behne in the 1920s.[22] But through the mists of a rather confused rhetoric one glimpses the troubled social Utopianism that was to throw Gropius into the camp of the anti-technological Expressionists at the end of the First World War. For the moment, however, Gropius did not doubt that the machine could be spiritualized by means of art, and advocated an architecture of technical rationalism, even presenting to Emil Rathenau, director of AEG,[23] a memorandum on the rationalization of the housing industry.[24]

Why, then, was Gropius the most implacable of all Muthesius's critics at the Cologne congress? The answer must lie in the ambiguous nature of the concept of 'totalization' to which both he and Muthesius subscribed. Both believed that the artist (or the architect-as-artist) was now an intellectual charged with the task of inventing the forms of the machine age, considered as a cultural totality. But for Gropius it was precisely this totalizing, legislative, quasi-ethical role that demanded that the artist should remain free of political interference. Only the best and the most original ideas would be worthy of mechanical reproduction. In this, Gropius was at one with Van de Velde. He violently rejected the idea of the control of artistic conceptualization by the state bureaucracy or its proxy, big business, which was being promoted by Muthesius. But at the level of theory Gropius's position

was no different from that of Behrens in its postulation of two realms, one of which—nature–technology—would be transfigured by the other—spirit (*Geist*).

In Gropius's architecture, however, there is something new, and we can get some idea of it if we compare his Fagus Factory (1911–12) [**42, 43**] at Alfeld an der Leine, built in collaboration with Adolf Meyer (1881–1929), with Behrens's Turbine Factory. Much of the difference between the two buildings can be attributed to their radically different programmes. Gropius and Meyer's small, provincial shoe-last factory—or rather its administrative wing, which was the only part of the factory complex over which the architects had full control—could hardly be said to invoke the world-historical themes of Behrens's factory, built in the nation's capital for one of Germany's most important cartels. Yet it was precisely the Fagus Factory's modesty and lack of symbolic charge that enabled Gropius to follow his more down-to-earth agenda and to produce a work which would come to be seen as prophetic of the 'objective' (*Sachlich*) Modern Movement of the 1920s.

Not that the building lacks optical tricks. But it no longer makes any of Behrens's grandiose symbolic claims. Gropius starts with Behrens's projecting bay window and recessed, tilted masonry as his main motifs, but transforms them. The tilt is now, it seems, a pragmatic (though probably expensive) solution, by means of which the brick piers can appear to be recessed without the glazing unit having to be cantilevered out at its sill. Whereas Behrens rhetoricizes his repeating columns, giving them maximum corporeality to create the effect of classical monumentality, Gropius tries to make his necessarily massive brick piers disappear, so that the main façade of his building looks as if it is made entirely of glass. Whereas Behrens strengthens his corners with illusionistic buttresses, Gropius voids his with real transparency. Whereas Behrens impressionistically rounds his corners, Gropius sharpens his with the precision of a surgeon's knife-cut. Finally, whereas the Turbine Factory abounds in overt classical references, the classicism of the Fagus Factory is discreet and abstract—a matter of geometry.

But though the Fagus Factory can thus be read off against the Turbine Factory, it is not simply a mannerist inversion; it has its own agenda. Its illusionism, though still owing something to Behrens, is a matter of bringing out the transcendent qualities of materials—particularly glass with its mystical connotations (see the discussion of glass symbolism on page 92)—rather than working against the nature of materials as Behrens often did. In this Gropius was truer to the 'functional' tradition of Jugendstil, even though he jettisoned most (if not all) of its craftsman-like individualism. In the Fagus factory, materiality and form are synthesized in a new way—a way that seems to show the influence of the American factories that Gropius had illustrated

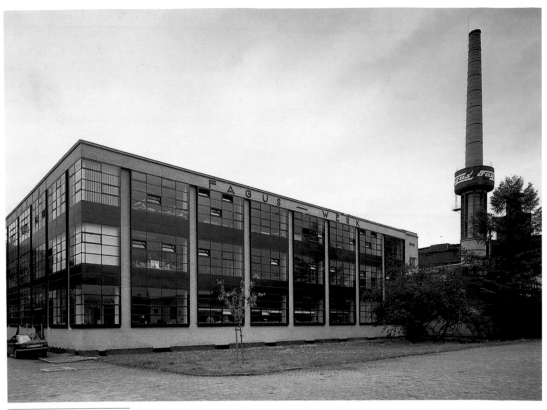

42 Walter Gropius and Adolf Meyer

Fagus Factory, 1911–12, Alfeld an der Leine
South-east façade, administration wing. This building is a kind of polemical reversal of Behrens's Turbine Factory. There the glass surface slopes back and is recessed behind the solid structure. In the Fagus Factory the structure slopes back and the glass projects in front of it. The negative becomes positive, empty space becomes palpable.

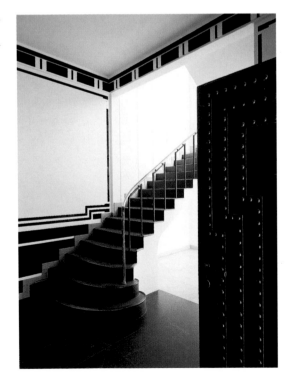

43 Walter Gropius and Adolf Meyer

Fagus Factory, 1911–12, Alfeld an der Leine
Entrance lobby. Note vestiges of Jugendstil decoration.

while editing the *Jahrbuch des Deutschen Werkbundes*. In Gropius's attitude to design, art and pragmatism seem to coexist, and this is reflected in a theoretical position that sees no contradiction between *Typisierung* and the continuing role of the individual artist–architect. In this—and despite his connections later with Expressionism, which will be discussed in chapter 5—Gropius's work was prophetic of the new architectural discourse that was to emerge in Germany around 1923.

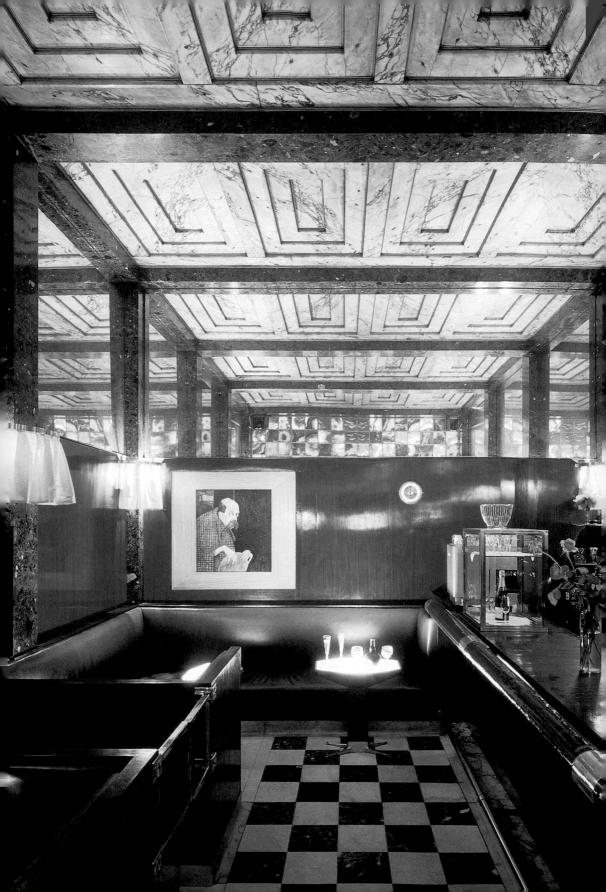

The Urn and the Chamberpot: Adolf Loos 1900–30

4

Adolf Loos (1870–1933) occupies a unique place in the history of modern architecture. A maverick who refused to join any 'club', he was not only a powerful thinker able to expose the contradictions of contemporary theory but an architect whose work, though small in output, was provocative and highly original. His influence on the succeeding generation of architects, particularly Le Corbusier, was enormous, and his ideas have, through successive reinterpretations, maintained their relevance to the present day.

The son of a stonemason, Loos was born in Brno, Moravia, and studied at the Imperial State Technical College in Vienna, and the Dresden College of technology. In 1893 he travelled to America, where his uncle had emigrated, visiting the Columbia World's Fair and eventually starting a small practice in New York before returning to Austria in 1896. As a result of this experience, he was to retain a lifelong admiration for Anglo-American culture.

Although he belonged to the same generation as the main figures of the Art Nouveau and Jugendstil movements, Loos reacted strongly against their attempt to replace Beaux-Arts eclecticism with what he saw as a superficial system of ornament. He was not, of course, alone in his rejection of Jugendstil and its ideology of the *Gesamtkunstwerk*. In Germany by 1902, as we have seen, designers like Richard Riemerschmid and Bruno Paul had abandoned this style, and in Austria Josef Hoffmann, the founder of the Wiener Werkstätte, had drastically simplified the Secessionist vocabulary. But Loos's critique was more fundamental than theirs; it was based on a rejection of the very concept of 'art' when applied to the design of objects for everyday use. Whereas Van de Velde and the Jugendstil movement had wanted to eliminate the distinction between the craftsman and the artist, Loos saw the split between them as irreversible. Far from believing in a unified culture in which the craftsman and the artist would be reunited, he readily accepted the distinction between the objects of everyday life and imaginative works of art. But for Loos that distinction was not based on the division of hand-work and machine-work or of mental conception and execution—the issue that was so important for the ideologues of the Werkbund. What defined the useful object

44 Adolf Loos

Kärntner Bar, 1907, Vienna
The sense of intimacy is enhanced by the choice of dark, soft materials, and an atmosphere of subdued excitement is created by the use of mirrors.

73

was not its mode of manufacture but its purpose. Perfection of execution should be the aim of hand-work and machine-work alike. In both cases the maker should not express individuality but should be the transmitter of impersonal cultural values. Loos's enthusiasm for the English Arts and Crafts movement was based not only on the quality of its workmanship, but also on the fact that it did not strive for the wilfully new, but respected tradition and custom.

It was as a writer of polemical articles that Loos first became known. His aphoristic, witty, and sarcastic pieces, which gained him as many enemies as friends, resembled the writings of his close friend, the poet Karl Kraus (1874–1936), editor and sole writer of the satirical journal *Die Fackel* (*The Torch*), published from 1899 to 1936. In this journal Kraus pursued a relentless campaign against the Austrian cultural and political establishment and its journalists, whose abuse of language he saw as betraying unfathomable depths of hypocrisy and moral degradation.[1] Loos himself started a journal—*Das Andere* (*The Other*)—which, however, appeared in only two numbers in 1903, as supplements in Peter Altenberg's journal *Die Kunst*. This publication, subtitled *A Journal for the Introduction of Western Civilization into Austria*, paralleled *Die Fackel's* cultural critique in the sphere of the useful arts, comparing Austrian culture unfavourably with that of England and America. Loos's articles attacked not only Austrian middle-class culture, but also the very 'avant-garde' culture that aimed to supersede it.[2]

Loos's writings shifted the debate on the reform of the applied arts into a new register—one that was eventually to turn him into the unwitting father figure of the 1920s Modern Movement. In his essay 'Ornament and Crime' (1908), he claimed that the elimination of ornament from useful objects was the result of a cultural evolution leading to the abolition of waste and superfluity from human labour. This process was not harmful but beneficial to culture, reducing the time spent on manual labour and releasing energy for the life of the mind.

The essay was not merely an attack on the Viennese Secession and Jugendstil, it was also an attack on the Werkbund, founded a year earlier. As we have seen, Muthesius's aim for the Werkbund was to give the artist a form-giving role within industry, and thus to establish the *Gestalt* of the machine age. To Loos, this was unacceptable—not, as for Van de Velde and Gropius, because it would destroy the freedom of the artist but precisely because it envisaged the artist as the primary agent in the creation of everyday objects. Loos believed that the 'style of an epoch' was always the result of multiple economic and cultural forces. It was not something which the producer, aided by the artist, should try to impose on the consumer: 'Germany makes, the world takes. At least it should. But it does not want to. It wants to create its own forms

for its own life rather than have them imposed by some arbitrary producers' association.'[3]

With his aim of involving the artist in industry, Muthesius (Loos's argument implied) was merely substituting form for ornament in an attempt to add a fictitious 'spiritual' quality to the social economy and to bind *Kultur* and *Zivilisation* together in a new organic synthesis. But such a synthesis was neither possible nor necessary. An ineradicable gap had opened up between art-value and use-value. In tearing them apart, capitalism had liberated them both. Art and the design of use-objects now existed as independent and autonomous practices: 'We are grateful to [the nineteenth century] for the magnificent accomplishment of having separated the arts and the crafts once and for all.'[4] The search for the 'style of the time' that Muthesius's types were intended to express was still based on a nostalgia for the pre-industrial 'organic' society. In fact, a style of the modern age already existed—in industrial products without any artistic pretensions:

All those trades which have managed to keep this superfluous creature [the artist] out of their workshops are at present at the peak of their ability . . . [their] products . . . capture the style of our time so well that we do not even look on them as having style. They have become entwined with our thoughts and feelings. Our carriage construction, our glasses, our optical instruments, our umbrellas and canes, our luggage and saddlery, our silver cigarette cases, our jewellery . . . and clothes—they are all modern.[5]

The attempt consciously to create the formal 'types' of the new age was doomed to fail, just as Van de Velde's attempt to create a new ornament had failed: 'No one has tried to put his podgy finger into the turning wheel of time without having his hand torn off.'[6]

According to Loos, art could now survive in only two (absolutely antithetical) forms: firstly as the free creation of works of art that no longer had any social responsibility and were therefore able to project ideas into the future and criticize contemporary society; and secondly in the design of buildings which embodied the collective memory. Loos schematized these buildings as *Denkmal* (the monument) and *Grabmal* (the tomb).[7] For Loos, the private house belonged to the category of the useful, not to that of the monument, hence the rarity in his houses of a fully developed classical language, except for a brief period between 1919 and 1923 (see page 83).

Decorum

Loos identified the surviving realm of the monument with the antique: 'The architect', he said, 'is a stonemason who has learned Latin,'[8] echoing Vitruvius's statement that knowledge of building grows equally out of *fabrica* (material) and *ratio* (reason).[9] His attitude to the

classical tradition differed from that of Otto Wagner or Behrens, for whom a synthesis between art (spirit, soul) and rationality was still possible, and who wanted to adapt classicism to modern conditions. For Loos, as for Kraus, the antique had preserved in language the search for a 'lost image of the primordial'.[10] Its syntax should either be imitated to the letter, even if made with modern materials, or not at all: 'Modern architects seem more like Esperantists. Drawing instruction needs to proceed from classical ornament.'[11] By the same token, both he and Kraus believed in the importance of the tradition of rhetoric, particularly its distinction between genres and its concept of *decorum*, which divides the continuum of lived experience into discrete units. As Kraus wrote:

Adolf Loos and I, he in reality, I in words, have done nothing else than show that there is a difference between an urn and a chamberpot and that this difference is necessary because it guarantees the game of culture. The others, on the contrary, the defenders of 'positive' values, are divided between those who mistake the urn for a chamberpot and those who mistake the chamberpot for an urn.[12]

For Loos, this sensibility of 'difference' was exacerbated, not eliminated, by the dislocations brought about by industrialization. As Massimo Cacciari has pointed out, modernity, for Loos, was constituted by different and mutually intransitive 'language games'.[13] Loos thought in terms of art *and* industry, art *and* handicraft, music *and* drama, never in terms of a *Gesamtkunstwerk* that would synthesize these different genres in a modern 'community of the arts'.

In his designs for the War Ministry in Vienna (1907) and the monument to the Emperor Franz Josef (1917), Loos adopted a neoclassicism which, though clearly mediated by the Beaux-Arts, was more literal than the classicizing work of Wagner or Behrens. These types of building belonged to the category of *Denkmal*. But what about those buildings in the public realm which could make, at best, only weak claims to monumentality—commercial buildings? In the latter part of his career Loos designed several large office blocks and hotels, none of which were built.

The only realized project in which Loos addressed the problem of inserting a large commercial building in a historical urban context was the 'Looshaus' in Michaelerplatz of 1909–11 [**45**]. The ground floor and mezzanine of this building were to be occupied by the fashionable gentlemen's outfitters, Goldman and Salatsch, and the upper floors by apartments. The problem faced by Loos was that of designing a modern commercial building in a fashionable shopping street close to the Imperial Palace. Here, Loos's idea of *decorum* came into full play; he decorated the lower floors, which belonged to the public realm, with a Tuscan order faced in marble, and stripped the apartment floors, with

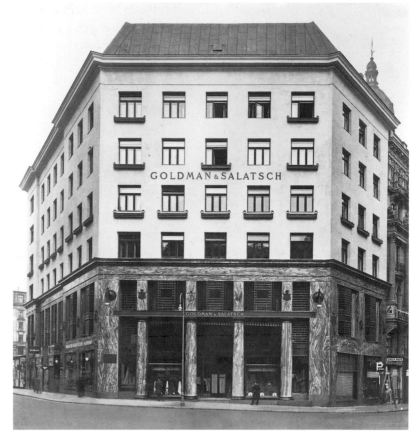

their purely private connotations, of all ornament. In creating a hiatus between two parts of the same structure, Loos turned the building into a provocation—an illustration of his article 'Potemkin City',[14] in which he had attacked the bourgeois apartment blocks on the Ringstrasse for using false façades to look like Italian *palazzi*. Instead of creating a unified classical 'palace', Loos treated each part of the building in a way appropriate to its function, the building's disjunctive parts reflecting the disjunctions of modern capitalism. Whereas Behrens in his Turbine Factory carefully masked his distortions of the classical syntax in order to create an apparently seamless fusion of the classical and the modern, Loos drew attention to them, presenting them in terms of an 'impossible' juxtaposition.

The interior

Nearly all of Loos's early projects were for interior remodellings, and he continued to do this kind of work for the rest of his career. His domestic interiors resemble those of Bruno Paul and Richard Riemerschmid in their rejection of the 'total design' philosophy of Jugendstil in favour of separate, matching pieces of furniture (see pages

32–3). But Loos's critique of the *Gesamtkunstwerk* went further than theirs. Unlike Bruno Paul's rooms, where the recognizably classical furnishings were unified by the architect's personal style, Loos's interiors were made up of found objects. 'The walls', Loos said, 'belong to the architects . . . all mobile items are made by our craftsmen in the modern idiom (never by architects)—everyone may buy these for himself according to his own taste and inclination.' Loos designed very few pieces of furniture himself [**46**]. He usually specified eighteenth-century English furniture, which he had copied by the cabinet-maker Joseph Veillach. If his interiors had unity, it derived more from a selective taste than from originality of design. In this, Loos's work also differed from that of Josef Hoffmann. Although Hoffmann had abandoned curvilinear Art Nouveau for a severely rectilinear style in 1901 (a fact that Loos acknowledged, attributing it, with customary modesty, to his own influence), his furniture and fittings were still covered with decorative 'inventions'. Loos only used natural surfaces such as marble facings or wood panelling.[15]

In his interior architecture, Loos often combined classical motifs with a vernacular style directly indebted to M. H. Baillie Scott, whose interiors for the Grand Ducal Palace in Darmstadt (1897) had acted as a stimulant to the anti-Jugendstil reaction in Germany.[16] The living rooms in Loos's apartments are frequently a central space with low-ceilinged alcoves. The room becomes a miniature social space surrounded by private sub-spaces. As in the work of Scott, considerable use is made of exposed, dark-stained beams (as purely semantic elements; they are usually false), high timber wainscoting, and brick-

46 Adolf Loos

Chest of drawers, *c.*1900
Loos's removal of applied ornament from objects of everyday use was as much an attack on Jugendstil and the Viennese Secession as it was on 'ornament' in the general nineteenth-century sense. It was a return to what he saw as a mislaid classical tradition.

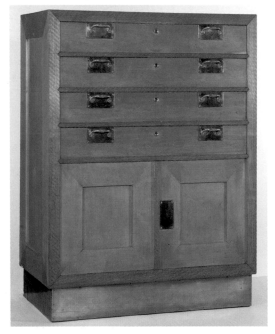

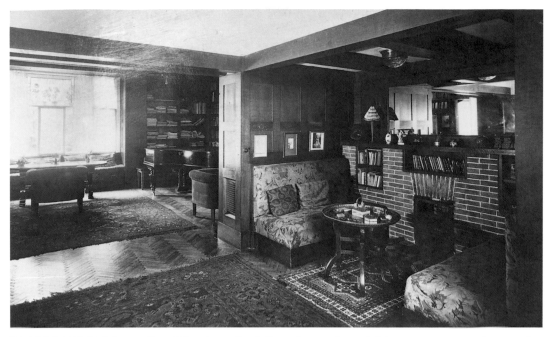

47 Adolf Loos

Scheu House, 1912, Vienna
Interior view, showing the
low-ceilinged fireplace
alcove, with the brick
chimney breast
characteristic of the work of
Baillie Scott. The wide
opening between rooms was
probably more indebted to
American houses of the same
period than to English
houses, where the rooms
were generally isolated from
each other.

faced fireplaces [**47**]. Loos later adapted this apartment typology to the demands of the multi-storey house.

Loos's commercial interiors have the same anonymous quality as his apartments. The journal *Das Interieur* described Loos's first shop for Goldman and Salatsch (1898) as follows: 'The Viennese gentlemen's outfitters shows unmistakably that the creator was aiming at English elegance, without reference to any particular model. Smooth reflecting surfaces, narrow shapes, shining metal—these are the main elements from which this impeccably fashionable interior is composed.'[17] The decor included built-in storage units, glazed or mirrored, with close verticals which recall Wagner's work, as well as refined and geometrical ornament reminiscent of the Wiener Werkstätte. In addition to shops, Loos designed several cafés. For the Museum Café in Vienna (1899)—which, to Loos's delight, acquired the nickname Café Nihilismus because of its iconoclasm—Loos used specially designed Thonet chairs and marble tables. By contrast, in the Kärntner Bar in Vienna (1907) Loos exploits the intimacy of a small room at the same time as he extends the space to infinity by the use of uninterrupted mirror on the upper part of the wall [**44** (see page 72)].

The house

In his *Entretiens*, Viollet-le-Duc had noted a fundamental difference between the traditional English country house and the French *maison de plaisance*.[18] The English house was based on the need for privacy. It consisted of an aggregation of individual rooms, each with its own

48 Adolf Loos

Müller House, 1929–30,
Prague

This drawing shows the
mechanics of Loos's concept
of the *Raumplan*. Changes of
level between the reception
rooms are negotiated by a
complex arrangement of
short stair flights.

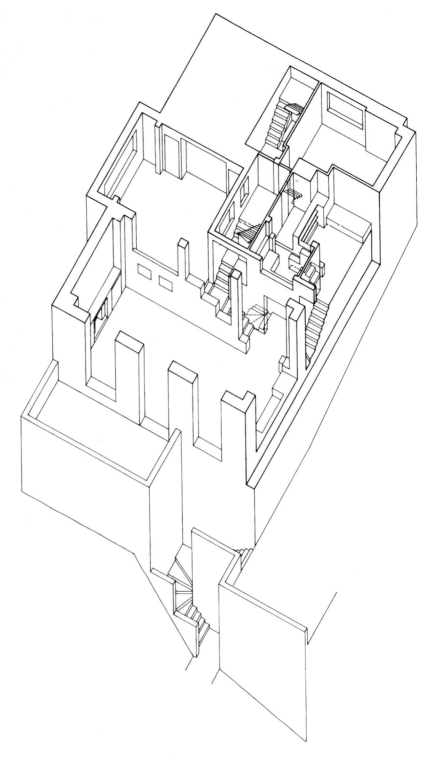

purpose and character. The parts dominated the whole. In the French house, on the contrary, the ruling principle was the family unit. The rooms were thinly partitioned subdivisions of a cubic volume, ensuring constant social contact. It was the English type that became increasingly popular in the late nineteenth century, responding to the prevailing spirit of bourgeois individualism. What Viollet did not mention was that, under the influence of neo-medieval ideas of social harmony, this individualism was modified by the appearance of a large central hall, based on the traditional English manor house. Originating with Norman Shaw in the 1860s, this double-height space became a prominent feature of the houses of Baillie Scott (Blackwell, Bowness, 1898), Van de Velde (Bloemenwerf, 1895), H. P. Berlage (Villa Henny, 1898), Josef Hoffmann (Palais Stoclet, 1905–11), and countless other houses of the period.

This evolution culminated in the series of large suburban villas that Loos built between 1910 and 1930. In these Loos converted the central hall into an open staircase and compressed a number of highly individualized rooms into a cube, thus synthesizing Viollet-le-Duc's two models. The greatest differentiation between the rooms occurred on the *piano nobile*, where reception rooms at different levels and with different ceiling heights were connected to each other by short flights of stairs, their increments forming a kind of irregular spiral ascending through the house [48]. Loos described this spatial organization in somewhat apocalyptic terms:

This is architecture's great revolutionary moment—the transformation of the floor plan into volume. Before Immanuel Kant, men could not think in terms of volume; architects were forced to make the bathroom the same height as the great hall. The only way of creating lower ceilings . . . was to divide them in half. But [as] with the invention of three-dimensional chess, future architects will now be able to expand floor plans into space.[19]

Loos's *Raumplan* (as he called it) turned the experience of the house into a spatio-temporal labyrinth, making it difficult to form a mental image of the whole. The way the inhabitant moved from one space to another was highly controlled (though sometimes there were alternative routes), but no a priori system of expectation was established, as it would be in a classical plan. In the late Moller and Müller houses an intimate Ladies' Room was added to the set of reception rooms and placed at the highest point of the sequence, so that it acted simultaneously as a command post and an inner sanctum.[20] Often, diagonal views were opened up through sequences of rooms [49].

In the spatial ordering of these houses, the walls played an essential role, both phenomenally and structurally. The variability of floor levels demanded that the walls (or at least their geometrical traces—sometimes they are replaced by beams resting on piers) continued vertically

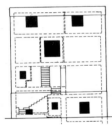

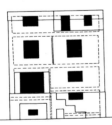

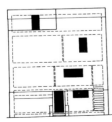

49 Adolf Loos (right)

Moller House, 1927–8, Vienna

Plan and section showing the framed vistas throughout the house.

50 Adolf Loos (below)

Rufer House, 1922

Diagrammatic elevations, showing the randomly placed windows. This is Loos's most literal reference to the house built by Councillor Krespel in the story by E. T. A. Hoffmann. Mies van der Rohe, in his three brick houses of the early 1920s also allowed the plan to dictate the position and size of the windows.

through all floors. Spatial continuity between rooms was created not by omitting walls but by piercing them with wide openings so that views were always framed and the sensation of the room's spatial closure was maintained. Often the connection between rooms was only visual, as through a proscenium. At their interface, these spaces had a theatrical quality. Beatriz Colomina has wittily noted that in a Loos interior someone always seems about to make an entrance.[21] The external walls played a different though equally important role. They were pierced by relatively small openings which did not allow any sustained visual contact with the outside world. Loos's houses were hermetic cubes, difficult to penetrate.

When Loos said 'The walls belong to the architect' he did not mean the contemporary architect, who had 'reduced building to a graphic art',[22] but the *Baumeister* who fashions the object he is making directly in three dimensions. This return to a pre-Renaissance concept connects Loos to the Romantic movement. Whatever the differences between Loos and the Expressionist architect Bruno Taut (see pages 90–2), they shared the Romantic idea that architecture should be a natural and spontaneous language.[23] His *Baumeister* is a descendant of the eponymous hero of E. T. A. Hoffmann's story *Councillor Krespel*. In this story, the Councillor, instead of using plans, traced the outline of his house on the ground and when the walls reached a certain height instructed the builder where to cut out the openings.[24] The analogy with Loos seems especially apt in the case of the Rufer House (1922), with its square plan and its random windows which obey the secret rule of the interior [50].

Externally, Loos's villas were cubes without ornament [51]. In reducing the outside to the barest expression of technique, Loos was making a conscious analogy with modern urban man, whose standardized dress conceals his personality and protects him from the stress of

51 Adolf Loos

Scheu House, 1912, Vienna
The stepped profile provides
roof terraces at each floor.

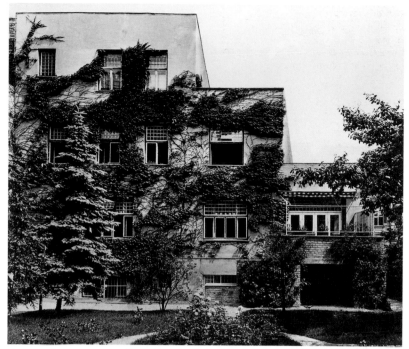

the modern metropolis.[25] But, in Loos's houses, once he has penetrated the external wall, this 'man of nerves' is enmeshed in a 'feminine' and sensuous complexity, full of those residues of cultural memory and association that have been banished from the building's exterior. The disjunction between the inside and the outside echoes Loos's concept of an irrevocable split in modernity between tradition and the modern techno-scientific world—between lived-in 'place' (*Ort*) and calculated 'space' (*Raum*).[26]

After the First World War, Loos's houses underwent certain changes. Between 1919 and 1923, he designed a series of villas, none of which were built, with elevations and plans that are neoclassical in style, though in some, for example the Villa Konstadt of 1919, neoclassical symmetry and *Raumplan* traits coexist. At the same time, villas such as the Rufer House combined classicism in its cornices and cubic shape, with vernacular in its irregular windows. A picturesque neoclassicism was not uncommon in central Europe at this time—we find it, for example, in the work of Peter Behrens, Karl Moser, and Jože Plečnik. But for Loos it was a complete volte-face. These houses give back the right of monumental representation to the interior, and use the same stylistic code for interior and exterior alike—something that was assiduously avoided in the pre-war houses.

But this neoclassical interlude was short-lived and Loos picked up the thread of his earlier *Raumplan* designs in his three last houses: the Tzara House (1926) in Paris (where Loos lived from 1923 to 1928), the Moller House in Vienna (1927–8), and the Müller House in Prague

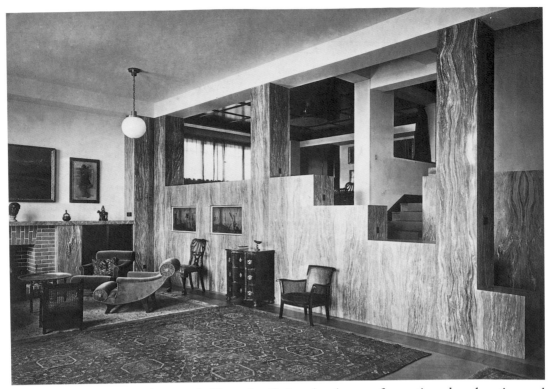

52 Adolf Loos

Müller House, 1929–30, Prague

View of living room, looking towards the dining room. The wall between the two rooms is perforated, without destroying their volumetric integrity. Informality of living and a dramatic sense of anticipation are combined with a certain formal decorum.

(1929–30). Though offering the chance of a continued exploration and refinement of the *Raumplan*, however, these houses were not simply a return to his pre-war practice. The Arts and Crafts and eclectic references that had persisted in the furnishing of the earlier houses gave way to more abstracted, rectilinear forms (although Loos continued to provide a sense of warmth through the use of marble and wood panelling). These showed the influence of architects who had matured after the First World War, particularly Le Corbusier, who had in turn been deeply influenced by Loos. As in Loos's neoclassical houses, interior and exterior draw closer to each other, but in the opposite direction—now it is the neutrality of the exterior that begins to invade the interior [52].

The critical reception of Loos

Until the 1970s, architectural historians tended to cast Loos as a proto-Modernist and to attribute the apparent contradictions in his writings and work to his position as a 'transitory' historical figure. The chief problem for these critics lay in what seemed to be Loos's ambivalence towards conflicting values of tradition and modernity. On the one hand, his harsh rejection of ornament and the applied arts and his belief in the implacable forces of history suggested that he had settled for a new technical culture, devoid of the 'aura' of the pre-industrial

world but still somehow heir to an anonymous craft tradition. On the other hand he appeared as the defender of this tradition against the encroachments of Modernism.

However, certain critics of the 1970s argued that beneath the 'contradictions' of Loos's thought lay a more profound consistency and the possibility of an architecture (and by extension a culture) in which tradition would continue to coexist in unresolved tension with a dominant technology.[27]

It is undeniable that in Loos's architecture there is a resistance to the Hegelian idea of history as a process of overcoming (*Aufhebung*) and a tendency to create montages of different 'languages'. Yet, Loos's most persistent idea—that the forms of use-objects, including those of non-monumental architecture, should owe nothing to artistic intention—seems to contradict his own practice. The removal of ornament from the façades of his houses was a deliberate 'artistic' gesture. Certainly it was taken as such by the next generation of architects, who sought by this means to create precisely the resolution between technology and art that Loos said was impossible. For Loos the unadorned façade concealed individuality, for Le Corbusier it revealed Platonic beauty.

Expressionism and Futurism

5

Around 1910, the visual arts reached a new level of abstraction, going further in the rejection of the concept of art as imitation than ever before. These new developments originated in French Post-impressionist and Fauve painting and quickly spread to other European countries, taking the form of Expressionism in Germany and Futurism in Italy. In France, progressive art movements and conservative art institutions were to a large extent capable of coexistence, but when the new formal experiments spread to Germany and Italy, they became associated with movements that were diametrically opposed to the academic establishment. As a result the architectural avant-gardes were increasingly assimilated into the sphere of the visual arts and detached from a specifically tectonic tradition.

Both German Expressionism and Italian Futurism started as movements in the visual arts and literature, though they soon attracted architects dissatisfied both with a moribund Jugendstil and its neo-classical alternative. The Expressionists and Futurists were in close touch with each other: the Futurists' various manifestos were published in the Expressionist magazine *Der Sturm* and in 1912 the Futurists exhibited their work in *Der Sturm* gallery. But although their artistic roots were the same, the two movements differed in at least one crucial respect: while the Expressionists were torn between a Utopian view of modern technology and a Romantic nostalgia for the *Volk*, the Futurists totally rejected tradition, seeing in technology the basis for a new culture of the masses.

Expressionism

The word 'Expressionism' was originally coined in France in 1901 to describe the paintings of the circle of artists around Henri Matisse, who modified their representations of nature according to their own subjective vision. But the word did not enter international critical discourse until 1911, when it was adopted by German critics to denote Modernist art in general and then—almost immediately afterwards—a specifically German variant.[1]

Expressionism was centred on three secessionist groups: the artists'

53 Antonio Sant'Elia

Power Station, 1914

In this set of drawings recognizable elements make their appearance: pylons, chimneys, lattice structures, and viaducts.

54 Oskar Kokoschka

Murderer, Hope of Women, 1909

This was Kokoschka's poster for his own one-act play of this title, first performed in Vienna in 1909 and published by *Der Sturm* in 1910. Kokoschka, returning to the themes of the Romantic movement, based his play on Heinrich von Kleist's tragedy *Penthesilia*.

groups Die Brücke (founded in 1905 in Dresden) and Der Blaue Reiter (founded in 1911 in Munich); and *Der Sturm*, a magazine and art gallery founded in Berlin in 1910 which published poetry, drama, and fiction as well as visual art. Expressionist painting was characterized by a tone of extreme agonism and pathos, quite alien to the French movements from which it sprang [**54**]. Independently of its derivation from French painting, Expressionism was influenced by late-nineteenth-century German aesthetic philosophy. Particularly important were Conrad Fiedler and Adolf Hildebrand's theory of pure visibility (*Sichtbarkeit*), and Robert Vischer's theory of empathy (*Einfühlung*), both of which challenged the classical concept of mimesis.

But it was the more popular writings of the art historian Wilhelm Worringer that exercised the most direct influence on Expressionist painters and architects. In an essay published in *Der Sturm* in 1911, Worringer attributed all Modernist painting to a primitive, Teutonic 'will to expression' (*Ausdruckswollen*).[2] In his earlier and extremely influential book *Abstraction and Empathy*, Worringer had foreshadowed a nascent Expressionist movement, describing the Gothic architecture which would inspire it in the following emotional terms:

No organic harmony surrounds a feeling of reverence toward the world, but an ever-growing, self-intensifying, restless striving without deliverance, which

sweeps the inharmonious psyche away with it in an extravagant ecstasy . . .
The relatively calm proportions between verticals and horizontals which
prevail in Romanesque architecture are conspicuously abandoned.

Basing his argument on Riegl's relativistic doctrine of the *Kunstwollen*
(will to art) Worringer claimed that people failed to appreciate the
Gothic because they were trapped within a classical horizon. He
believed that by escaping from this, 'we perceive the great beyond . . .
the road that lies behind us suddenly seems small and insignificant in
comparison with the infinitude that is now unfolded to our gaze'.[3]

Expressionist architecture

Expressionist architecture is notoriously difficult to define. As Iain
Boyd Whyte has observed, the movement has usually been defined in
terms of what it is not (rationalism, functionalism, and so on) rather
than what it is,[4] and there is some truth in the opinion that
Expressionism is a permanent and recurrent tendency in modern
architecture. Buildings which are commonly classified as Expressionist
include such divergent groups as the early work of Hans Poelzig, the
Jugendstil 'Amsterdam School', and architects of the 1920s such as
Erich Mendelsohn and Hugo Häring; but these are also often more
fruitfully discussed in other contexts. Here, we will concentrate on
what is generally recognized as the crowning period of Expressionism
as a multi-genre and politically involved movement between 1914 and
1921. The focus will be on the group that formed round the architect
Bruno Taut (1880–1930) during this period, the most important
members of which —beside Taut himself—were Walter Gropius and
the critic and art historian Adolf Behne (1885–1948).

Although Adolf Behne was the first to use the term 'Expressionist'
in connection with architecture (in an article in *Der Sturm* of 1915), it is
probably an article by Taut of February 1914 in the same journal—enti-
tled 'A Necessity'—which has a more legitimate claim to being the first
'manifesto' of Expressionist architecture.[5] This article repeats several
of Worringer's ideas. Taut notes that painting is becoming more
abstract, synthetic, and structural and sees this as heralding a new unity
of the arts. 'Architecture wants to assist in this aspiration.' It should
develop a new 'structural intensity' based on expression, rhythm, and
dynamics, as well as on new materials such as glass, steel, and concrete.
This intensity will go 'far beyond the classical ideal of harmony'. He
proposes that a stupendous structure be built in which architecture
shall once again become the home of the arts as it was in medieval
times. One of the most striking features of this article is the view it pre-
sents of architecture as following the lead of painting. In spite of its use
of the Romantic image of the cathedral as a *Gesamtkunstwerk*, there is

no mention of the crafts. And, where Loos had seen architecture as bound either to the antique or to the vernacular, Taut saw it as belonging to the free, Utopian realm that Loos had reserved exclusively for painting (see page 75).

Bruno Taut

Bruno Taut was the leading architect associated with the Berlin wing of the Expressionist movement. After studying with Theodore Fischer in Munich from 1904 to 1908, Taut opened a practice in Berlin with Franz Hoffmann. Later his brother Max joined him, but although they shared the same architectural ideals, they never collaborated on projects. Bruno Taut appears to have conceived of architecture as operating between two extreme poles: practical individual dwellings and symbolic public buildings[6] binding the individual and the *Volk* in a transcendental unity. Throughout the early part of his career Taut worked simultaneously at both these poles, emphasizing one or the other according to what he saw to be the objective needs of the moment.

Much of the early work of his practice consisted of low-cost housing within a Garden City context. One of the most original features of this work was the use of colour on the external surfaces of

55 Bruno Taut

Haus des Himmels, 1919
This drawing appeared in Taut's magazine *Frühlicht*. It was one of his many representations of the *Stadtkrone*, which here appears as a star-shaped light-emitting crystal.

56 Bruno Taut

Snow, Ice, Glass, from *Alpine Architektur*, 1919
In this and other images in the book the 'real' world of the Volk, with its little houses and allotments, is almost entirely dissolved by an apocalyptic vision of the alchemical transformation of matter into spirit.

SCHNEE
GLETSCHER
GLAS

·Die Ausführung ist gewiss ungeheuer schwer und opfervoll, aber nicht unmöglich. „Man verlangt es selten von den Menschen das Unmögliche." (Goethe)

10

buildings—a motif that Taut continued to pursue throughout his career.[7] Simultaneously he was developing the concepts of the *Volkhaus* (house of the people) and the *Stadtkrone* (city crown), first outlined in his article 'A Necessity'. In these two closely related concepts he sought to define a structure that would capture the essence of the medieval city in modern terms. He visualized it as 'a crystal building of coloured glass' that would 'shine like a sparkling diamond'[8] over each new Garden City, a secular version of the medieval cathedral [**55**]. During the First World War, in a period of forced inactivity, Taut prepared two books, *Die Stadtkrone* and *Alpine Architektur*, both published in 1919. The first was concerned mainly with historical examples of buildings symbolizing the *Volk*. The second contained apocalyptic visions of an imaginary architecture, mixing images and texts rather in the manner of a Baroque emblem book [**56**].

Before writing these two books, Taut had already built the 'Glass Pavilion' at the Werkbund exhibition of 1914 in Cologne. This building

57 Bruno Taut

Glass Pavilion, Werkbund
Exhibition, 1914, Cologne

In Taut's exhibition building,
a 12-sided drum faced with
glass bricks supports a ribbed
dome of coloured glass.

anticipated the *Volkhaus* in miniature [**57**]. Financed by a group of glass manufacturers, it was at once an exhibition of glass products, a 'house of art', and a sort of allegory. The visitor was guided through a sequence of sensuously calibrated spaces in which the effects of coloured glass and cascading water predominated, experiencing an ascent from telluric darkness to Apollonian clarity.

Both the Glass Pavilion and the two wartime books owed much to the ideas of Taut's friend, the novelist Paul Scheerbart (1836–1915), described by Herwarth Walden, editor of *Der Sturm*, as 'the first Expressionist'. In a series of proto-science-fiction novels, culminating in *Glasarchitektur* of 1914, Scheerbart described, sometimes in great technical detail, a universal architecture of glass and steel—transparent, colourful, and mobile—that would usher in a new age of social harmony. Scheerbart's Utopia was largely derived from writers of the Romantic period, particularly Novalis, who had revived the light and crystal symbolism of Judeo-Christian and Islamic mysticism (Scheerbart himself had studied Sufi mysticism).[9]

Taut's ideas on urbanism should also be seen in another context—that of the contemporary international movement in town planning, which flourished in both Europe and America. This movement, which has been briefly discussed on page 49, was an outgrowth of both the Garden City and the City Beautiful movements. Taut's Utopian city with its central symbolic building has a family resemblance to such visionary projects as the World City dedicated to world peace, pro-

moted by the industrialist and railway developer Paul Otlet, and designed by Ernst Hébrard and Hendrik Andersen in 1912.[10]

Several projects in Germany belonging to the period during or directly after the First World War can be compared to Taut's idea of the *Stadtkrone*, if only because they too in some measure were intended to act as social condensers in a new age of mass culture. The theatre, because of its close connection with Richard Wagner's idea of the *Gesamtkunstwerk*, is a particularly important type within this genre.[11] One of the most ambitious theatre projects was the Grosses Schauspielhaus in Berlin of 1919. Popularly known as the 'The Theatre of 5000', it was designed by Hans Poelzig and commissioned by the impresario and director Max Reinhardt [**58**]. This huge theatre—adapted from an existing market hall that had already been converted into a circus—was the result of Reinhardt's involvement with the People's Theatre movement, which had spread rapidly in Germany in the late nineteenth century.[12] Poelzig designed the interior as a fantastic spectacle. The ceilings were covered with plaster stalactites, simultaneously recalling a grotto and the Alhambra in Granada. Externally, the almost windowless walls were faced with close-set Rundbogenstil pilasters very like those of the thirteenth-century monastery of Chorin, favourite haunt of the Wandervogel movement, to which Bruno Taut and Adolf Behne had belonged in their youth.[13]

58 Hans Poelzig

Grosses Schauspielhaus, 1919, Berlin (demolished *c*.1980)

This building was notable for its colour: burgundy red externally and yellow in the auditorium. Colour was an important aspect of Expressionism's populist philosophy and Taut was not its only exponent.

59 Wassili Luckhardt

Project for a People's Theatre, 1921, external view, plan, and section

This building takes the ziggurat form common in Expressionist public buildings. The stage tower, usually an intractable problem for architects, is easily absorbed into its mountain-like profile.

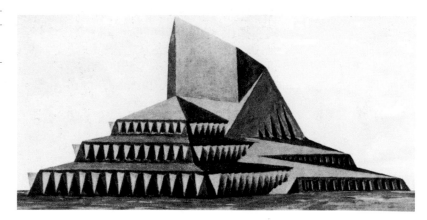

VOLKSTHEATER

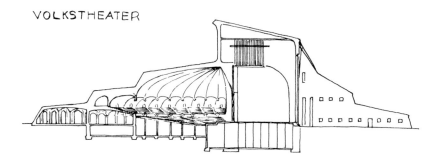

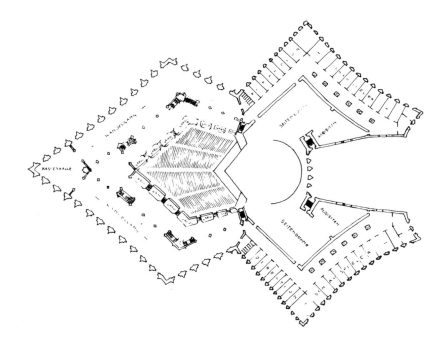

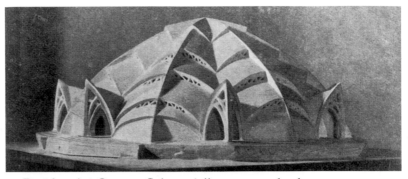

60 Otto Bartning

Sternkirche, 1922

This project is a reinterpretation of Gothic architecture. The structure, spatial form, and system of daylighting are all integrated.

Besides the Grosses Schauspielhaus, several other contemporary projects were inspired by the idea of a public building able to focus the life of the *Volk*. Three of these may be mentioned because of their use of the new Expressionist manner to communicate directly with the public on an emotional level: a People's Theatre project (1921) by Wassili Luckhardt (1889–1972) [**59**], the Sternkirche project (1922) by Otto Bartning (1883–1959) [**60**], and a Goetheanum at Dornach (1924–8) by Rudolf Steiner (1861–1925) [**61**]. All these structures were intended as the symbols and instruments of a dawning age of mass culture, serving commercial, festive, recreational or religious purposes.

Expressionism and politics

Taut's city crown was an attempt to give artistic form to Pyotr Kropotkin's anarchism.[14] Based on the idea of dispersed Garden Cities as the alternatives to the modern metropolis, it represented an anti-urban ideology which—for all their ideological differences—was shared by the radical conservatives.[15] But, despite his antagonism to many aspects of Marxism, Taut supported workers' councils and, like many other Expressionists, became involved with the revolution that swept Germany in 1918. With Gropius and Behne, he founded the Arbeitsrat fur Kunst (AFK). This was a trade union of artists modelled on the workers' soviets that were a feature of the revolution, and more particularly on the Proletarian Council of Intellectual Workers, an outgrowth of Kurt Hiller's Activist literary movement. Taking his cue from the political ambitions of that movement, Taut envisaged a group of architects within the AFK who would take control of every aspect of the visual environment. In an open letter of November 1918 addressed 'To the Socialist Government', he wrote:

Art and life must form a unity. Art should no longer be the delight of the few, but the good fortune of the life of the masses. The aim is the fusion of the arts under the wing of a great architecture . . . From now on, the artist alone will be the modeller of the sensibilities of the *Volk*, responsible for the visible fabric of the new state. He must determine the form-giving process from the statue right down to coin and the postage stamp.[16]

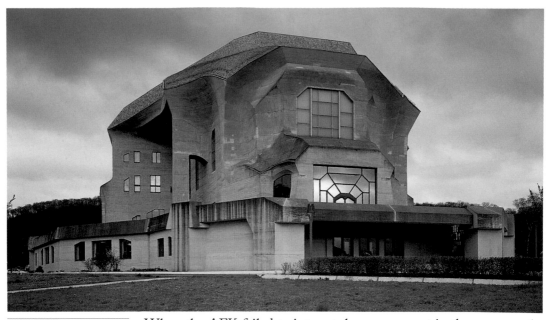

61 Rudolf Steiner

Goetheanum, 1924–8, Dornach

In this building exposed reinforced concrete is used as both structure and skin. Curved and planar forms merge to form a continuous surface.

When the AFK failed to interest the government in these proposals, Taut conceived the idea of an 'Exhibition for Unknown Architects' which would appeal directly to the people, but he resigned the chairmanship before it came to fruition, being succeeded by Walter Gropius.

Gropius agreed with Taut's reformist aims but not with his provocative methods. With his accession to the chairmanship, the AFK abandoned its revolutionary programme, moving 'to the right politically and to the left artistically'.[17] Gropius's aim was to turn the AFK into a small group of radical architects, painters, and sculptors, concerned only with artistic matters—a 'conspiratorial brotherhood' working secretly and avoiding a head-on collision with the art establishment. But even these plans evaporated when, in December 1919, the AFK ran out of money and was absorbed by the Novembergruppe. Gropius had meanwhile become the director of the Bauhaus (Spring 1919) and this now became the centre of his long-term plans to unify the arts under the leadership of architecture within a social-democratic framework. During the following year Taut himself abandoned revolutionary politics and began to concentrate on the design of social housing.

The Exhibition for Unknown Architects

The most important event during Gropius's leadership of the AFK was the Exhibition for Unknown Architects, mounted in April 1919. As already mentioned, the exhibition had been proposed by Taut before his resignation. Entry was not restricted to architects, and entrants were encouraged to submit visionary schemes unrestricted by

programmatic or aesthetic constraints. Though it was unsuccessful in its popularizing aims, it turned out to be an event of great significance in the history of modern architecture.

The work shown at the exhibition fell into two more or less distinct categories. The first comprised drawings depicting possible buildings, however unconventional, of two formal types: the crystalline–geometrical and the amorphous–curvilinear. The amorphous type was represented exclusively by the work of Hermann Finsterlin [**62**], while the work of most exhibitors belonged to the crystalline type [**63**]. The

63 Wenzel Hablik

Exhibition Building, 1920
Hablik's faceted, pyramidal constructions were close to Taut's crystalline ideal.

second category consisted of pictorial fantasies that made use of architectural subject matter [**64**]. Whereas the first category represented objects naturalistically, the second tended to be anti-naturalistic: even when implying depth the images were two-dimensional in a way that suggested primitive or child art, and were often deliberately fantastic, even absurd.

Images similar to those shown at the exhibition appear in the letters of the *Gläserne Kette* (*Glass Chain*)—a group of architects and artists close to Taut, who began a correspondence in 1919 (on Taut's initiative) for the purpose of exchanging architectural ideas and fantasies. Many of the drawings originating in the *Glass Chain* were subsequently published by Taut in his magazine *Frühlicht* (*Dawn*) (1920–2).

Dada and Expressionism

Some of the pictorial fantasies exhibited in the Exhibition for Unknown Architects were by artists associated with the Berlin Dada movement—for example Jefim Golyscheff and Raoul Hausmann. The work of this group stands somewhat apart from that of the main group of Expressionists, not only in terms of artistic technique but also in terms of ideology. The Berlin Dada movement had emerged from Expressionist cabaret, but its rhetoric was often activist in tone and it rejected the Expressionist belief that ethical and cultural change could be effected by a 'spiritual' revolution. 'It is a false notion', wrote Dadaist Richard Hülsenbeck in 1917, 'that an improvement in the world can be achieved via the power of intellectuals'.[18] Two years later Hausmann, Hülsenbeck, and Golyscheff wrote a satirical manifesto calling for a 'battle most brutal against all schools of so-called *Geistige Arbeiter* [spiritual

awakening] . . . against their concealed middle-classness and against Expressionism and neoclassical culture as represented by *Der Sturm*'.[19]

The Dadaists belonged to the extreme Left and had supported the Communist Spartacus League which led a workers' uprising in January 1919. In contrast to the earnestness of the AFK, they used the weapons of mockery and ridicule to discredit the Expressionist movement, which in their opinion had betrayed the revolution of 1918 by siding with the Social Democrats rather than the Communists. In the style of their rhetoric and in some of their formal techniques, though not in their ideology, the Dadaists owed a great debt to Marinetti and the Futurists. It is to this movement that we will now turn.

Futurism

The last quarter of the nineteenth century had seen an unprecedented development of new technologies, including electric light, the telephone, and the automobile. Futurism was the first artistic movement to see these developments as necessarily implying a total revolution in everyday culture. Whereas previous avant-gardes, from Art Nouveau to Expressionism, had sought to rescue tradition by means of the very modernity that threatened to destroy it, Futurism advocated the obliteration of all traces of traditional culture and the creation of a totally new, machine-based culture of the masses.

The movement, based in Milan, was 'founded' when the writer Filippo Tommaso Marinetti (1876–1944) published 'The Foundation and Manifesto of Futurism'[20] on the front page of the Parisian daily newspaper *Le Figaro* in 1909. The manifesto was a hymn of praise to the total mechanization of life. Marinetti's ideas were strongly influenced not only by Henri Bergson, with his concept of reality as process, but also by Georges Sorel who, in his book *Reflections on Violence* (1908), had promoted the idea of a spontaneous activism based on myth, arguing that violence was a necessary and purifying force in the political life of the proletariat. Combining two apparently contradictory ideas, anarchism and nationalism, Marinetti believed that the spontaneous vitality of the masses had to be harnessed by an elite to the interests of the state. As he was to write in the 1920s: 'We should aspire to the creation of a type of man who is not human, from whom will have been eliminated moral pain, goodness, and love, the passions that alone can corrode inexhaustible vital energy.'[21] Marinetti deliberately aimed at a mass audience. In attacking humanist values he made use of a wide range of rhetorical devices, including burlesque, parody, and hyperbole, as well as of sheer buffoonery. In his use of new grammatical and typographical forms he transformed the medium of the manifesto into a literary genre in its own right—one that was to exert a strong influence on Dada and the Russian avant-garde.[22]

Between 1909 and 1914 Marinetti and a small group of writers, painters, and musicians published about 50 manifestos on every conceivable aspect of cultural life, deliberately mixing high and low art forms. These manifestos contained ideas that have remained important sources for all subsequent avant-gardes and neo-avant-gardes. The chief theoretical statement of the movement was 'The Technical Manifesto of Futurist Painting',[23] published in April 1910 and signed by the painters Umberto Boccioni (1882–1916), Carlo Carrà, Luigi Russolo, Giacomo Balla, and Gino Severini. The manifesto sought to adapt the mimetic practices of art to epistemological changes implied by nineteenth-century mathematics and physics, especially in the representation of change and movement. The theory that it presented was a kind of subjective realism, strongly influenced, as was Expressionism, by late-nineteenth-century German aesthetic philosophy, much of which had been translated into Italian,[24] as well as by non-Euclidean geometry and Einsteinian physics. The painting, it was argued, should no longer be conceived as the imitation of an external scene but as the registration of the mental states caused by the scene. Both painter and object were seen to occupy a unified spatio-temporal field: 'The gesture that we would reproduce will no longer be a fixed moment in a universal dynamism, it will be the dynamism itself.'[25] Later, Boccioni gave this idea more precision:

This synthesis—given the tendency to render the concrete in terms of the abstract—can be expressed only . . . by precisely dimensioned geometrical forms, instead of by traditional methods (now devalued by the mechanical media) . . . If we thus make use of mathematical objects, it is the relation between them that will provide the rhythm and the emotion.[26]

The Futurists became aware of Cubism in 1911 and quickly assimilated its techniques. Boccioni's susceptibility to Cubism and collage is shown in his description of his own subsequent practice: 'The dislocation and dismemberment of objects . . . freed from accepted logic and independent from each other.'[27] Yet the contradiction between Cubism's demand for the autonomy of art and the Futurists' desire to fuse art and life was never fully resolved. This was to remain one of the main doctrinal conflicts in the history of Modernism, as we shall see when we consider the development of Modernist architecture after the First World War.

Futurism and architecture

Two manifestos of Futurist architecture were written early in 1914. The first was by 20-year-old Enrico Prampolini, who belonged to the Roman branch of the movement, and the second was by Boccioni (although it was not published until 1960). Boccioni's manifesto bears a

definite relationship to his 'Technical Manifesto of Futurist Sculpture' (1910).[28] In the latter text, Boccioni saw the sculptural figure as no longer isolated from its surrounding space: 'We must split open the figure and place the environment inside it' [65]. In his 'Technical Manifesto of Futurist Architecture',[29] he arrives at the same idea. The modern city can no longer be thought of as a series of static panoramas as in the past, but as an enveloping environment in a constant state of flux. He sees the outside of the individual building, analogously, as broken up in response to the pressures of the interior. In both sculpture and architecture, therefore, Boccioni proposes to absorb the art work back into the world, so that it will become an intensification of the environment, not something idealistically set against it.

Antonio Sant'Elia

The probable reason that Boccioni's architectural manifesto remained unpublished despite its obvious importance was that in July 1914 another such manifesto was written by Antonio Sant'Elia (1888–1916). This architect's accession to the Futurist movement coincided with an exhibition of the work of a rival group of artists, the Nuove Tendenze, in which Sant'Elia showed an extraordinary series of perspective

66 Antonio Sant'Elia

Modern Building, 1913

This drawing still retains the compositional characteristics of Wagnerschule and Baroque drawings, dramatizing the subject by the use of oblique and low-viewpoint perspective.

67 Jože Plečnik

Sketch, 1899

An undoubted source for Sant'Elia's power stations.

drawings representing his idea of the architecture of the future. The relationship between these drawings and the Futurist movement has long been the subject of controversy.

The ideas expressed in Sant'Elia's 'Manifesto of Futurist Architecture'[30] and in the slightly shorter version of it published in the exhibition catalogue (the 'Messaggio'[31]), correspond closely with the ideology of the movement, but the drawings themselves seem to contradict it in important ways. It is likely that Sant'Elia had been in contact with the Futurists for some time, and that behind the manifesto and the 'Messaggio' there existed an urtext written in part by Marinetti or Boccioni or both, so as to provide the appropriate stylistic (if not intellectual) credentials. This may explain the reason for the discrepancies between the drawings and the text, but the discrepancies themselves need further elucidation.[32]

Except for three very small structures, Sant'Elia's legacy consists exclusively of architectural drawings. These are either for actual but unbuilt projects, mostly façade studies, or perspectives of an imaginary architecture. The façades are in a highly ornamented Liberty–Secessionist style and Sant'Elia continued to produce such work until his death. The perspectives are of three kinds. The first are totally unornamented, astylar compositions with generic titles such as 'Modern building', 'Monument', and 'Industrial building', dated 1913 [66]. Almost certainly these drawings were influenced by the photographs of North American grain silos illustrated by Gropius in the *Jahrbuch des Deutschen Werkbundes* of 1913, and quite possibly by the stage designs of Gordon Craig and Adolf Appia.[33] The second kind is a set of drawings in which similarly abstract forms are adapted to one particular industrial building type: the hydroelectric power station—a type of building almost synonymous with the rapid industrialization of the Po Valley in the first years of the twentieth century [53 (see page 86) and 67].

Finally there is a set of drawings entitled La Città Nuova (The New City). These are very detailed and their technique is harsher and less atmospheric [68]. Stepped-back floors of multi-storey apartment blocks (resembling the powerful sloping walls of the hydroelectric dams) are contrasted with vertical elevator towers, to which they are connected by bridges. The ground is completely eroded with a multi-level network of transport viaducts. The drawings depict a city from which all traces of nature have been removed, a city dominated by a plethora of horizontal and vertical distribution systems, against which the façades of the apartment units seem to play a passive and secondary role. Sant'Elia took elements of his city from various sources, including popular illustrations of the New York City of the future, Henri Sauvage's Maison à Gradins in Paris (1912), and above all Otto Wagner's drawings of his new transport infrastructure for Vienna

68 Antonio Sant'Elia

La Città Nuova, 1914

In the set to which this drawing belongs, the elements of the two previous sets are transformed into a mechanized urban landscape. The multi-level transport viaducts and their attendant pylons are derived from Otto Wagner's Vienna Stadtbahn. Although human beings are absent, the pylons stand around like calcified giants.

[69]. Out of such 'found' elements Sant'Elia created a synthesis which was, from a pictorial point of view, utterly convincing.

But, impressive as Sant'Elia's drawings are in their dramatic representation of the city of the future, their forms and technique contradict many of the ideas put forward in the Futurist manifestos. While the manifestos stress lightness, permeability, and practicality, the drawings express mass and monumentality; while the manifestos place the spectator within the work, the drawings imply that the viewer is an external observer by providing a panoramic and perspective view of the world; while the manifestos condemn static, pyramidal forms, the drawings abound in them.

In fact, Sant'Elia's drawings are also derived from the work of students of the Austrian Academy of Fine Arts (the Wagnerschule) at

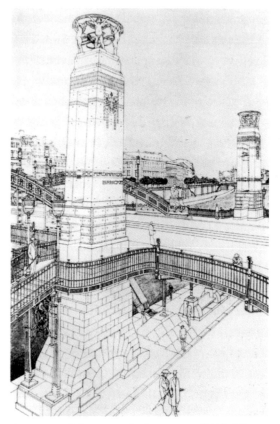

the turn of the twentieth century [**70**]. The truncated, abstract forms
of these designs, set at an oblique angle and seen from a low level,
reappear in most of Sant'Elia's drawings. Sant'Elia's technique of rep-
resentation had been developed during his studies at the Brera
Academy under Giuseppi Mentessi, by whom he was introduced to
late Baroque theatre design with its system of oblique perspective
(*scena per angolo*).[34] Indeed, Sant'Elia's drawings are less those of an
architect than of a *vedutista* in the tradition of Piranesi and the
Bibienas. They offer an objectified spectacle far removed from
Boccioni's conception of the spiritualized and transparent object, and
present a striking contrast with Futurist images such as Boccioni's 'X-
Ray'-like axonometric drawing *Table + bottle + houses* [**71**].

Sant'Elia's drawings are not the only contemporary avant-garde
works that betray Jugendstil and Secessionist influences. Most of the
architecture usually characterized as Expressionist is close to the same
source. In fact, in Expressionism and Futurism alike, there exists an
unresolved tension between emotional and analytical approaches—
between an attitude towards the modern in which feelings are
projected onto technology (just as the Romantics had projected theirs
onto nature), and an attitude that seeks to engage with technology on
its own terms—from within, as it were.[35] For all his use of scientific and

70 Emil Hoppe

Sketch for a tower, 1902
The sloping walls and low viewpoint of this drawing reappear in Sant'Elia's drawings

59 Hoppe, Skizze, 1902

71 Umberto Boccioni

Table + Bottle + Houses, 1912
In this axonometric drawing, the solid objects have become transparent as in an X-ray. For Boccioni, axonometric projection was associated with the fourth dimension and space–time—as it would be for van Doesburg.

mathematical analogies, Boccioni himself resisted in many ways the onset of the age of mechanical reproduction which he himself had announced, stressing the act by which the artist's hand transforms the material and rejecting—for example—photography, with its impersonal and mechanical procedures. In the end, therefore, Sant'Elia's 'excitable' reaction to technology may not be so far removed from that of Boccioni, whose work seems so much more 'modern'. The fact remains, however, that Sant'Elia's vision of the future was that of a late Romantic, and that his influence on the next generation of architects was limited. By contrast, the influence of Futurism in the other genres—sculpture, graphics, theatre, music, and photography—was very considerable.

In trying to place Expressionism and Futurism in a historical perspective, a salient fact emerges: both movements, whatever their other differences, rejected the Enlightenment tradition of reason and stressed the importance of myth and instinct in the social life of nations. They denounced a rationalistic civilization which they believed had sown discord in a previously unified and organic society. They espoused a set of ideas—anti-materialist, anti-liberal-democratic and anti-Marxist—which became increasingly influential in the countries of western Europe in the years leading up to the First World War and which, in their extreme form, found political expression in the Fascism and National Socialism of the inter-war years.

The Avant-gardes in Holland and Russia

6

As in the case of Expressionism and Futurism, the architectural avant-gardes in Holland and Russia were at first dominated by painting and sculpture. In both countries formal experiments that were possible in theoretical or small-scale projects met with considerable resistance when applied to the constructional and programmatic needs of buildings. After the First World War, as soon as the economic and political situation allowed building to resume, architectural projects in both countries began to take on the characteristics of a more sober, international architecture and to lose national traits which had originated largely from interpretations of Cubism, Expressionism, and Futurism. This chapter will describe these national movements—De Stijl in Holland; Suprematism, Rationalism, and Constructivism in Russia—and their transition to a Europe-wide 'Modern Movement' (also known as 'Neue Sachlichkeit', 'Functionalism', 'Rationalism', or 'Neues Bauen').

In both the Dutch and the Russian avant-gardes, the logic of the machine became the model for art and architecture; the mind was considered to be able to create form independently of traditional craft, implying a new alliance between painting, architecture, and mathematical reason. Art and architecture were seen as impersonal and objective and not based on individual 'taste'.

The avant-garde in Holland

Two opposed movements in architecture and the decorative arts flourished in Holland during and immediately after the First World War—the Amsterdam School and De Stijl. Both these movements were related to Art Nouveau and the Arts and Crafts movement as well as to German Expressionism; both believed in a unified style reflecting the spirit of the age; both inherited the Morrisian idea that society could be transformed by art; and both rejected the eclectic use of past styles, striving for a new, uncoded architecture. But each inherited a different strand of the earlier movements—the vitalistic, individualistic strand in the case of the Amsterdam School and the rationalist,

Detail of 77 Theo van Doesburg

Counter-construction (Construction de l'Espace-Temps II), 1924

impersonal strand in the case of De Stijl. Each movement condemned the other, ignoring their shared aims and origins.[1]

The work of the Amsterdam School—whose chief exponent was Michel de Klerk (1884–1923)—was characterized by the use of traditional materials, in particular brick, and the free, fantastical but craftsman-like working of these materials. The forms of traditional architecture were not so much abandoned as transformed and made strange. Much of the most important work of the Amsterdam School was built between 1914 and 1923 and is to be found in the many public housing projects that were part of the vast urban renewal programme being undertaken in Amsterdam at the time under the direction of Berlage.

De Stijl

The De Stijl movement, though its origins lay, like those of the Amsterdam School, in the decorative arts, developed an ornamentation that reflected the influence of Cubism and rejected craftsmanship in favour of a geometrical anti-naturalism. In 1917 the painter Theo van Doesburg (1883–1931) published the first issue of *De Stijl*, a magazine promoting modern art. The term 'De Stijl' is normally applied to both the magazine and the movement to which it gave its name. The original group included the painters Piet Mondrian (1872–1944), van Doesburg, Vilmos Huszar (1884–1960), and Bart van der Leck (1876–1958), the sculptor Georges Vantongerloo (1886–1965), and the architects Jan Wils (1891–1927), Robert van't Hoff (1887–1979), Gerrit Rietveld (1888–1964), and J. J. P. Oud (1890–1963). The group's identity, however, had less to do with its specific membership, which was highly volatile, than with its doctrine as defined in the first De Stijl Manifesto of 1918 and in later issues of the magazine. *De Stijl* was edited and dominated by van Doesburg and became an important organ of the international avant-garde until it ceased publication in 1932.

Theory

The theoretical apparatus of De Stijl was a variant of existing (mostly Symbolist and Futurist-derived) doctrine, and the movement saw itself as a crusade in the common cause of Modernism. It maintained close ties with avant-garde movements in the different arts abroad, including Dada (van Doesburg himself, under the pseudonym Aldo Camini, published Dada poetry in *De Stijl*).

The three main postulates of the movement can be roughly summarized as follows: each art form must realize its own nature based on its materials and codes—only then can the generative principles governing all the visual arts (indeed, all art) be revealed; as the spiritual awareness of society increases, so will art fulfil its historical (Hegelian)

destiny and become reabsorbed into daily life; art is not opposed to science and technology—both art and science are concerned with the discovery and demonstration of the underlying laws of nature and not with nature's superficial and transient appearance (the theory, however, did not take into account the possibility art could still be a form of imitation).

De Stijl belonged to the millennialist tradition of Expressionism and Futurism. Although it lacked any obvious political dimension, it was nonetheless Utopian; it imagined a future in which social divisions would be dissolved and power dispersed. It combined a commitment to modernity with an idealism that associated scientific and technical change with spiritual as well as material progress. The metaphysics of the movement were to a large extent taken from the Theosophist and Neoplatonist M. J. H. Schoenmaeker, whose book *The Principles of Plastic Mathematics* (1916) claimed that plastic mathematics was a 'positive mysticism' in which 'we translate reality into constructions controlled by our reason, later to recover these constructions in nature, thus penetrating matter with plastic vision'. Schoenmaeker believed that the new plastic expression ('Neoplasticism'), born of light and sound, would create a heaven on earth.[2]

The two main theorists of the movement were Mondrian and van Doesburg, but they by no means agreed on all points of doctrine. Mondrian's concept of Neoplasticism, based partly on Schoenmaeker and partly on Kandinsky's influential book *Uber das Geistige in der Kunst* (*Concerning the Spiritual in Art*) of 1911, was restricted to painting, whereas van Doesburg attempted to apply it to architecture as well. Although both Huszar and Van der Leck made important contributions to the early development of Neoplasticism, it was Mondrian who worked out its logical implications. The system that he eventually arrived at was based on a radical process of reduction in which the complex, accidental appearance of nature was refined to the variations of an irregular orthogonal grid, partly filled in with rectangles of primary colour [72]. According to Yve-Alain Bois, Mondrian organizes the picture surface in such a way that the traditional hierarchy between figural objects and an illusionistic ground is abolished. In Mondrian, 'no element is more important than any other, and none must escape integration'.[3] These structural principles of non-redundancy and non-hierarchy are similar to those underlying Schoenberg's atonal and serial music.[4] In traditional painting it is the figural object that conveys the symbolic or lyrical content (as does melody in music);[5] in Mondrian's paintings the meaning is transposed from the represented object to the abstract organization of the two-dimensional surface—an effect analogous to Boccioni's idea that it was no longer objects (reduced to lines, planes, and so on) that provided rhythm and emotion, but the relations between them (see page 100).

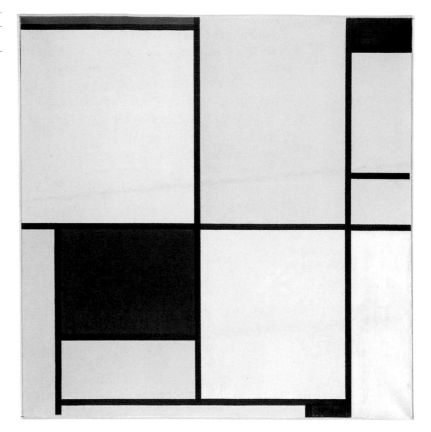

72 Piet Mondrian

Composition 1 with Red, Yellow and Blue, 1921
This was one of a group of paintings begun in 1920 in which Mondrian first arrived at an organization that was neither a repetitive grid nor the representation of a figure upon a ground.

The relation between architecture and painting

In the early phase of the De Stijl movement, there was an emphasis on the collaboration between architecture and painting. The following remarks by Van der Leck are typical of this position:

Modern painting has now arrived at the point at which it may enter into collaboration with architecture. It has arrived at this point because its means of expression have been purified. The description of time and space by means of perspective has been abandoned; it is the flat surface itself that transmits spatial continuity . . . Painting today is architectural because in itself and by its own means it serves the same concept as architecture.[6]

This statement is in many ways unclear. For example, if it is true that painting and architecture are becoming increasingly indistinguishable, what sense does it make to say that they should enter into a collaboration? Collaboration can only take place between things that are different—as in the Wagnerian concept of the *Gesamtkunstwerk*.

During the 1920s, a split between painters and architects developed, epitomized by a correspondence that took place between J. J. P. Oud and Mondrian. In this correspondence, Mondrian claimed that

painting was able to anticipate the desired merging of art and life precisely because it remained on the level of representation, and was not, like architecture, compromised by its immersion in reality. Until architecture freed itself from this condition, it could not participate in the movement towards the unification of art and life. For Oud, on the other hand, if art was eventually to merge with life, it could only be at the level of existing reality. Far from being antagonistic to the purification of artistic form, the principles of utility and function were inseparable from it (in this Oud's position was the same as that of Le Corbusier). Mondrian's extreme idealism and Oud's aesthetic materialism were incapable of finding common ground.[7]

Van Doesburg's position differed from that of both Oud and Mondrian. He accepted Mondrian's idealist resistance to the pragmatics of architecture, but he believed that architecture, by the very fact that it existed in real as opposed to virtual three-dimensional space, would play a privileged role in achieving the union of life and art. The ideal (which he shared with the Futurists) of an observer no longer separated from that which was observed, was already immanent in architecture and needed only to be brought out.

The interior

The Decorative Arts movement (Arts and Crafts and Art Nouveau) had sought to unify the visual arts and architecture. But this had only fleetingly been achieved, in the person of the 'artist–craftsman'. One of

73 Vilmos Huszar
Spatial Colour Composition for a Stairwell, 1918
While in traditional architecture decoration was considered supplementary to the constructed surfaces of a building, in De Stijl the rectangles of primary colour applied to the walls were thought of as an integral part of the architecture itself, modifying the space defined by the walls.

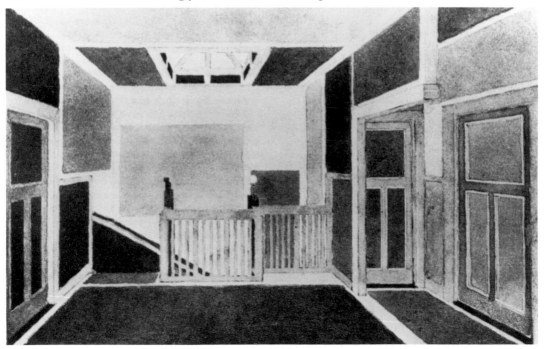

the aims of the De Stijl artists was to occupy the void created by the demise of this artist–craftsman, but to occupy it as painters. In 1918, van Doesburg decorated the interiors of a house by J. J. P. Oud (The De Vonk House, 1917–18) with coloured floor tiles and stained-glass windows which were simply added to the architectural framework. But in the same year, both Van der Leck and Huszar took a more holistic approach, either by designing and colouring all the tectonic elements of a room—doors, cupboards, furniture—so as to create a unity of rhyming rectangular forms, or by applying colour patches to walls and ceilings, often 'against the grain' of the architectural structure [73]. The effect of these interventions was to merge structure, ornament, and furniture in a new unity. The difference between ground (architecture) and figure (ornament, furniture, etc.) was erased, reversing the trend initiated by the interiors exhibited in Germany around 1910 by, for example, Bruno Paul, and reverting to the Jugendstil practice of treating the interior as an indivisible, abstract unity—as in Van de Velde and Wright.

Van Doesburg and architecture

In external form, the influence of De Stijl as well as that of Wright can already be seen in several architectural projects in Holland in the period immediately after the First World War. In these the geometrical, horizontal, and vertical elements that emphasized the main forms still looked like ornamental additions to the structure—for example in the work of Jan Wils and Robert van't Hoff [74]. Van Doesburg also experimented in external architectural forms, but his

74 Jan Wils

De Dubbele Sleutel, 1918
Here the building mass is broken up into cubic volumes roughly in the form of a pyramid. The horizontal and vertical planes are accentuated by cornices, string courses, chimneys, in the manner of Frank Lloyd Wright.

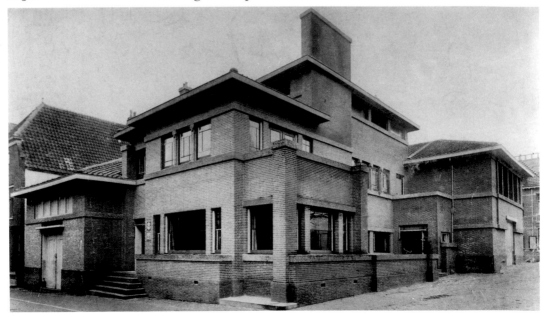

approach was different. In 1917, in collaboration with Jan Wils, he designed a small, pyramidal public monument made up of prisms—a type of abstraction that can be traced back to Joseph Hoffmann's decorations at the 14th Vienna Secession Exhibition of 1902.[8] By 1922, van Doesburg had begun to 'activate' such purely sculptural forms by making them coincide with habitable volumes. In work executed by his pupils from the Weimar Bauhaus, asymmetrical house plans were projected vertically to create interlocking prismatic volumes [75]. These researches reached a climax in 1923 when, in collaboration with the young architect Cornelis van Eesteren (1897–1988), he exhibited three 'ideal' houses at Léonce Rosenberg's L'Effort Moderne gallery in Paris. Two of these houses—an 'Hôtel Particulier' and a 'Maison d'une Artiste'—were variants of a single type of house, which,

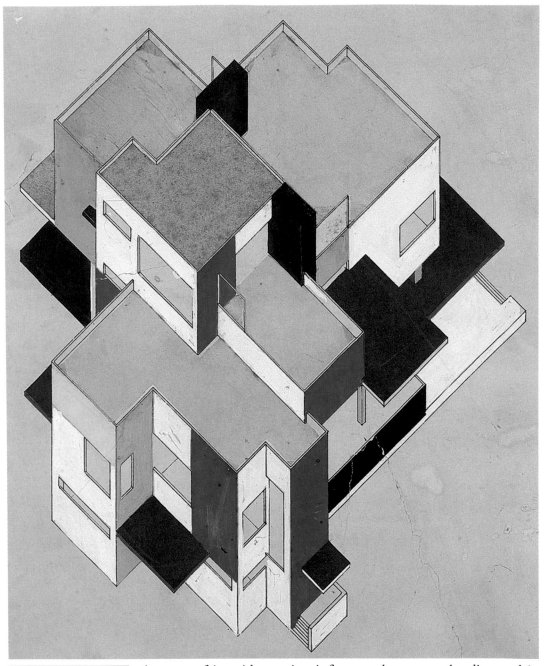

**76 Theo van Doesburg and
Cornelis van Eesteren**

Axonometric drawing of Hôtel
Particulier, 1923

A development of van
Doesburg's earlier studies (see
75), the cubic composition is
further broken up by arbitrarily
placed rectangles of colour.

because of its wide-ranging influence, deserves to be discussed in
some detail [**76**].

The house consists of an aggregation of interlocking cubic volumes
which appear to 'grow' from a central stem or core in a manner that
recalls Wright's Prairie Houses. In its underlying organization the
house is systematic but in detail it is accidental and variable. This idea
recalls the system-plus-variety of Mondrian's paintings, particularly

77 Theo van Doesburg

Counter-construction
(Construction de l'Espace-
Temps II), 1924

This is one of a series of axono-
metric drawings giving van
Doesburg's concept of a
Neoplasticist architecture in
which cubic volumes have
been reduced to planes,
making internal and external
space continuous. Colour and
form are now integrated.

the early figural works which show the transformation of a tree into a binary system of vertical and horizontal dashes. Because of its centrifugal, stem-like structure the house has no front or back and seems to defy gravity. It is a self-referential and self-generated object with a form that is not 'composed' from the outside but results from an internal principle of growth. The Maison d'une Artiste can be seen as an allegory of nature, in which an initial, unitary principle exfoliates into an infinity of individuated forms. Primary colours are added to the planes to differentiate between them. In van Doesburg's Counter-constructions of a year later [**77**], the whole composition is reduced to

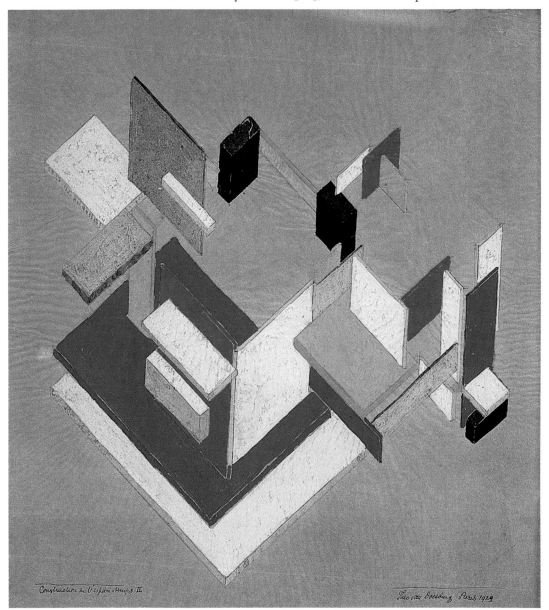

these hovering and intersecting coloured planes, allowing space to flow between them, in accordance with Futurist principles. Van Doesburg defined this spatial system as follows:

The subdivision of the functional spaces is strictly determined by rectangular planes, which possess no individual forms in themselves since, although they are limited (the one plane by the other), they can be imagined as extended into infinity, thereby forming a system of coordinates, the different points of which would correspond to an equal number of points in universal, open space.[9]

In these drawings, axonometry is more than a useful graphic tool. It is the only method of representation that does not privilege one part of the building over another (for example, the façade over the interior). In 'real life', the only way to recall such a house in its totality would be to trace and retrace its interior spaces in time, as in the case of Loos's *Raumplan* houses. Axonometry converts this temporal, semi-conscious process into an experience that is instantaneous and conscious. For van Doesburg these drawings seem to have symbolized his techno-mystical vision of an architecture identical with the flow of lived experience. They were idealized representations of the ineffable. Axonometry was also fundamental to van Doesburg's attempts to represent four-dimensional space.[10]

The only building in which van Doesburg's formal principles were applied was the Schroeder House in Utrecht (1924) by Gerrit Rietveld. Externally the house appears as a montage of elementary forms, but its fragmentation turns out to be a purely surface effect. It is in the interior that the house comes to life. Rietveld has reinterpreted van Doesburg's Counter-constructions in terms of the earlier experiments of Van der Leck and Huszar, and the furniture and equipment of the house is transformed into a vibrant composition of rectilinear forms and primary colours.

Architecture beyond De Stijl

But apart from Rietveld, modern architecture in Holland developed in a different direction from De Stijl, sharing only a certain number of principles such as formal abstraction, immateriality, and the avoidance of symmetries. The emerging architecture rejected De Stijl's rigorous reduction and fragmentation and returned to closed forms and frontality. The work of J. J. P. Oud in the 1920s is hardly touched by De Stijl [78], while that of Johannes Brinkman (1902–49) and Leendert Cornelis van der Vlugt (1894–1936) shows De Stijl's influence in a rather *ad hoc* use of interlocking volumes, cantilevered floors, and floating vertical planes. By the early 1930s, in such works as the Van Nelle Factory (1927–9) and the Sonneveld House (1928) [79], both in Rotterdam, De Stijl forms have been totally assimilated into a

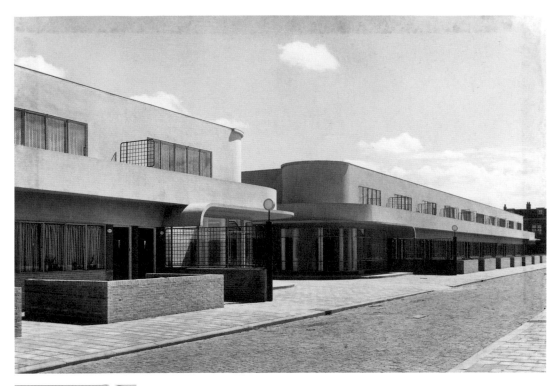

78 J. J. P. Oud

Social Housing, 1924–7,
Hook of Holland

In this project Oud's early De Stijl-inspired work has given way to a more conventional architecture in which the different rooms are enclosed in single volumes of Platonic purity. The surfaces give the effect of thin, white, smooth membranes.

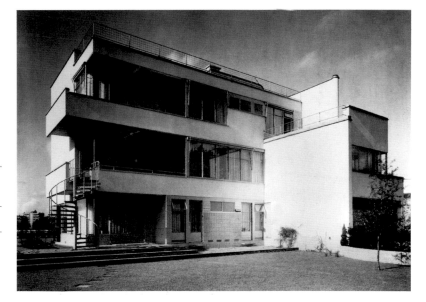

79 Johannes Brinkman and Leendert Cornelis van der Vlugt

Sonneveld House, 1928, Rotterdam

More Constructivist than Oud's work, this house, with its generous balconies and glass walls, suggests a world of heliotropic hygiene.

Constructivist architecture of smooth, machine-like surfaces and extensive glazing. Van Doesburg himself, in the studio house he built in Paris in 1931, abandoned his earlier Neoplasticism and built a relatively simple, functional box.

The tension that developed between De Stijl and the new architecture of the 1920s is revealed by J. J. P. Oud in the book *Nieuwe Bouwkunst in Holland en Europe* published in 1935:

Remarkable as it may sound the Nieuwe Sachlichkeit (New Objectivity) developed in large part from the initial development of the liberal arts—above all painting. The origins of its forms lay much more in the aesthetic domain than in the domain of the objective . . . Horizontal and vertical intersections of parts of buildings, suspended floors, corner windows, etc . . . were for a time very much in vogue. Their derivation from painting and sculpture can be easily demonstrated and they have been continually used with or without any practical aim.[11]

Oud's play on the word 'objective' in opposition to 'aesthetic' and his disapproval of the 'unpractical' influence of painting and sculpture, clearly indicate the emergence of the new 'functional' parameters. Despite this, the idealism and formalism of van Doesburg's work made it a catalyst for Modernist architects seeking a new formal language, just as Frank Lloyd Wright's work had been a few years earlier. As a result of van Doesburg's exhibitions in Weimar and Paris in 1922 and 1923 respectively, and his presence 'off-stage' at the Bauhaus in 1921, Neoplasticism exerted a considerable influence on architects like Le Corbusier, Walter Gropius, and Mies van der Rohe at critical moments in their careers.

The Russian avant-garde

The reform movement in the arts followed much the same trajectory in Russia as in Western Europe. A revival of the vernacular arts and crafts inspired, as elsewhere, by William Morris, was initiated at two centres: the estate of the railway magnate Savva Mamontov near Moscow (in the 1870s) and the estate of Princess Tenisheva at Smolensk (in 1890). Both were closely associated with the Pan-Slav movement. But in 1906 this movement itself underwent a transformation with the founding of the Organization for Proletarian Culture ('Proletkult'), by Alexandr Malinovsky, self-styled 'Bogdanov' (God-gifted). Bogdanov had abandoned the Social Democrats for the Bolsheviks in 1903, and his new organization initiated a shift from the concept of the folk to that of the proletariat, and from handicraft to science and technology. According to Bogdanov the progress of the proletariat towards socialism would have to take place simultaneously on the political, economic, and cultural planes. These ideas were in fact closer to those

of Saint-Simon than those of Marx, particularly in their call for a new 'religion' of positivism.

A common pattern in Russia and the West can be found not only in the change of emphasis from handicraft to machine-work, but also in the re-emergence of the fine arts as the most important site of experiment, linked to the concept of *Gestalt*. The only substantial difference was that in Russia the industrial art and fine art movements occurred simultaneously and became locked in a destructive ideological battle, whereas in the West, though they overlapped, they occurred sequentially.

The diversity of artistic movements that characterized the pre-revolutionary avant-gardes in Russia, especially those deriving from Cubism and Futurism, persisted in the post-revolutionary period, presenting the historian with a bewildering array of acronyms. Support for the revolution came from all artistic factions, including the most conservative, each faction identifying with its aims. For those avant-garde artists and architects who joined the revolution, the Utopian fantasies of the period before the First World War seemed about to become a historical reality.[12] The revolution released an explosion of creative energy, in which the paths opened up by the pre-war European avant-gardes were redirected towards the achievement of socialism.

Art institutions

The Ministry of Enlightenment that was set up after the revolution under Commissar Lunacharski, who had been associated with Proletkult, was more tolerant of Modernist art than was the party establishment as a whole. Under the new ministry, there was a general reform of the art institutions. The Free Workshops, founded in Moscow in 1918 and renamed the Higher State Artistic and Technical Workshops (Vkhutemas) in 1920, were the successors of the two main pre-revolutionary Moscow art schools—the Stroganov School of Industrial Design and the Moscow School of Painting, Sculpture, and Architecture. The fusion of the old school of art with a craft school which, since 1914, had been training students for industry, created a fundamental institutional break with the past—similar to that which occurred at the same time in the Weimar Bauhaus—a change epitomized by the introductory design course or 'Basic Section', which was shared by all departments. The progressives in the school were divided into two ideological camps: the Rationalists, led by the architect Nikolai Ladovsky (1881–1941) and his United Workshops of the Left (Obmas), and the Constructivists, whose members included the architect Alexander Vesnin (1883–1959) and the artists Varvara Stepanova (1894–1958), Alexander Rodchenko (1891–1956), and Alexei Gan (1889–1940). Another important institution was the Moscow Institute

of Artistic Culture (Inkhuk). It was within Inkhuk that the leftist First Working Group of Constructivists was formed in 1921, and that a significant debate took place between this group and the Rationalists over the question of 'construction' versus 'composition'.[13]

Rationalism versus Constructivism

Though in their forms the Rationalists and Constructivists were often similar, they were ideologically fundamentally opposed to each other. According to the Rationalists, the first task in the renewal of art was its purification and the discovery of its psychological, formal laws; according to the Constructivists, art, being an intrinsically social phenomenon, could not be isolated as a purely formal practice.

The Rationalists, starting from the architectural fantasies of Expressionism, elaborated a system of formal analysis based on *Gestaltpsychologie* [**80**]. Ladovsky's course at the Vkhutemas was the core of the Basic Section until the school was reshaped on more conservative lines in 1930. In 1923 Ladovsky founded the Association of New Architects (ASNOVA) to counteract the growing influence of the utilitarian Constructivists within Inkhuk.

Another essentially formalist group must be mentioned here: the Suprematists. Founded by the painter Kasimir Malevich (1878–1935) in 1913, this movement had much in common with Dutch Neoplasticism, including its geometrical reductivism and its involvement with Theosophy—in the case of Malevich, with the writings of P. D. Ouspensky.[14] Unlike Mondrian's paintings, the Suprematist work of Malevich still relied on a figure-ground relationship between represented objects and illusionistic space—even if this space was now featureless and Newtonian. Also unlike Mondrian, but like van Doesburg, Malevich extended his system of ideas to architecture. In a series of prismatic, quasi-architectural sculptures (which he called 'Arkhitektons') he sought to demonstrate the timeless laws of architecture underlying the ever-

80 Nikolai Ladovsky

Design for a Commune, 1920
Such early products of
Ladovsky's Rationalism
continued the tradition of
Dada and Expressionism,
which Ladovsky was to supply
with a pseudo-scientific
system of rules.

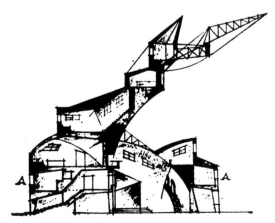

81 Kasimir Malevich

Arkhitekton, 1924

Malevich's Arkhitektons resemble early De Stijl compositions in which ornament is non-figural and 'form' and 'ornament' are differentiated only by scale. These studies are purely experimental and the buildings have no function and no internal organization.

changing demands of function [**81**]. The Darmstadt-trained architect El Lissitzky (1890–1941) was associated with Malevich at the art school in Vitebsk in the early 1920s. The paintings which he grouped under the name 'Proun' ('Project for the affirmation of the new') explored the common ground between architecture, painting, and sculpture. Many of them consisted of Arkhitekton-like objects floating in a gravity-free space, represented in spatially ambiguous axonometric projections. Like van Doesburg, Lissitzky was interested in the possibility of representing four-dimensional space, though he later repudiated this idea.

In contrast to the Rationalists, the Constructivist group held that what constituted the essence of modern art was not the principle of form, but that of construction. The First Working Group of Constructivists (founded by Rodchenko, Stepanova, and Gan) represented the group's most radical wing. The group extended the Futurist concept of the work of art as a 'construction'—a real object among real objects—rather than a 'composition' of represented objects, maintaining that this necessarily entailed the total elimination of fine art in

favour of applied or industrial art (or 'production art' as they preferred
to call it). They thus converted the Hegelian idea of the sublation of art
into life—already present in pre-First World War avant-garde theory
(for example, in that of Mondrian)—from a vague Utopian fantasy
into an actual political project. This programme was set out in Alexei
Gan's manifesto, 'Konstruktivizm', of 1922.[15]

The chief paradigm for this 'constructed' object was the three-
dimensional work of Vladimir Tatlin (1885–1953)—particularly his
'Counter-reliefs' of 1915, based on Boccioni's 1914 reinterpretation of
Picasso's relief collages, and his maquette for a Monument to the
Third International (1919–20), a fusion of Cubo-Expressionist form
and quasi-rational structure [**82**]. The First Working Group saw such
works, which were palpably non-utilitarian, as a halfway house to the

creation of a hitherto non-existent human type: the 'artist–constructor', who would unite the skills of the artist and the engineer in one person. The scholastic mystifications of much of this debate masked an attempt on the part of the First Working Group to reconcile artistic idealism with Marxist materialism. It is clear from Tatlin's occasional writings that for him it was the mimetic and intuitive understanding of complex mathematical forms that constituted the necessary link between modern art and political revolution, not the literal production of these forms. The artist's work was not part of technology, but its 'counterpart'.[16]

The essential concern of the First Working Group was the artist's role in an industrial economy—a concern common to all avant-garde groups since the founding of the Deutscher Werkbund 14 years earlier. The Constructivist theorist Boris Arvatov suggested that the craft shops of the Vkhutemas should be used for 'the invention of the standard forms of material life in the field of furniture, clothing, and other types of production'.[17]

Artists like Rodchenko, Stepanova, and Lyubov Popova (1889–1924) and their students set about designing the components of the new socialist micro-environment [83]. Unlike the furniture produced by the Werkbund-inspired German workshops before the First World War, these objects never entered the production cycle and their designers did not have the factory experience which might have led to

83 Alexander Rodchenko

Drawing of a chess table, 1925

This was one of the pieces of furniture for the workers' club section of the USSR Pavilion at the Exposition des Arts Décoratifs in Paris in 1925.

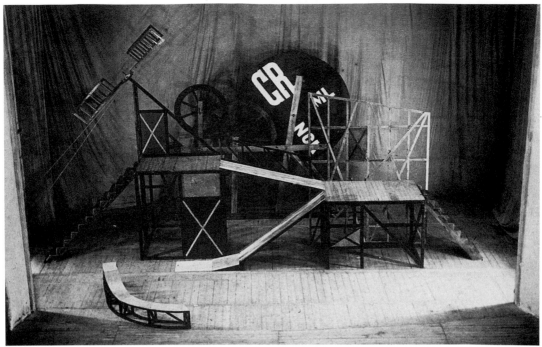

84 Lyubov Popova
Set for Meyerhold's Bio-
mechanical Theatre, 1922
This set is a playful
representation of social life
dominated by the machine—
a kind of mechanization
without tears.

the evolution of the artist–constructor. However, in remaining the creations of artists they belonged to a new economy of furniture design, depending on new materials such as plywood, bentwood, and tubular steel, with forms that depended less on traditional craft skills than on a certain kind of inventive wit. This type of utilitarian design was to culminate in the designs of the Bauhaus and the furniture of architects like Mart Stam and Marcel Breuer and would eventually create its own market for 'designer furniture'. The 'productivist' designers were therefore the unwitting pioneers of a kind of market production which was the very opposite of the one they envisaged.

The didactic aim of these designs was also characteristic of the stage-sets designed by Popova, Alexander Vesnin and others, for Vsevolod Meyerhold's propagandist 'Bio-mechanical Theatre' [**84**], in which the influence of American industrialism was evident. These were ironic and playful wooden constructions symbolizing the synthesis of man and machine and depicting an environment of mechanistic efficiency, in the spirit of the time-and-motion studies of the American engineer F. W. Taylor, but with all the threatening aspects removed—'a new world in which freedom of action could be integrated with a planned use of the machine'.[18]

Constructivist public architecture

Lenin's partial reintroduction of free-market capitalism in the New Economic Plan (NEP) of 1920 initiated an ambitious programme of

mixed state and privately financed corporate buildings. After 1922 numerous competitions were launched. Though few resulted in built projects, it was from these competitions that the first permanent, large-scale Constructivist architecture emerged. Its chief characteristics were the elimination of all ornament and the external expression of the structural frame, showing the influence of American factory design, and of Walter Gropius's and Ludwig Hilbersheimer's separate entries for the *Chicago Tribune* competition of 1922. Although the Proletkult movement had been suspended in 1923, some of these ponderous monoliths were enlivened with written signs and mechanical or electrical iconography reminiscent of the agitprop kiosks of the early years of the revolution and connected with Lenin's Plan of Monumental Propaganda of 1918. Vesnin's design for the Moscow headquarters of the Leningrad *Pravda* (1924) was little more than an oversized and regularized kiosk, with its transparent frame and pithead imagery, and its icons of communication—and it had some of the playfulness of his and Popova's stage-sets [**85**]. In other cases, such as Vesnin's competition entry for the Palace of Labour (1922–3) and Ilya Golosov's Workers' Club in Moscow (1926), the building mass is broken up into huge Platonic volumes containing the main programmatic elements.

OSA

In 1925 a new professional group was formed within the Constructivist faction under the intellectual leadership of Moisei Ginsburg (1892–1946) and the patronage of Alexander Vesnin, called The Union of Contemporary Architects (OSA). This group was opposed to both the Rationalists and the First Working Group. It sought to steer the avant-garde away from the Utopian rhetoric of the Proletkult tradition, towards an architecture grounded in scientific method and social engineering. The group's aims reflected a trend in the Russian avant-garde towards reintegration and synthesis. As Leon Trotsky pointed out in his book *Literature and Revolution* (1923): 'If Futurism was attracted to the chaotic dynamics of the revolution . . . then neoclassicism expressed the need for peace, for stable forms.' This was equally true of avant-gardes in the West, where—as we shall see—there was a turn to neoclassical calm and precision as a reaction against the irrationalism of Expressionism, Futurism, and Dada.

The group published a journal—*Contemporary Architecture*[19]—and established close ties with avant-garde architects in Western Europe. Ginsburg's book *Style and Epoque* (1924) was closely modelled on Le Corbusier's *Vers une Architecture* (though opposed to the idea of Platonic constants), and was influenced by Riegl's concept of the *Kunstwollen*. OSA posited an architecture of equilibrium in which aesthetic and technical–material forces would be reconciled. It was

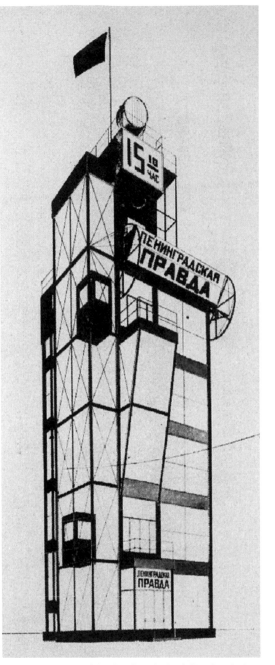

85 Alexander and Viktor Vesnin

Competition Design for the Moscow Headquarters of the Leningrad *Pravda*, 1924
This building is a transparent information machine in which the structure and equipment of the building and its media attachments become the vehicles of rhetoric and propaganda. The building has become a sign of its own function.

fiercely opposed by Ladovsky's ASNOVA for its positivist attitude and its emphasis on technology.[20]

An earlier manifestation of such internationalist ideas had been the short-lived journal *Veshch* (*Object*) published in Berlin in 1922 by El Lissitzky—spokesman of the Russian avant-garde in Germany—and the poet Ilya Ehrenberg. The main purpose of this journal, which was mostly written in Russian, was to acquaint Russian readers with

European developments.[21] The journal emphasized the autonomy of the aesthetic object: 'We do not wish to see artistic creation restricted to useful objects alone. Every organized piece of work—be it a house, a poem or a painting—is a practical object. Basic utilitarianism is far from our thoughts.'[22] Though ostensibly promoting the latest Constructivist ideas, the magazine completely ignored the anti-aesthetic doctrine of the First Working Group.

OSA architects concentrated on housing and urbanism as the main instruments of socialist development. Ginsburg was not an advocate of communal living in its more doctrinaire form, according to which a strict Taylorism should be applied to both work and leisure time and family life should be virtually abolished. But despite the importance Ginsburg attached to the opinions of ordinary people, the types of apartment that he provided in his Narkomfin Housing in Moscow (1928–9) were unpopular because, with their minimal surface area, they did not allow for the kind of untidy extended family life to which people were accustomed.[23] The building reflects the influence of Le Corbusier in its plastic and sectional organization and its combination of family dwellings and communal facilities [86].[24]

In the field of urbanism, OSA was caught up in the controversy between the urbanists and the disurbanists. In this debate, the urbanists proposed the moderate decentralization of existing cities, preserving them in their substance, and the creation of Garden Suburbs along the lines of Raymond Unwin's Letchworth and Hampstead Garden Suburb in Britain. The disurbanists, on the contrary, called for the progressive demolition of existing cities, except for their historical cores, and the dispersal of the population over the whole countryside. Ginsburg's disurbanist views are evident from his competition projects for the Green City (a leisure city to be built near Moscow), and for the steel city of Magnitogorsk in the Urals, one of the new cities planned as part of the first Five Year Plan of 1928. For Magnitogorsk, Ginsburg designed light, wooden houses on *pilotis*, suitable for a new kind of nomadic life. These plans were based on the theories of the sociologist Mikhail Okhitovitch (1896–1937),[25] who proposed the dispersal of industry and a balanced relationship between urban and rural life, predicated on the Fordist model of universal automobile ownership.[26] In their projects OSA adopted the concept of the linear city as proposed by the Spanish urbanist Soria y Mata (1844–1920) and his Russian disciple Nikolai Milyutin (1889–1942), who was also the client for Ginsburg's Narkomfin Housing.

Two visionary architects

Among the many architects of talent who emerged in the 1920s in Russia, two figures stand out: Konstantin Melnikov (1890–1974) and

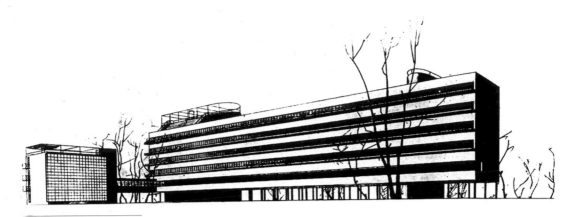

86 Moisei Ginsburg

Narkomfin Housing, 1928–9, Moscow

This was not typical of Russian mass housing projects in the 1920s, being based on avant-garde and Utopian principles of communal living that were not generally accepted by the Stalinist government. Predicated on an internationalist view of modern architecture, the scheme, at a formal level, is highly indebted to the work of Le Corbusier.

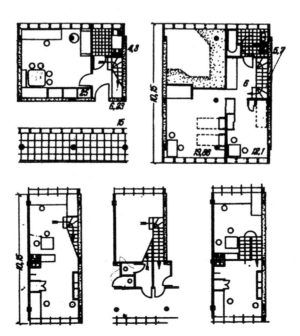

Ivan Leonidov (1902–59). Melnikov had a pre-revolutionary background, whereas Leonidov was formed within the culture of the post-revolutionary avant-garde. Both, however, were committed equally to socialism and Modernism and sought to give symbolic form to the ideals of the revolution while at the same time exploring architectural ideas for their own sake.

Melnikov was old enough to have been influenced by the Romantic classicism fashionable when he was a student, after which he came under the spell of Expressionism and the Proletkult movement. His approach was in many ways similar to the formalism of Ladovsky; but he believed Ladovsky's ideas to be too theoretical and schematic and, with Ilya Golosov, he set up a separate Vkhutemas studio—The New Academy—that taught a more individual and spontaneous approach to design. In Melnikov's projects the forms and spaces were based on a close study of the programme, which he interpreted in terms of clashing and distorted geometries, as in the USSR Pavilion at the Exposition des Arts Décoratifs in Paris in 1925 [**87**]. His buildings gave rise to associations and ideas beyond architecture and acted as signs within the existing urban context, as, for example, in the Rusakov Workers' Club of 1927. Their similarity, in this respect, to the *architecture parlante* of Claude-Nicolas Ledoux (1736–1806), who was popular among architects in Russia at the time, has often been noted.

Melnikov rejected a purist definition of modern architecture either in a formal or a technical sense and his buildings exhibit an eclectic mixture of structural expressionism, formal abstraction, and the allegorical use of the human figure. Such 'kitsch' elements, as found in the

87 Konstantin Melnikov

The USSR Pavilion, Exposition des Arts Décoratifs, 1925, Paris

A hybrid structure that was simultaneously a building and a sign, the pavilion is penetrated diagonally by a public footpath—an idea that Le Corbusier was to recall when he designed the Carpenter Center at Harvard in the 1960s.

PAVILLON **U.R.S.S.**
PARIS 1925

Commissariat for Heavy Industry of 1934, appear in his work with increasing frequency in the 1930s and probably reflect the official demand for a Social Realist architecture. But since Melnikov used them as additional weapons in his armoury of shock tactics—bringing to mind the critic Viktor Shklovsky's theory of the 'making strange' of traditional practices[27]—rather than aiming at a reconciliation with tradition, his work suffered the same official neglect in the 1930s as that of the Constructivists and Rationalists.

Ivan Leonidov, 12 years younger than Melnikov, was a product of OSA and Ginsburg's formalist–functionalist wing of Constructivism. In complete contrast to the physicality and drama of Melnikov's work, Leonidov's designs seem to exist in a disembodied Neoplatonic world in which technology has been converted into pure Idea. His reputation rests largely on a series of Utopian projects designed between 1927 and 1930. The first and most significant of these was a project for the Lenin Institute of Librarianship [88], which was shown at the first Exhibition of Contemporary Architecture at Moscow in 1927. This project resembles a Suprematist composition. It is dominated by a slender glazed tower and a translucent sphere (the auditorium), the latter apparently prevented by tension cables from floating off into space. A second project, for a Palace of Culture (1930), was a transformation of the typical workers' club into an institution for proletarian education on a national scale. Unlike that of the Lenin Monument, which expands dynamically from a central point, the plan of the Palace

88 Ivan Leonidov
The Lenin Institute of Librarianship, 1927
The metaphor of transparency and weightlessness is here combined with Platonic forms, synthesizing Suprematism and Constructivism and symbolizing a socialism in which the ideal and real, the spiritual and the material, have become fused.

of Culture consists of a static rectangular field, subdivided by a square grid on which the different Platonic elements—glazed hemispheres, cones, and pyramids—are deployed like pieces on a chessboard. These and other projects by Leonidov are remarkable for the apparent effortlessness with which they summarize and integrate the Suprematist and Constructivist traditions.

The end of the Russian avant-garde

Throughout the 1920s Russian avant-garde architects struggled to hold onto their freedom of action, which usually meant the freedom to put forward ideas that were more radical, both socially and artistically, than those of the Communist Party. But towards the end of the 1920s the gap between the avant-garde and the political establishment increased. As the Stalin government became increasingly authoritarian and culturally conservative, so the architects became more Utopian—as the work of Leonidov demonstrates. The same was true at the level of urbanism. While the architects of OSA condemned the traditional city, the Communist Party saw it as a cultural heritage that was understood by the masses and should therefore be preserved, extended, and improved. The plan for Moscow of 1935 (architect: V. N. Semenov), though based on the city's unique medieval structure, followed the general principles of such nineteenth and early-twentieth-century city plans as Haussmann's Paris, the Ringstrasse in Vienna, and Burnham's Chicago. The official view was summed up in the slogan: 'The people have a right to columns.'

With Stalin's first Five Year Plan of 1928, the government embarked on a ruthless programme of industrial development and agricultural collectivization. This programme included the construction of a number of new industrial cities sited near sources of raw material. The solutions that Ginsburg and Milyutin proposed for Magnitogorsk were ignored in favour of conventional centralized cities. Showing little faith in Russian architects with their lack of practical experience and preoccupation with long-term, Utopian ideas, the new city managers hired foreign architects with experience in the techniques and management of new settlements. These included the German architect Ernst May and the Swiss Hannes Meyer (who moved to Russia in 1930 after losing hope that socialism might be established in western Europe). Such architects, however, completely misjudging the true situation in Russia, were disappointed when they discovered that their clients were more interested in their technical skills than their Modernist aesthetics—which in any case could hardly be realized under the primitive conditions of the Russian building industry.

Two events symbolize the final death of the avant-garde in Soviet Russia. The first was the dissolution in 1932 of all autonomous

89 Boris Iofan

Palace of the Soviets, 1931–3
This project represents the Stalinist concept of a bourgeois architecture inherited by the masses. It marked the death knell of modern architecture in the USSR. The project was never executed.

architectural professional groups except the Stalinist-dominated All Union Society of Proletarian Architects (VOPRA),[28] which resulted in increased government control over the profession. The second event was the result of the prestigious Palace of the Soviets competition, held between 1931 and 1933. After a long drawn-out procedure a young 'centrist' architect—Boris Iofan—was awarded first prize from a list of entrants that included many of the stars of European Modernism, among them Gropius, Mendelsohn, and Poelzig from Germany, Brasini from Italy, Lamb and Urban from America, and Auguste Perret and Le Corbusier from France [**89**].

Henceforth the state maintained a firm grip on architectural policy. The architects of the avant-garde either vainly attempted to adapt their style to the approved monumentalism or became bureaucrats (for example, Ginsburg), working for technical improvement within a cultural policy of Socialist Realism that contradicted all that they had lived for in the 1920s.

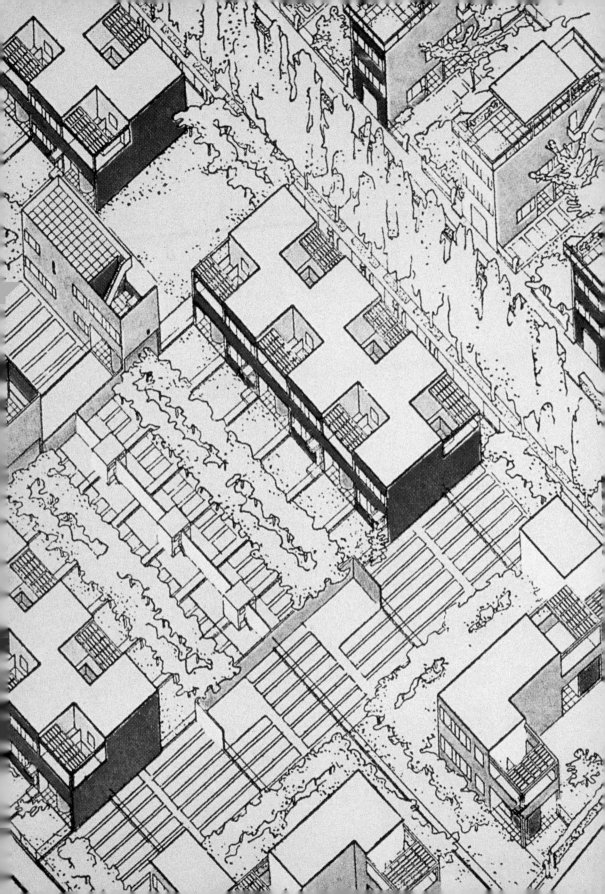

Return to Order: Le Corbusier and Modern Architecture in France 1920–35

7

After the war of 1914–18 there was a strong reaction in artistic circles in France against the anarchy and uncontrolled experimentalism of the pre-war avant-gardes. A 'return to order' was seen to be necessary. But while for some this meant a return to conservative values and a rejection of modernity, for others it meant embracing the imperatives of modern technology. What further complicated the situation was that both cultural pessimists like the poet Paul Valéry and technological Utopians like Le Corbusier invoked the spirit of classicism and geometry.

In the aftermath of the war, there was little architectural activity in France until 1923, and architects were largely restricted to the design of private dwellings. This chapter will discuss the development of the French avant-garde as it emerged from this situation, with Le Corbusier as its most creative and energetic representative.

Le Corbusier before the First World War

Charles Eduard Jeanneret (1887–1965), later known as Le Corbusier, received his training in the school of arts and crafts at La Chaux-de-Fonds in French Switzerland, where he learned a trade—watch engraving—before taking the Cours Supérieur with Charles L'Eplattenier, who persuaded him to become an architect. He worked for a few months with Auguste Perret in Paris in 1908 and from 1910 to 1911 he spent several months in Germany preparing a report on German applied art commissioned by his teacher in Switzerland, Charles L'Eplattenier.

While in Germany he met Theodore Fischer, Heinrich Tessenow, and Bruno Paul, worked briefly in the office of Peter Behrens, and attended an important Deutscher Werkbund conference sponsored by the cement industry at which most of the luminaries of the German avant-garde were present. He then travelled to the Balkans, Istanbul, and Athens. The journal and letters that Jeanneret wrote during this

voyage show that he was caught between his love of the 'feminine' vernacular arts of Eastern Europe and Istanbul, and his admiration for the 'masculine' classicism of ancient Greece, which he identified with the spirit of modern rationalism. The effect of the Parthenon, combined with the teaching of Perret and Behrens, converted him to classicism, and he renounced the medievalizing Jugendstil tradition in which he had been trained.

In his report on German applied art, which was entitled 'Etude sur le Mouvement de l'Art Décoratif en Allemagne' ('Study on the Decorative Art Movement in Germany'), Jeanneret eulogized the tradition of the French decorative arts, which he saw to be threatened by German commercial competition. He was full of praise for the organizational skill of the Germans, but denigrated their artistic taste. Somewhat inconsistently, however, he admitted his admiration for the new German neoclassical movement, claiming that 'Empire' was the progressive style of the day, being at once 'aristocratic, sober, and serious'.

Jeanneret's early work already shows the desire to reconcile architectural tradition with modern technology that was to characterize his entire career. While practising in La Chaux-de-Fonds between 1911 and 1917 he was engaged in three types of project: research into the application of industrial techniques to mass housing within a Sitte-esque Garden Suburb framework; bourgeois interiors in the Empire and Directoire styles; and the design of neoclassical villas. Of the three villas that he built in the vicinity of La Chaux-de-Fonds—the Villa Jeanneret (1912), the Villa Favre-Jacot (1912), and the Villa Schwob (1916)—the first two were strongly influenced by Behrens's neoclassical houses and the third by Perret's use of the reinforced-concrete frame. During this period, frequent visits to Paris kept him in touch with both Perret and French decorative art circles, in which his 'Etude' had enjoyed something of a *succès d'estime*.[1]

In 1917 Jeanneret moved permanently to Paris, where he was able to set up an office within the business ramifications of an old friend, the engineer and entrepreneur Max Dubois. He also began to paint in oils under the guidance of the artist Amédée Ozenfant, whom he met in 1918. Calling themselves 'Purists', the two immediately collaborated on a book, *Après le Cubisme*, and with the poet Paul Dermée founded the magazine *L'Esprit Nouveau* in 1920.

L'Esprit Nouveau

The review (from which Dermée was soon ejected on account of his Dada tendencies) was published between October 1920 and January 1925 in 28 editions. Its original subtitle, *Revue Internationale d'Esthétique*, was soon changed to *Revue Internationale Illustrée de l'Activité Contemporaine*, and the following list of subjects was announced:

literature, architecture, painting, sculpture, music, pure and applied science, experimental aesthetics, the aesthetic of the engineer, urbanism, philosophy, sociology, economics, politics, modern life, theatre, spectacles, and sports. Most of the articles were written by Ozenfant and Jeanneret themselves under various pseudonyms.[2] (At this point, Jeanneret adopted the name of Le Corbusier, though he continued to sign his paintings with his family name until 1928.)

The principal theme of *L'Esprit Nouveau*, already developed in *Après le Cubisme*, was the problematic relation between art and industrial society. The review shared with De Stijl the idea that the modern industrialized world implied a change from individualism to collectivism. Both also agreed that art and science were not opposed to each other, even if they used different means, and that their union would result in a new aesthetic. What differentiated *L'Esprit Nouveau* from De Stijl was the belief that this new aesthetic would be classical in spirit. This idea was underlined by the constant juxtaposition of old and new: monographs on such French classical 'masters' as Poussin and Ingres were interleaved with articles by Charles Henry on the science of aesthetics;[3] the Parthenon was compared to a modern automobile, and so on. The affinity between art and science was seen to be based on their common approximation to a condition of stasis, harmony, and invariability. Science and technology had reached a state of perfection of which the Greeks had only dreamed. Reason could now create machines of extreme precision; feeling, allied to reason, could create works of art of an equally precise plastic beauty: 'No one today denies the aesthetic that emanates from the constructions of modern industry . . . machines display such proportions, plays of volume and materiality that many are true works of art, because they embody number, which is to say order.'[4] There was nothing new in the identification of modern technology with classicism—it had been an essential part of Muthesius's post-Arts and Crafts aesthetic doctrine (see page 58). But Cubism had opened the way to a more abstract, Platonic idea of classicism, and it was in this form that the equation technology–classicism reappeared in *L'Esprit Nouveau*.

The connection between science and Platonic forms depended on a highly selective view of modern science. It tended to ignore such nineteenth-century developments as the life sciences and non-Euclidean geometries with their counterintuitive, often destabilizing, models of reality. Even more problematic was the fact that in the new world of objectivity and collectivism anticipated by *L'Esprit Nouveau* the position of the artist remained untouched. De Stijl and the Constructivists, arguing from similar principles to *L'Esprit Nouveau*, had foreseen a time when the artist would become redundant. But for *L'Esprit Nouveau*, the artist played an essential role within a modern society dominated by science and technology—that of making visible the

unity of the age. Françoise Will-Levaillant's judgement is difficult to dispute: 'The positivism applied by *L'Esprit Nouveau* founders on the contradiction between materialism, to which it leans a priori, and idealism, which completely overdetermines all reasoning and choice.'[5] An unresolved dualism was, indeed, at the very core of Le Corbusier's system of ideas. 'The first goal of architecture', he wrote, ' is to create organisms that are perfectly viable. The second, where modern architecture really begins, is to move our senses with harmonized forms and our minds by the perception of the mathematical relationships which unify them.'[6] In such statements the connection between technical viability and aesthetic form is merely asserted, never argued. Although forms became 'lawful' only through technique, they were nonetheless somehow self-validating. This unresolved contradiction between materialism and idealism was not, however, restricted to the pages of *L'Esprit Nouveau*; to one degree or another it characterized the Modern Movement of the 1920s as a whole.

The *objet-type*

It was in formulating an ideology of modern painting that Ozenfant and Jeanneret developed many of the architectural ideas that later appeared in *L'Esprit Nouveau*. In *Après le Cubisme* (1918) and in the essay 'Le Purisme'[7] an idea that was to play an important part in Le Corbusier's architectural theory was introduced: that of the *objet-type*. In these texts, the authors praise Cubism for its abolition of narrative, its simplification of forms, its compression of pictorial depth, and its method of selecting certain objects as emblems of modern life. But they condemn it for its 'decorative' deformation and fragmentation of the object and demand the object's reinstatement. 'Of all the recent schools of painting, only Cubism foresaw the advantages of choosing selected objects . . . But by a paradoxical error, instead of sifting out the general laws of these objects, Cubism showed their accidental aspects.'[8] By virtue of these general laws, the object would become an *objet-type*, its Platonic forms resulting from a process analogous to natural selection, becoming 'banal', susceptible to infinite duplication, the stuff of everyday life [90].[9]

The Pavillon de L'Esprit Nouveau

Although he had continued to design neoclassical interiors and furniture until his move to Paris in 1917, Jeanneret had been having doubts about his use of this style since 1913. In 1914 he wrote a report in which he said that, to be in tune with the spirit of the age, designers would have to look at 'domains abandoned by the artist and left to their natural evolution',[10] an idea patently derived from Adolf Loos. (Loos's

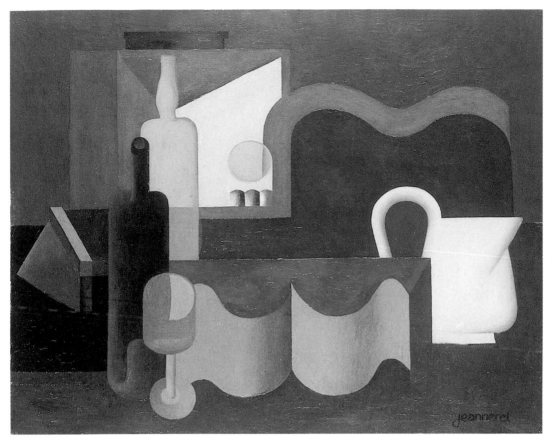

90 Jeanneret/Le Corbusier

Still Life, 1919

This typical Purist work takes from Cubism its flattening of pictorial depth and overlapping of planes, but the object has now been reinstated in its integrity, acquiring solidity and weight. It has become an *objet-type*, representing unchanging values and resisting the relativistic fragmentation of reality that had been the hallmark of Cubism.

essays 'Ornament and Crime' and 'Architecture' had been translated into French two years earlier in the anarchist journal *Les Cahiers d'Aujourd'hui*). The year before, Jeanneret had written to the architect Francis Jourdain (a follower of Loos) expressing his admiration for a room Jourdain had exhibited in the Salon d'Automne.[11] This room contained solid, astylar, rather peasant-like furniture—a far cry from the Empire style with its high-bourgeois overtones.[12]

Le Corbusier resolved these years of doubt in a series of articles in *L'Esprit Nouveau*, published in 1925 as *L'Art Décoratif d'Aujourd'hui*, and his new ideas received their first practical demonstration in the Pavillon de L'Esprit Nouveau that he and his cousin and new partner, Pierre Jeanneret, built at the Exposition des Arts Décoratifs in Paris in 1925. The aim of the exposition, which had been planned before the First World War, was to reassert French dominance in the decorative arts, and most of the work was a 'modernized' form of the French artisanal tradition.[13] In his pavilion Le Corbusier designed an interior that fundamentally challenged this tradition, flying in the face of the French art establishment to which he had so eagerly sought an *entrée* only a few years before. The pavilion proposed nothing less than the abolition of the decorative arts as such. Far from being a tastefully

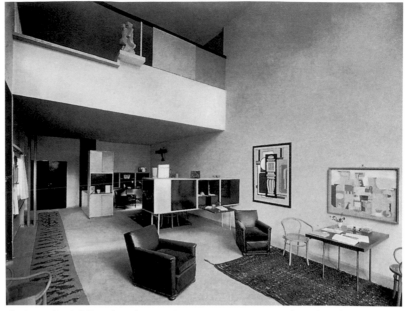

designed middle-class home, it was an apartment for a kind of generic 'man without qualities' living in a post-war economy dominated by mass consumption and mass production.

Arthur Rüegg has called the pavilion a 'curious mixture of Spartan simplicity and the heterogeneous deployment of objects'.[14] The furniture was of two kinds: fixed and mobile. The fixed elements—modular storage units or *cassiers standard*—were integrated into the architectural background, while the free-standing furniture was chosen from products available in the market—for example, leather chairs from Maples and bentwood dining chairs by Thonet. While the other exhibitors presented rooms which were 'artistic wholes', the Pavillon de L'Esprit Nouveau was a montage of found *objets-type* lacking any fixed formal relation to each other [91]. Of the objects that laconically littered this carefully arranged space, Le Corbusier later wrote: '[They] were instantaneously readable, recognizable, avoiding the dispersal of attention brought about by particular things not well understood.'[15] Le Corbusier's ideas of fixed and mobile furniture came directly from Loos. What was quite un-Loosian, however, was the return of the *Gesamtkunstwerk* in a new form—the aesthetically unified expression of the industrial age.

The aesthetics of the reinforced-concrete frame

The modern architecture of the 1920s was born under the sign of reinforced concrete, even though much of the work made limited use of this material.[16] To the 'naive observer', 'concrete architecture' meant architecture that *looked* monolithic and cubic. It was from Auguste

Perret that Le Corbusier learned to regard reinforced concrete as the modern structural material *par excellence*, but his view of it became very different from that of his teacher. Perret adhered to the academically enshrined principles of French structural rationalism, according to which the structure of a building should be legible on the façade. For Perret, the advent of reinforced concrete modified but did not invalidate this tradition; he looked on concrete as a new kind of stone [92].

Unlike Perret, Le Corbusier saw reinforced concrete as a means towards the industrialization of the building process.[17] His first embodiment of this idea was the Dom-ino frame (1914), designed with the help of Max Dubois, in which the columns and the floorplate constituted a prefabricated system independent of walls and partitions [93]. In the earliest projects for which this system was proposed, the external walls, though structurally redundant, still looked as if they were of masonry construction.[18] But starting with the Citrohan House

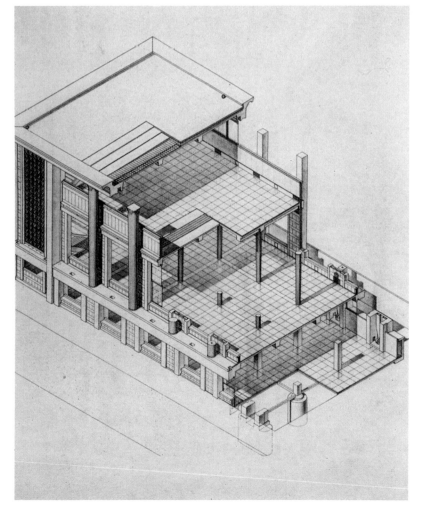

92 Auguste Perret

Musée des Travaux Publics, 1936–46, Paris

Perret reinterpreted the French neoclassical–rationalist masonry tradition in terms of reinforced concrete. In this case there is both a detached peristyle and a structural wall with revetment. The structure, whether free-standing or embedded in the wall, is perfectly legible.

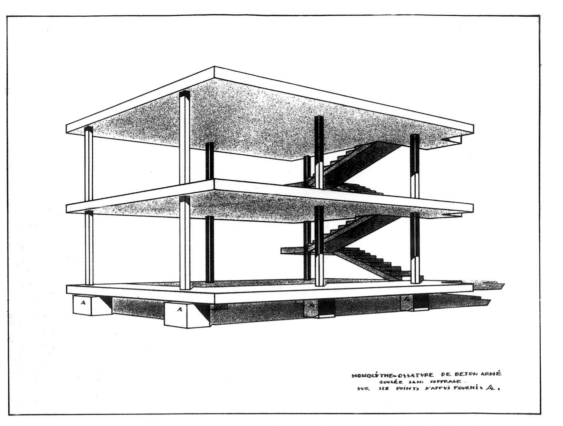

MONOLYTHE-OSSATVRE DE BETON ARMÉ
COVLÉE SANS COFFRAGE.
SVR SIX POINTS D'APPVIS FOVRNIS A.

93 Le Corbusier

Dom-ino Frame, 1914
In this building the concrete frame is conceived as being independent of the spatial planning, and as a means towards the industrialization of the building process, not as a linguistic element as it was for his teacher Perret. Its logical independence frees artistic form from its traditional dependence on tectonics. The building is now presented as an industrial product.

project of 1920, such features disappear and the building becomes an abstract prism. In all Le Corbusier's mature work, even where the external wall is an infill between columns, the columns are suppressed, and the entire surface is covered with a uniform coat of white or coloured plaster. In becoming homogenized and dematerialized the walls of the building lose, as it were, their tectonic memory, just as in Cubism the painting, becoming fragmented, loses its narrative memory. As in Cubist painting, architecture no longer reiterates history: it becomes reflexive.

Although the structure of the proposed Citrohan House is suppressed, its presence is indicated by a number of devices. In this subtle revealing of a hidden frame structure, the work of Le Corbusier differs from that of his Modernist colleagues in France such as Robert Mallet-Stevens (1886–1945), André Lurçat (1894–1970), and Gabriel Gurévrékian (1900–70), who like him exhibited at the Salons d'Automne of 1922 and 1924, in which the new 'cubic' style became known to the public. If we compare, for example, Le Corbusier's Citrohan House of 1925–7 [**94**] with Mallet-Stevens's 'Project for a Villa' of 1924 [**95**] the difference is particularly striking.

The Citrohan House is a single cubic volume. Its window openings extend to the corner reinforced-concrete column, leaving only the

94 Le Corbusier

Citrohan House, 1925–7,
Weissenhofsiedlung,
Stuttgart

This was the last in the series
of Citrohan-type houses
begun in 1920. The house is
a pure prism, an expression
of volume rather than mass,
the walls reading as thin
membranes, the frame
invisible though palpable.

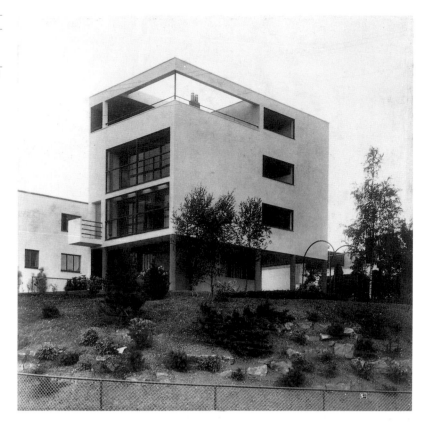

95 Rob Mallet-Stevens

Project for a Villa, 1924

In contrast to the Citrohan
House, the building appears
to have thick walls,
suggesting masonry
construction. It is a
pyramidal composition of
cubes owing much to van
Doesburg.

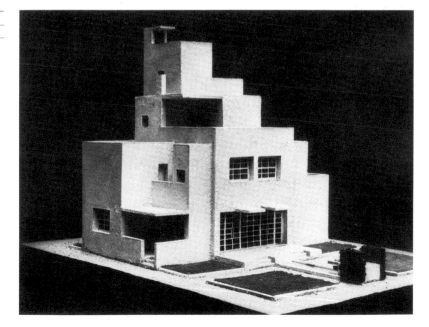

96 Le Corbusier

Housing, 1928, Pessac
The use of colour probably
indicates the influence of van
Doesburg, but Le Corbusier
applies a single colour to
whole façades or buildings,
resisting van Doesburg's
isolation of the plane, just as
he had rejected Cubist
fragmentation. In the 1920s,
unlike van Doesburg, Le
Corbusier preferred earth and
pastel colours but in the
1950s—for example at the
Unité d'Habitation at
Marseilles—he was to adopt
the De Stijl palette of primary
colours.

thickness of this column separating the window opening from the circumambient air, destroying the building's apparent mass. This effect is accentuated by the bringing forward of the windows almost to the wall planes so that the walls appear as a thin diaphragm. Furthermore, because the entire weight of the building is carried on widely spaced columns, the window openings can be of any size or shape and their relationship to the wall is no longer that of figure to ground. In contrast, Mallet-Stevens's villa consists of a pyramidal aggregation of cubes, their thick walls pierced with windows surrounded by substantial areas of wall. Whatever the structure was intended to be, it gives the impression of having been carved out of a solid block. Indeed, Mallet-Stevens himself, in an article of 1922, claimed that, in modern architecture, the concepts of the architect and the sculptor are identical: 'It is the house itself that becomes the decorative motif, like a beautiful piece of sculpture . . . thousands of forms are possible and unexpected silhouettes are created.'[19] The villa, in fact, seems to be derived from van Doesburg's studies in Weimar in 1922, which were equally ambiguous structurally. In both cases an irregular set of rooms dances round a vertical stair shaft, generating an asymmetrical, pyramidal composition of cubes. Ornament has been replaced by picturesque sculptural form.

The Citrohan House was the antithesis of this type of fragmented object which exhibited on its exterior the volumes out of which it was made. Such a building was 'a hirsute agglomeration of cubes; an uncontrolled phenomenon'.[20] 'We have got used', Le Corbusier wrote to a client, 'to compositions which are so complicated that they give the impression of men carrying their intestines outside their bodies. We claim that these should remain inside . . . and that the outside of the house should appear in all its limpidity.'[21] These remarks reveal Le Corbusier's conception of the relation between modern technology and the laws of architecture. Technology, continuously changing, makes the building functionally efficient, satisfying, and giving rise to needs. But like the machinery of a car, the technology of the house should be invisible. Both house and car are *objets-type*—complex sets of functions sheathed in Platonic membranes.

Although Le Corbusier rejected van Doesburg's literal fragmentation of the envelope of the building, his interiors show the influence of van Doesburg's composition by planes,[22] and he sometimes adopts the Dutch architect's external use of polychromy [**96**].

The 'Five Points of a New Architecture'

The Citrohan House referred to above was one of a pair of houses Le Corbusier built for the Deutscher Werkbund-sponsored exhibition at the Weissenhofsiedlung in Stuttgart of 1927. It was in the context of

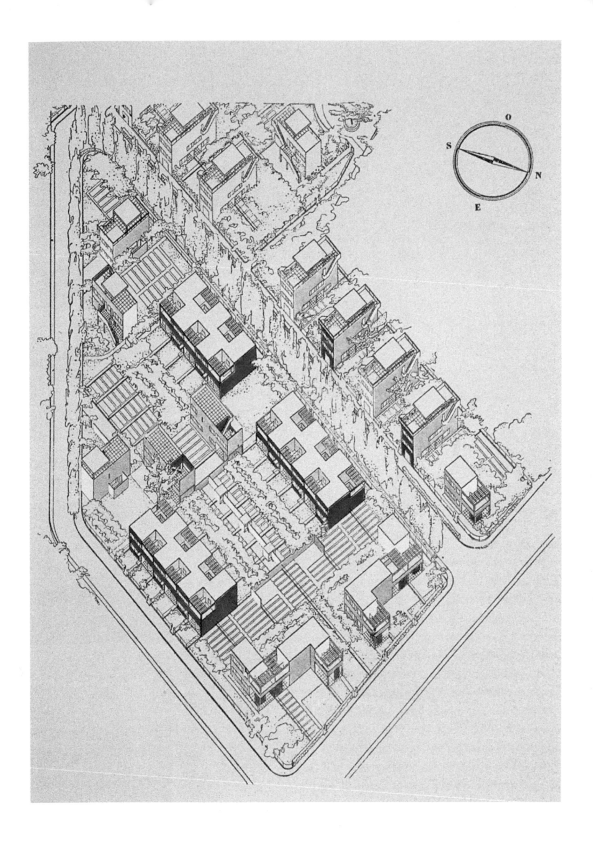

this building that he published his 'Five Points for a New Architecture', in which he prescribed the rules of a new architectural system. These were: *pilotis*; the roof garden; the free plan; the horizontal window; and the free façade. Each point, inverting a specific element of the academic tradition, is presented as a freedom achieved by means of modern technology, a decoding of the conventions of a supposedly 'natural' architecture. But this declaration of freedom can also be read as a series of displacements *within* a broader set of architectural rules. It does not accept the absolute licence of Expressionism or the mystical Utopia of van Doesburg. It is the purification of the architectural tradition, not its abandonment.

Implicit in the Five Points is an opposition between the rectangular enclosure and the free plan, each of which presupposes the other [**97**]. Le Corbusier underlined this opposition when, describing the Villa Stein, he wrote: 'On the exterior an architectural will is affirmed, in the interior all the functional needs are satisfied.'[23] But he went beyond the functionalism implied by this statement, exploiting the aesthetic possibilities inherent in the free plan. The interior becomes a field of plastic improvisation triggered by the contingencies of domestic life and giving rise to a new kind of *promenade architecturale*. Le Corbusier compares this 'disorderly order' to the chaos of a dining table after a convivial dinner, which becomes an allegory of the occasion of which it is the trace.[24] According to Francesco Passanti, Le Corbusier owed this concept of 'life art' to the poet Pierre Reverdy.[25]

The tension between the free interior and the 'limpid' exterior in Le Corbusier's work of the 1920s reaches a climax with the Villa Savoye at

97 Le Corbusier

Four House Types, 1929
Le Corbusier's brilliant typological analysis of his own houses clearly reveals his concept of the dialectical relationship between a Platonic exterior and a functional interior—two incommensurate forms of 'order' existing side by side.

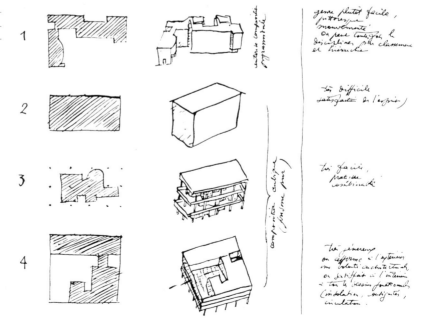

Poissy (1929–31). The house is raised on *pilotis* and appears as a pure white prism hovering above the convex surface of the field in which it is sited [98]. The arriving car drives under the house and a ramp takes the visitor from the entrance lobby to the main floor—a walled enclosure occupied partly by the accommodation and partly by a terrace garden. Within the geometrical purity of the enclosing cube, the interior is free and asymmetrical, obeying its own dynamic logic [99]. Yet the wall separating the two worlds of inside and outside is only a thin membrane, cut by a continuous horizontal window. The inhabitant having first been separated from the Virgilian landscape is re-presented with its framed image. The cube is first established and then burst open [100].

Writing of Le Corbusier's houses of the 1920s, Sigfried Giedion said: 'Like no one before him, Corbusier had the ability to make resonate the ferro-concrete skeleton that had been presented by science . . . the solid volume is opened up whenever possible by cubes of air, strip windows, immediate transitions to the sky . . . Corbusier's houses are neither spatial nor plastic . . . air flows through them.'[26]

Urbanism

As we have seen, Le Corbusier's earliest urban projects in Chaux-la-Fonds were related to the Garden City movement. But in 1920, he turned his attention to the problem of the modern metropolis, addressing issues of circulation and hygiene with which the urbanists in Paris had been concerned for some time.[27] The first such project—the Ville Contemporaine, shown at the Salon d'Automne of 1922—was a schematic proposal for a city of 3 million people on an ideal site [101]. The project is based on the belief that the metropolis is valuable a priori. Its efficiency as a node of culture depends on its historical association with a particular location. But to be preserved it has first to be destroyed. To counter the city's increasing congestion and the consequent flight of its inhabitants to the suburbs, it will be necessary both to increase its density and to decrease the area covered by buildings. Using American skyscraper technology, the project proposes widely spaced office towers 200 metres high, and continuous residential superblocks of 12 storeys, the rest of the space being turned into parkland traversed by a rectilinear network of high-speed roads. Modern technology makes it possible to combine the advantages of the Garden City with those of the traditional city. Instead of the population moving to the suburbs, the suburbs move into the city.

The linear superblocks in the Ville Contemporaine are arranged in a pattern of 'setbacks'—'*à redents*'. This idea had two sources: the *boulevards à redans* proposed by Eugène Hénard in 1903,[28] and Le Corbusier's own studies of Dom-ino housing around 1914.[29] In the

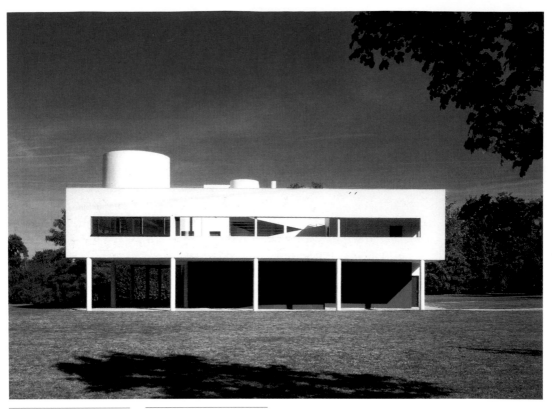

98 Le Corbusier (above)

Villa Savoye, 1929–31, Poissy

Though 'classically' proportioned, the Villa Savoye seems to have alighted from outer space, so lightly does it rest on the ground. This was one of Le Corbusier's most surreal buildings and the occasion of his most lyrical use of *pilotis*.

99 Le Corbusier (right, top)

Villa Savoye, 1929–31, Poissy

The main rooms are on the first floor, together with a roof terrace. This is a variation on the medieval theme of the *hortus conclusus*, a closed garden of contemplation set apart from the surrounding landscape, which is, however, visible through a continuous horizontal window in the terrace wall.

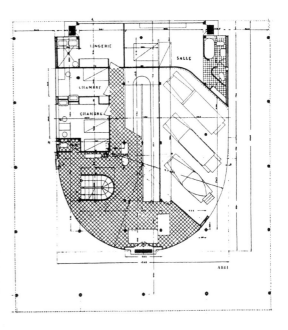

100 Le Corbusier (below)

Villa Savoye, 1929–31, Poissy, plans of ground, first, and roof floors

The ramp is a vestige of an earlier sketch in which the car is shown driving up to the first floor.

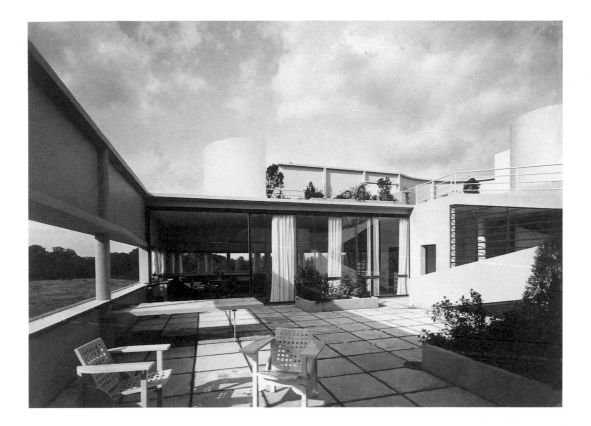

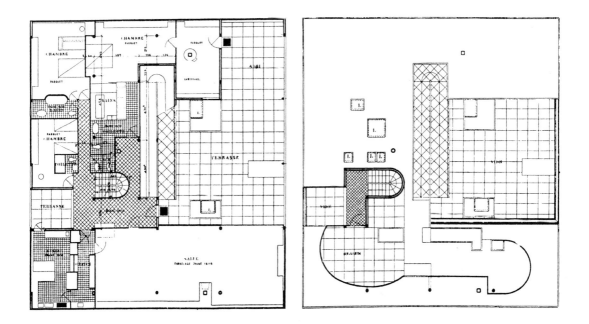

29711
FONDATION LE CORBUSIER

101 Le Corbusier

Ville Contemporaine, 1922
In this drawing the shining
and unforgiving technology of
the office towers hardly
impinges on nature or on the
untroubled lives of the haute
bourgeoisie sipping their
coffee on a roof terrace.

Ville Contemporaine, as in these studies, the housing blocks do not align with the road system but are arranged in counterpoint to it. In the later Ville Radieuse (1933) the blocks are raised on *pilotis*, and pedestrian movement at ground level is unobstructed. The urban space becomes isotropic; there are no 'fronts' and 'backs' and the spatial distinction between public and private is abolished. Although Le Corbusier modified these first urban models in various ways, their basic form remained unaltered, even after he had developed completely different systems of urbanism for Rio de Janeiro, Algiers, and Chandigarh (see page 210).

In the Ville Contemporaine and the Ville Radieuse, two absolute values are juxtaposed: nature and technology. Work and domestic life take place in high-rise structures; cultivation of the spirit and the body takes place in parkland. As a result of this disjunction, the element of chance is eliminated from urban experience. The social problems connected with this separation of living from the spontaneous and random aspects of city life have become increasingly obvious in the intervening years. Despite its faults, however, the Corbusian city drew attention to the division of labour inherent in industrialized society by creating an urban image in which technology and nature become separated. We may quarrel with Le Corbusier's Cartesian interpretation of this separation, but hardly with its underlying truth.

Public buildings

In the late 1920s and early 1930s Le Corbusier designed a number of major public buildings, including two unbuilt competition designs—the League of Nations Building for Geneva (1927) and the Palace of the Soviets for Moscow (1931)—and two completed buildings—the Centrosoyus Building in Moscow (1929–35) and the Cité de Refuge in Paris (1929–33) [**102**]. In these buildings he adopted a strategy very different from that of his houses. Instead of containing the functional irregularities within a Platonic exterior, the building is broken up into its component parts. These consist mainly of linear bars (containing repeating modules such as offices) and centralized volumes (containing spaces of public assembly). These elements are then freely recomposed in such a way that they tend to fly apart and multiply

102 Le Corbusier

Cité de Refuge, 1929–33, Paris

In a brilliant solution to a difficult site, the building is approached through a set of initiatory volumes, seen as figures against the wall plane of the main dormitory block.

[**103**], forming small cities on their own. In the Corbusian ideal city, public buildings lead a rather shadowy and insecure existence.[30]

Regional Syndicalism

In the late 1920s Le Corbusier became a militant member of the Neo-Syndicalist group led by Hubert Lagardelle (1874–1958) and Philippe Lamour (1903–1992). The group was anti-liberal and anti-Marxist and ideologically aligned with contemporary Fascist movements in France and Italy. Le Corbusier became an editor and major contributor to the group's journal *Plans* and its successor *Prélude*. Influenced by Pierre-Joseph Proudhon and Georges Sorel, the group called for the abolition of parliamentary democracy, and for the creation of a government of technical elites, on the Saint-Simonian principle of the 'administration of things, not the government of people', dedicated to a planned economy. It believed that the alienation of modern social life could be alleviated not by socialism, with its concept of abstract man, but by a return to *l'homme réel* and to the spirit of community characteristic of pre-industrial societies.[31] This anti-Enlightenment, anti-materialist position was the equivalent of the *Volkisch* movement in Germany, and had the same tolerance for a technological Modernism on condition that it was not dominated by finance capital.[32]

Le Corbusier's new journalistic activities coincided with a revival of his earlier interest in vernacular architecture—an interest which had been submerged but never destroyed by his concern for new systems of architectural production. In his book *Une Maison, un Palais* he wrote in lyrical if somewhat patronizing terms of the fishermen's cottages at Le Piquey near La Rochelle where he spent his summer vacations

between 1928 and 1932.[33] In building their huts, he says, 'the fishermen are very attentive to what they do. When deciding where to place something, they turn round and round like a cat deciding where to lie down; they weigh up the situation, unconsciously calculating the point of equilibrium . . . intuition proposes, reason reasons.'[34]

Between 1930 and 1935, vernacular forms make their appearance in several small rural houses by Le Corbusier and Jeanneret in which the pitched roof and the masonry wall, outlawed in the 1920s, reappear [**104**]. Yet these houses are no mere return to vernacular models; natural materials are reinterpreted in terms of Modernist aesthetics. Vernacular references are less evident in the Radiant Farm and a Village Coopératif (1934–38) [**105**]—two linked (unrealized) projects in which modern building technologies and Modernist aesthetics were applied to agriculture.[35] These projects originated in an issue of *Prélude* devoted to regional reform, edited by a radical peasant-farmer, Norbert Bézard, who commissioned Le Corbusier to design a model farming community. The grass-covered Catalan vaults of these projects have rural overtones, but with their *montage à sec* (dry) construction and their clean, white, geometrical forms, they were clearly intended to make the greatest possible contrast with existing rural conditions. The rather surprising six-storey block of apartments in the cooperative village was justified by Le Corbusier in semiological rather than functional or social terms—it was, he said, 'a new architectural sign

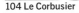

104 Le Corbusier
Villa de Mandrot, 1931, Pradet
This was the first in a series of rural houses using traditional materials and marking a phase in Le Corbusier's career in which he began to stress vernacular building traditions.

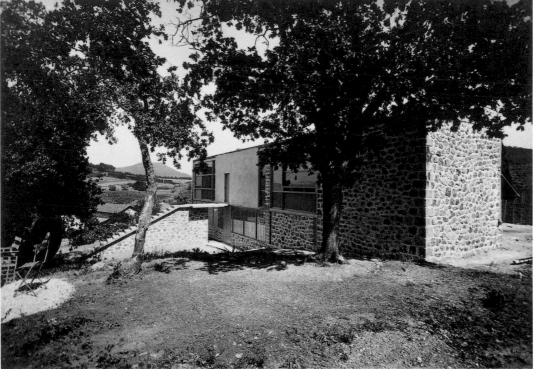

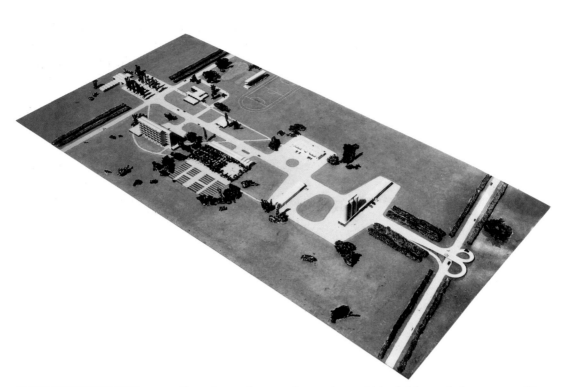

standing above the meadows, the stubble fields, and the pastures'[36]—an emblem of the new modern spirit.

If we compare Le Corbusier's Neo-Syndicalist ideas with those he had expressed in *L'Esprit Nouveau* 15 years earlier, we find a considerable shift of emphasis. The main problem for *L'Esprit Nouveau* was the conflict between eternal cultural values and modern technology, which it tried to resolve by conflating technology with Platonic 'invariables'. In the late 1920s Le Corbusier modified this static model, acknowledging the existence of uncertainty and change. Elements that had been recessive in the *L'Esprit Nouveau* philosophy—disorder, organic forms, immediate experience, intuition—come to the forefront. If geometry and balance are still seen as the ultimate measures of value, they are now thought to be as much the result of instinct as of an abstract rationality. The task of modern architecture is seen as the fusion of universal technology with age-old wisdom:

Architecture is the result of the state of the spirit of the epoch. We are in the face of an international event . . . techniques, problems posed, like scientific means, are universal. However, the regions are distinct from each other, because climatic conditions, racial currents . . . always guide the solution towards forms which they condition.[37]

Le Corbusier's earliest contact with regional ideas had been in 1910, under the influence of Alexandre Cingria-Vaneyre, an advocate of a classical, Mediterraneanized Suisse-Romande. With the Neo-

Syndicalists he now encountered similar ideas on a global scale. The Neo-Syndicalists believed that Europe should be divided into three 'natural' zones: the Germans in the north-west, the Slavs in the east, and the Latin races in the south (including North Africa). Under the sway of such racial theories—which were quite common in Europe in the 1930s—Le Corbusier began to think in terms of a global modern architecture in which technology would come into direct confrontation with the natural geographical forces of different macro-regions. His extensive travels in South America and Algeria in the 1930s generated a series of urban projects in the developing world, culminating in his work in Chandigarh, India, in the 1950s. These and other later projects will be discussed in chapter 11.

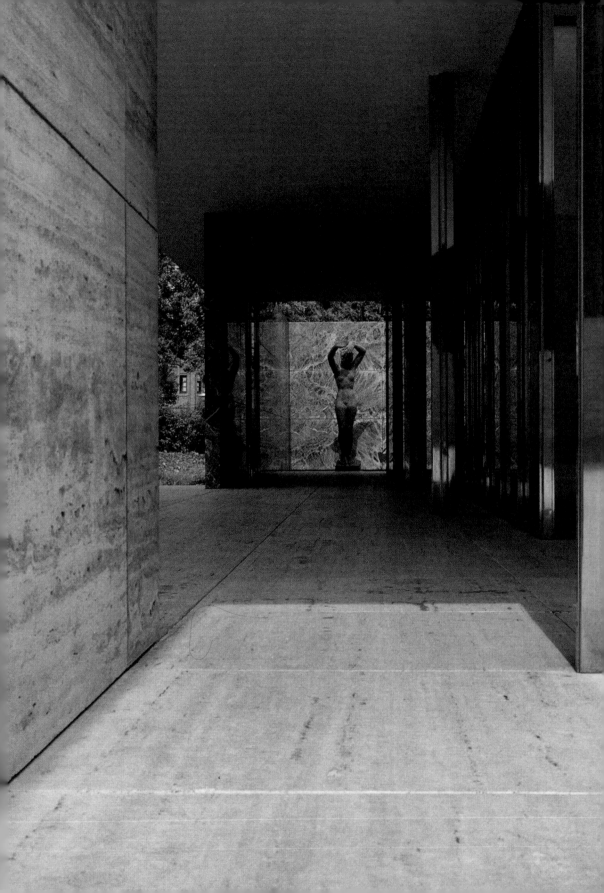

Weimar Germany: the Dialectic of the Modern 1920–33

8

In Germany, as in France, there was a 'return to order' after the First World War, though it was delayed by political and economic crisis. When it came it rejected not just Expressionism but the values of the Wilhelmine culture that Expressionism had attacked. Whereas in France the return to order, even its progressive form, could be seen as re-affirming an established and triumphant national tradition, in Germany, defeated in the war, it implied a radical break with the national past and a search for alternative principles.

The architecture that began to emerge in Germany around 1922 reflected a dramatic change of orientation in the visual arts as a whole. The movement known as 'Neue Sachlichkeit' ('New Objectivity' or more accurately ' Fact-like-ness'),[1] was indicative of a new realism. The term was first used in 1923 in the context of painting by museum director Gustav Hartlaub, who defined it as 'realism with a socialist flavour'. The movement was sometimes interpreted as a form of cynicism—a reaction to the horrors of a disastrous war—and sometimes as a 'magic realism'. The art critic Franz Roh expressed the situation thus: 'The Expressionist generation had rightly opposed Impressionism with the man of ethical principles . . . The most recent artist corresponds to a third type, one who shares Expressionism's far-sighted aims, but is more down-to-earth and knows how to enjoy the present.'[2]

In architecture, the change was registered by Adolf Behne. As chief spokesman of Expressionism and a key figure in the Arbeitsrat für Kunst (AFK), Behne had held strongly anti-technological views, as is clear from his essay 'Die Wiederhehr der Kunst' ('The Restoration of Art') of 1918. But by 1922 he had completely reversed his position. In his essay of that year, 'Kunst, Handwerk, Technik' ('Art, Craft, and Technology')[3] he renounced his earlier views, claiming that the division of labour inaugurated by the machine was an improvement on the old 'organic' relation between the individual craftsman and his products, since it brought into play a 'higher awareness'. After a transitional period, the worker would come to understand his role within the totality of industrialized society. *Zivilisation* and *Gesellschaft* were now embraced at the expense of the old paradigms of *Kultur* and *Gemeinschaft*. Behne's new concept of the relation between the worker

and his work was similar to the view that Gropius had already expressed in his 'Kunst und Industriebau' speech of 1911 in an earlier 'return to order' (see page 68).

The Bauhaus: from Expressionism to Neue Sachlichkeit

When Gropius was appointed to succeed Henry van de Velde as director of the Academy of Fine Art at Weimar in 1919, he was given the task of creating a new School of Architecture and Applied Art which would unify the existing Academy with the recently disbanded School of Arts and Crafts. The integration of fine arts with crafts was standard policy in German art schools at the time.[4] But as we have seen Gropius had grander ambitions: he wanted the Academy (which he now renamed the Bauhaus) to become the spearhead of the AFK's programme for the transformation of German artistic culture under the wing of architecture (see page 96). This programme was predicated on the belief that artistic culture was threatened by the materialism of industrial capitalism and could only be saved by a spiritual revolution. In the 'Bauhaus Manifesto' of 1919, Gropius wrote, in Expressionist vein, 'Let us conceive a new building of the future . . . architecture, painting, and sculpture rising to Heaven out of the hands of a million craftsmen, the crystal symbol of the new in the future' [**107**].[5]

Between 1919 and 1923, however, the Bauhaus abandoned its Expressionist ideology and began to absorb the ideas of Neue Sachlichkeit, De Stijl, and *L'Esprit Nouveau*. The initial impulse for this change came in 1921 when van Doesburg set himself up in Weimar in opposition to the Bauhaus, giving a series of lectures attended by many Bauhaus students in which he advocated an approach to design diametrically opposed to the ideology of craftsmanship and artistic 'intuition' that still dominated the Bauhaus curriculum.

A second influx of ideas came from Russian Constructivism. During the early 1920s there was considerable cultural interchange between Germany and Soviet Russia. In 1922 the first Exhibition of Soviet Art was shown at the Grosse Berliner Kunstausstellung. This coincided with the publication of El Lissitzky's journal *Veshch* (see page 128). In 1921 the Constructivist-based Congress of International Progressive Artists was held in Düsseldorf, and this was followed by a Constructivist Congress in Weimar in 1922, organized by a splinter group from the Düsseldorf congress, including van Doesburg, the Hungarian artist and photographer László Moholy-Nagy, El Lissitzky, and the Dada artists Hans Richter, Hans Arp, and Tristan Tzara. These events greatly affected the climate of opinion within the Bauhaus.

The first institutional change within the school took place in 1922, when the Swiss painter Johannes Itten was replaced by Moholy-Nagy

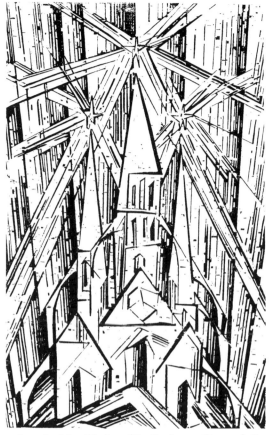

107 Lyonel Feininger
Cover of the 'Bauhaus Manifesto', 1919
In this Expressionist representation of the Cathedral of Socialism the future is projected in terms of the pre-industrial past.

as head of the *Vorkurs* (Preliminary Course). In contrast to Itten, whose mystical approach to art teaching was based on psychological–formalist principles,[6] Moholy-Nagy (1895–1946) introduced into the school an 'objective' Constructivist approach involving the manipulation of industrial materials such as steel and glass and mechanical techniques of assembly. The difference between Itten's and Moholy-Nagy's ideas roughly corresponded to that between the Rationalists and the Constructivists within the Russian avant-garde (see page 122). The change in the *Vorkurs* was later described rather laconically by Moholy-Nagy's fellow teacher Josef Albers: '[The course] aimed at the development of a new, contemporary visual idiom . . . and this—over time—led from an emphasis on personal expression . . . to a more rational, economic, and structural use of material itself . . . in pictorial terms, from collage to montage'.[7] As Reyner Banham pointed out, however, the move from subjectivity to machine rationalism did not eliminate the concept of ideal beauty. Moholy-Nagy, no less than Le Corbusier, believed in the connection between machines and Platonic forms.[8]

The real turning point came in 1923, when the Bauhaus organized its first exhibition. In line with the new technical emphasis, the stated

theme of the exhibition was to be 'Art and Technology: a New Unity'. But Gropius also had a more purely architectural agenda—one which would present, as he said, 'international architecture from a completely pre-determined point of view, namely the development of modern architecture in the dynamic functional direction, without ornament or mouldings.'⁹ A model house—the 'Haus am Horn'—was built, containing furniture designed and produced by the Bauhaus workshops as prototypes for mass production. Elementarist wooden furniture, based on that of Gerrit Rietveld, was designed by Bauhaus student Marcel Breuer (1902–81), who three years later—after he had joined the Bauhaus staff—was to design the tubular-steel, Constructivist 'Wassily' chair.

In 1925, the Thuringian State government withdrew its financial support and the Bauhaus moved to the town of Dessau, where the municipality funded a new school building, incorporating an existing trade school and new staff houses. With the move, several of the existing staff resigned and their places were taken by a new generation of Bauhaus-trained teachers—including Marcel Breuer, Joseph Albers, and Herbert Bayer—who had acquired from the Bauhaus a new aesthetic theory and a new set of technical skills. That same year, Gropius wrote, 'The Bauhaus workshops are essentially laboratories in which prototypes of products suitable for mass production and typical of our time are carefully developed and improved,' triumphantly celebrating the union of art and technology. Writing in the Bauhaus journal in 1926, however, Bauhaus teacher Georg Muche struck a discordant note, advancing the rather Loosian view that the laws of fine art and those of technical design were fundamentally different. While Muche clearly underestimated the importance of the new relation between art and technology, his critique does suggest that the change to more machine-oriented design might be better explained as a 'paradigm shift' on the part of the artist, than as the fusion of artist and technician that Gropius implied. The designs that became commercially successful after the move to Dessau were in fact the result of the collaboration with industry of Bauhaus artists such as Marianne Brandt and Christian Dell [108].¹⁰

The school building and the masters' houses at Dessau were the first major structures realized by Gropius in the new 'dynamic functional' manner. The body of the school building was broken down into programmatic elements and reassembled to form an open, centrifugal form that was possibly inspired by Mies van der Rohe's project for a Concrete Country House [117]. The school building [109, 110], with its bridge to the new trade school, and the masters' houses with their interlocking prisms, show the influence of both Constructivism and De Stijl. The pure cubes which form these buildings reflect the work of Oud in Holland and Le Corbusier and Lurçat in France. The school

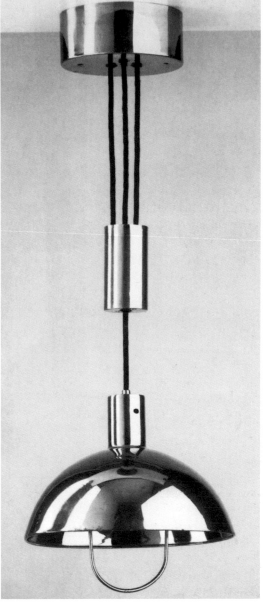

building also has certain features from Gropius's earlier work, such as the projection of the glazing slightly in front of the wall plane, so that it is not interrupted by the columns.

Social housing

With the Dawes Plan of 1924 and the consequent influx of American capital, the building industry in Germany began to recover. Cities were now able to take advantage of 1919 legislation giving them limited control over the use of land, and to activate programmes to alleviate the

109 and 110 Walter Gropius

Bauhaus Building, 1926, Dessau

The swastika form of the plan exemplifies the Futurist–Constructivist centrifugal free-standing building with the different programmatic elements articulated, as opposed to the traditional courtyard type. Compare with public buildings by Le Corbusier, Hannes Meyer, and the Vesnin brothers for different interpretations of the same idea.

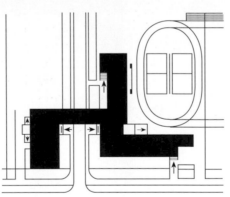

housing shortage caused by several years without building activity and considerable wartime migration to the cities.[11]

During the second half of the nineteenth century there had been increasing concern among reformist groups in all the industrial countries over the lack of affordable housing for unskilled and semi-skilled workers. By 1914 the housing reform movement in Germany had gathered considerable momentum and non-profit building societies were widespread—even if the results so far were meagre. In 1924, therefore, when the Social Democratic Party municipal authorities put in place their housing programmes, they were able to benefit from institutions and powers already in place.[12] A remarkable characteristic of this housing campaign was the extent to which it was

dominated by the avant-garde, though a precedent for this had been set in Holland, where both Berlage and Oud had also received official city appointments.[13]

After the First World War Germany was rich in technically competent, ideologically progressive architects, and many of these were put in charge of city housing programmes between 1924 and 1931, including Otto Haesler (1880–1962) in Celle, Max Berg (1870–1947) in Breslau, Fritz Schumacher (1869–1947) in Hamburg, Ernst May (1886–1970) in Frankfurt-am-Main, and Martin Wagner (1885–1957) in Berlin.

Like the Garden Suburbs before the First World War, the post-war *Siedlungen* consisted of enclaves of new housing on the outskirts of existing cities. But they differed from the Garden Suburb model in several respects. They were, for example, built to higher densities and consisted mostly (though not exclusively) of apartment blocks of up to five storeys (considered the maximum walk-up height). These were generally laid out on the *Zeilenbau* principle of parallel blocks aligned north–south at right angles to the access street (a system that had already been proposed before the war).[14] This gave to each apartment the fresh air and sunlight that had been conspicuously absent in the late-nineteenth-century tenements—the so-called *Mietkasernen* ('rental barracks')—with their dark courtyards. At the aesthetic and symbolic level, they followed the rules of Neue Sachlichkeit—that is to say they were stripped of all ornament and had flat roofs. Ornament was replaced by the fairly extensive use of coloured surfaces. Some of the larger *Siedlungen* included public buildings such as schools and hospitals, and the housing was generally provided with public facilities such as central heating and laundries.

The design of the individual apartments reflected the influence of new concepts of domestic management, strongly promoted by the women's movement, which drew their inspiration largely from America where, as we have seen, they had been discussed since the 1890s (see page 50). Erna Meyer's highly successful *Der Neue Haushalt* (*The New Household*, 1926) and Grete Schütte-Lihotsky's Frankfurt Kitchen design were based on Christine Frederick's *Scientific Management in the Home* of 1915. The new minimum dwelling affected the middle classes even more than the workers.[15]

Except for the use of reinforced concrete for floors, roofs, and occasionally columns, and for some experiments in prefabricated concrete wall panels, the materials and techniques used in the *Siedlungen* were traditional. Walls were of plastered brick or clinker block. The windows had wooden frames and tended to be small. These small windows, large, smooth wall surfaces, and heavy attic floors often gave an almost cosy, vernacular effect to the blocks.[16]

The ruthlessly 'rational', *Zeilenbau*-type layouts, like that of Gropius and Haesler for Dammerstock Estate at Karlsruhe (1927–8)

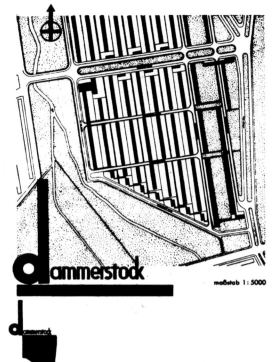

[111], were not always popular. The critic Adolf Behne, although he supported the Neue Sachlichkeit movement in principle, attacked this project, accusing it of being both formalist and scientistic, and of treating the inhabitant as an 'abstract dweller'. In this approach, he said, the architect becomes more hygienic than the hygienist: 'Medical research has shown that the inhabitants of those houses that are considered to be unhygienic are healthier than the inhabitants of hygienic houses.'[17] Other projects were given some degree of formal differentiation. At the company town of Siemensstadt in Berlin, where Walter Gropius, Fred Forbat (1897–1972), Otto Bartning, and Hugo Häring (1882–1958) designed buildings within an overall plan by Hans Scharoun (1893–1972), a number of short parallel blocks were subordinated to and unified by a long, curved building following the road alignment [112]. At the Britz-Siedlung (1928) in Berlin, Bruno Taut, working for the building society GEHAG, focused his layout on a large, horseshoe-shaped open space and used every opportunity to introduce variety into the project by means of colour, contrasting materials, curved streets, and broken lines of housing. In his Berlin housing projects Taut, despite his new *Sachlich* credentials, carried on a sort of private guerrilla war against the more *Sachlich* Modernists.[18]

The most comprehensive housing programme was that at Frankfurt-am-Main, where Ernst May, appointed city architect in 1925, set about implementing an unbuilt 'satellite' project that he had

designed for Breslau in 1921. The whole design, which was developed between 1925 and 1931, consisted of a number of small *Siedlungen*, most of which were set slightly apart from the city in unspoilt meadowland. Of all the *Siedlungen*, those of Frankfurt, with their semi-rural setting and high proportion of single family houses, were perhaps the closest to the Garden Suburb ideals of Raymond Unwin, for whom May had worked before the war. Most of the 'satellites' were designed in May's office, but some were farmed out, including that of Hellerhof by the

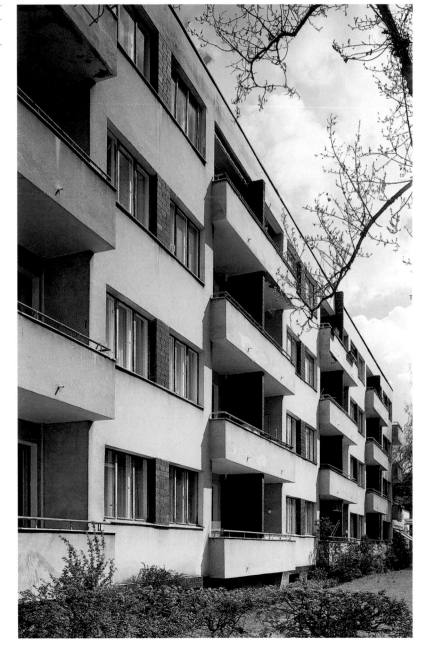

112 Walter Gropius
Apartment Block, 1928, Siemensstadt, Berlin
This is one of the short parallel blocks at Siemensstadt. Note the use of brick to give the impression of longer spans in windows and balconies. These kinds of *trompe-l'oeil* effects are typical of Gropius, a man of compromise, both aesthetic and political.

Dutch architect Mart Stam (1899–1986). The public response to the 'New Frankfurt' was generally favourable.

The Weimar Republic's social housing programme seems in retrospect to have been an extraordinary act of collective architectural will. Yet it was barely able to scratch the surface of the housing problem. In spite of government subsidies and the use of non-profit building societies, the price of the dwellings remained too high for unskilled workers. Nonetheless, the programme's achievements, both on a practical and on a symbolic level, were considerable. In a series of projects that acted as architectural manifestos, it created the image of an orderly, healthy, and harmonious society, contrasting with the squalid tenements of the nineteenth century.

Despite the predominance of Neue Sachlichkeit architects in the Weimar housing programme, there were many architects in Germany who believed that domestic architecture should follow vernacular models [113]. Many of these had belonged to the Arts and Crafts and

113

Housing, 1925–7, Düsseldorf
The *Heimat* style became increasingly associated with National Socialism and the extreme Right, in opposition to the Modernism favoured by the Social Democratic Party.

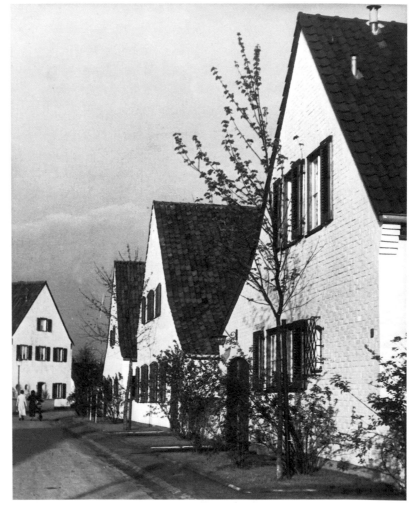

Garden City movements and had been 'avant-garde' in their day. The most vocal and influential of these was Paul Schultze-Naumburg (1869–1949), who carried on a relentless campaign against Neue Sachlichkeit in support of the Heimatschutz (Protection of the Home) movement. Between 1926 and 1928 Schultze-Naumburg published a series of books that became progressively more nationalist and racist in tone.[19] These helped to polarize the public debate between Modernists and traditionalists, identifying the latter with the ideas of National Socialism, although their opinions were more or less those of conservative people everywhere (in other words, the majority).

Functionalists versus rationalists

One of the main conflicts within the German avant-garde of the 1920s was that between the 'functionalists' and 'rationalists'. In one of the first attempts to define the Neue Sachlichkeit movement, *Der Moderne Zweckbau* (*The Modern Functional Building*, written in 1923 but not published until 1926), Adolf Behne drew attention to this conflict and analysed the ideological differences which underlay it. According to Behne, the functionalists (whom he might more accurately have called 'organicists') created unique, non-repeatable buildings whose forms were shaped round their functions, whereas the rationalists looked for typical and repeatable forms that were able to fulfil generalized needs. Behne equated the functionalists with the ex-Expressionist architects, who, under the guise of being true to the laws of nature, in fact created singular buildings that were unable to become parts of a greater whole: 'As the functionalist looks for the greatest possible adaptation to the most specialized purpose, the rationalist looks for the most appropriate solution for many cases.'[20] The functionalists are individualists, while the rationalists accept a responsibility to society.

Theo van Doesburg, in one of his articles in the journal *Het Bouwbedrijf*,[21] made the same distinction as Behne, though he put greater stress than Behne on problems of aesthetics. For van Doesburg the functionalists, in their search for a close fit between forms and functions, ignored the psychological need for 'spare space' in buildings, and he cited Henri Poincaré's concept of 'tactile space' to support this idea.[22]

Looking at the problem today, it seems clear that these critics were putting forward two 'ideal types', and that actual buildings seldom conformed completely to one or the other: the Neue Sachlichkeit tendency was, by definition, concerned with generic rather than individual problems; and even the most extreme Expressionists had, by 1924, accepted rationalist principles. However, although the work of the Luckhardt brothers, Hans (1890–1954) and Wassili (1889–1972), and of Erich Mendelsohn (1887–1953) after the Einstein Tower of 1920–4, can

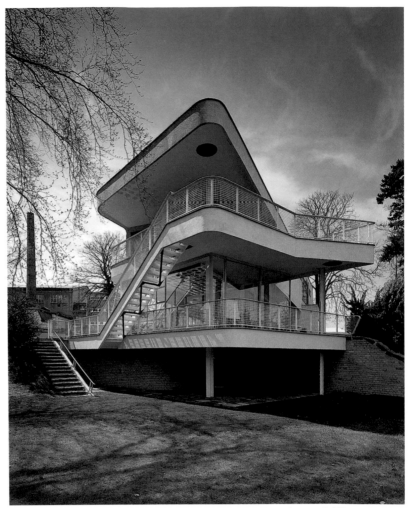

easily be assimilated to Neue Sachlichkeit, that of Häring and Scharoun is often characterized by curvilinear, functionally 'expressive' forms which reject the rectilinearity typical of the movement as a whole [**114, 115**].

Mies van der Rohe and the spiritualization of technique

Although no one architect in the Germany of the 1920s dominated the professional scene as Le Corbusier did in France, the reputation of Mies van der Rohe (1886–1969) in the sphere of aesthetics seems to have been equal to that of Gropius in the sphere of organization. A man of few, if weighty, words, Mies was not only an astute self-publicist, but an architect with the ability to reduce every problem to a kind of essential simplicity—a simplicity that continues to give rise to conflicting interpretations of his work to this day.

In Mies's work, two opposing tendencies struggled for dominance.

One could be described as the enclosure of function in a generalized cubic container not committed to any particular set of concrete functions—a tendency partly derived from his early allegiance to neoclassicism. The other was the articulation of the building in response to the fluidity of life. This second tendency, however, seldom involved him in figural shaping, as it did the Expressionists, nor did it align Mies with what Behne called 'functionalism'. Following a

Constructivist or Neoplasticist logic, neutral forms could create systems flexible enough to respond to any imaginable life situation, every building taking on a unique configuration while being made from similar elements. It was such a process that Mies adopted when he abandoned the house as a single pavilion and broke it up into its basic elements. I will discuss here the houses Mies produced between the wars, in which he attempted to reconcile these conflicting ideas—neoclassical objectification on the one hand and Neoplasticist fragmentation on the other.[23]

Mies's architectural formation was remarkably similar to Le Corbusier's, though their response to the conditions of modernity that they both recognized could hardly have been more different. Both had been trained in craft schools and had climbed into the professionally and socially higher sphere of architecture and the 'fine arts'; both changed their names;[24] both worked their way through a formative period of neoclassicism (in the design of furniture as well as that of houses) based on the example of the same two masters—Bruno Paul and Peter Behrens; in both cases, their Modernist work followed on without interruption from their neoclassical work and was strongly influenced by it. But, whereas Le Corbusier designed only two neoclassical houses before moving on to other explorations (though he continued to design Empire style interiors for several years), Mies's 'Biedermeier' period lasted from 1907 to 1926 and was the basis of a successful architectural practice. He was over 40 when he completed his first Modernist–Constructivist building, the Wolf House in Guben (1925–7).

All Mies's neoclassical houses are symmetrical two-storey prisms, sometimes with minor appendages. These houses, especially the Riehl House (1907) [**116**], borrowed heavily from the illustrations of eighteenth-century vernacular–classical houses in Paul Mebes's book *Um 1800* of 1905. The Riehl House differs from the others in its siting. Like Le Corbusier's Maison Jeanneret and Favre-Jacot at La Chaux-de-Fonds (and like Giulio Romano's Villa Lante on the Giannicolo in Rome which might have influenced both Le Corbusier and Mies) it is sited on a steep incline. One of its gable ends is frontalized by means of a loggia and plunges unexpectedly down to connect with a long retaining wall. This might be called the building-as-dam type, and is a variant of the *Stadtkrone*, tending to be shown towering above the viewer, in the Wagnerschule manner. It is also found in other projects by Mies: the competition scheme for the Bismarck Monument of 1910 (which probably had its origin in Schinkel's Schloss Orianda project of 1838), the Wolf House, the Tugendhat House (1928–30), and the Mountain House project of 1934.

When he resumed his practice in Berlin after the First World War, Mies met the experimental filmmaker and Dadaist Hans Richter and

joined his circle of artists and writers, which included van Doesburg and El Lissitzky.[25] Mies's conversion from mimetic eclecticism to Constructivist abstraction dates from this first encounter with the Berlin avant-garde. In 1922, Richter, El Lissitzky, and the artist and filmmaker Werner Gräf founded the journal *G: Material zur Elementaren Gestaltung* (*G: From Material to Form*). It was here that Mies published his earliest Constructivist projects together with brief

(a) (b) (c)

118 Mies van der Rohe

Wolf House, 1925–7, Guben
(demolished)
This photograph shows
Mies's attachment to
conventional ideas of
picturesque composition in
his drawings. He seldom used
axonometric projection, and
made much use of diagonal
perspective views, presenting
buildings from the most
favourable angle.

polemical articles in which he took a strongly anti-formalist position: 'We know no forms, only building problems. Form is not the goal but the result of our work.'[26]

These early Constructivist projects in which Mies explored some of the fundamental problems posed by new techniques and materials, comprise two Scheerbartian glass skyscrapers (1921–2), an eight-storey office block in reinforced concrete (1922), and two single-storey houses—a Concrete Country House (1923) and a Brick Country House (1924). The houses in this group, together with the little-known Lessing House project (1923), summarize the dialectic in Mies's work [**117**]. In the Concrete Country House the cube is dissolved into a spread-eagled, swastika-like form; in the Lessing House the cube is broken up into smaller cubes, interlocking with each other in echelon; in the Brick Country House the cubes are replaced by a system of planes. This progressive fragmentation and articulation, in which the external form of the house reflects its internal subdivision, betrays the indirect influence of the English free-style house, Berlage, and Wright, but its immediate ancestor is De Stijl.[27]

The Wolf House [**118**], and the Lange and Esters houses, both built in Krefeld in 1927, explore the Lessing type. Built of the local building material, brick, they are broken up into interlocking cubes to form roughly pyramidal compositions of two and three storeys. The principal rooms on the ground floor are opened up to each other to form

sequences in echelon. The bedroom floors are set back to provide roof terraces.

The Tugendhat House at Brno in the Czech Republic marks a new stage in Mies's development [**119, 120, 121**]. No longer in brick, it is rendered and painted white. Its organization results from a site condition that recalls that of the Riehl House. Built against a steep slope, the house consists of a monolithic cubic mass with a set-back, fragmented upper floor, through which one enters from the street to descend to the living room on the floor below. The living room is an enormous space divided by fixed but free-standing screens. The monolithic volume of the house is wedged solidly into the sloping ground. The south and east sides of the living area are fully glazed with floor-to-ceiling,

119 Mies van der Rohe

Tugendhat House, 1928–30, Brno, Czech Republic
The building is wedged into the sloping site like the Riehl House. The living room with its continuous floor-to-ceiling window is one floor below street level.

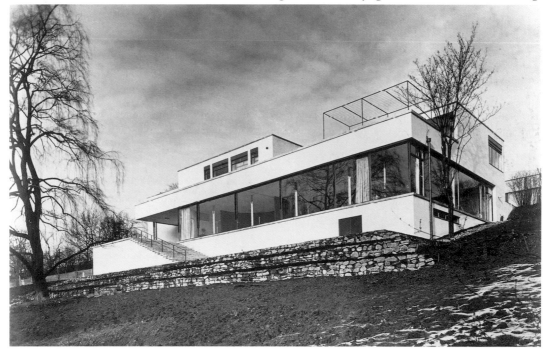

120 Mies van der Rohe

Tugendhat House, 1928–30, Brno, Czech Republic
Interior view, showing the panorama of the garden to the south and east through retractable glass walls. Sumptuous materials— polished marble screens and chrome columns—take the place of conventional detailing and ornament.

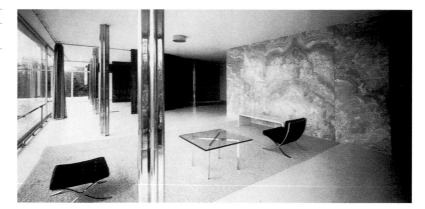

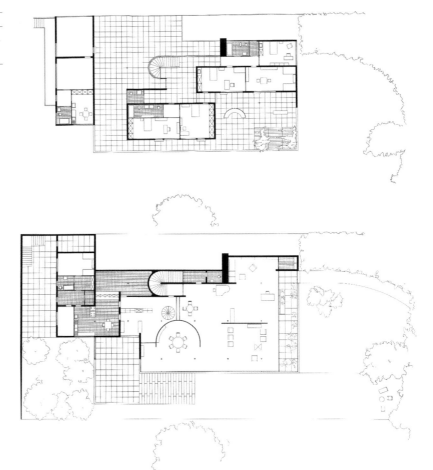

121 Mies van der Rohe

Upper and lower-floor plans,
Tugendhat House, 1928–30,
Brno, Czech Republic

The entrance floor has two
bedroom pavilions set back
from the face of the main
volume as viewed from the
garden. A third pavilion on
the right creates a semi-
enclosed courtyard.

mechanically retractable, plate-glass windows, opening to a panoramic view. Thus, the inflected space, which in the Brick Country House extends out to infinity, is here contained within a cubic volume. But at the same time, this volume is made totally transparent. Classical closure and the infinite sublime are combined by means of modern technology.

Contemporaneous with the Tugendhat House is the German Pavilion for the Barcelona International Exposition of 1929, known as the Barcelona Pavilion [**106** (see page 158), **122**]. Here, the enclosing cube is dispensed with and the entire space is defined in terms of independent horizontal and vertical planes. But instead of disappearing into infinity, the wall planes turn back on themselves to form open courts which clamp the building to the two ends of the site. Sited astride one of the exhibition routes, the pavilion was not so much a dam as a filter.

In both the Tugendhat House and the Barcelona Pavilion, in contrast to the Brick Country House, the roof is supported by an inde-

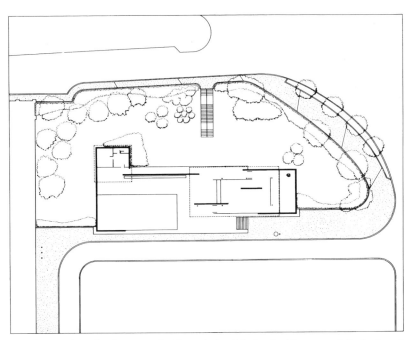

122 Mies van der Rohe

Site and floor plan, German Pavilion, International Exposition, 1929, Barcelona (demolished, rebuilt 1992)

Wall planes at right angles to the flow of movement acted as a filter for visitors passing through the building from one part of the exposition to another.

pendent grid of columns. At first sight this looks like an oddly belated discovery of the principle of the free plan. But at second glance the columns seem too slender to carry the roof without some help from the wall planes (their slenderness is enhanced by their reflective finish). Rather than columns they seem more like signs marking the modular grid.

Between 1931 and 1935, Mies designed a series of houses which adapted the Barcelona Pavilion plan-type to domestic use. The first was a model house in the 1931 Berlin Building Exposition. This was followed by a series of unbuilt projects, including the Ulrich Langer House (1935), for single-storey houses within closed courts. These designs become more and more introverted. In one sense they can be seen to be following the same Mediterranean prototypes as other avant-garde architects of the 1930s—in this respect Le Corbusier's enclosed garden at Poissy makes an interesting comparison. But they also suggest that Mies (or his clients) might have been withdrawing into a private world, unconsciously reacting to a threatening political situation. In spite of this tendency towards enclosure, however, the more elaborate projects of this period, such as the Hubbe House, were left partially open to give framed views of nature [**123, 124**]. Indeed, the natural landscape is omnipresent in Mies's sketches at this time, suggesting that the main function of the house had become that of framing a view in which nature is idealized. Mies later acknowledged this distancing effect: 'When you see nature through the glass walls of the Farnsworth House it gets a deeper meaning than from outside. More is asked from nature because it becomes part of a greater whole.'[28]

123 Mies van der Rohe

Hubbe House, 1935,
Magdeburg, perspective of
living room and terrace with
Elbe River

The external wall has become
transparent, allowing an
unobstructed view of nature.

124 Mies van der Rohe

Hubbe House, 1935,
Magdeburg, plan with
furniture placement

Neoclassical enclosure has
migrated from the house
proper to the garden court,
but here the court is prised
open to allow for entry and a
framed view of nature. The
plan shows a fusion of the
Lessing and De Stijl types.

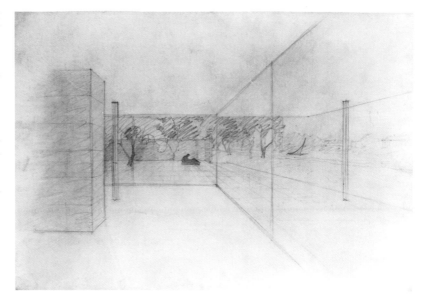

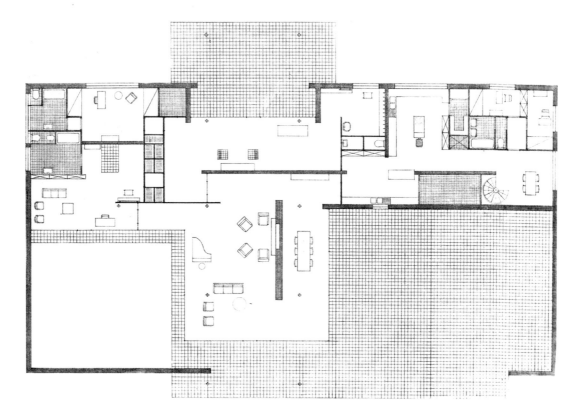

According to a common misconception, Mies's minimalist distillation of architecture was the result of a deep engagement with the craft of building. Certainly, Mies was obsessed by certain craft-like aspects of architecture, but he was more concerned with idealizing and mediating techniques of graphic representation than with construction. As is clear from his writings, Mies realized that the traditional relationship between the craftsman and his product had been destroyed by the machine. His criteria were ideal and visual, not constructional—not even 'visual–constructional'. It is true that unlike, for instance, Le Corbusier, Mies displays the materiality of his building elements, but he assembles these elements like montages; their connections are never visible. Even more than that of the other Modernists, Mies's work runs counter to the 'tectonic' tradition.

Recently, in a justified reaction against the myth of Mies-the-constructor, critics have invented a Post-Modern Mies—one who primarily operated with surfaces and effects, within the endless play of the signifier.[29] But this interpretation errs in the opposite direction. It ignores Mies's fear of post-Nietzschean chaos and it also assumes that an aesthetic of materials and their ephemeral appearance (as signified by the German word *Schein*) is incompatible with a belief in foundational values. Mies's conception of architecture followed the dialectical tendency of German Idealism to think in terms of opposites. According to the Neoplatonic aesthetics that influenced his thinking, the transcendental world is reflected in the world of the senses (Mies was fond of quoting St Augustine's dictum: 'Beauty is the radiance of truth'). When modified by the concept of the 'will of the epoch', this became the basis of his belief that the spiritual could only become active in the world in a historicized form, that is to say in the form of technology.[30] Such problems of surface and depth, the contingent and the ideal, also lay behind the anti-formalism of Mies's articles in *G* in 1923. These did not represent a 'materialist' phase (later to be abjured) as most commentators claim; they reflected a topos of Modernist aesthetics derived from German Romanticism, according to which the forms of art should, like those of nature, reveal an inner essence and not be imposed from the outside.[31]

To enquire into Mies's philosophical background is, of course, in no way to suggest that his architecture was an 'expression' of philosophical ideas. For Mies, it was precisely the auto-referentiality of the work of architecture that gave it access to the world of spiritual meaning. Mies's Modernism and his idealism were perfectly compatible.

Materialism versus idealism: the Swiss contribution

The Swiss journal *ABC* represents the extreme 'materialist' wing of the New Objectivity movement within the German speaking world.[32]

Published in nine issues between 1924 and 1928, the journal was edited by an international group of architects, including the Swiss Hans Schmidt (1893–1972) and Emil Roth (1893–1980), the Dutch Mart Stam, and the Russian El Lissitzky (who ceased to be an editor when he was expelled from Switzerland in 1925). The Swiss architect Hannes Meyer (1889–1954) was also closely connected with *ABC*. The original impetus for the group's formation came from Swiss–Dutch connections that had been forged by two architects of the older generation, Karl Moser (1860–1936) and H. P. Berlage, and the interest on the part of young Swiss architects in Berlage's plan for South Amsterdam.

The group was strongly opposed to De Stijl's idealist and aesthetic approach. As Jacques Gubler has observed: 'Where De Stijl postulated the absolute of art and elementary form, *ABC* postulated the absolute of technique and material.'[33] *ABC* believed that only a 'dictatorship' of science and technology would be able to satisfy the collective needs of society.[34] There are obvious connections between this philosophy and that of the Constructivist First Working Group in Soviet Russia (see pages 123–5).

In their projects, Mart Stam and Hans Schmidt were primarily interested in systems of prefabrication, particularly in reinforced concrete. Despite their anti-art stand, their main concern was to develop an architectural 'language' which reflected serial production. Their discourse was not essentially different from that of Neue Sachlichkeit as a whole but it claimed to be more scientifically rigorous. Stam's researches into prefabrication included 'reinterpretations' of Mies van der Rohe's glass skyscraper of 1921–2 and Concrete Office Building of 1922 [**125**].[35] Stam adapted Mies's ideas to the needs of mass production; for example the curvilinear plan of the glass skyscraper was transformed into a circle, and the two-way structure of the office building into a linear, additive structure.

Hannes Meyer's theoretical position was also close to that of the Constructivist Left. He claimed that architecture was merely one instance of the technical–productive process: 'The depreciation of all

125 Mart Stam

Reinterpretation of Mies van der Rohe's Concrete Office Building of 1922

In this illustration in the journal *ABC* (1925), Mies's structure has been 'improved' to make it suitable for prefabrication. Form is seen to follow process.

art works is an indisputable fact, and there is no doubt that their replacement with a new exact science is merely a matter of time . . . art is becoming invention and controlled reality.'[36] His early work—particularly the Freidorf-Siedlung near Basel (1919–21)—was in the neoclassical style typical of the Swiss Garden City movement, in which he played an active part. After his rather late conversion to Modernism in 1924, the projects he undertook with Hans Wittwer varied between a rhetorical, mechanistic Constructivism (the projects for the League of Nations competition of 1927 and the Petersschule in Basel of 1926) and a dry rationalism (the Trade Union League School in Bernau, Germany of 1928–30). When he succeeded Gropius as director of the Bauhaus in 1928, Meyer introduced a rigorously 'productivist' and anti-aesthetic regime which reversed Gropius's assiduously apolitical policy.

From Rationalism to Revisionism: Architecture in Italy 1920–65

9

The strong connection between the architectural avant-garde and Fascism in Italy during the 'heroic' period of modern architecture has always been an embarrassment to architectural historians. Yet in their support for Fascism Italian modern architects reflected an anti-liberal, anti-democratic attitude that was far from uncommon within the European avant-gardes from the 1910s to the 1930s. The search for a 'third way' between Marxism and capitalism that would combine pre-capitalist communitarian values with modernization became translated into political reality only in Nazi Germany and Fascist Italy. The Germans made a distinction between 'modernization' and 'Modernism', embracing the first but restricting the second to specific building types such as factories. The Italian Fascist Party was split: the right wing was opposed to Modernism; the left wing supported it. The Modernist architects, for their part, sympathized wholeheartedly with a movement that shared their dislike of nineteenth-century liberalism and their desire simultaneously to modernize and return to ancient roots.

The Novecento

Two progressive movements in architecture made their appearance in Italy after the First World War. Both rejected what they saw as the individualism and nihilism of the Futurists and promised a 'return to order'. This found expression in all the arts, for example in the Valori Plastici movement in painting, which took its point of departure from the metaphysical realism of Giorgio di Chirico.

The first of the movements was the 'Novecento', which emerged towards the end of the war. This was a 'moderate' avant-garde that had much in common with the German Biedermeier movement of a few years earlier. It promoted an architecture which, though 'modern', would restore its links with an anonymous classical tradition. The leading architect of this movement was Giovanni Muzio (1893–1983),

whose Ca' Brutto apartment building in Milan (1919–22) was typical of a style that emphasized the surface of the building and took pleasure in mannerist, ironic deformations of conventional classical motifs.

Rationalism

The second progressive post-war movement was born in 1926 with the formation of Gruppo 7. The members of this group, which included Adalberto Libera (1903–63), Luigi Figini (1903–84), and Gino Pollini (1903–91), were all students at the Milan Polytechnic and belonged to a new, post-war generation. Their aims were summarized thus in the journal *Rassegna Italiana*: 'The hallmark of the previous avant-garde was . . . a vain aesthetic fury . . . that of today's youth is a desire for lucidity and wisdom . . . we do not intend to break with tradition . . . the new architecture should be the result of a close association between logic and rationality.'[1] The rationalists' programme, with its fusion of functionalism and the classical spirit, was largely borrowed from Le Corbusier's articles in *L'Esprit Nouveau*. The intellectual leaders of the movement were the art critic Edoardo Persico (1900–36) and the architect Giuseppe Pagano (1896–1945), respectively the director and chief editor of the journal *Casabella* from the late 1920s.

During the first half of the 1930s the political fortunes of the rationalists were in the ascendant following their successful participation in a number of public projects. The most important of these were:

- the University of Rome (1932–5)—although the traditionalist Marcello Piacentini (1881–1960) was the architect in charge, several individual buildings were assigned to rationalists, including the Physics Building by Pagano.
- work for the Ministry of Communications, including a new railway station in Florence by the Gruppo Toscana.
- the new towns built on the reclaimed Pontine marshes south of Rome, the most celebrated of which was Sabaudia, designed by a group led by Luigi Piccinato (1899–1983), in which equal attention was paid to socio-economic and symbolic–aesthetic issues.

In the north (beyond the immediate influence of Rome), rationalism was also relatively successful despite the indifference and sometimes the hostility of the Fascist Party. Important rationalist projects, both private and public, were carried out by, among others, Figini and Pollini (for example Figini's own house in Milan of 1934–5), and by Giuseppe Terragni (1904–43) whose Casa del Fascio in Como (1932–6) was a fusion of classical monumentalism and Modernist abstraction [127]. Terragni was the most gifted of the Gruppo 7 architects. His work is notable for, among other things, its complex interplay of

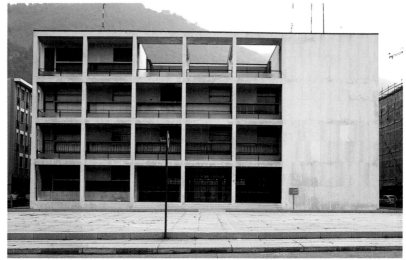

127 Giuseppe Terragni

Casa del Fascio, 1932–6, Como

For Terragni the open structural frame signified Fascist transparency and public accessibility. But the building also has a dream-like, timeless quality reminiscent of the paintings of Giorgio de Chirico.

surface and structural frame, as in the east façade of the Casa del Fascio and in the Casa Giuliani-Figerio in Como (1939). Although Terragni justified the Casa del Fascio in terms of 'the Mussolinian concept that Fascism is a glass house into which all can enter',[2] the classicizing aspects of the building prompted Pagano to condemn it as formalist and as representing an 'aristocratic sensibility'.[3] The conflict between Pagano and Terragni was not political (they were both ardent Fascists); it was the same conflict that had divided Hannes Meyer and Le Corbusier—that between a moralistic rigour on the one hand and an idealist aestheticism on the other.

In 1934 Mussolini himself belatedly announced his support of the rationalists.[4] But with the increase of patriotic sentiment at the outbreak of the Abyssinian War, the party veered to the right, and towards the end of the 1930s the traditionalists, under the leadership of Piacentini, became the dominant architectural faction. In the E42 Exposition near Rome of 1942 (now called EUR) most of the rationalists abandoned their Modernist position in favour of a stripped, monumental classicism.

Post-war reconstruction

Under Fascism the development of an international Modernism had been relatively free of political interference, despite antagonistic elements within the Fascist Party. Therefore there was considerable continuity between pre-war and post-war architecture in Italy. But paradoxically there were also strong revisionist pressures. Since most Modernist architects in Italy had been keen supporters of Fascism, the profession was driven, after the defeat of Fascism, to search for a new architectural identity. Architects became engaged in a succession of ideological debates which opened up the Modernist tradition to new

interpretations.[5] In these debates Milan and Rome represented opposite poles. The Milanese architects continued the pre-war rationalist programme established by Persico and Pagano, associating rationalism with leftist politics.[6]

In Rome, where rationalism had never been a strong force, a critique of the rationalists was mounted by the architect–critic Bruno Zevi (b. 1918). In two books, *Towards an Organic Architecture* (1945) and *A History of Modern Architecture* (1950), he called for a more humane architecture that would follow the examples of Frank Lloyd Wright and Alvar Aalto. Zevi's Association for Organic Architecture announced the promotion of 'an architecture for the human being . . . shaped to the human scale and satisfying the spiritual and psychological needs of man in society . . . organic architecture is therefore the antithesis of a monumental architecture used to create official myths'.[7]

In its attack on the architecture of the Fascist era, Zevi's critique was aimed at both neoclassicism and rationalism. But he shared most of the ideals of the rationalists, particularly that of creating a genuinely modern architecture in which social progress and technical innovation would go hand in hand. These hopes were shattered when, in 1948, at the beginning of the Cold War, the centre-right Social Democrats were returned to power. Far from inaugurating a programme of social reform and technical modernization, the government concentrated on shoring up the tangle of existing interest groups within the construction industry. In 1949 it created INA Casa (the Institute of Home Insurance), with the aim of making 'provisions for increasing worker employment, facilitating the construction of workers' housing'.[8] The priority given to reducing unemployment had the effect of inhibiting technical advance in an industry still largely at a pre-industrial level.[9]

Neorealism

The artisanal state of the construction industry was also behind the 'Neorealist' movement, which was closely involved with INA Casa. The movement was initiated by the architects Mario Ridolfi (1904–84) and Ludovico Quaroni (1911–87) in a series of housing projects. These included the Tiburtino Housing Estate (1944–54) by Ridolfi and Quaroni [128], and housing in the Viale Etiopia (1950–4) by Ridolfi, both in Rome. The projects made use of a constructional vocabulary based on Ridolfi's book *Manuale dell'architetto* (*The Architect's Manual*), published by the National Research Council in 1946, which aimed to create a vernacular Esperanto that would be understood by ordinary people.[10] Ridolfi and Quaroni's projects were influenced by Swedish housing and had much in common with the populist aims of Backström and Reinius. Another Neorealist project—the unbuilt community centre for the Falchera housing estate in Turin (1950) by

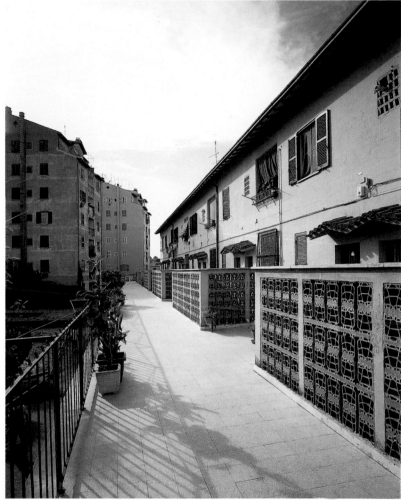

Giovanni Astengo (1915–90)—seems to have been directly influenced by the Ärsta Social Centre in Stockholm by the Ahlsén brothers (see page 197).

Contextualism

If the Neorealist movement marks the first appearance of what Vittorio Gregotti has called 'the striving for reality' in Italian post-war architecture, the same striving can be found in Ernesto Rogers's concept of an architecture that responds to its urban context. In a series of articles in *Casabella* in 1954–5 under such titles as 'The Experience of Architecture' and 'Pre-existing Conditions and Issues of Contemporary Building Practice'[11] Rogers (1909–69) advocated an architecture which, while remaining explicitly modern in its techniques, would respond formally to its historical and spatial context—an architecture based on an existential rather than an idealized reality.

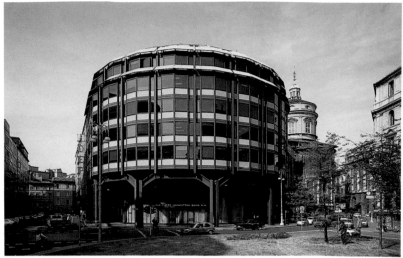

This concept had already been broached in practical design before it was theorized by Rogers. Two projects may be singled out as representing contrasting solutions to the same problem. In the INA Casa offices in Parma (1950) by Franco Albini (1905–77) a visible concrete frame provides a grid through which a play of vertically stressed solids and voids is threaded. The complexities of daily life and the patterns of the existing street façade are suggested without disturbing the underlying rationality of the idealized grid. In contrast to this, Rogers and his partners Lodovico Belgiojoso (b. 1909) and Enrico Peressutti (1908–75) (BPR), in their office building in the Piazza Meda in Milan (1958–69), deform the rational structural grid to create a classical hierarchy of different floors [**129**]. In the first example two 'orders' are dialectically superimposed; in the second a hybrid is created, not attempting to imitate its context but creating its analogue.

A more literal interpretation of 'context' can be seen in the work of the Roman architect and theorist Severio Muratori (1910–73). For Muratori, in his headquarters for the Christian Democratic Party in the EUR quarter of Rome (1955), 'response to context' meant communicating with the public by way of familiar signs and reasserting tradition. Muratori, like Ridolfi and Quaroni, was influenced by Swedish architecture, but in its earlier, neoclassical phase. A more superficial nostalgia for the past was characteristic of the 'Neoliberty' movement which emerged in the mid-1950s, as exemplified by the villa on Via XX Settembre in Milan (1954–5) by Luigi Caccia-Dominiani (b. 1913). Neoliberty was concerned neither with the immediate context nor with an eternal classicism; it believed that Jugendstil was still capable of representing a culturally unfulfilled urban bourgeoisie.

Many Italian architects rejected contextualism—including Giancarlo de Carlo (b. 1919) who, after a brief flirtation with Neorealism in his early housing project at Matera in the 1950s, reverted to a rational-

ist–Brutalist style in his student housing at the University of Urbino (1963–6). But the main criticism came from abroad, particularly from the newly formed 'Team X', at the 1959 CIAM congress in Otterlo (see page 218). The chief objects of this attack were BPR's Torre Velasca in Milan (1954–8), the Zattere apartments in Venice (1954–8) by Ignazio Gardella (1905–99), and de Carlo's Matera scheme.

The dialectic of rationalism and organicism

For a number of architects, breaking with the straitjacket of the rationalist tradition did not entail any stylistic negotiations with history. Like Zevi, these architects accepted the abstract language of Modernism but sought to extend it to freer realms of metaphor and expression. The work of Giovanni Michelucci (1891–1991) developed from a rationalism that made some attempt to harmonize with its urban context (for example at the Savings Bank in Pistoie of 1950) to a pure Expressionism. In the Church of S. Giovanni overlooking the Autostrada del Sole near Florence (1960–4) [130], he created an isolated Expressionist monument of pure German provenance (though it also makes an oblique reference to Le Corbusier's chapel at Ronchamp). The hermetic and intensely private work of Carlo Scarpa (1902–78) contrasts sharply with Michelucci's public rhetoric. Scarpa's subtle museum designs, such as the Gipsoteca Canoviana in Possagno, Treviso (1956–7) [126 (see page 182)] and the Castelvecchio Museum in Verona (1964), make a unique contribution to a genre which Italian architects after the Second World War—including also Albini and BPR—made their own.

130 Giovanni Michelucci
Church of S. Giovanni, 1962, Autostrada del Sole, Florence
The building shows the influence of both German Expressionism and Le Corbusier's chapel at Ronchamp.

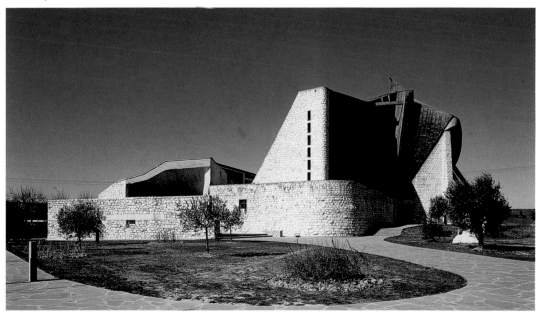

A harder, less precious tendency emerged in the mid-1950s characterized by the use of exposed-face concrete structures, for example in the Marchiondi Spaghiari Institute in Milan (1953–7) by Vittoriano Viganò (1919–96). Sometimes—as in the apartment building in the Via Campania, Rome (1963–5) by the Passerelli brothers (Vincenzo, b. 1904; Fausto, b. 1910; and Lucio, b. 1922) and an office building in the Via Leopardi, Milan (1959–60) by Ludovico Magistretti (b. 1920)—the structure is clearly differentiated from a lighter infill. These projects are related to international 'Brutalist' currents deriving from the late work of Le Corbusier.

A new urban dimension

At the end of the 1950s the attitude of Italian architect-planners to the problem of the city underwent an important shift. Demographic movements due to south-north migration as well as technical developments in the building industry led to a redefinition of the scope of urban planning, now seen to embrace larger 'city regions'. According to Manfredo Tafuri:

Italian intellectuals were becoming aware of a new reality; convulsive urbanization and the diffusion of mass communication had effected profound transformations in society. These changes, along with rapid economic growth, encouraged the formation of interpretative models that quickly replaced those of the preceding decade . . . Neorealist myths were replaced by technological ones . . . The entire concept of urban planning would be overhauled in the early 1960s.[12]

The concept of the 'city region', seen as a set of dynamic relations in a state of constant change, took the place of the fixed model.[13]

An essential precondition of this concept was the revalidation of the city as such. In 1959 the architect Giuseppe Samonà (1898–1983) published a book entitled *Urbanism and the Future of the City* in which he defended the big city and attacked the social assumptions of the Garden City movement and the Anglo-American concept of the small-town neighbourhood that had dominated Italian urban theory since the war. At the same time a number of competitions were held for the design of new business and administrative centres to be inserted within existing cities. The first and most influential of such projects was Quaroni's design for the Quartiere Cepalle Barene di S. Giuliano in Mestre (1959) [**131**], in which the city fabric, free to develop with the minimum of planning constraints, was given focus by a monumental group of buildings facing the lagoon. In this and similar projects, the city was conceived as two parts, one fixed and symbolic, the other continuously changing and essentially uncontrollable.[14]

In other contemporaneous projects, this dualistic concept was given

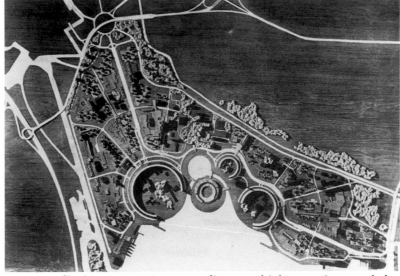

a more radical interpretation, according to which a continuous skele-
ton or infrastructure would contain randomly changing infill.[15] This
development was not confined to Italy: similar concepts emerging in
Sweden will be discussed in the next chapter and in the context of the
Megastructural movement in chapter 11.

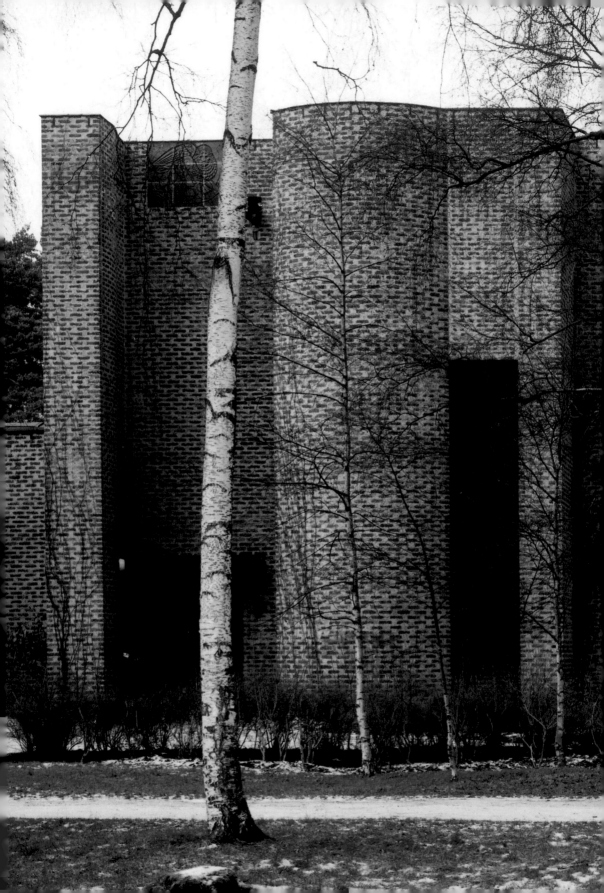

Neoclassicism, Organicism, and the Welfare State: Architecture in Scandinavia 1910–65

10

After the Second World War, the Modern Movement became identified with the victorious democracies and was adopted by the professional establishments in Europe and America. With the emergence of the welfare state in Western Europe, a new concept of 'planning' took shape—one compatible with liberal democracy and based on Keynesian economic doctrine.[1] The chief model for this combination of planning and capitalism was to be found in the Scandinavian countries. Sweden in particular became a role model for many architects in Western Europe and America. In order to understand the nature of this influence it will be necessary to trace the development of architecture in Scandinavia since just before the First World War.

From neoclassicism to Modernism in Denmark and Sweden

The European neoclassical movement of the first decade of the twentieth century had a strong impact in Scandinavia, whose architects came under the spell of the German Biedermeier revival disseminated by Paul Mebes, Paul Schultze-Naumburg, and Heinrich Tessenow. The initial impulse for this tendency came from Denmark, where architects had been studying such neoclassical predecessors as H. C. Hansen since the 1880s.[2] Danish and Swedish architects became fascinated by their own vernacular and classical traditions as exemplified in sixteenth-century castles, Baroque palaces, and early-nineteenth-century neoclassical buildings. An eclectic neoclassicism that borrowed from local traditions, German eighteenth-century vernacular classicism, Friedrich Gilly (1772–1800), Claude-Nicolas Ledoux, and the Tuscan Renaissance, dominated Scandinavian architecture

from the First World War to the late 1920s. The severe Doricist museum in Fäborg (1912–15) by Carl Petersen (1874–1923) set the tone of the entire movement.

In Germany, Expressionism intervened between neoclassicism and the New Objectivity, but in Scandinavia there was a direct transition from one to the other, revealing their similarities rather than their differences. Both Denmark and Sweden inaugurated programmes of state-sponsored housing during the First World War to meet a housing shortage that had been particularly acute in Scandinavia. At that time the model being used for urban housing was that of eighteenth-century perimeter blocks. The clearest examples of the transition from this model to Modernism can be seen in Denmark, in the Hans Tavsensgade project in Norrebro (1919) by Paul Baumann (1887–1963), where perimeter housing encloses a central communal garden.[3] With the new ideology of science and hygiene, there was a progressive opening up of the courtyard to the outside, as in the Ved Classens Have project in Copenhagen (1924–9) by Carl Petersen and Paul Baumann.[4] Eventually, as in Blidah Park (1932–4) by Ivar Bentsen (1876–1943), the perimeter block disappeared altogether, to be replaced by linear bars set in parkland.[5] At the same time the regularly pierced classical wall surface gave way to the free façade, even when load-bearing wall construction was still in use. Unlike Germany in the 1920s, however, hybrid, semi-enclosed layouts immediately appeared, as in the Bellavista Estate at Klampenborg near Copenhagen (1934–7) by Arne Jacobsen (1902–71).[6]

In Sweden, the arrival of the New Objectivity was announced by two public projects: the student hostel in the Royal Institute of Technology by Sven Markelius (1889–1972) and the Stockholm Industrial Arts Exhibition buildings by Erik Gunnar Asplund (1885–1940) with a team of other architects, both completed in 1930. Whereas Markelius's building was a competent work in the manner of Oud or Dudok, Asplund's lakeside exhibition buildings brilliantly exploited the lightness and transparency of modern materials in an architecture that was popular, carnivalesque, and nautical [132]. By 1930 Asplund already had a distinguished neoclassical *œuvre* to his credit, including the rustic–classical Woodland Chapel at the Cemetery of Enskede in Stockholm (1918–20)[7] and the Ledoux-like Stockholm Public Library (1920–8). His successive designs for the addition to the Courthouse at Gothenburg (1913–36) show the evolution of his style from the national romanticism of the original competition design, through neoclassicism, to Modernism. It is probable that Asplund, though undoubtedly a genuine convert to the New Objectivity, never fully accepted the rigorous schematism of the French and German movements and that for him the eighteenth-century categories of *bienscéance* (propriety) and 'character' still had

132 Erik Gunnar Asplund

Entrance Pavilion, Industrial Arts Exhibition, 1930, Stockholm

The spirit of festival pervades this building with its flag-bedecked nautical references. An open structure forming a *porte cochère* to the whole exhibition shelters a smaller structure within with terraces like the upper decks of a liner.

some meaning. His last completed building, the Woodland Crematorium (1935–40), with its clever fusion of Modernist and classical elements, would seem to bear this out.

The Modern Movement in Sweden

Social reform and housing

In Sweden, the new architecture was, from the start, closely identified with the social reform movement—just as it had been some ten years before in Germany. In 1932 the Social Democrats came to power and instituted a series of reforms inspired by Prime Minister Per Albin Hansen's slogan comparing the state to 'the house of the people' (*Folkhemmet*).[8] These reforms were carried out within a liberal democracy, but facilitated by a long tradition of state interventionism. At their core was the housing programme. During the 1920s a vigorous cooperative movement had paved the way for legislation which was to result, after 1945, in a fully fledged welfare state. Housing built by the cooperatives (which often had their own architectural departments) was extremely influential in the spread of Modernist architecture in Sweden—for example the layout of the Kvarnholmen Company housing project by the architects of the KV cooperative[9] was to be widely imitated abroad.

Because of the success of the housing programme and the comparative lack of public opposition to the new architecture, the Modern Movement in Sweden was completely lacking in the Jacobinism of the French and German movements. Swedish critics found Le Corbusier's ideas too theoretical and those of the German Modernists too dogmatic, believing that the new should be reconciled with the existing. This attitude was summed up in the words of the critic Hans

133 Sven Backström and Lief Reinius

Rosta Housing Estate, 1946, Orebro

This project is typical of Swedish social housing in the 1940s, with its pitched roofs and pairs of small windows.

Eliot when he wrote: 'It seems to me that in Sweden—unlike for Le Corbusier in a France weighed down by style—there exists a culture of dwelling that is both suited to modern purposes and derived from tradition.'[10]

The New Empiricism

The architects Sven Backström (1903–92) and Lief Reinius (1907–95) led the way in a Swedish revisionist movement after the Second World War. They mixed Modernist macro-typologies with familiar constructional techniques and decorative forms still in the repertoire of ordinary builders and within the taste range of ordinary users [**133**], seeking a more popular architecture that would acknowledge 'psychological and irrational factors that please us—and—why not?—beauty'.[11] This ideology—enthusiastically dubbed 'The New Empiricism' by the British journal *Architectural Review* in 1947—was not in fact universally accepted in Sweden. The Swedish journal *Byggmästeren*—which had 'gone modern' in 1928—ran a debate on the relative merits of a rational 'Apollonian' and an irrational 'Dionysian' architecture,[12] reviving, in the post-war context, a controversy that had smouldered beneath the surface of the avant-garde since the 1920s.

Backström and Reinius's housing estates at Danvikskippan, Gröndal, and Rosta were widely published in the international architectural press. Their 'honeycomb' layout, breaking with the rectilinearity of rationalism (in fact, borrowed from a 1928 project by the German architect Alexander Klein)[13] was adopted in the New Town of Cumbernauld in Scotland and the Valco san Paulo housing estate in Rome in the 1950s. British interest in the New Empiricism was reciprocated by Swedish planners and architects who were influenced by British urban planning theory as laid out in Patrick Abercrombie's Greater London Plan of 1944. The concept of neighbourhood community planning was adopted in the Ärsta Social Centre (1943–53) built by Eric and Tore Ahlsén (1901–88 and 1906–91), in the suburbs of Stockholm as a pilot scheme intended to correct what was perceived as the principal defect of Swedish housing—its lack of social facilities.[14]

Systems design

During the 1960s and 1970s there was a dramatic increase in housing production in Sweden. A programme was instituted which aimed at providing one million dwellings between 1965 and 1974.[15] Within this programme, 40 per cent of dwellings took the form of high-rise, high-density projects, using a 'Systems' approach to planning and construction. This approach maximized the use of standardized parts and large-scale prefabrication, and was modelled on the technique of Systems engineering used by the United States defence industry.[16] The approach was not restricted to Sweden. In Denmark—to speak of Scandinavia alone—there was also a technically driven development in mass housing which resulted in dense, high-rise projects such as that of Hoje Gladsaxe (1960–70).[17]

In the late 1960s there was growing public opposition to this kind of development, which was often unsatisfactory even at a purely technical level. This reaction, which was exacerbated by the fall-out from the French student revolt of 1968, was to lead to revisions in government policy in both housing and urban renewal. Meanwhile, faced with increasing exclusion by the building industry, architects tended to react in one of two ways: either by accepting technological developments and trying to take control of them; or by retreating into a world of one-off projects of modest scale, where the economics of mass production and mass consumption did not apply.

Large programmes

An attempt in the public sector simultaneously to rationalize and humanize large-scale construction can be seen in the 'Structuralist'

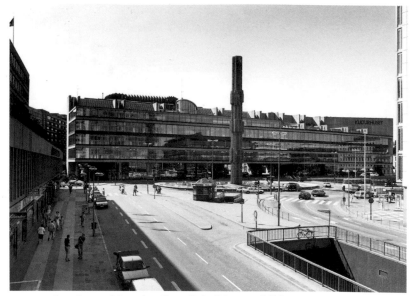

approach adopted by the Swedish National Planning Board.[18] This inaugurated a new way of thinking about the design of large buildings predicated on the separation of two systems with different rates of obsolescence: on the one hand, the building envelope with its structural support; on the other, the functional infill.

Two projects by individual architects also addressed the problem of large-scale urban buildings in different and more pragmatic ways. The first is Citizen's House in Orebro (1965) by Eric and Tore Ahlsén.[19] This multi-purpose cultural centre occupies an entire city block; the architects attempted to reduce its apparent mass by the articulation of the different floors and variations of surface treatment. The second project, the Culture House complex in Stockholm (1965–76) by Peter Celsing (1920–74), had weightier urban and national implications [**134**]. It has three elements: a large theatre, the resited Bank of Sweden, and a cultural centre.[20] The theatre is assimilated into the existing urban fabric, while the other two elements stand out as objectified, representative buildings. The complex closes the main north–south axis of the city, and is sited on the historical boundary between the old town and the nineteenth-century commercial district. Celsing preserved this distinction by attaching the bank and the cultural centre to opposite sides of a thick 'service' wall, which symbolically represents the ancient city wall. The bank, which faces the old town, is a hermetic, classicizing cube. The cultural centre, which faces the new town, has a long, uninterrupted, fully glazed façade with accentuated floorplates. The brief for this building was written by Pontius Hultén, later to become the first director of the Centre Pompidou in Paris, with which Celsing's building shares the Constructivist idea of a transparent multi-purpose building in which

visible interior functions take the place of traditional ornament. Celsing's project, in giving a different character to each of its components, resists the homogenizing effect of modern technology and preserves the historical structure of the city; but it accepts the change of aesthetics and scale brought about by economic and technical developments.

Small projects

The second kind of response adopted by Swedish architects—the retreat from technology to the small-scale—can be illustrated by a series of small churches built in the 1950s and 1960s to cater for an expanding suburban population. The most interesting of these were by Peter Celsing and, from an earlier generation, Sigurd Lewerentz (1885–1975). Celsing's Härlanda Church in Gothenburg (1952–8) is a space defined by three shed-like brick structures.[21] Lewerentz built two churches during the same period: St. Mark's, Biörkhaven (1956–60) [135] and St. Peter's, Klippan (1962–6).[22] Early in his career Lewerentz had been joint winner, with Asplund, of the Woodland Cemetery competition (see note 7). In the 1950s he worked with Peter Celsing on proposals for the restoration of Uppsala Cathedral. His last

135 Sigurd Lewerentz
St. Mark's Church, 1956–60, Biörkhaven
The blind brick façade of this church is given meaning by the signs of interior activity—windows and projecting chapels—which occur randomly. In Lewerentz's later buildings such functional symbolism, with its Gothic connotations, makes a strange contrast with the architect's earlier neoclassicism.

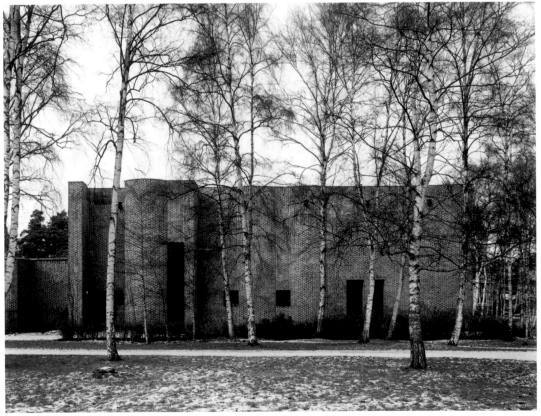

two churches show the influence of the younger architect but while they are similar to Celsing's in their use of exposed brick externally as well as internally, Lewerentz's churches are both more daring in their primitivist interpretation of tradition, and richer in symbolism, as for example in the cruciform central column supporting the roof of St. Peter's Church.

The Modern Movement in Finland

Rationalism and neoclassicism

In 1904 the critic–architects Sigurd Frosterus and Gustav Strengell published a pamphlet entitled 'Architecture: a Challenge to our Opponents', criticizing the result of the competition for Helsinki Railway Station (1906–16), which had been won by Eliel Saarinen with a late-Jugendstil design. The pamphlet attacked national romanticism—which had been closely associated with Finnish national liberation—proposing in its place an architecture that was rationalist and internationalist. In response to this criticism the final versions of Saarinen's design for the station and Lars Sonck's design for the Stock Exchange (1911) were both modified. This turn to a structurally expressive rationalism based on the teachings of Viollet-le-Duc was, however, short-lived. It was soon overtaken by the Swedish-inspired neoclassical movement. Like rationalism, this movement was opposed to the individualism of national romanticism, but the norms it proposed were formal and classical rather than structural.

Alvar Aalto and the New Objectivity

Both the rationalist and the neoclassical interludes paved the way for the reception in Finland of the New Objectivity. Among the group of young architects who turned to the new movement, Erik Bryggman (1891–1955) and Alvar Aalto (1898–1976) stand out. Their joint entry for the Turku Fair competition of 1929 is widely seen as having introduced the new movement to the Finnish public.

Alvar Aalto soon emerged as the leader of the group with his competition-winning designs for the Public Library in Viipuri (1927–35) and the Tuberculosis Sanatorium in Paimio (1929–33) [**136, 137**]. The original entry for the Viipuri Library competition was neoclassical, but during the prolonged design development it was transformed into a Modernist scheme. The final version, with its two hermetically sealed bars sliding against each other in echelon, skewered by a transverse entry system, was Constructivist in its dynamic asymmetry, though it retained the ghost of its original Beaux-Arts plan. Paimio Sanatorium, on the contrary, was Modernist from the start, with

136 Alvar Aalto

Tuberculosis Sanatorium,
1929–33, Paimio

View of entrance courtyard.
The wing on the right
contains the wards.

slender, loosely articulated wings, angled to engage with the surrounding landscape.[23] In both buildings, smooth white wall surfaces with Mediterranean overtones are even more in evidence than in other examples of international Modernism. But a new feature was the attention paid to details; in the Paimio Sanatorium Aalto designed all the furniture and fittings. It was because of their concern for the intimate and tactile aspects of modern design, as well as their manifest formal qualities, that these two buildings instantly became icons of a more resilient Modernism.

Regionalists and organicists

In the late 1930s, Finnish Modernist architects followed the European trend in questioning the mechanistic premises of the New Objectivity, returning to natural materials and traditional details. This is true of both Bryggman and Aalto; but whereas Bryggman, in the Resurrection Funerary Chapel in Turku (1938–41), introduced direct quotations from tradition in the form of vaults and arches, Aalto, like

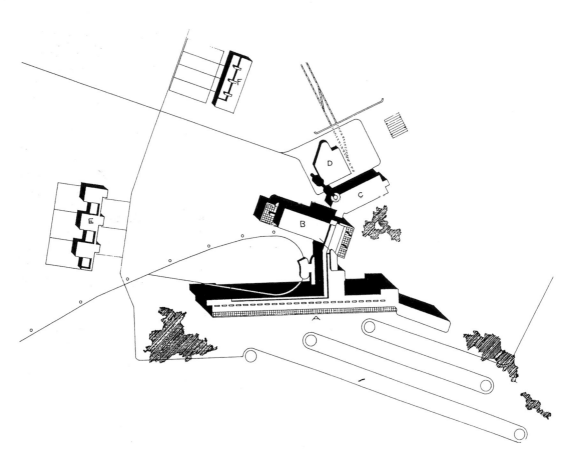

Le Corbusier, retained the 'empty' language of the new movement, seeking to fill it with new metaphors. In the Villa Mairea at Noormarkku (1937–9) [**138, 139**], taut, curved walls faced with wood sidings are contrasted with sharp-edged brick walls painted white. In the living room—which like Mies's Tugendhat House combines different living zones within a single space—screens of wooden poles in random clusters become metonyms for the fir forest visible through wall-to-wall plate-glass windows, creating a synthesis of modern technology, artisanship, and nature. This building, with its abruptly juxtaposed elements and its metaphors of nature, was a radical departure from the linear logic of the New Objectivity.

The Villa Mairea was built for the entrepreneurs Harry and Maire Gullichsen, for whom Aalto became architect in 1934, building the Sunila Pulp Mill and its company workers' housing (1936–9). In the same year he co-founded, with Maire Gullichsen, the Artek furniture company and started designing chairs in laminated plywood. These were inspired by the Luther Company in Tallinn, Estonia,[24] but they were also a development of the bentwood and tubular steel traditions. In Aalto's furniture the application of new techniques to natural materials resulted in shapes reminiscent of the paintings of Hans Arp.

138 Alvar Aalto

Villa Mairea, 1937–9,
Noormarkku
This interior view shows the
screen protecting the
staircase, which mimics the
larch forest surrounding the
house.

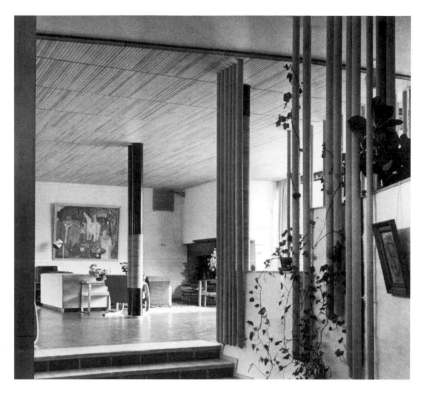

139 Alvar Aalto

Villa Mairea, 1937–9,
Noormarkku
Ground-floor plan, showing
the way the house wraps itself
round the garden to form a
protected clearing.

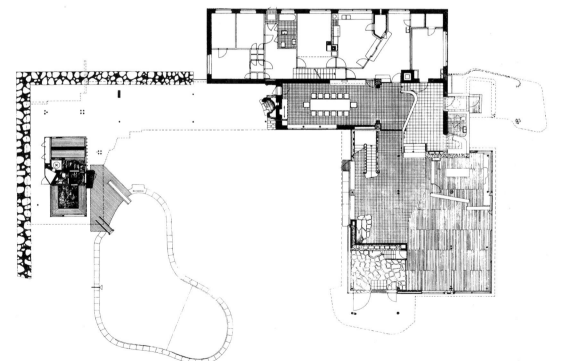

Aalto's enjoyment of the Gullichsens' patronage kept his exploration of mechanical techniques within a certain Jugendstil tradition.

After the war, Aalto began to receive many commissions for public buildings, including urban projects such as the Pensions Institute in Helsinki, and rural projects such as the Town Hall in Säynätsalo (1949–52) [**140**] and the Jyveskylä University Campus (1950–7). These projects constitute a well-defined middle period in Aalto's work, characterized typologically by semi-enclosed courtyards reminiscent of vernacular farm buildings, and materially by the extensive use of handmade brick and clear-varnished wood. The return to picturesque compositions dominated by volumes signifying community, indicates a partial revival of the spirit of national romanticism.

In the late 1950s, beginning with the Vuoksenniska Church in Imatra (1957–9) [**141**], another change takes place in Aalto's work. Rustic brickwork is replaced by white plaster or marble facings, while at the same time the forms become increasingly complex. This elaboration—which many critics (using a risky analogy) have called 'Baroque'—can to some extent be attributed to a change in the type of programme, from buildings providing the post-war infrastructure of the modern welfare state (universities, administrative buildings) to those with a more symbolic function (cultural centres, concert halls, libraries, churches). But in spite of these changes, what remains constant in Aalto's work is its drawing on the forms of the natural world to express growth and movement as a metaphor of human life. In this it has certain affinities with the work of Frank Lloyd Wright.

Rationalists and Constructivists

Aalto's well-deserved reputation has tended to obscure other tendencies at work in Finnish Modernism. In the 1950s there were two broad

cultural models operating in Finnish architecture: on the one hand Aalto's organic, regionalist model; on the other, a more rationalist or purist model upheld by architects like Viljo Revell (1910–64) and Aulis Blomstedt (1906–79), who continued to work in a vein closer to the ideas of the early Modern Movement, particularly in its social concerns and its interest in modern materials and techniques. Aspects of this tendency were prolonged into the 1960s by younger architects such as Aarno Ruusuvuori (1925–92) and Pekka Pitkänen (b. 1927). The latter's Funerary Chapel in Turku (1967) is a sensitive, minimalist work in precisely formed *in situ* concrete [**142**]. Its pure, abstract forms are in strong contrast with the nearby Resurrection Chapel by Bryggman.

At the end of the 1960s the conflict between these two models came into the open. The young rationalists (or 'Constructivists', as they called themselves) opposed what they saw as the Romantic tendencies in the later work of Aalto and followers like Reima Pietilä (1923–93). They accused the older generation of concentrating on monumental 'cultural' buildings based on a subjectivist aesthetic lacking methodology, and of ignoring the social role of architecture.[25] They were supported by Aulis Blomstedt, head of the Helsinki University of Technology since 1959—a prominent theoretician who had developed a modular system with the aim of reconciling modern mass production with traditional architectural values.[26]

The Constructivists, who played an important part in Finnish architectural discourse until the early 1970s, upheld the early Modern

141 Alvar Aalto

Vuoksenniska Church, 1957–9, Imatra

This building marks the beginning of a more sumptuous phase in Aalto's work, in which refined materials such as marble facings replace rustic brickwork. The forms also become geometrically more complex and curvilinear.

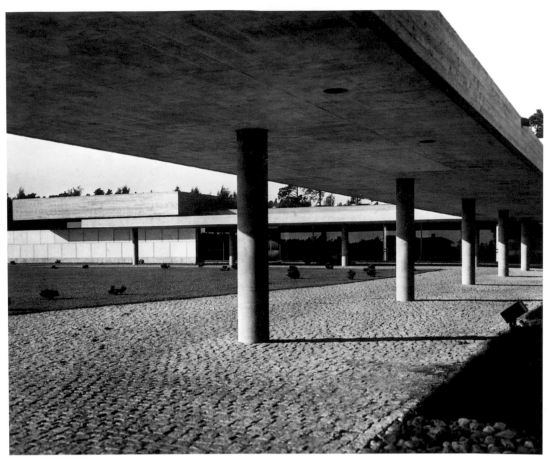

142 Pekka Pitkänen

Funeral Chapel, 1967, Turku
The work of this interesting
architect represents a
rationalist tendency in
Finnish architecture in the
1960s that was, at least in
part, a reaction against
Aalto's increasingly
naturalistic approach. Unlike
some of the other rationalists,
however, Pitkänen's work was
more purist than
technological or social in
spirit.

Movement ideal of collaboration between the architect, the engineer,
and the building industry. But after they had realized some interesting
small-scale industrial buildings, it became apparent that in the larger
field the building industry was not prepared to operate on their terms.
In a later book, Kirmo Mikkola (1934–86), who was himself an influen-
tial member of the Constructivist faction, put the matter thus: 'The
truth [of a technology-based architecture] was more difficult than the
ideal. The sought-after collaboration with industry did not material-
ize. The big construction companies stuck to their rigid unit system
created in the 1960s without any assistance from the architects.'[27]
At the same time Mikkola acknowledged that the Constructivists
had excluded 'plastic and symbolic means of expression' from their
buildings.

As in Sweden, the Systems-based approach described by Mikkola
had its greatest impact in the field of public housing. Since the 1930s
low-cost social housing in Finland had consisted largely of dormitory
suburbs with few social facilities. (A notable exception to this was the
Garden City of Tapiola, begun in 1953 to the master plan of Arne Ervi,
which was conceived as a self-contained community.) One of the chief

models for these was Aalto's Sunila Housing, in which low-rise terraces were freely deployed in an Arcadian setting. This type became known as 'Forest Housing'. The social drawbacks of 'Forest Housing' had meanwhile become obvious. The application of large-scale Systems design to isolated suburbs had the effect of aggravating these deficiencies, creating aesthetically poor and socially alienating environments. The mechanical application of industrial techniques to housing, and the concomitant planning strategies, therefore led to environmental results that were the exact opposite of the idyllic symbiosis of technology and nature envisaged by the Modern Movement—especially by the rural and regionalist version of it promoted by Alvar Aalto.

From Le Corbusier to Megastructures: Urban Visions 1930–65

11

Urbanism and housing in late Le Corbusier

After his 1929 lecture tour of South America, Le Corbusier became involved in a series of urban projects that were very different from his previous city plans. Whereas the Ville Radieuse had been a schematic design for an ideal site, the projects for Rio de Janeiro (1929) and the 'Obus' ('explosive shell') plans for the city of Algiers (1932–42) were intended for actual sites. They were also closely linked to Le Corbusier's new-found interest in *l'homme réel* and regional cultures based on local customs and geographies. In these projects modern architecture and engineering extend their reach to vast colonial and post-colonial territories and assume a new cosmological significance in their struggle with primordial nature.

In Rio and Algiers Le Corbusier did not abandon his earlier urbanism, but its forms became more sensitive to local topographies, and there is a greater absorption of private life by monumental, collective forms. Already in 1922, the Ville Contemporaine had envisaged a new integration of private and collective life. For example, public circulation was seen as a single system, with the corridors serving the flats becoming streets-in-the-air replacing access roads. In the Rio and Algiers plans the integration of circulation and housing became the dominant theme. Housing was slung under a viaduct carrying the main highway, recalling the 'Roadtown' project of 1910 by the American architect Edgar Chambless [**144**]. In Algiers, the housing viaduct followed a long sinuous route along the coast, while a separate group of apartments—through which another road was cut at mid-level—was sited further inland on the Fort de l'Empereur hills, connected by a high-level viaduct to the business centre at the port, the *'cité d'affaires'*. Roads and housing were treated as a single, integrated system. One of the most interesting aspects of the project is the separation of infrastructure and infill, allowing the inhabitants to build their own houses

143 Constant

New Babylon: Group of Sectors, 1959

This first-floor plan of New Babylon shows an unplanned city of the future, conceived of as expanding indefinitely until it eventually covers the whole earth.

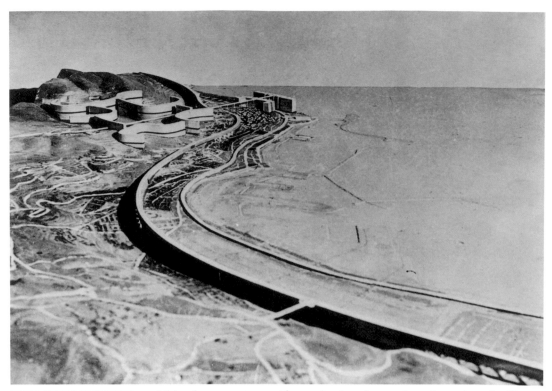

144 Le Corbusier

Model, Obus A Project for Algiers, 1933

In this first project mass housing is built under the coastal viaduct while the political and administrative classes are housed on the hills of Fort de l'Empereur. The latter is linked to the business centre at the port by a viaduct that flies over the Arab city, ensuring its preservation and minimal contact between colonizers and the native population.

within the structure as if on suburban lots—the adaptation the Domino idea of 1914 (see page 143) to a multi-storey building [**145**]. A publicly financed highway provides the framework for privately financed housing.

Le Corbusier's Algiers project coincided with growing public pressure for a development plan for the rapidly growing city. At the same time that he was designing his unsolicited schemes, other proposals of a more conventional kind were being pursued by the Algiers authorities themselves. Le Corbusier's first plan was submitted in 1933 and was immediately followed by two further proposals (1933–4) in which the housing component was progressively eliminated. The project was definitively rejected in 1934, but Le Corbusier continued to submit—with equal lack of success—further proposals for the *cité d'affaires* for several years.[1]

It was while working on these that Le Corbusier developed the idea of the sun-breaker (*brise-soleil*), first proposed for the Durand project in Algiers in 1933. This 'invention' had enormous consequences in his later style. Much more than a means of solar protection, the sun-breaker was an expressive device giving back to the Corbusian façade the plasticity and play of scale that had been sacrificed with the suppression of structure. Nothing shows more clearly the similarities and differences between Le Corbusier and the Beaux-Arts. In his final version of the Algiers office tower Le Corbusier reverts to a primitive

145 Le Corbusier

Obus A Project for Algiers, 1933
This drawing of the Fort de l'Empereur housing shows the separation of support structure and apartments, which have a shorter life cycle and can be in any style.

classicism quite different from the historical classicism of August Perret. The 'orders' are replaced by *brise-soleils* which give scale and meaning to the façade through the representation of the hierarchy of spaces within the building [**146**].

In 1945, Raoul Dautry, Minister of Reconstruction in the first post-war French government, commissioned Le Corbusier to build a *unité d'habitation* (approximately: 'unit of housing') in Marseilles.[2] The key concept was that the structure should be large enough to incorporate the communal services required to support the daily lives of its inhabitants. The idea of such a collective was not new: examples were to be found in the Soviet Union and Sweden dating from the 1930s. Where the completed Unité d'Habitation (1946–52) differed from these was in its strong monumental presence. Although clearly influenced by such Russian schemes as the Vesnin brothers' communal housing project for Kusnetsk of 1930,[3] the building does not reflect the Vesnins' socialist agenda. According to Le Corbusier it was the culmination of his 'concept of modern middle-class housing'.[4] It is closer to Charles

146 Le Corbusier

Obus E Project for Algiers, 1939
This office tower is the first appearance in Le Corbusier's work of the *brise-soleil* (sun-breaker) as an integral part of a concrete structure, by means of which the internal hierarchy of the building is made legible.

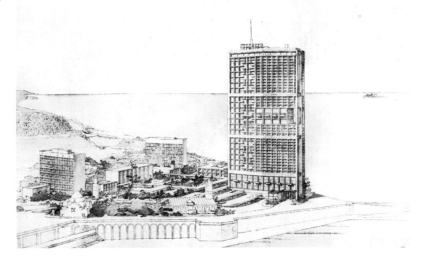

Fourier's ideal collective palace, the *phalanstère* (which similarly had a population of 1,800), a Carthusian monastery, or a transatlantic liner—all of them self-contained communities. Internally, Le Corbusier used a modified version of the interlocking duplex apartments first proposed for the Ville Contemporaine in 1922. Externally a system of concrete sun-breakers, doubling as loggias and derived from the Algiers office tower, made legible the internal spaces. Le Corbusier described the Algiers office tower as 'a palace, no longer a box—a palace worthy of reigning over the landscape'.[5] He could equally well have been describing the Unité.

Comparing Le Corbusier's Unité d'Habitation with his housing at Algiers we see that they represent two very different concepts. While the Unité is a discrete whole, designed to the last detail by the architect, Algiers is an endless infrastructure with random infill. A similar difference existed between two new urban concepts that emerged during and after the Second World War, both of which challenged the orthodoxies of the rationalist tradition. The first was that of the New Monumentality, the second the rather complex urban philosophy of Team X.

The New Monumentality

The idea of a New Monumentality was formulated by the older generation of modern architects in Europe and America in the 1940s. Already, in the mid-1930s, there had been a call by architects to re-introduce the concept of the monument into the Modernist canon. By 'monument' they did not mean 'memorial' in the strict etymological sense, but the broader idea, introduced around the turn of the twentieth century, of representative as opposed to utilitarian buildings. In Europe the concept was certainly influenced by the return to classicism in Nazi Germany and Stalinist Russia, but for the Modernists a return to monumentality meant a return to underlying principles not to a specific style, and the debate remained at a somewhat abstract level.[6] One of the most striking post-war examples of such a non-historicist monumentality was Le Corbusier's Pilgrimage Church of Notre-Dame-du-Haut at Ronchamp (1951–5).

It was only in the 1940s that the proponents of a New Monumentality began to connect it with a specific set of social and political ideas. This happened when American Modernists re-identified the monument with democracy—just as their predecessors had at the time of the City Beautiful movement. The context of this re-evaluation was the American government's New Deal building programme, which included the Tennessee Valley Authority. In 1941, the architect George Howe declared: 'The power plants and living centres of TVA are an effort to carve a new pattern of life out of earth,

air, and water . . . and make the land the likeness of the people so that the people can come to be a likeness of the land.'[7] Three years later, Elizabeth Mock, a curator of architecture at the Museum of Modern Art in New York, wrote:

A democracy needs monuments, even though its requirements are not those of a dictatorship. There must be occasional buildings which raise the everyday casualness of living to a higher and more ceremonial plane, buildings which give dignified and coherent form to that interdependence of the individual and the social group which is the very nature of democracy.[8]

In 1943, Sigfried Giedion—then in exile in the United States—entered the debate. In collaboration with the French painter Fernand Léger and the Catalan architect Josep Lluis Sert (1902–83) he wrote a manifesto entitled 'Nine Points on Monumentality',[9] and followed it up with an essay called 'The Need for a New Monumentality'.[10] In this essay, Giedion focused on the need for civic centres symbolizing the idea of 'community' in which all the visual arts would collaborate, creating a new *Gesamtkunstwerk*. His construction of 'community' is different from that of Howe and Mock. It does not invoke the idea of democracy, but rather—at least by implication—the German concept of *Volk*. His description of the civic centre reminds one of Taut's *Volkhaus*, though his more immediate source is Le Corbusier. According to Giedion: 'Only the imagination of real creators is suited to building the lacking civic centres, to instil once more in the public the old love of festivals, and to incorporate all the new materials, movement, colour, and technical possibilities. Who else could utilize them for opening up new ways to invigorate the masses?'

In Le Corbusier's work, the civic centre makes its first tentative appearance in 1934 with the projects for the Radiant Farm and the city of Némours in North Africa. One year earlier Sert had planned the new industrial town of Cidade des Motores near Rio de Janeiro. The distinctly Corbusian buildings of its civic centre are arranged to form a semi-enclosed square reminiscent of an Iberian Plaza Mayor. As if in response Le Corbusier, in his civic centre for St. Dié of 1946, included a loosely defined square. In this project the group of buildings forming the civic centre includes a *unité d'habitation*, clearly indicating Le Corbusier's intention of giving monumental status to housing.

Two capital cities: Chandigarh and Brasilia

The capital cities of Chandigarh[11] and Brasilia[12] both embody the idea of monumentality, but their monumental centres have national as opposed to local connotations.

The original plan for Chandigarh—the capital of the new state of East Punjab—was prepared by the American planner Albert Mayer.

After the untimely death of his Polish-American associate Matthew Nowicki in 1950, Mayer was replaced by the team of Jane Drew, Maxwell Fry, and Pierre Jeanneret, with Le Corbusier as consultant and sole architect of the Capitol (state government buildings). For the overall plan Le Corbusier merely regularized Mayer's Garden City layout, but for the Capitol he started again from the beginning. Nowicki's first scheme for the Capitol (which he later modified) was a rectangular walled 'city' based on the seventeenth-century Mogul forts of Agra and Delhi. Le Corbusier rejected any such model. The three elements of the programme—the High Court, the Assembly, and the Secretariat—were designed as a vast acropolis of separate monumental structures, set against the backdrop of the Himalayan foothills [**147**]. These buildings have the strong *Gestalt* of Le Corbusier's late style, and in addition they are invested with a symbolism which, although partly based on a private, associative language, has an immediately felt power [**148**]. Le Corbusier's primitive, classical Esperanto reflected his concept of a universal modern architecture modified by regional traditions.[13] It fitted well with Prime Minister Jawarhalal Nehru's aspirations to make India into a modern secular state.

The city of Brasilia has to be seen in the context of the unique development of Modernism in Brazil. The Modern Movement was embraced almost overnight by the younger generation of Brazilian architects in 1930—the year that the future dictator Getulio Vargas was elected president. Above all, it was Le Corbusier's rhetorical language that appealed to the Brazilian architects. It was as if the force of an idea could give instant birth to the new architecture and charge it with popular symbolism. Among the many impressive public buildings in which the language of Le Corbusier was adapted to Brazilian conditions, the Ministry of Education and Public Health in Rio (1936–45) is outstanding [**149**]. Designed by a team which included Lúcio Costa (1902–98), Jorge Moreira (1904–92), Affonso Reidy (1909–64), and Oscar Niemeyer (b. 1907) working in close collaboration with Le Corbusier himself, the building broke with the universal perimeter block pattern of the Rio street grid, becoming an *objet-type* in the centre of the block. In its diagrammatic separation of offices and collective functions this building seemed to many—even in Europe—a more perfect realization of Corbusian ideas than Le Corbusier's own public buildings, constrained as they often were by odd-shaped urban sites. For Sigfried Giedion it was an early example of a truly modern monumentality, 'with a far-reaching influence on the design of large buildings all over the world'.[14]

The idea for a new capital city of Brazil on the central plateau, which had been envisaged ever since the eighteenth century, was finally realized by President J. Kubitschek de Oliveira in 1956. The competition for the masterplan was won by Lúcio Costa, and Oscar

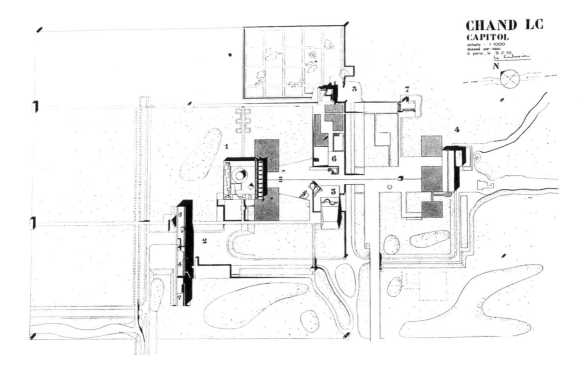

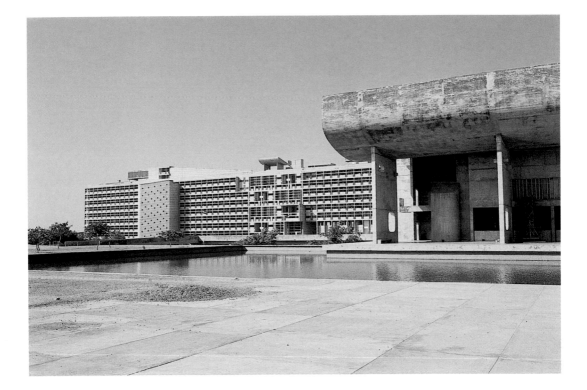

149 Lúcio Costa, Oscar Niemeyer, and others; consultant Le Corbusier

Ministry of Education and Public Health, 1936–45, Rio de Janeiro

This remarkable design is the purest built example of a new type, already proposed by Le Corbusier in his unbuilt Rentenanstalt project for Zürich (1933). The office slab is set back from the street frontage on *pilotis*, freeing the entire site for public open space. It was also the first building to use Le Corbusier's *brises-soleil*.

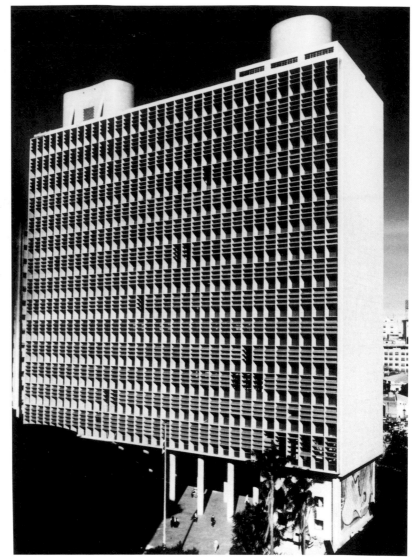

Niemeyer was appointed architect of the government centre. Costa's plan was simplistically schematic: it comprised two axes, one residential and the other honorific, the latter terminating at one end in the institutions of central government and at the other in those of the municipality. The central commercial and cultural facilities occurred at the intersection of the two axes—an abstract point in space. Perhaps for this reason, Brasilia seems to be a city without a centre. Niemeyer's government complex was developed in a brilliant, theatrical style that had all the facility but little of the vigour of his early work and seems diminished by the infinitude of the surrounding landscape.

Chandigarh and Brasilia are both middle-class cities from which lower-paid workers, necessary for the cities' economies, are excluded. In Chandigarh, though officially non-existent, such workers are

allowed to squat in the interstices of the city;[15] in Brasilia, they are banished to unplanned satellite towns from which they commute daily to work [**150**]. The two cities, despite their Modernist and universalist pretensions, owe much to the persistent traditions of their respective countries.

CIAM and Team X

After the Second World War the urban doctrine tacitly accepted by architects of the Modern Movement was that promoted by the Congrès Internationaux d'Architecture Moderne (CIAM). CIAM had been founded in 1928 as the international platform of the Modern Movement, which at that time was still opposed by large sections of the profession. Branches were quickly formed in the different countries of Western Europe and America. The first meeting was held at La Sarraz, Switzerland, in the chateau of Hélène de Mandrot, a wealthy patroness of the arts who had been a keen supporter of Art Deco until persuaded by Le Corbusier and Sigfried Giedion to take up the cause of modern architecture (and who was to commission a house from Le Corbusier at Le Pradet near Toulon the following year).[16] Four further meetings were to take place before the Second World War. Housing and urbanism soon became the main focus of discussion at these congresses. The early debates reflected the conflict between the leftists, who saw the movement as an arm of the socialist revolution, and the liberals for whom the aims of the movement were primarily cultural and technical. After 1930, when most of the leftists moved to Russia, CIAM became increasingly dominated by Le Corbusier and the general secretary of the organization, Sigfried Giedion.

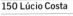

150 Lúcio Costa

Brasilia Masterplan, 1957
The plan shows the original concept entirely engulfed by unplanned satellite development.

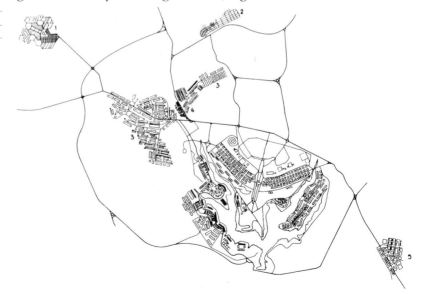

CIAM urban doctrine became enshrined in the 'Charte d'Athènes' ('Athens Charter'). Published by Le Corbusier in 1942, while France was under German occupation, this document was Le Corbusier's heavily edited version of the unpublished proceedings of the fourth CIAM meeting, which had taken place on the SS *Patris en route* from Marseilles to Athens in 1933. Most of the book was a restatement of commonplaces so general as to be acceptable to almost anyone, but it was strictly rationalistic and analytical in tone and was based on a classificatory system that divided the city into four watertight functions: living, working, recreation, and circulation. This Cartesian and formalistic approach to the complex problems of the city was unacceptable to younger members of CIAM who joined after the war.

In spite of the ideas reflected in the Athens Charter, Le Corbusier himself, as we have seen, had been moving steadily away from his earlier rationalism, although he had never fully disavowed it. It was this ambiguity that allowed him to remain an important figure for the post-war generation, who felt that his ideas had been trivialized by most of the second generation of modern architects—those born in the first decade of the twentieth century. A sort of alliance was formed between Le Corbusier and the young members, who began—with Le Corbusier's complicity—to play a dominant role in CIAM discussions from the ninth congress at Aix-en-Provence (1953) onwards. In 1954, after the Dutch 'Doorn Group' had explicitly repudiated the Athens Charter, the CIAM council entrusted an enlarged Doorn Group with the organization of the tenth CIAM meeting, to be held in Dubrovnik in 1956. At this point, the Doorn-based group started calling itself 'Team X'.[17]

Dubrovnik was to be the last meeting of CIAM in its old form. As a result of the irresolvable conflict that arose during the meeting between the middle and the younger generations, CIAM, which had clearly ceased to represent a monolithic Modern Movement, was dissolved and replaced by a new 'CIAM research group for social and visual relationships'. The first and only congress under the new aegis took place at Otterlo, Holland, in 1959. It was at this meeting that the British architects Alison and Peter Smithson (Alison 1928–93; Peter b. 1923) and the Dutch Aldo van Eyck (1918–99) attacked the Italian 'contextualists' (see page 187).

Team X was opposed not only to the Athens Charter but also to the New Monumentality. It is true that both wanted to reintroduce into modern architecture the experience of 'community', but while the New Monumentality aimed at creating the symbols of community within an urban framework that was still rationalistic, Team X wanted an architecture that was the expression of community. Whereas one accepted architecture as a mediated representation, the other sought a primal language in which form and meaning would be one. In attack-

151 Alison and Peter Smithson

Urban Reidentification, 1959
This drawing, similar in concept to Golden Lane, is an adaptation of Le Corbusier's *à redent* housing to local contingencies, giving an impression of organic growth.

ing the Athens Charter, the Smithsons claimed: 'Our hierarchy of associations is woven into a modified continuum representing the true complexity of human association . . . we are of the opinion that a hierarchy of human association should replace the functional hierarchy of the Charte d'Athènes.'[18] For them the key to community in the city did not lie in a separate 'city core' consisting of representative public buildings, but within the realm of dwelling itself, where a more immediate relationship between the nuclear family and the community could be established.

It is important to realize, however, that in spite of Team X's manifest opposition to Le Corbusier's rationalist urban theory, it was from Le Corbusier that they drew an important part of their inspiration. This was particularly true of the Smithsons and of Georges Candilis (1913–95), Alexis Josic (b. 1921), and Shadrach Woods (1923–73) (who had formed part of the design team working on the Marseilles Unité d'Habitation). The Smithsons' Golden Lane workers' housing competition project of 1952 was essentially a modification of Le Corbusier's *à redents* housing project for Ilôt no. 6 in Paris of 1936, with its supple adaptation to the contingencies of progressive slum clearance and its 'streets in the air' [151].

According to the Smithsons, infrastructure should do more than facilitate spontaneous community formation—it was needed to give 'coherence' to the urban structure: 'The aim of urbanism is comprehensibility, i.e. clarity of organization.'[19] In this, they seemed to acknowledge that there was a gap between spontaneous human association and its formal representation.[20] For the Smithsons, however, this problem could be overcome by means of a dualistic planning strategy that developed 'road and communication systems as the urban infrastructure . . . [using] the possibilities offered by "throw-away"

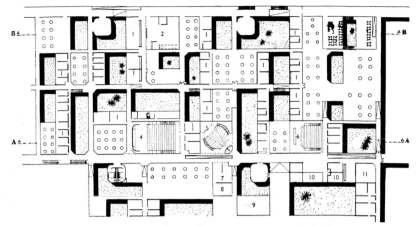

technology to create a new sort of environment with different cycles of change for the different functions'.[21]

These ideas were developed in a series of projects in the early 1960s. For example, the partnership of Candilis, Josic, and Woods developed schemes with circulation networks to which different functional volumes were randomly attached. These networks were either tree-like (as in the Toulouse-le-Mirail or Caen Hérouville projects, both 1961) or grid-like (as in the Free University of Berlin, 1964–79) [**152**]. The same concept of a defining network of circulation lay behind an earlier project: the Burgerweeshuis Orphanage in Amsterdam (1957–60) by Aldo van Eyck [**153**]. Anticipating the Free University in some respects, the orphanage is a 'mat' building, isomorphous with the space it occupies. But here, instead of a dialectic between a fixed infrastructure and a random infill, we find a dialectic between repeating external forms and interior spaces that move freely across their borders, creating—in Van Eyck's terminology—'in-between spaces' and 'thresholds' by which private and public spaces are connected.

Systems theory

By the end of the 1950s there existed two conceptual models for the kind of urban ideas being explored by Team X. The first model was a conflation of social theories based on the concept of 'community' (*Gemeinschaft*) and the psychology of perception.[22] These ideas often seem to lie behind the 'tree' and 'threshold' metaphors used by Woods, the Smithsons, and Van Eyck. But latent in much of the work of Team X there was another model that had been gaining ground in the human sciences since the Second World War: 'Systems theory'. This seeks to apply the common principle of self-regulation to machines, psychology, and society—in fact to all 'organized' wholes. Founding itself on the belief that instrumental technology now replaces all other

153 Aldo van Eyck

Burgerweeshuis Orphanage, 1957–60, Amsterdam
The plan shows how in this project a number of semi-autonomous 'houses' are unified within a tree-like circulation structure to form a community.

tendencies, it sees societies as information systems designed to maintain 'homeostasis'—decentralized wholes in which no one level is 'in control'.[23]

Though both models differ from rationalism in being organic and holistic (i.e. they cannot be mechanically broken down into separate parts), they are nonetheless in conflict with each other. The first looks back to the lost 'wholeness' of craft-based communities and cultures: the second looks forward to a capitalist world of open structures within which democracy, individualism, commodification, and an ethos of consumption are unimpeded by any a priori set of cultural codes. That this contradiction may have affected the Smithsons never to be fully

resolved seems to be reflected in the somewhat indecisive quality of their later work.

Aspects of Systems theory, particularly cybernetics, found their way into architectural discourse in the late 1950s. Swedish and Dutch Structuralism and the Megastructure movement all saw them as applicable to the complex problems of design in modern mass society. A 'cybernetic', self-regulating element was introduced into the way cities and large buildings were conceptualized. Instead of users being presented with predetermined spatial patterns, they were now—at least in theory—offered the means to alter their own micro-environment and decide their own patterns of behaviour.

Dutch Structuralism

In 1952 the Dutch architect Wim van Bodegraven underlined the need for architects to create a structure of forms that could change with time yet retain its coherence and 'meaning'.[24] This demand, as well as the example of Van Eyck's orphanage with its superimposition of centralized order and local freedom, were the inspiration behind a new tendency in Holland known as 'Structuralism'. This was initiated by Piet Blom (b. 1934) and Joop van Stigt in their 1962 Prix de Rome design for a 'Village of Children', in which the combination of order and flexibility, centrality and dispersal, was achieved in terms of a prefabricated system which allowed identical, 'recognizable' units to be combined according to a set of rules [**154**]. This basic idea was further developed by Herman Herzberger (b. 1932) and others in Holland, where its application became rather widespread in the 1960s and 1970s.[25]

154 Piet Blom and Joop van Stigt

Village of Children, 1962
In this opening salvo of Dutch Structuralism, Van Eyck's concept of additive 'houses' forming a higher-order community is systematized in three dimensions.

Megastructures

The Megastructural movement, which was contemporaneous with Dutch Structuralism, was not concerned with fixed, recognizable units. It was posited on a built environment without cultural norms and in a continuous state of flux. In a publication of 1964, the architect Fumihiko Maki (b. 1928), one of the original members of the Japanese Metabolists, distinguished between three types of what he called 'collective form': firstly, Compositional form—in which there is a fixed relation between different pre-formed buildings (this is the classical way of achieving collective form and includes the civic centre at St. Dié by Le Corbusier and that of Brasilia by Niemeyer); secondly, Megastructural form—a large frame in which all the functions of a city are housed (this involves the coexistence of structures with different rates of obsolescence); and thirdly, Group form—an additive collection of typologically similar building units (characteristic of 'unplanned' vernacular villages).[26]

Within this broad classification, 'Megastructural form' presents an array of different approaches. A very broad distinction can be made between projects which stress the long-term elements and those which stress the variable elements—a matter of emphasis, since examples of flexible and fixed elements occur in both groups. Within the first category the Japanese Metabolists and the British Archigram will be discussed.

Metabolism and Archigram

The Metabolists emerged at the World Design Conference in Tokyo of 1960, simultaneously with the publication of the Tokyo Bay Project by Kenzo Tange (b. 1913). In describing this project, Tange used words with biological connotations such as 'cell' and 'metabolism'[27] and he later claimed that the project was a breakthrough from 'functionalism' to a 'structural approach',[28] suggesting that he was aware of at least some aspects of Systems theory. Tange's project proposed the construction of a new city of 10 million people over the water in Tokyo Bay as a solution to the acute problem of urban congestion in Tokyo. The new city was centred around a double transport spine which housed all the public buildings and to which were attached extendible secondary spines of housing. Tange had worked in Le Corbusier's atelier, and the plan resembled that of the Ville Radieuse in its overall structure. But it differed from the Ville Radieuse in its total detachment from any natural terrain and in its randomized, abacus-like housing units [155]. In two other projects—Cities in the Air (1959) by Kiyonori Kikutake (b. 1928), also proposed for Tokyo Bay, and the Joint Core Stem

155 Kenzo Tange (left)
Tokyo Bay Project, 1960
Like the Ville Radieuse, this project consists of a spine of public buildings flanked by housing able to expand laterally. But where the pattern of housing is predetermined in Le Corbusier's scheme, here it is shown as unpredictable. Only the macro-structure is controlled. The micro-structure is self-regulating.

156 Arata Isozaki (above)
Joint Core Stem system, 1960
In this project a quasi-molecular pattern is given monumental scale.

proposal (1960) by Arata Isozaki (b. 1931)—there is a complete break with Corbusian precedent. In both, repeating series of multi-storey cylindrical nodes form the infrastructure, either standing alone or connected by deep lattice beams which contain housing [**156**].[29]

In the Metabolist projects, Utopian and pragmatic aspects are not clearly differentiated, which seems to be a general characteristic of Japanese Modernism. The work of the British Archigram group, on the contrary, was unashamedly Utopian and apocalyptic in its imagery. The group was founded by Peter Cook (b. 1936) in 1961 and its internationally distributed broadsheets helped to consolidate the Megastructural movement's international self-image. The rich iconography of projects such as Plug-in City (1964) was derived from many sources, including space comics, popular science fiction, Pop Art, and the technology of oil refineries and underwater research, as well as from such Metabolist projects as Kikutake's cylindrical towers. The use of ready-made and popular images was a deliberate assault on architecture as a conventionalized, 'upper-class' discipline—an invasion of 'low art' into architecture's hallowed precincts, especially those of the Modern Movement itself. In their almost obsessive elaboration of detail, in the frank eclecticism of their imagery, and in their presentation of projects from the outside, Archigram's drawings bear a certain resemblance to those of Sant'Elia's Città Nuova (see pages 103–5). But there is a pervasive irony in the work that seems carefully designed to prevent the technological environment it conjures up from becoming too menacing [**157**].[30]

Homo Ludens

The projects that fall within the second category of Megastructural form are primarily concerned with the ability of cybernetic machines

157 Archigram

Plug-in City, 1964

In this project eclectic typologies are interconnected in an endless web-like structure.

to make it possible for a built environment to be self-regulating, in other words to adapt to the changing desires of the human communities that inhabit it. This idea is implicit in Archigram and Metabolism, but in the work of Cedric Price (b. 1934), Yona Friedman (b. 1923), Michael Webb (b. 1927), and Victor E. Nieuwenhuys, known as Constant (b. 1920), it becomes the central issue. For all these designers, the leading idea is that of 'play'. According to Constant, speaking of his New Babylon (1957–70): 'The environment of Homo Ludens ('man at play') has first of all to be flexible, changeable, making possible any change of place or mood, any mode of behaviour.'[31]

Cedric Price's Fun Palace (1961)—commissioned by the impresario Joan Littlewood and designed in collaboration with the structural engineer Frank Newby and the cybernetics expert Gordon Pask—was aborted due to lack of funds, but only after most of the technical details had been prepared. Michael Webb's Sin Centre (1957–62) represents the seductive image of an organic structure in a state of pulsating desire. Yona Friedman, in his impressionistic drawings for l'Urbanisme Spatiale (1960–62), proposed—with a complete lack of technical detail—a multi-storey metal space-frame suspended high above Paris in which 'the usable volumes occupy the voids of [the] infrastructure and their arrangement follows the will of the people' [**158**].[32]

Among Megastructuralists the work of Constant is unique in its conscious connections with the early twentieth-century avant-gardes—Futurism, Constructivism, and De Stijl. A member of the COBRA group of painters, Constant joined Guy Debord's Situationist International in 1957.[33] It was in this context that he began the series of models and drawings depicting the city of New Babylon (the name was suggested by Debord)—a series that he continued for another ten years after his break with Debord in 1960.[34] New Babylon sets out to

158 Yona Friedman
L'Urbanisme Spatiale, 1960–2
A seven-storey open structure of unconvincing lightness—here shown against the backdrop of Manhattan—hovers above an uninterrupted ground level reserved for transport and parks.

159 Constant

New Babylon (1959–): view of New Babylonian Sectors, 1971

Constant's representations are less picturesque than those of Archigram or Friedman and give a more ad hoc and more uncompromising image of a totally mechanized spatial world.

give architectural form to the Situationist concept of *dérive* (drifting) and of the 'psycho–geographical' mapping of the city. Its main concepts can be traced back to a 1953 essay (published in 1958) entitled 'Formulary for a New Urbanism', by Lettrist International member Gilles Ivain (pseudonym for Ivan Chtchegloff).[35]

Constant's city [**143** (see page 208), **159**] is based on a long-term prognosis of modern society. His writings predict a world in which nature will have been totally superseded by technology, fixed communities by nomadic flows, work by leisure. In his city, production and mechanical transportation (which are said to have destroyed social life in existing cities) occur at ground level, while all social life, now free to develop without any impediment, takes place within a vast structure raised on *pilotis*. This structure, which forms a network that will eventually cover the entire globe, is a continuous multi-storey loft space containing all living and social functions, which will be continuously rebuilt by the population, aided by cybernetic machines. The permanent structure, like that of Le Corbusier's Algiers viaduct, is a series of fixed floorplates constituting the 'ground levels' of the city (unlike Cedric Price's Fun Palace where the floors are mobile). The population will migrate at will from one part of the city to another and communities will continually form and reform. Since work has been abolished, life will be spent in creative social interaction and imaginative play in an environment that has been completely aestheticized. Contrary to Constant's avowed intentions, the dominant impression of this aesthetic Utopia is one of boredom and claustrophobia. It is like an endless shopping mall without exit signs. Moreover, while social life is in a state of constant agitation, economics and government seem, like

industrial production, to have vanished into a state of automated perfection. It pictures a lobotomized world from which power and conflict have been eradicated.

Whether Megastructures emphasize a relatively fixed infrastructure or its self-regulating, responsive infill, they are all predicated on a dominant idea—that of the city as an open web or network, the contents of which can develop according to an internal dynamic. In contrast to the traditional Cartesian schema promoted by the Athens Charter, according to which the city consists of a closed hierarchy of discrete parts controlled by a centre, the Megastructural city is presented as an indivisible, organic, self-regulating whole. Problems seem to arise when this abstract concept is hypostasized and given form as an architectural image. The idea immediately takes on the clothing of a Utopia or a dystopia, depending on whether the hidden mechanism of the system is read as benign or sinister. It is all too easy to see Constant's New Babylon, for example, as an allegory for a post-industrial, capitalist world, in which an invisible network, though able to maintain and reproduce itself efficiently, is no longer guided by any rational telos.

Pax Americana: Architecture in America 1945–65

12

The defining moment for the introduction of the Modern Movement into America is usually seen to have been the exhibition at the New York Museum of Modern Art (MoMA) of 1932 and the accompanying book, *The International Style*, by Philip Johnson and Henry Russell Hitchcock. This book presented the Modern Movement as an incident in the evolution of style, and downplayed its progressive social content. The explanation for this can probably be found in the different cultural and political conditions prevailing in America and Europe at the time.

In Europe, the period between 1910 and 1930 was one of unprece dented social and cultural upheaval. Sweeping social reforms were being initiated by liberal governments, particularly in the realm of public housing. At the same time there was a powerful avant-garde movement in all the arts supported by a small but influential minority of the cultural elite. During the same period in America this parallelism between socially progressive ideas and the artistic avant-garde was largely lacking. Garden City settlements of the 1920s and 1930s, like Sunnyside Gardens in New York, Radburn in New Jersey, and Greenbelt near Washington, DC, all by Clarence Stein and Henry Wright, were still basically within the Arts and Crafts tradition. Projects derived from the 1920s European avant-garde, such as Stonorov and Kastner's Carl Mackley Houses in Philadelphia, were rare. Given the lack of commonly perceived connection between the avant-garde and social reform it is hardly surprising that Hitchcock and Johnson should have emphasized the purely stylistic aspects of the Modern Movement. Yet there were other voices; for example, in parallel with the 'International Style' exhibit, MoMA mounted an exhibition of social housing curated by the architectural critic Lewis Mumford (1895–1990) and his assistant Catherine Bauer, which included examples of the Arts and Crafts movement and Neue Sachlichkeit in Germany.

Lewis Mumford's writings in the 1920s still carried the imprint of William Morris's rejection of modern technology. But towards the end of the decade he came increasingly under the influence of the optimistic evolutionism of the Scottish urbanist Patrick Geddes. According to

160 Mies van der Rohe
Seagram Building, 1954–8, New York

Geddes, the present 'paleotechnic' phase in civilization would give way to a 'neotechnic' phase in which electricity would succeed coal as a source of power, and biological principles would replace mechanistic ones. After visiting the new housing in Weimar Germany in 1932, Mumford became convinced that such a neotechnic phase was in the making. His books *Technics and Civilization* (1934) and *The Culture of Cities* (1938) contained the essence of his new philosophy.[1]

Mumford's partner on the German tour was Catherine Bauer—a young writer whose visit to Ernst May's New Frankfurt two years earlier had, in her own words, transformed her 'from an aesthete into a housing reformer'. After turning the research material collected on the German tour into a book, *Modern Housing*, she became acknowledged as the foremost American expert on social housing. Bauer realized (unlike Mumford) that the success of social housing in America depended on grass-roots political action. In 1934, she became director of the Philadelphia Labor Housing Conference, founded by the architect Oskar Stonorov and John Edelman of the Hosiery Workers Union, whose purpose—ultimately abortive—was to create a labour-sponsored housing cooperative.

Mumford and Bauer's enthusiasm for the German housing movement must be seen against the background of the general openness to European social ideas that characterized the New Deal, as the Roosevelt administration searched for ways to alleviate the effects of the Depression. But the flow of ideas across the Atlantic in the inter-war period was not only from east to west. Especially during the early 1920s, European reformers, both in Western Europe and in Soviet Russia, envious of the high living standards of American workers, sought to harness American ideas to their various programmes of reconstruction and reform. American technology and production management were emulated by European industry and became important early points of reference for the Modern Movement.[2]

After the Second World War the situation changed radically. America emerged from the war as the dominant power and as the creditor of an impoverished and ruined Europe. Though some of the welfare programmes inaugurated by the New Deal remained intact, there was now unbounded confidence in American capitalism. Modern architecture became accepted worldwide by the architectural profession, but it was pursued under totally different political conditions in America and Europe. In the welfare state economies of post-war Europe modern architecture, whether orthodox or revisionist, became the norm for public projects. Within this ethos architects, working either in government or private offices, began to study problems of large-scale architectural production. In England in the late 1940s, for example, Hertfordshire County Council implemented a school programme based on a modular system of prefabrication.[3] In

Europe as a whole the many points of connection between modern architecture and the welfare state encouraged the experimental work of Team X and the Megastructuralist movements (see pages 217 and 223).

During the same period in America the most vital developments in modern architecture were in the private sector. Even public projects were financed by private agencies (albeit with federal or state help) and this tended to inhibit, though it did not altogether eliminate, the development of an ideology-driven Modernism. Precisely because of the different conditions of architectural production in America and Europe, however, the mutual influence was still strong. In Europe this influence was chiefly felt in two areas: the first, technology, reinforced the tradition of Modernist rationalism; the second, popular and rapidly changing cultural forms, ran counter to it.

In this chapter three major themes will be examined: firstly, the individual house—in particular, the Case Study House Program; secondly, corporate office building; and thirdly, critiques of Modernist rationalism, the pressures of consumerism, and the search for an architecture of public symbolism.

The Case Study House Program

In the 1920s in Western Europe, the individual house had played an important role in the birth of the Modern Movement. But in the two decades after the Second World War, European domestic building was largely confined to government housing programmes, which consisted mostly of high-rise apartments or row houses in the cities or the new towns. In America, by contrast, most new housing took the form of large suburban settlements, made necessary by the accelerated migration of white middle-class families from the cities to the outer suburbs and carried out by private developers.[4] At the same time there was a large market in one-off family houses, extending from the modest and pre-designed to the lavish and purpose-designed.

The stylistic tendencies within the housing market were the result of a complex interplay between various interested parties, including the loan agencies, the building industry, and professional and cultural pressure groups. Museums such as the Museum of Modern Art in New York and progressive journals such as *Architectural Record* tried to popularize modern house design, but with only modest success. In 1951 *Architectural Record*, commenting on a House of Ideas sponsored by the journal *House and Garden*, described it as a fusion of the 'crisp, clean lines of the International Style and the rambling openness of the Ranch House Style'. The design typified a 'no-nonsense' Modernism unencumbered by theory which gained some popularity in the United States in the 1950s.[5]

In this encounter between Modernism and the housing market, the

example of southern California played a crucial role. Ever since the early years of the twentieth century, with such buildings as the Gamble House by Greene and Greene (1907–8) and Dodge House by Irving Gill (1914–16), Los Angeles had shown itself to be receptive to an innovative domestic architecture. This tradition had been continued in the 1920s with the Los Angeles houses of Frank Lloyd Wright and the work of Austrian immigrants Rudolph Schindler (1887–1953) and Richard Neutra (1892–1970)—for example, the justly admired houses that each of them built for Dr Phillip Lovell (1923–5 and 1927–9 respectively).

It was in Los Angeles after the Second World War that a vigorous attempt was made to influence the more expensive end of the post-war house market in the direction of modern architecture: the Case Study House Program. This was initiated by John Entenza, an amateur of modern art and architecture who became owner–editor of the magazine *Arts and Architecture* in 1938, turning it into a mouthpiece of the avant-garde. In the July issue of 1944 Entenza—together with photographer and graphic artist Herbert Matter and architects and designers Ray and Charles Eames (1912–88 and 1907–78), Eero Saarinen (1910–61), and Richard Buckminster Fuller (1895–1983)—published a manifesto calling for the application of wartime technology to the post-war housing problem. The montages by Herbert Matter announcing the manifesto showed a familiarity with Futurist and Constructivist graphics, but they placed a new emphasis on the analogy between machines, the human nervous system, and molecular structures. The manifesto recast Bauhaus and Corbusian ideology in terms of post-war American technology. In defining the principles on which the post-war house should be based, it declared:

The house is an instrument of service. Degrees of service are real and can be measured. They are not dependent on taste. The house should not assert itself by its architectural design. In fact, the better integrated the services of the house become, the less one is apt to be conscious of the physical way in which it has been done. The kitchen, bathroom, bedroom, utilities, and storage will profit most by an industrialized system of prefabrication. In the living–recreational areas variation becomes a valid personal preference. A designer must know what the house must supply to meet the physiological and psychological needs of the members of the family.[6]

Optimistic and positivistic in tone, the manifesto promoted the belief that an art based on psychological laws and an architecture based on scientific method would lead to a unified culture in tune with the modern age. The aim of the manifesto was not social revolution but a revolution in aesthetics, starting with the enlightened bourgeoisie and filtering down to the masses. Nonetheless, the manifesto had a moral and social as well as an aesthetic agenda: the particular aesthetic it pro-

moted was one of transparency and 'authenticity', inseparable, it was thought, from the ideals of a rational and just social order. Prefabrication techniques, combining standardization and choice, would make the new aesthetic principles available to everyone. Where it differed from the European Modern Movement and from social reformers like Lewis Mumford and Catherine Bauer was in its assumption that the uniform culture it envisaged was compatible with a market-based capitalism.

To carry out this ambitious agenda Entenza commissioned or adopted a series of suburban houses in southern California by Modernist architects, including among others William Wurster (1895–1973), Ralph Rapson (b. 1914), and Richard Neutra, in order to build up a 'case study' of the new domestic architecture. In spite of their differences these houses had many features in common, not all of which were derived from the theory presented in the manifesto. They were, for a start, nearly all of one storey with flat roofs. The plans were open and informal but tended to be bi-nuclear, the living rooms and bedrooms being remote from each other. The inside was opened up to the outside by means of large areas of glazing. A tendency towards picturesque dispersal was counteracted by the economic need for cubic simplicity. Nearly all the houses had unrendered brick fireplaces—a reassuring reference to the pre-industrial past. The layouts reflected a somewhat ritualized suburban life style—non-rational and conformist rather than rational and free as the theory claimed. Despite the use of forms connoting prefabrication and mechanization most of the houses were built of blockwork with wood framing, and the flexibility of the plans owed as much to traditional American building techniques as they did to new technology and materials.

Around 1950, the Case Study houses underwent a marked change, which first becomes noticeable in those by Raphael Soriano (1907–88), Craig Ellwood (1922–92), and Pierre Koenig (b. 1925) [161]. In these houses there was a new concentration on modular construction and prefabrication. The houses were thought of more as assembled systems than as 'designs' in the traditional sense. It became possible to talk of an architecture of steel and glass. Nearly all the houses now had steel frames and the structure and method of assembly became clearly visible while the plans became simpler and less picturesque. Discussing Craig Ellwood's House 17 of 1954–5, the Italian journal *Domus* wrote: 'In fact, we do not find here innovations in the scheme of composition, in the treatment of space, structure or materials, but solutions of details, perfections of equipment and materials, which make this architecture more profound and more concrete.'[7]

Two Case Study houses built between 1945 and 1949 stand somewhat apart from the other houses of the earlier phase, though they foreshadow the second phase in many ways: Case Study House 9, built

161 Pierre Koenig

Case Study House 21, 1958,
Los Angeles

This house, with its
panoramic view, unites inside
and outside space, private
life and the infinite–sublime.
Although largely
prefabricated, it is highly
site-specific.

for John Entenza, was designed by Charles Eames and Eero Saarinen, and House 8 was designed by Charles Eames and his wife Ray for their own use.[8] The two houses shared the same site in Pacific Palisades. Charles Eames and Eero Saarinen had met in 1937 when Eames was on a fellowship at Cranbrook Academy of Art, of which Eero's father Eliel was both designer and director. During the early 1940s they frequently collaborated, particularly in the design of moulded plywood furniture, in which Eames was an important pioneer. The Entenza House is a single-storey volume compressed within a square perimeter. Externally the house is enigmatically neutral; its qualities lie entirely in its interior, ingeniously calibrated to the needs of a bachelor–aesthete.

The Eames House is altogether more remarkable [**162**]. It is almost unique among case study houses in being organized on two storeys. It consists of a steel and glass cage with one long side built close up against a steep embankment and the other sides open to the undulating, eucalyptus-strewn site. Its proportions are roughly those of Le Corbusier's Maison Citrohan—both have a double-height living room at one end overlooked by a bedroom balcony—but in relation to the Maison Citrohan the Eames House is rotated through 90 degrees and the blank flank wall has become a front. Instead of being monolithic,

162 Charles and Ray Eames
Case Study House 8,
1945–9, Pacific Palisades
This house is assembled from standard industrial elements and is non-site-specific. Its light, nomadic quality relates it more to the ideas of Le Corbusier, Ginsburg, or Buckminster Fuller, than to the typical ground-hungry American house of the period.

like Le Corbusier's house, it is additive. Its slender steel frame is absorbed into the thickness of the skin. The anonymous grid of standard factory glazing, slightly reminiscent of the screen walls of a traditional Japanese house, conceals an interior of cluttered, sensuous, fetishistic objects—a far cry from the chilly rituals of the other Case Study houses. There is no doubt that the Eames House looks back to the Arts and Crafts tradition in certain ways. Its brilliance lies in the fact that it achieves its effects by the use of as-found factory components and without sentimentality.

The corporate office building

Perhaps the greatest single achievement of American architecture after the Second World War was the establishment of the modern corporate office building as a type, imitated all over the world. Skidmore, Owings, and Merrill (SOM) were the leaders of this development. Founded in Chicago in 1933 by Nathaniel Owings (1903–84) and Louis Skidmore (1897–1962), the firm came to prominence during the war with the commission to build the city of Oak Ridge in Tennessee for the Manhattan Project for the development of the atomic bomb. After the war, the firm grew into a huge multi-partner organization with

This was the first of SOM's
skyscraper office blocks. Its
curtain wall was widely
imitated throughout the
world.

offices in Chicago and New York and later in San Francisco and
Portland, Oregon.

The first high-rise office building by SOM was Lever House in
New York (1951–2) [163]. This was one of four American buildings
which were the first to realize Mies van der Rohe's and Le Corbusier's
pre-war visions of the glass skyscraper. The other three were: the
Equitable Life Assurance Building in Portland, Oregon (1944–7) by
Pietro Belluschi (1899–1994); the United Nations Secretariat in New
York (1947–50) by Wallace Harrison (1895–1981) with Le Corbusier as
consultant; and Lake Shore Drive Apartments, Chicago (1948–51) by
Mies van der Rohe.[9] To this list should be added the pre-war Ministry
of Education building in Rio de Janeiro (1936–45) by a team including
Lúcio Costa and Oscar Niemeyer, with Le Corbusier as consultant
(see page 216).

In its site organization Lever House is similar to, and probably
derived from, the Rio building.[10] It was the first building in Manhattan
to be set back from the plot boundary, though unlike the Rio building
the tower rises up from a three-storey perimeter courtyard block on
pilotis. But in its use of a uniform curtain wall on all surfaces it followed
a Miesian rather than a Corbusian prototype. From 1952, indeed, Mies
became the dominant influence on SOM. Due to the firm's decentral-
ized office organization and its somewhat empirical approach to
design, its work showed considerable variation in detail, but these vari-
ations occurred within a strict set of functional parameters: maximum
flexibility of spatial planning; maximum standardization of parts and
modular coordination of all systems;[11] air conditioning; fully glazed
and sealed curtain walls; all-day artificial lighting; and deep office
space.

The firm of SOM was a new phenomenon in the history of
Modernism. For the first time the anonymity that had been aimed at
by the rationalist wing of the Modern Movement appeared to have
been achieved. Thanks to technical and professional efficiency com-
bined with a simple and consistent aesthetic, SOM were able to marry
the ambitions of Modernist rationalism with those of advanced capi-
talism and corporate bureaucracy [164, 165]. In their work modern
architecture—or at least a convincing version of it—became normal-
ized within the political structures of the Cold War and the
'military–industrial complex'.

SOM may have been unique in its size and in the anonymity of its
organization but it was part of a general post-war expansion of corpo-
rate office building in which many architects took part. Among these
the work of Eero Saarinen is of particular interest. Eero was the partner
of his father Eliel until the latter's death in 1950, and he had inherited
from his father a belief in the high mission of the individual creative
architect. He also adhered to the Beaux-Arts maxim that a building's

form should express its character. This led him, in the design of the General Motors Technical Center in Warren, Michigan (1948–56) [166], which he took over on the death of his father, to develop an architecture that embraced and promoted GM's technical, stylistic, and corporate ideas. The design was highly inventive—for example, in its adaptation of the neoprene gasket from car to building design, in the 'luminous ceiling' of the dome of the sales hall, and in its use of bright, glazed-tile colour-coding on the gable walls of each department building. At the level of organization, the design both facilitated and represented GM's corporate policy of decentralized control and flexibility. A universal grid of 5 feet allowed for interchangeability of parts and flexibility of planning, while on the façades the module was endlessly repeated in the window mullions at the expense of any expression of structure. The office campus, grouped round an artificial lake, was designed to be seen from a moving car. Thus, a predisposition towards expressive functionalism inherited from his father's Jugendstil

165 Skidmore, Owings, and Merrill

Union Carbide Building, 1957–60, New York
In SOM's interiors, modular coordination is both the means and the meaning of the corporate office.

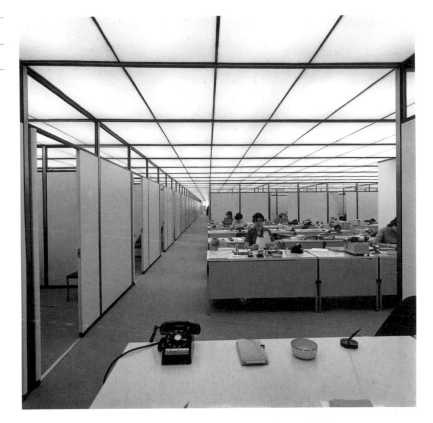

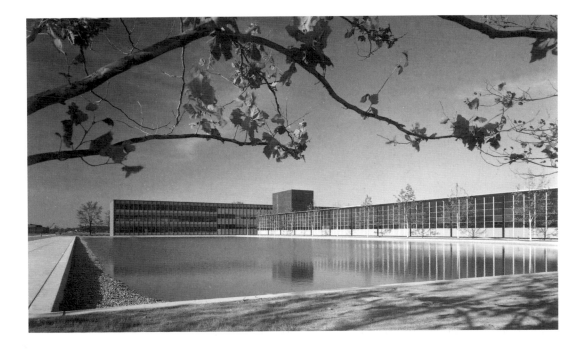

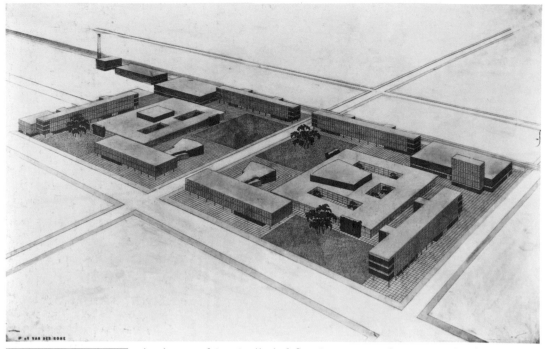

background ironically led Saarinen to produce a copybook design of rationalist anonymity.[12]

Mies van der Rohe in America

The American work of Mies van der Rohe occupies a position that is both central and peripheral to the development of the corporate office building: central in the sense that Mies's designs for the Illinois Institute of Technology in Chicago (1940–56) and Lake Shore Drive Apartments provided the basic formal syntax for the corporate buildings of SOM and Saarinen; peripheral in the sense that Mies maintained a certain detachment from the immediate needs of his clients. Mies's first scheme for the IIT campus was classical with two identical, symmetrically placed auditoria [**167**], continuing the compositional characteristics of his German work—for instance, the Silk Industry Offices in Krefeld of 1937. When it was discovered that the existing road grid could not be altered, Mies changed the layout, turning an articulated composition into an assemblage of rectangular pavilions in a way that conformed to the abstract conditions of the American grid [**168**]. All Mies's energy went into discovering and perfecting the types corresponding to what he saw as the 'will of the epoch', and once he had arrived at a typical solution he simply repeated it. Whereas in the work of SOM the same rational schema would often vary in detail from project to project, for Mies there was no difference between the personal solution and the type. A case in point is his use of

168 Mies van der Rohe

Alumni Hall, Illinois Institute of Technology, 1945–6

The abstract yet neoclassical severity of Mies's IIT pavilions had an enormous influence on American architecture in the 1950s, particularly that of the corporate office block and the work of SOM and Eero Saarinen.

I-beams in his curtain wall façades. First adopted in Lake Shore Drive Apartments, these elements—which among other functions provide stiffening for the window sections—read ambiguously as both mullions and columns, recalling the equally ambiguous vertical elements of Sullivan's Wainwright Building (see page 243) and Eliel Saarinen's *Chicago Tribune* offices. Mies's I-beam is an as-found element with definite structural connotations, but at the same time it is explicitly decorative, being welded to the surface of a pre-existent structure [**160** (see page 230), **169, 170**]. Mies claimed to be creating an anonymous vernacular and repudiated Le Corbusier's 'individualism',[13] but his minimal forms are still rhetorical and speak of the remnants of a high art tradition even as they reject any reconciliation between history and modernity.

Countercurrents

We must now look at some of the countercurrents that began to make themselves felt in the 1950s. These were active at very different levels

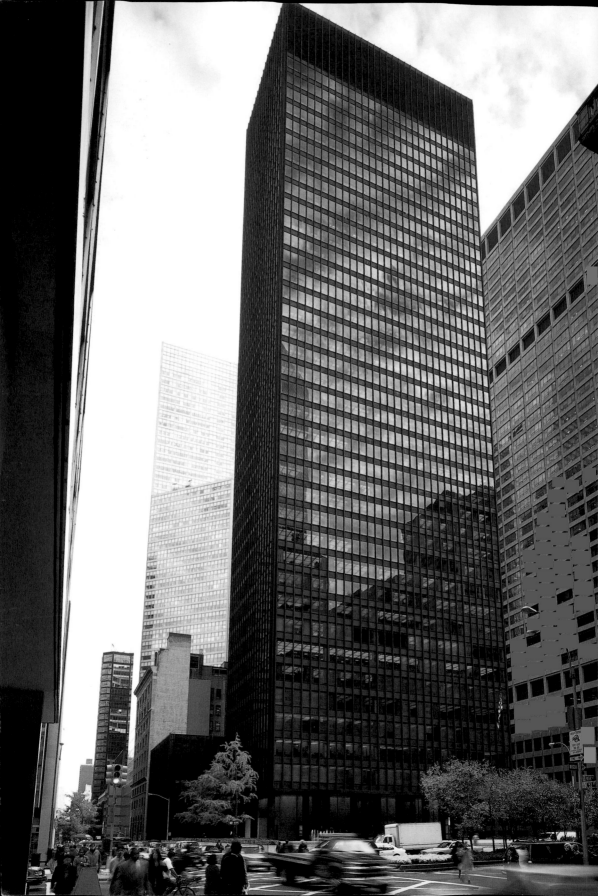

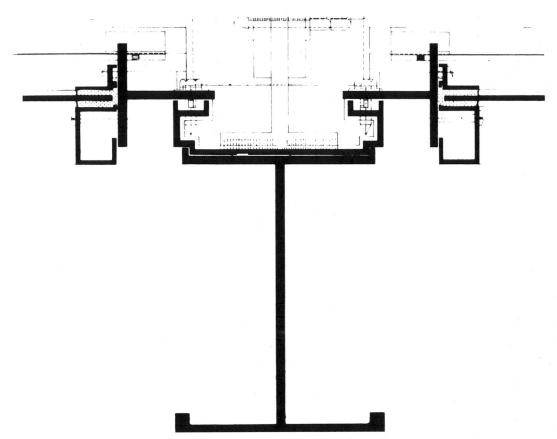

169 Mies van der Rohe (left)

Seagram Building, 1954–8, New York

The I-beam mullions create an ornamental surface that is quasi-structural—a treatment of the office façade that goes back to Sullivan's Wainwright Building. Note the illuminated ceiling grid, which extends the façade module into the body of the building.

170 Mies van der Rohe (above)

Seagram Building, 1954–8, New York

In this detail of the curtain wall the supplementary, ornamental nature of the I-beam mullion is clear.

and often pulled in opposite directions. Some were broad analyses of American society carried out by academic sociologists or journalists; others were attempts by designers or architects to correct what they saw as the weaknesses of Modernist artistic and architectural theory.

The critique of corporatism

Mies's carefully worked out idealist philosophy and his disdain for the trivia of everyday life in favour of a purified expression of the *Zeitgeist* coincided exactly with the worldly demands of corporate discipline—a discipline that was accepted by SOM uncritically and on its own terms. It was precisely this corporate discipline that was attacked by writers like David Riesman (*The Lonely Crowd*, 1950) and William H. Whyte (*The Organisation Man*, 1956), who saw the corporation as a dehumanized collective producing a new type of 'other-directed' character, nervously conforming to the opinions of (corporate) peers. These criticisms were markedly different from those of late-nineteenth-century German sociologists like Georg Simmel. Whereas for Simmel individualism (the blasé type) was a defensive mechanism developed to deal with the loss of community in an economy based on money, for

Reisman and Whyte individualism was a primary American virtue, threatened by corporate conformism.

The critique of corporatism was also mounted on a more political level. C. Wright Mills (*The Power Elite*, 1956) saw the signs of a new, insidious kind of totalitarianism in the very dispersal of power that was the essence of corporate capitalism—evident in the multiple links between the corporations, the military, and government. Mills's pessimism was not shared, however, by fellow sociologist Talcott Parsons, for whom the web-like structure of modern political power was symptomatic of a well-performing, self-regulating social system that necessarily resulted in the sacrifice of the individual to the organic whole (see Systems theory, page 220).

Beyond rationalism: desire and community

The Case Study houses and the corporate architecture of SOM can be seen to have represented a sort of ideal moment when post-war political and technical optimism in America coincided with the cultural philosophy of a normative Modernist architecture. But there were commercial and industrial currents that threatened this ideology. A challenge to the cultural assumptions of mainstream Modernism had already been laid down in the late 1920s when the General Motors Corporation, breaking with the Fordist tradition, adapted their production cycle to allow for different rates of obsolescence: a slow one for the chassis, following the laws of technical evolution; a fast one for the body, following those of fashion.[14]

The introduction of 'styling' into the automobile industry set the pace for a whole generation of American industrial designers like Norman Bel Geddes, Raymond Loewy, and Henry Dreyfus, who sought to reconcile the Bauhaus principles of 'good design' with the demands of the market. Art theorist and teacher Georgy Kepes recommended applying the principles of *Gestalt* psychology to advertising to counteract the formlessness of modern life.[15] Ernst Dichter in his book *The Strategy of Desire* (1960), spoke of the dual responsibility of the designer to understand the sociology and psychology of the public, and to uphold public taste.[16] However, once the market had been accepted as a player in the culture of modernity it was obvious that the Werkbund–Bauhaus ideal of universal norms of taste for the whole design field, from the commodity to the building, could not be sustained. This was abundantly clear to British Pop Artists such as Richard Hamilton who assimilated advertising to high art, making ironic use of the unconscious drives that champions of the Bauhaus tradition like Kepes sought to sublimate.

At the architectural end of the spectrum, there were attempts to reintroduce into architecture the monumentality outlawed by main-

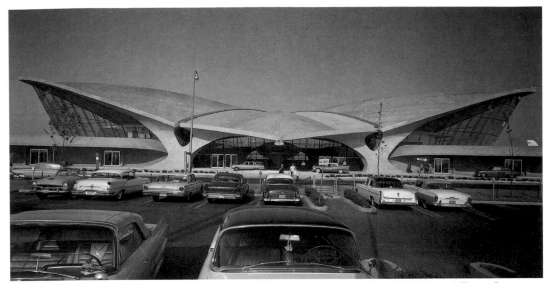

171 Eero Saarinen

TWA Terminal, JFK Airport, 1956–62, New York

In his later work Saarinen became increasingly Expressionist in his approach, attempting to capture the essential 'character' of each project.

172 Edward Durrell Stone

US Embassy, 1954, New Delhi, India

This work is representative of American neoclassicism of the 1950s.

stream rationalism. The corporate work of SOM and Eero Saarinen was clearly rationalist in spirit, yet this did not prevent them introducing 'symbolic' buildings at the appropriate moment, as in SOM's Expressionist chapel for the US Air Force Academy at Colorado Springs (1954–62). Indeed Saarinen became increasingly obsessed with the expression of the 'character' of each building. This can be seen in his auditorium and chapel at MIT (1950–5), in the dormitories at Yale University (1958–62), and in the TWA terminal at Idlewild (now JFK) Airport (1956–62) [**171**].

In the late 1950s many Modernist architects turned to neo-Palladianism, including TAC (Gropius's firm), Philip Johnson, John Johansen, Edward Durrell Stone [**172**], and Minoru Yamasaki. This often took the form of symmetrical plans and a 'Pompeian'[17] reading of

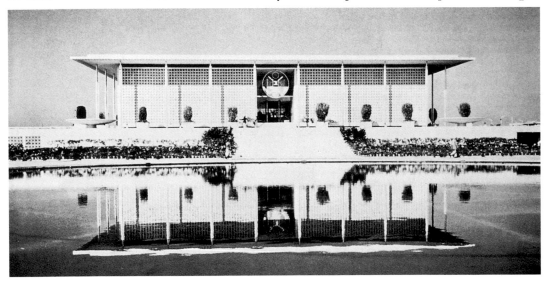

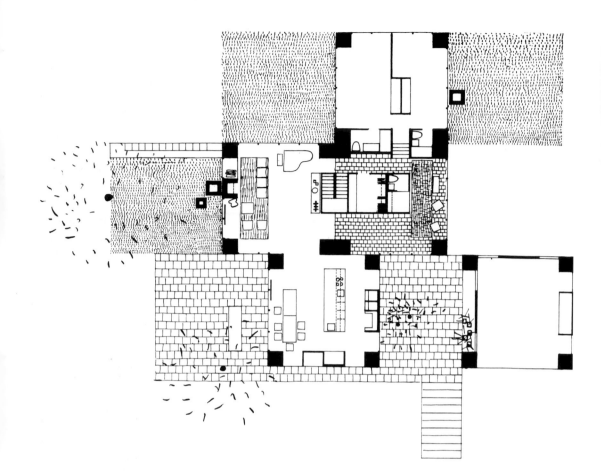

Modernist lightness and transparency—as in the many new American embassies that were springing up at that time in the capital cities of Europe and Asia.

Louis Kahn

In the work of Louis Kahn (1901–74) the critique of mainstream Modernism was both more subtle and more radical than that of the architects so far mentioned. Nonetheless, Kahn's work can best be approached in the context of the New Monumentality movement promoted by Sigfried Giedion, Josep Lluis Sert, and Kahn's mentor, George Howe.[18] From his early years as an architect Kahn was actively involved in the housing reform movement and spent the years from 1940 to 1947 as the chief designer in successive partnerships with George Howe and Oskar Stonorov, working on government housing projects. He was deeply sympathetic to the communitarian ideas of writers like Lewis Mumford, Paul and Percival Goodman, and Hannah Arendt, and shared their belief in the need for a civic architec-

ture that would inspire people with a sense of common purpose and democratic participation.

A few years after he started practising on his own in 1947, Kahn's work began to depart radically from the received Modernist tradition. In his new work there seems to have been a fusion of the ideas of Viollet-le-Duc and those of neoclassicism (traceable, in particular, to the writings of the early-nineteenth-century theoretician Quatremère de Quincy), both available to Kahn through the Beaux-Arts tradition in which he was formed. On the one hand he was drawn to Viollet's structural organicism. On the other hand he believed in the concept of unchanging forms or types.[19]

For Kahn, a convergence between the two traditions was suggested by the Platonic geometries found in nature, as demonstrated in the books of Ernst Haeckel and D'Arcy Wentworth Thompson.[20] A similar interest in these geometries was shown by Buckminster Fuller, Robert Le Ricolais (1897–1977), and Konrad Wachsmann (1901–80),

174 Louis Kahn

Jewish Community Center, 1954–9, Trenton

Here the structural aedicules are organized on binary grid. There are two kinds of space: primary (served) and secondary (servant). Partitions may occur only on grid lines and are optional, depending on distribution requirements. For extra-large spaces columns are omitted but the roof pattern remains constant.

175 Louis Kahn

Richards Medical Research
Laboratories, University of
Pennsylvania, 1957–65,
Philadelphia

Here the served–servant
principle is adapted to a
multi-storey building. It
proved difficult to reconcile
the demanding technical
requirements of the
laboratories with Kahn's
formal system.

whose polyhedral space-frame structures strongly influenced Kahn's architecture in the early 1950s (Kahn referred to space-frames as 'hollow stones').

Kahn's critique of Modernism started with a rejection of the 'free plan'. He believed that in uncoupling form from structure the free plan as variously interpreted by Mies van der Rohe and Le Corbusier had opened up a void that could only be filled by subjective intuition. 'Mies's sensitivities', he said, 'react to imposed structural order with little inspiration . . . Le Corbusier . . . passes through order impatiently and hurries to form'.[21] Kahn's breakthrough to a different ordering principle came with his Adler and DeVore house projects (1954–5) [**173**] and the Trenton Bath House (1957), where the aggregation of identical 'rooms' reduced architecture to its most primitive unit of meaning. In subsequent projects these units were organized in a number of ways: as close-packed agglomerations, as strings, as random clusters, or as small spaces grouped round a central space. The significant element is always

the room-space itself. As Kahn expressed it: 'Space made by a dome and then divided by walls is not the same space . . . a room should be a constructed entity or an ordered segment of a construction system.'[22]

Kahn's double allegiance to structural organicism and classicism— to a whole that has not yet appeared and a whole that has been lost—cuts across this generalized schema. The unbuilt project for a Jewish Community Center at Trenton (1954–9) [174] exhibits both these tendencies. A new arbitrary relation between form and function appears. Architectural forms no longer correspond to immutable causal relationships as they are supposed to do in functionalism. A binary grid is set up in which the only fixed hierarchy is that between positive (served) and negative (servant) spaces. Apart from this, any combination of functions can be inserted.

In the adaptation of an architectural programme to this a priori system a new tension arises between Platonic and circumstantial orders.[23] In the Richards Medical Research Laboratories at the University of Pennsylvania (1957–65) [175] Kahn had difficulty in reconciling a highly technical programme to the system.[24] In the Salk Institute for Biological Sciences in La Jolla (1959–65) he solved the problem by relegating the bulk of the programme to two enormous, flexible sheds and restricting symbolic expression to fixed administrative pavilions facing the plaza (there is an analogy here to the exhibition pavilions in the Chicago World's Fair).

At the other extreme lie projects like the First Unitarian Church in Rochester (1961) [176] and the National Assembly Building at Dhaka,

176 Louis Kahn

Plan, First Unitarian Church, 1961, Rochester, New York
In this building the secondary rooms are clustered according to empirical needs around the church hall. Kahn avoids strict classical symmetry.

Bangladesh (1962–83) [**177, 178**],[25] where secondary spaces are grouped round a central volume, as in Byzantine and centralized Renaissance churches. In the final version of the Rochester building, the symmetry is distorted by circumstantial, 'secular' pressures. But in the Dhaka Assembly the geometrical expression of unity is unremitting; nothing circumstantial disturbs the rigidly hieratic order. It is clear that for Kahn the Dhaka Assembly had taken on strong religious connotations. We no longer find the connection between democratic social practices and symbolic forms that were characteristic of his early civic designs.

From the very outset of the Modern Movement a fissure had opened up between two dominant and opposed concepts—organic expression

177 Louis Kahn
National Assembly Building, 1962–83, Dhaka
The Platonic volumes are punctured by geometrical openings that avoid stylistic reference. The building is monumental and hermetic, suggesting a religious rather than secular purpose.

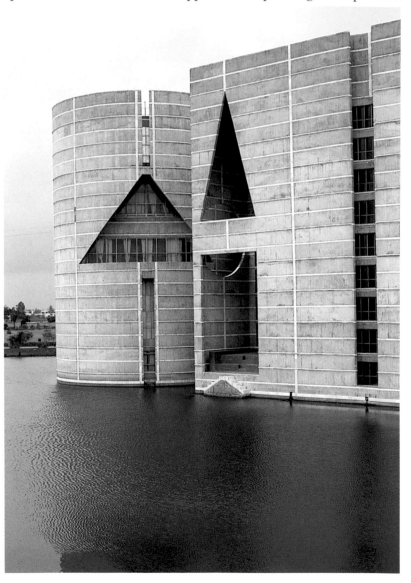

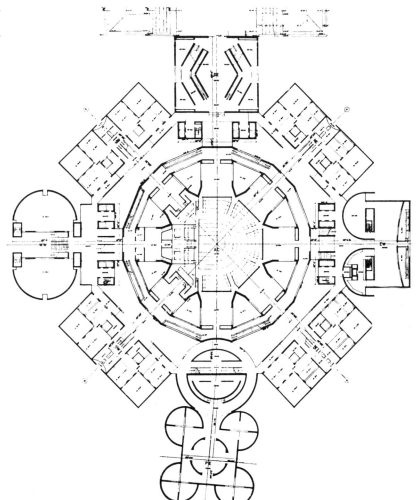

on the one hand and the normative and standardized on the other.
Adolf Behne's distinction between 'functionalism' and 'rationalism',
Le Corbusier's concept of the free plan, and the dislocation in Mies van
der Rohe's American phase between the regular building envelope and
its variable content, were merely particular, working formulations of a
more general problem of disjunction.

Louis Kahn, whether we see his work as derived from Viollet-le-
Duc or the classical tradition, started from the same problem, but
moved in a different direction. This direction was being explored at the
same time by Team X, and had been adumbrated by Le Corbusier in
his accentuation of each living cell in the Unité d'Habitation and other
post-war projects. For Kahn—going much further than Le Corbusier
in this direction—architecture only took on meaning when a unit of
structure coincided with a unit of habitable space. This made the free
plan inoperative and gave rise to a new problem: instead of being free to

develop independently, as they were according to the logic of the free plan, ideal and circumstantial orders were now locked in a dialectic, directing attention to the conflict between transcendent architectural values and the contingencies of the modern economy.

Louis Kahn belonged firmly to the Modernist tradition in at least one respect: he wanted to create an architecture that would embody a new politico-moral order. In his attempt to achieve this he arrived at a surprising new formulation of an old problem—how to achieve an architecture that would be absolutely new but at the same time would reaffirm timeless architectural truths.

The effect of this effort was to bring to a head and accelerate the existing crisis within the Modern Movement. Rational functionalism had seemed to take on a new lease of life in post-war America, but by the 1960s its principles seemed incapable of dealing with the web-like complexities of late capitalism. The Utopian promise of a new, unified, and universal architecture was becoming increasingly implausible. If there could still be said to be a 'spirit of the epoch', a *Zeitgeist*, it was now the self-contradictory one of pluralism. Modernism was to survive, but only after abandoning its totalizing claims and by a process of continual self-cancellation. Paradoxically, the work of Louis Kahn—anchored as it was in a belief in a transcendent order—was one of the chief propelling agents in this emerging regime of uncertainty.

Notes

Chapter 1. Art Nouveau 1890–1910

1. Debora L. Silverman, *Art Nouveau in Fin-de-Siècle France: Politics, Psychology and Style* (Berkeley and Los Angeles, 1989), 172–85.

2. François Loyer, 'France: Viollet-le-Duc to Tony Garnier', in Frank Russell (ed.), *Art Nouveau Architecture* (London, 1979), 103.

3. For example, Eugènia W. Herbert, *The Artist and Social Reform: France and Belgium, 1885–1898* (New Haven, 1961), 74–8; H. Stuart Hughes, *Consciousness and Society: the Reorientation of European Social Thought 1890–1930* (New York, 1961, 1977), 33–66; David Lindenfeld, *The Transformation of Positivism: Alexis Meinong and European Thought 1880–1920* (Berkeley and Los Angeles, 1980), 7–8.

4. Herbert, *The Artist and Social Reform*, 75.

5. Ibid., 77.

6. Jean-Paul Bouillon, *Art Nouveau 1870–1914* (New York, 1985), 11–31.

7. Ibid., 26.

8. Wolfgang Herrmann, *Gottfried Semper: in Search of Architecture* (Cambridge, Mass., 1984), 139–52.

9. Bouillon, *Art Nouveau 1870–1914*, 223.

10. See Amy Fumiko Ogato, *Cottages and Crafts in Fin-de-Siècle Belgium* (PhD dissertation, Princeton University, 1996).

11. Maurice Culot, 'Belgium, Red Steel and Blue Aesthetic', in Russell, *Art Nouveau Architecture*, 79, 96.

12. Victor Horta, quoted in Culot, ibid., 99.

13. Carl Friedrich von Rumohr, 1785–1843.

14. Richard Padovan, 'Holland', in Russell, *Art Nouveau Architecture*, 138.

15. Luís Domènech i Montaner, quoted in Timothy Benton, 'Spain: Modernismo in Catalonia', in Russell, *Art Nouveau Architecture*, 56.

16. The catenary had already been studied in France and England in the late eighteenth century. In Germany, Heinrich Hübsch (1795–1863) proposed the catenary as a method of determining the forces in vaulted buildings; Georg Germann, *The Gothic Revival in Europe and Britain: Sources, Influences and Ideas* (London, 1972), 175–6.

17. Alois Riegl, *Die Spatromanische Kunstindustrie* (Vienna, 1901), trans. R. Winkes, *Late Roman Art Industry* (Rome, 1985), and *Stilfragen* (Berlin, 1893), trans. *Problems of Style: Foundations of a History of Ornament* (Princeton, 1992).

18. Akos Moravánszky, *Competing Visions: Aesthetic Invention and Social Imagination in Central European Architecture, 1867–1918* (Cambridge, Mass., 1998), chapter 4, 'Art Nouveau'.

19. Ibid., chapter 2, 'The City as Political Monument'.

20. Max Eisler, quoted in Ezio Godoli, 'Austria', in Russell, *Art Nouveau Architecture*, 248.

21. Nancy Troy, *The Decorative Arts in Fin-de-Siècle France: Art Nouveau to Le Corbusier* (New Haven, 1991), 52–102.

Chapter 2. Organicism versus Classicism: Chicago 1890–1910

1. William H. Jordy, *American Buildings and their Architects: Progressive and Academic Ideals at the Turn of the Century* (Anchor Books, New York, 1972), chapter 1, 'Masonry Block and Metal Skeleton', 28–57.

2. Michael J. Lewis, 'Rundbogenstil', in Jane Turner (ed.), *The Dictionary of Art* (London, 1996).

3. For an analysis of the formal evolution of the Chicago office façade, see Heinrich Klotz, 'The Chicago Multi-storey as a Design Problem', in John Zukovsky (ed.), *Chicago Architecture* (Art Institute of Chicago, 1987).

4. Donald Drew Egbert, 'The Idea of Organic Expression in American Architecture', in Stow Persons, *Evolutionary Thought in America* (New Haven, 1950), 336–97.

5. H. W. Janson, *Form Follows Function—or Does It?* (Maarssen, Netherlands, 1982).

6. Dankmar Adler, quoted in Narciso Menocal, *Architecture as Nature: the Transcendentalist Idea of Louis Sullivan* (University of Wisconsin, Madison, 1981), 43.

7. Henry Adams, *The Education of Henry Adams: An Autobiography* (1918), quoted in Mario Manieri-Elia, 'Toward the "Imperial City": Daniel Burnham and the City Beautiful Movement', in Giorgio Ciucci, Francesco Dal Co, Mario Manieri-Elia and Manfredo Tafuri, *The American City: From the Civil War to the New Deal* (Cambridge, Mass., 1979), 39.

8. For a detailed account of the World's Fair see Manieri-Elia, ibid., 8–46.

9. Fiske Kimball, *American Architecture* (New York, 1928), 168; Manieri-Elia, ibid.

10. For the Chicago plan and the City Beautiful movement see Manieri-Elia, ibid., 46–104.

11. Charles W. Eliot, 'The New Plan of Chicago', quoted in Manieri-Elia, ibid., 101.

12. Francesco Dal Co, 'From Parks to the Region', in *The American City*, 200–4; for the re-emergence of this idea in the 1920s, see Jeffry Herf, *Reactionary Modernism: Technology, Culture and Politics in Weimar and the Third Reich* (Cambridge, Mass., 1984); Manieri-Elia, ibid.

13. Gwendolyn Wright, *Building the American Dream: Moralism and the Model Home* (Chicago, 1980), 160; Manieri-Elia, ibid., 91.

14. Gwendolyn Wright, *Building the American Dream*, chapter 4, 'The Homelike World'; Manieri-Elia, ibid.

15. H. Allen Brooks, *The Prairie School: Frank Lloyd Wright and his Mid-west Contemporaries* (Toronto, 1972), 31, 64, 65.

16. *Inland Architect and News Record*, vol. 37, no. 5, June 1901, 34, 35; Brooks, *The Prairie School*, 39, 41; David Van Zanten, 'Chicago in Architectural History', in Elizabeth Blair MacDougall (ed.), *The Architectural Historian in America* (National Gallery of Art, Washington, DC, 1990).

17. These were summarized as: Composition, Transition, Subordination, Repetition, and Symmetry; Arthur Wesley Dow, *Composition* (New York, 1899), 17.

18. Reyner Banham, *Theory and Design in the First Machine Age* (London and New York, 1960), chapter 3.

19. Frank Lloyd Wright, 'The Art and Craft of the Machine' (catalogue of the 14th Annual Exhibition of the Chicago Architectural Club, 1901), reprinted in Bruce Brooks Pfeiffer (ed.), *Frank Lloyd Wright: Collected Writings*, vol. 1 (New York, 1992).

20. Giorgio Ciucci, 'The City in Agrarian Ideology and Frank Lloyd Wright: Origins and Development of Broad Acres', in *The American City*, 304; Leonard K. Eaton, *Two Chicago Architects and their Clients: Frank Lloyd Wright and Howard Van Doren Shaw* (New York, 1969), demonstrates that, while Howard van Doren Shaw's clients were members of the establishment and connected with old money, Wright's were mostly 'outsiders'. This would appear to be consistent with their respective architectural tastes.

Chapter 3. Culture and Industry: Germany 1907–14

1. The English equivalent of *Volk* is 'folk', but where its resonances in English are merely quaint, in German it is more or less the equivalent of 'Germanness', particularly as distinct from French civilization—a connotation that goes back to the dawn of German national consciousness in the late eighteenth century.

2. Joan Campbell, *The German Werkbund: the Politics of Reform in the Applied Arts* (Princeton, 1978), 24.

3. Friedrich Naumann, quoted in Stanford Anderson, 'Peter Behrens and the Cultural Policy of Historial Determinism', in *Oppositions*, no. 11, Winter, 77.

4. Fritz Schumacher, quoted in Anderson, ibid., 66.

5. Campbell, *The German Werkbund*, 38–56.

6. Marcel Franciscono, *Walter Gropius and the Creation of the Bauhaus in Weimar* (Urbana, London, 1971), 32, n. 45.

7. The word *Gestalt* is used here in the sense given by Wolfgang Köhler, in *Gestalt Psychology* (New York, 1961), 177–8: 'In the German Language—at least since Goethe—the noun "Gestalt" has two meanings: besides the connotation of "shape" or "form" as a property of things, it has the meaning of a concrete, individual, and characteristic entity, existing as something detached and having a shape or form as one of its attributes.'

8. For a discussion of German formalist aesthetics, see Harry Francis Mallgrave and Eleftherios Ikonomu, *Empathy, Form and Space: Problems of German Aesthetics 1873–1893* (Los Angeles, 1994), Introduction.

9. For a discussion of 'type' as a concept in late-eighteenth-century French neoclassical discourse, see Anthony Vidler, 'The idea of Type: the Transformation of the Academic Ideal', *Oppositions*, 8, Spring 1977. Though today it is hardly possible to discuss the notion of type without reference to this French tradition, Muthesius's awareness of it can only have been indirect at best—probably via Durand and Schinkel.

10. Hermann Muthesius, proclamation at the Werkbund Congress at Cologne, 1914, quoted in Ulrich Conrads, *Programs and Manifestos of 20th-Century Architecture* (Cambridge, Mass., 1971), 28.

11. Frederick J. Schwartz, *The Werkbund: Design Theory and Mass Culture before the First World War* (New Haven, 1996), 106–20.

12. Ibid., 164–76.

13. Ibid., 151–61.

14. According to the critic Franz Servaes, writing in 1905, 'The curtailment of the personality [is] the first commandment of style'; quoted in Schwartz, ibid., 162.

15. See anon., 'Recent English Domestic Work' in the special issue of *The Architectural Review*, vol. 5, Mervyn E. Macartney (ed.) (London, 1912); and Horace Field and Michael Bunney, *English Domestic Architecture of the XVII and XVIII Centuries* (Cleveland, Ohio, 1905).

16. Manfredo Tafuri and Francesco Dal Co, *Modern Architecture* (London, 1980), 96.

17. Peter Behrens, quoted in Franciscono, *Walter Gropius and the Creation of the Bauhaus*, 32.

18. Franciscono, *Walter Gropius and the Creation of the Bauhaus*, 30.

19. Schwartz, *The Werkbund*, 206.

20. Georg Simmel, 'The Metropolis and Mental Life', published as 'Die Grosstadt und das Geistesleben' in *Die Grosstadt, Jahrbuck der Gehe-Stiftung* 9, 1903. Published in English in Donald Levine (ed.), *Georg Simmel: On Individuality and Social Forms* (Chicago, 1971), 324–39.

21. Walter Gropius, quoted in Reyner Banham, *Theory and Design in the First Machine Age* (London and New York, 1960), 198.

22. Adolf Behne, 'Kunst, Handwerk, Technik', *Die Neue Rundschau*, 33, no. 10, 1922, trans. 'Art, Craft, Technology', in Francesco Dal Co, *Figures of Architecture and Thought* (New York, 1990), 324–8.

23. Emil Rathenau's son, Walter, was a pupil of Wilhelm Dilthey and Hermann Helmholtz and believed passionately in the power of technology to improve society.

24. Tafuri and Dal Co, *Modern Architecture*, 98.

Chapter 4. The Urn and the Chamberpot: Adolf Loos 1900–30

1. For Kraus see Peter Demetz, 'Introduction', and Walter Benjamin, 'Karl Kraus', in Peter Demetz (ed.), *Reflections: Walter Benjamin* (New York, 1978).

2. Loos later published two collections of essays: *Ins Leere Gesprochen*, Vienna, 1932, trans. *Spoken into the Void* (Cambridge, Mass., 1982), consisting chiefly of articles which appeared in the *Neue Freie Presse* on the occasion of the Vienna Jubilee exhibition of 1898; and *Trotzdem* (Innsbruck, 1931) (not translated into English), containing essays written between

1900 and 1930 (including a selection from *Das Andere*).

3. Adolf Loos, 'Ornament and Education', 1924, in *Trotzdem*.

4. Adolf Loos, 'The Superfluous', 1908, in *Trotzdem*.

5. Ibid.

6. Adolf Loos, 'Cultural Degeneration', 1908, in *Trotzdem*.

7. Adolf Loos, 'Architecture', 1909, in *Trotzdem*.

8. Loos, 'Ornament and Education'.

9. Vitruvius, *The Ten Books on Architecture* (New York, 1960), book 1, chapter 1.

10. Karl Kraus, *Nachts* (Leipzig, 1918), 290, quoted in Massimo Cacciari, *Architecture and Nihilism: on the Philosophy of Modern Architecture* (New Haven, 1993), chapter 10, 147.

11. Loos, 'Ornament and Education'.

12. Karl Kraus, *Die Fackel*, December 1913, 389–90.

13. Cacciari, *Architecture and Nihilism*, chapter 11, 151. The phrase refers to Wittgenstein's concept of 'language games' in the *Philosophical Investigations*.

14. Adolf Loos, 'Potemkin City', 1898, in *Spoken into the Void*.

15. Loos explicitly connected this use of materials with Gottfried Semper's theory of *Bekleidung*.

16. James D. Kornwolf, *M. H. Baillie Scott and the Arts and Crafts Movement* (Baltimore, 1972), 170. Kornwolf, 208, n. 35, convincingly argues that Baillie Scott was the main source for Loos's Arts and Crafts related interiors, not Richardson, as stated by Ludwig Münz and Gustav Künstler in *Adolf Loos, Pioneer of Modern Architecture* (Vienna, 1964; London, 1966), 201.

17. Münz and Künstler, *Adolf Loos*, 39.

18. Eugène Viollet-le-Duc, *Entretiens sur l'Architecture* (Paris 1863–71), trans. *Discourses on Architecture* (New York 1889, 1959), chapter 19, 'Domestic Architecture—Country Houses'.

19. Adolf Loos, 'Joseph Veillich', 1929, in *Trotzdem*.

20. Beatriz Colomina, *Privacy and Publicity: Modern Architecture and Mass Media* (Cambridge, Mass., 1994), 244.

21. Ibid., 250.

22. Loos, 'Architecture'.

23. According to Loos's partner Heinrich Kulka, he would make many alterations during construction, saying, 'I do not like the height of this ceiling. Change it.' Colomina, *Privacy and Publicity*, 269.

24. Leonard J. Kent and Elizabeth C. Knight (eds), *Selected Writings of E.T.A.Hoffmann*, vol. 1 (Chicago, 1969), 168. This story was reprinted in Bruno Taut, *Frühlicht*, 1920.

25. Cacciari, *Architecture and Nihilism*, chapter 14. As Cacciari points out, the split between the exterior and the interior in Loos's houses echoes Georg Simmel's concept of the split in the psychology of modern man in the context of the metropolis. Exchange no longer takes place between individuals as it did in the traditional small town but is the result of an abstract rationality.

26. Ibid., 167.

27. This is the view of a group of Italian critics, whose chief representative was Massimo Cacciari.

5. Expressionism and Futurism

1. Donald E. Gordon, *Expressionism: Art and Idea* (New Haven, 1987), 174–176.

2. Ibid., 176.

3. Wilhelm Worringer, *Abstraction and Empathy* (London, 1967), 115, originally published 1908.

4. Iain Boyd Whyte, *Bruno Taut and the Architecture of Activism* (Cambridge, 1982), 1.

5. Rosemary Haag Bletter, 'Expressionist Architecture', in Rose-Carol Washton Long (ed.), *German Expressionism: Documents from the End of the Wilhelmine Period to the Rise of National Socialism* (New York, 1993), 122. The date of this article is extremely important, because it proves that Taut's millennialist ideas originated before the First World War.

6. On the tension in Taut's thought between the practical and symbolic role of architecture, see Marcel Franciscono, *Walter Gropius and the Creation of the Bauhaus in Weimar* (Chicago, 1971), 94–95.

7. See Bruno Taut, *Ein Wohnhaus* (Stuttgart, 1927), which documents the colour scheme for Taut's own house. In this connection see Mark Wigley, *White Walls: Designer Dresses* (Cambridge, Mass., 1995), 304–15.

8. Bruno Taut, *Die Stadtkronen* (Jena, 1919), quoted in Whyte, *Bruno Taut*, 78.

9. For a discussion of Expressionist symbolism, see Rosemary Haag Bletter, 'The Interpretation of the Glass Dream: Expressionist Architecture and the History of the Crystal Metaphor', in the *Journal of the Society of Architectural Historians*, 40, no. 1, 1981, 20–43. A fascination with mystical traditions had been widespread among architects and artists since the 1890s. This interest is reflected in the increased popularity of syncretist religions, such as Theosophy, as newly defined by Helena Blavatsky, and Anthroposophy, founded by Rudolf Steiner, which attempted to fuse the Indian and Christian gnostic traditions, and which were to continue to interest avant-garde architects well into the 1920s. A curious example of this fascination is the English Arts and Crafts architect W. R. Lethaby, who wrote a book, *Architecture, Symbolism and Myth* (London, 1891; New York, 1975), on the Oriental and Neoplatonic traditions. Taut's conception of the *Kristallhaus* clearly falls within this broad nexus of ideas.

10. Giuliano Gresleri and Dario Matteoni, *La Città Mondiale* (Venice, 1982). Otlet was to commission a new version of this project in 1926, Le Corbusier's Mundaneum.

11. Peter Behrens anticipated vast theatres in which works that included music would be staged; Franciscono, *Walter Gropius and the Creation of the Bauhaus*, 95–96.

12. Wolfgang Pehnt, *Expressionist Architecture* (New York, 1973), 13. Pehnt notes that the number of theatres in Europe rose from 302 in 1896 to 2,499 in 1926.

13. Ibid., 13.

14. Whyte, *Bruno Taut*, chapter 5.

15. According to Whyte, 'decentralizing and a return to the land were part of a vision which preoccupied both the exeme Right and the extreme Left', ibid., 105. Whyte cites Heinrich Tessenow's *Handwerk und Kleinstadt* (1918) as an example of the fusion of a conservative *Heimatschutz* and Kropotkin's anarcho-socialism.

16. Bruno Taut, quoted in Whyte, *Bruno Taut*, 99.

17. Whyte, *Bruno Taut*, 127.

18. Richard Hülsenbeck, *Der Neue Mensch* (1917), quoted in Whyte, ibid., 139.

19. Richard Hülsenbeck, Raoul Hausmann, and Jelim Golyscheff, quoted in Whyte, ibid., 140.

20. Umbrio Apollonio (ed.), *Futurist Manifestos* (London, 1973), 19.

21. Filippo Marinetti, *Futurismo e Fascismo* (1924), quoted in Adrian Lyttleton, *The Seizure of Power: Fascism in Italy 1919–1929* (Princeton, 1973), 368.

22. Marjory Perloff, *The Futurist Movement: Avant-Garde, Avant-Guerre and the Language of Rupture* (Chicago, 1986), chapter 1.

23. Apollonio, *Futurist Manifestos*, 27.

24. Esther Da Costa Meyer, *The Work of Antonio Sant'Elia: Retreat into the Future* (New Haven, 1995), 75.

25. Umberto Boccioni, 'Technical Manifesto of Futurist Painting' (1910), reprinted in Apollonio, *Futurist Manifestos*, 27.

26. Umberto Boccioni, quoted in Manfredo Tafuri, *History and Theories of Architecture* (Granada, 1980), originally published as *Teorie e storia di architettura* (Laterza, 1976).

27. Umberto Boccioni, quoted in Perloff, *The Futurist Movement*, 52.

28. Apollonio, *Futurist Manifestos*, 51.

29. Da Costa Meyer, *The Work of Antonio Sant'Elia*, 139.

30. Apollonio, *Futurist Manifestos*, 161.

31. Da Costa Meyer, *The Work of Antonio Sant'Elia*, 211.

32. Da Costa Meyer, *The Work of Antonio Sant'Elia*, chapter 5, gives a detailed account of the history of Sant'Elia's manifesto.

33. Ibid., 68–71.

34. Ibid., 21.

35. Manfedo Tafuri, *History and Theories of Architecture*, 30–4.

6. The Avant-gardes in Holland and Russia

1. Wim de Wit, 'The Amsterdam School: Definition and Delineation', in *The Amsterdam School: Dutch Expressionist Architecture 1915–1930* (Cooper-Hewitt Museum, 1983), 29–66.

2. H. L. C. Jaffé, *De Stijl 1917–1931: the Dutch Contribution to Art* (Cambridge, Mass., 1986), 56–62.

3. Yves-Alain Bois, *Painting as Model*, 'The De Stijl Idea' (Cambridge, Mass., 1990), 102–106.

4. See Charles Rosen, *Arnold Schoenberg* (Chicago, 1975, 1996), 70–106.

5. According to Rosen 'Melody is a definite shape, an arabesque with a quasi-dramatic structure of tension and resolution', ibid., 99. 'Let's sit down, I hear melody,' Mondrian is reported to have said to a dancing partner; *Piet Mondrian* (Museum of Modern Art, New York, 1996), 77.

6. Bart van der Leck, *De Stijl*, vol. 1, no. 4, March 1918, 37, quoted in Bois, 'The De Stijl Idea', 111.

7. For an illuminating analysis of the controversy between Oud and Mondrian on the relation of architecture and painting, see Yves-Alain Bois, 'Mondrian and the Theory of Architecture', *Assemblage* 4, 103–30.

8. See Eduard F. Sekler, *Joseph Hoffmann: the Architectural Work* (Princeton, 1985), 59.

9. Theo van Doesburg, 'Towards a Plastic Architecture', *De Stijl*, VI, no. 6–7, 1924.

10. Linda Dalrymple Henderson, *The Fourth Dimension and Non-Euclidean Geometry in Modern Art* (Princeton, 1983), 321–34.

11. J. J. P. Oud, quoted in Jaffé, *De Stijl 1917–1931*, 193.

12. Manfredo Tafuri and Francesco Dal Co, *Modern Architecture* (London, 1980), 204.

13. Christina Lodder, *Russian Constructivism* (New Haven, 1983), 83–93.

14. Henderson, *The Fourth Dimension*, 274–99.

15. Lodder, *Russian Constructivism*, 98.

16. Ibid., 65.

17. Boris Arvatov, quoted in Lodder, *Russian Constructivism*, 107.

18. Tafuri and Dal Co, *Modern Architecture*, 208.

19. The word 'contemporary' was used to avoid 'modern', associated in Russian with Art Nouveau; Jean-Louis Cohen, verbal information.

20. For the conflict between OSA and ASNOVA, see Hugh D. Hudson Jr., *Blueprints and Blood: the Stalinization of Soviet Architecture* (Princeton, 1994), chapter 3.

21. Lodder, *Russian Constructivism*, 227.

22. El Lissitzky and Ilya Ehrenberg, *Veshch*, 1922, quoted in Lodder, ibid., 228.

23. Anatole Kopp, *Town and Revolution: Soviet Architecture and City Planning 1917–1935* (New York, 1970), 143.

24. The sectional interlocking of apartments and access corridors in the Narkomfin Building strongly resembles one of Le Corbusier's sketches for the Ville Contemporaine of 1922; see Le Corbusier, *Œuvre Complète*, vol. 1. (Zürich, 1929), 32. It has normally been assumed that Le Corbusier's cross-over apartment type for the Ville Radieuse and the Unité d'Habitation was influenced by Moisei Ginsburg.

25. Okhitovitch was arrested by the NKVD in 1935 and died in prison two years later; see Hudson, *Blueprints and Blood*, 160.

26. Jean-Louis Cohen, 'Architecture and Modernity in the Soviet Union 1900–1937', in *A+U*, June 1991, no. 6, 20–41.

27. See Victor Erlich, *Russian Formalism: History, Doctrine* (The Hague, 1955).

28. Founded in 1929, Hudson, *Blueprints and Blood*, 126.

Chapter 7. Return to Order: Le Corbusier and Modern Architecture in France 1920–35

1. For Jeanneret's early career see H. Allen Brooks, *Le Corbusier's Formative Years* (Chicago, 1997); for his early intellectual formation see Paul Venable Turner, *The Education of Le Corbusier* (New York, 1977); for his interior designs and furniture and his connections with the French decorative arts see Nancy Troy, *Modernism and the Decorative Arts in France* (New Haven, 1991), chapter 3.

2. All the articles signed Ozenfant–Jeanneret, Le Corbusier–Saugnier, and Ozenfant were later published by Crès in the *Collection de L'Esprit Nouveau* (Paris, 1925), which included *Vers une Architecture*, *L'Art Décoratif d'Aujourd'hui*, and *Urbanisme* by Le Corbusier, and *La Peinture Moderne* by Ozenfant and Jeanneret.

3. Charles Henry (1859–1926) was author of *L'Esthetique Scientific*; his psycho-physical theory of art influenced formalist aesthetics in the inter-war period.

4. Paul Dermée, 'Domaine de L'Esprit Nouveau', *L'Esprit Nouveau*, no. 1, October 1920, Introduction; quoted in Réjean Legault, *L'Appareil de l'Architecture: New Materials and*

Architectural Modernity in France 1889–1934 (PhD dissertation, MIT, 1997), 176.

5. Françoise Will-Levaillant, 'Norm et Form à Travers L'Esprit Nouveau', in *Le Retour à l'Ordre dans les Arts Plastiques et l'Architecture 1919–1925* (proceedings of a colloquium at the Université de Saint-Etienne, Centre Interdisciplinaire d'Etudes et de Recherche sur l'Expression Contemporaine, 8, 1974), 256.

6. Jeanneret, 'Ce Salon d'Automne', *L'Esprit Nouveau*, no. 28, January 1925, 2332–5, quoted in Legault, *L'Appareil de l'Architecture*, 261.

7. *L'Esprit Nouveau*, no. 4.

8. Ozenfant and Jeanneret, 'Purisme', *L'Esprit Nouveau*, no. 4, October 1920, 369.

9. For an analysis of Ozenfant and Jeanneret's theory of Purism see Kenneth E. Silver, *Esprit de Corps: The Art of the Parisian Avant-Garde and the First World War, 1914–1925* (Princeton, 1989), 381–9.

10. Jeanneret, quoted in Troy, *Modernism and the Decorative Arts in France*, 145.

11. Troy, *Modernism and the Decorative Arts in France*, 136–45.

12. Ibid., 139.

13. Ibid., chapter 4, ' Reconstructing Art Deco'.

14. Arthur Rüegg, 'Le Pavillon de L'Esprit nouveau en tant que musée imaginaire', in Stanislas von Moos (ed.), *L'Esprit Nouveau: Le Corbusier et l'Industrie 1920–1925* (Strasbourg, 1987), 134.

15. Ozenfant and Jeanneret, *La Peinture Moderne*, 168, quoted in Rüegg, ibid, 137.

16. Reyner Banham, *Theory and Design in the First Machine Age* (London and New York, 1960), 202.

17. Legault, *L'Appareil de l'Architecture*, 188.

18. Le Corbusier, *Œuvre Complète*, vol. 1 (Zürich, 1929), 25.

19. Robert Mallet-Stevens, interviews with Guillaume Janneau, *Bulletin de la Vie Artistique*, June 1923 and December 1924, quoted in Legault, *L'Appareil de l'Architecture*, 267, 283.

20. Le Corbusier, *Précisions* (Cambridge, Mass., 1991), 83.

21. Le Corbusier, letter to Madame Meyer, *Œuvre Complète*, vol. 1 (Zürich, 1929), quoted in Monique Eleb-Vidal, 'Hotel Particulière', in J. Lucan (ed.), *Le Corbusier, une Encyclopedie* (Paris, 1929), 175.

22. See Bruno Reichlin, 'Le Corbusier and De Stijl', in *Casabella*, vol. 50, no. 520–1, 1986, 100–8. Reichlin demonstrates the influence of van Doesburg in the entrance hall of the Maison La Roche of 1923.

23. Le Corbusier, *Œuvre Complète*, vol. 1 (Zürich, 1929), 189.

24. Le Corbusier, *Précisions*, 9.

25. Francesco Passanti, 'The Vernacular, Modernism and Le Corbusier', in *Journal of the Society of Architectural Historians*, vol. 56, no. 4, December 1997, 443. See also Christopher Green, 'The Architect as Artist', in Michael Raeburn and Victoria Wilson (eds), *Le Corbusier: Architect of the Century* (London, 1987), 117.

26. Sigfried Giedion, *Building in France, Building in Iron, Building in Ferro-concrete* (Los Angeles, 1995), 169.

27. See Norma Evenson, *Paris: a Century of Change 1878–1978* (New Haven, 1979), chapter 2.

28. Ibid., 31.

29. See Le Corbusier, *Œuvre Complète*, vol. 1 (Zürich, 1929), 26; Lotissement 'Dom-ino'.

30. See Alan Colquhoun, *Modernity and the Classical Tradition* (Cambridge, Mass., 1989), 'The Strategy of the Grands Travaux', 121–61.

31. On Le Corbusier's connections with neo-syndicalism see Mary McLeod, *Urbanism and Utopia: Le Corbusier from Regional Syndicalism to Vichy* (PhD dissertation, Princeton University, 1985), chapter 3, 'Architecture and Revolution: Regional Syndicalism and the Plan', 94–166. See also Robert Fishman, 'From Radiant City to Vichy: Le Corbusier's Plans and Politics 1928–1942', in Russell Walden (ed.), *The Open Hand: Essays on Le Corbusier* (Cambridge, Mass., 1977), 244–85. On Fascism and proto-Fascism in France between the late nineteenth century and the 1940s see Zeev Sternhell, *Neither Left nor Right* (Princeton, 1993).

32. See Jeffrey Herf, *Reactionary Modernism, Technology, Culture, and Politics in Weimar and the Third Reich* (Cambridge, 1984), chapter 1, 'The Paradox of Reactionary Modernism', 1–17.

33. Christopher Green, 'The Architect as Artist', 114 ff. It was at this time, as Green points out, that Le Corbusier began to include organic and non-geometrical objects in his paintings.

34. Le Corbusier, *Une Maison, un Palais* (Paris, 1928), 49, trans. author.

35. Le Corbusier, *Œuvre Complète*, vol. 2 (Zurich, 1929), 186.

36. Le Corbusier, 'Urbanisme des trois établissements humains', 1946, 93, quoted in McLeod, *Urbanism and Utopia*, chapter 5, 'La Ferme Radieuse', 296.

37. Le Corbusier, *Précisions*, 218.

Chapter 8. Weimar Germany: the Dialectic of the Modern 1920–33

1. For a discussion of the term 'Neue Sachlichkeit', see Rosemary Haag Bletter's Introduction to Adolf Behne's *The Modern Functional Building* (Los Angeles, 1996), 47–53. For an original and convincing definition of *Sachlichkeit* see Francesco Passanti, 'The Vernacular, Modernism and Le Corbusier', in *Journal of the Society of Architectural Historians*, vol. 56, no. 4, December 1997, 443 ff. In the unexpected context of a text on Le Corbusier, Passanti argues that '*sache*' ('thing' or 'fact') refers not to an abstract universal but to an object that is socially constructed and has become 'second nature'. Another way of putting this is to say that *sache* refers to something within language, not beyond it, following the theory of Jacques Lacan; see *The Seminars of Jacques Lacan, Book VII, The Ethics of Psychoanalysis 1959–60* (originally published in French as *Le Seminaire, Livre VII, L'Ethique de la psychanalyse, 1959–60*, Paris, 1986) translated by Dennis Porter, New York, 1922, 43–5.

2. Franz Roh, *Post-Expressionism, Magic Realism: Problems of Recent European Painting*, 1925, quoted in Rose-Carol Washton Long (ed.), *German Expressionism: Documents from the End of the Wilhelmine Period to the Rise of National Socialism* (New York, 1993), 294.

3. English translation in Dal Co, *Figures of Architecture and Thought* (New York, 1990), 324–8.

4. Marcel Franciscono, *Walter Gropius and the Creation of the Bauhaus in Weimar* (Chicago, 1971), 132.

5. The Bauhaus Manifesto is quoted in full in Gillian Naylor,

The Bauhaus Reassessed (London, 1985), 53–4.

6. See Franciscono, *Walter Gropius*, chapter 6, 173–236.

7. Josef Albers, quoted in Naylor, *The Bauhaus Reassessed*, 101.

8. Reyner Banham, *Theory and Design in the First Machine Age* (London and New York, 1960), 282.

9. Walter Gropius, quoted in Richard Pommer and Christian Otto, *Weissenhof 1927 and the Modern Movement in Architecture* (Chicago, 1991), 11.

10. Naylor, *The Bauhaus Reassessed*, 144–60.

11. Barbara Miller Lane, *Architecture and Politics in Germany, 1918–1945* (Cambridge, Mass., 1968), chapter 4.

12. See Nicholas Bullock and James Read, *The Movement for Housing Reform in Germany and France, 1840–1914* (Cambridge, 1985), chapters 10, 11, and 12, 217–76.

13. Manfredo Tafuri and Francesco Dal Co, *Modern Architecture* (London, 1980), 176. Manfredo Tafuri points out that for nineteenth-century town planners like Stübben there was no direct link between planning and the architectural avant-garde—a fact that he attributes to their political conservatism. In Weimar Germany, both planning and Modernist architecture were associated with a Socialist agenda.

14. Pommer and Otto, *Weissenhof 1927*, 39.

15. Nicholas Bullock, 'First the Kitchen then the Façade', in *Journal of Design History*, vol. 1, nos. 3 and 4, 1988, 177.

16. In 1927 a federal institution was founded for research into the economic and constructional problems of mass housing (the *Reichsforschungsgesellschaft*), but the housing programme was terminated before this research could take effect.

17. Adolf Behne, 'Dammerstock', in *Die Form*, H6, 1930, trans. Margerita Navarro Baldeweg and author.

18. See Rosemary Haag Bletter, 'Expressionism and the New Objectivity', in *Art Journal*, summer 1983, 108 ff.

19. Schultze-Naumburg's books included *ABC des Bauens, Art and Race*, and *The Face of the German House*; see Lane, *Architecture and Politics*, chapter 5.

20. Adolf Behne, *The Modern Functional Building*, 138.

21. Theo van Doesburg, *On European Architecture: Complete Essays from Het Bouwbedrijf 1924–1931* (Boston, 1990), 'Defending the Spirit of Space: Against Dogmatic Functionalism', 88–95.

22. See also Linda Dalrymple Henderson, *The Fourth Dimension and Non-Euclidean Geometry in Modern Art* (Princeton, 1983), 36–37.

23. Fragmentation of the box is the thesis of Bruno Zevi's influential book *Poetica dell'architettura neoplastica* (Milan, 1953). Though the thesis is still persuasive, Zevi's ethico-political interpretation now seems dated. See also Richard Padovan's important article, 'Mies van der Rohe Reinterpreted', in *IUA: International Architect*, no. 3, 1984, 38–43.

24. Mies adopted his mother's maiden name, Rohe, and added the faintly aristocratic-sounding 'van der'.

25. Other members of this circle included Ludwig Hilbersheimer, Hans Arp, Naum Gabo, Frederick Kiesler, Man Ray, Walter Benjamin, Philippe Soupault and Raoul Hausmann; Franz Schulze, *Mies van der Rohe: a Critical Biography* (Chicago, 1985), 89.

26. Mies van der Rohe, *G*, no. 2, 1923.

27. Though Mies denied any influence from De Stijl, van Doesburg's Counter-constructions are the most obvious source for the Brick Country House. Most critics, however, suggest that Mies's source was van Doesburg's painting *Rhythm of a Russian Dance* of 1918, which is graphically closer to the pattern of Mies's plan. Be this as it may, the spatial concept suggested by Mies's building is the same as that of the Counter-constructions as described by van Doesburg in *De Stijl* in 1924 (quoted in chapter 6).

28. Christian Norberg-Schulz, 'Talks with Mies van der Rohe', in *L'Architecture d'aujourd'hui*, no. 79, 1958, 100.

29. See the opening pages of Rosalind Krauss's essay 'The Grid, the Cloud and the Detail', in Detlef Mertins (ed), *The Presence of Mies* (Princeton, 1984).

30. This view is reinforced by Mies's reading of the existentialist philosopher Romano Guardini in 1925; see Fritz Neumeyer, *The Artless Word: Mies van der Rohe on the Building Art* (Cambridge, Mass., 1991), chapter 6, 196 ff.

31. According to F. W. J. Schelling: 'What must give the work of art as a whole its beauty can no longer be form but something above form, namely the essence . . . the expression of the spirit that must dwell there'. Quoted in Svetlan Todorov, *Theories of the Symbol* (Cornell University Press, Ithaca, NY, 1982), 169.

32. For ABC, see Jacques Gubler, *Nationalisme et Internationalisme dans l'Architecture Moderne de la Suisse* (Lausanne, 1975), 109–41.

33. Ibid., 117.

34. Ibid., 118.

35. In *ABC*, nos. 3–4, 1925.

36. Hannes Meyer, quoted in Tafuri and Dal Co, *Modern Architecture*, 168.

Chapter 9. From Rationalism to Revisionism: Architecture in Italy 1920–65

1. Gruppo 7, *Rassegna Italiana*, 1926, quoted in Vittorio Gregotti, *New Directions in Italian Architecture* (London, 1968), 13.

2. Giuseppe Terragni, quoted in Dennis Doordan, *Building Modern Italy, Italian Architecture 1914–1936* (Princeton, 1988), 137.

3. Giuseppe Pagano, quoted in Doordan, *Building Modern Italy*, 140. See also Benevolo, *History of Modern Architecture* (London, 1971), 596; and Manfredo Tafuri and Francesco Dal Co, *Modern Architecture* (London, 1980), 284–5. With apparent inconsistency, these authors praise Terragni for his formal subtlety, yet condemn him for his formalism.

4. Doordan, *Building Modern Italy*, 109.

5. Manfredo Tafuri, *History of Italian Architecture, 1944–1985* (Cambridge, Mass., 1989), 3.

6. Gregotti, *New Directions*, 39–40.

7. Bruno Zevi, quoted in Gregotti, *New Directions*, 40.

8. INA Casa's announcement of aims, quoted in Tafuri, *History of Italian Architecture*, 89.

9. Tafuri, *History of Italian Architecture*, 16.

10. Ibid., 11–13.

11. For an English translation of Ernesto Rogers's essays 'Pre-existing Conditions and Issues of Contemporary Building Practice' and 'The Evolution of Architecture', see Joan Ockman (ed.), *Architecture Culture 1943–1968* (New York, 1993), 200 and 300.

12. Tafuri, *History of Italian Architecture*, 74.

13. Ibid., 75.

14. Ibid., 76.

15. Gregotti, *New Directions*, 107, 115.

Chapter 10. Neoclassicism, Organicism, and the Welfare State: Architecture in Scandinavia 1910–65

1. According to the economist John Maynard Keynes, the periodic depressions that had plagued capitalism in the nineteenth century could be avoided by the use of deficit spending in times of recession. Keynes placed the emphasis on the stimulation of demand.

2. Hendrick O. Andersson, 'Modern Classicism in Norden', in Scio Paavilainen (ed.), *Nordic Classicism 1910–1930* (Museum of Finnish Architecture, Helsinki, 1992).

3. See Jorgen Sestoft and Jorgen Christiansen, *Guide to Danish Architecture Vol. I, 1800–1960* (Copenhagen, 1991), 212.

4. Ibid., 214.

5. Ibid., 218

6. Ibid., 220.

7. The Woodland Chapel at Enskede was part of a competition project won in collaboration with Sigurd Lewerentz. It is often difficult to distinguish between Asplund and Lewerentz's respective contributions.

9. The KV cooperative was a cooperative for the retailing of household goods and food, see Eva Rudberg, 'Early Functionalism' in *Twentieth-Century Architecture, Sweden*, 80.

10. Hans Eliot, quoted in Eva Eriksson, 'Rationalism and Classicism 1915–1930', in *Twentieth-Century Architecture, Sweden*, 46.

11. Backström, quoted in Rudberg, 'Building the Welfare of the *Folkhemmet*', 126.

12. Ibid., 126.

13. See Manfredo Tafuri and Francesco Dal Co, *Modern Architecture* (London, 1980), 187.

14. The neighbourhood idea, inherited from the Garden City movement, attempted to recover small-town community values. In the 1960s such neighbourhood social centres were increasingly challenged by the demand for leisure facilities that could be provided only by a larger urban catchment area; see Rudberg, op. cit. 'Building the Welfare', 118–21, 139.

15. Claes Caldenby, 'The Time for Large Programmes', in *Twentieth-Century Architecture, Sweden*, 142.

16. Ibid. See also the discussion of Systems theory in chapter 11.

17. See Kim Dircknick, *Guide to Danish Architecture, Vol. II, 1960–95* (Copenhagen, 1995), 57.

18. Caldenby, 'The Time for Large Programmes', 155. There was also a contemporary 'Structuralist' movement in Holland. Both movements shared some basic ideas, but differed in others. Dutch Structuralism is discussed in chapter 11 in the context of the Megastructural movement.

19. Caldenby, 'The Time for Large Programmes', 151.

20. Caldenby, 'The Time for Large Programmes', 153, and Wilfred Wang et al., *The Architecture of Peter Celsing* (Stockholm, 1996), 19, fig. 1 and 60 ff.

21. Wang, *The Architecture of Peter Celsing*, 82 ff.

22. Claes Dimling (ed.), *Architect Sigurd Lewerentz* (Stockholm, 1997), 146 ff and 165 ff.

23. It is probable that the Paimio Sanatorium was influenced by Johannes Duiker's Zonnestraal Sanatorium in Hilversum (1926–8). Aalto saw this building on his tour of modern buildings in France and Holland in the summer of 1928. For a discussion of this problem, see Eija Rauske, 'Paimio Sanatorium', in *Aalto in Seven Buildings* (Museum of Finnish Architecture, Helsinki, 1998), 13.

24. Paul David Pearson, *Alvar Aalto and the International Style* (New York, 1978), 141.

25. Kirmo Mikkola, *Architecture in Finland in the 20th Century* (Helsinki, 1981), 55.

26. Ibid., 53.

27. Ibid., 55, 56.

Chapter 11. From Le Corbusier to Megastructures: Urban Visions 1930–65

1. Mary McLeod, *Urbanism and Utopia: Le Corbusier from Regional Syndicalism to Vichy* (PhD dissertation, Princeton University, 1985), chapter 6.

2. The design was bitterly attacked by the Sociétée des architects diplomés par le gouvernement and the Conseil supérieur d'hygiéne, which warned that the building would endanger the mental health of its inhabitants; Stanislas von Moos, *Le Corbusier: Elements of a Synthesis* (Cambridge, Mass., 1979), 158.

3. Ibid., 177.

4. Le Corbusier, *Œuvre Complète*, vol. 4 (Zürich, 1929), 174.

5. Le Corbusier, quoted in McLeod, *Urbanism and Utopia*, chapter 6, 362.

6. For example, a debate in the Swiss journal *Das Werk* and the Swedish journal *Byggmästaren* between 1937 and 1940 involving the art critic Peter Meyer and the architects Hans Schmidt and Gunnar Sundbärg; see Christine C. and George R. Collins, 'Monumentality: a Critical Matter in Modern Architecture', in *Harvard Architectural Review*, vol. 4, no. 4, 1985, 15–35.

7. George Howe, quoted in Collins, ibid.

8. Elizabeth Mock, quoted in Collins, ibid.

9. Sigfried Giedion, Josep Lluis Sert, and Fernand Léger, 'Nine Points on Monumentality', originally planned for a 1943 publication by American Abstract Artists, reprinted in Joan Ockman (ed.), *Architecture Culture 1943–1968* (New York, 1993), 29–30.

10. Sigfried Giedion, 'The Need for a New Monumentality' in Paul Zucker (ed.), *New Architecture and City Planning* (New York, 1944), 549–68.

11. Norma Evenson: *Chandigarh* (Berkeley and Los Angeles, 1966).

12. Norma Evenson: *Two Brazilian Cities* (New Haven, 1973).

13. See Le Corbusier, *Précisions* (Cambridge, Mass., 1991), 218—quoted on page 156 of this book.

14. Sigfried Giedion, *Space, Time and Architecture*, 1941 (5th edition, Harvard, Mass., 1967), 134. Quoted in Ines Palma (unpublished essay 1999).

15. For a discussion of the gap between concept and reality in Chandigarh, see Madhu Sarin, 'Chandigarh as a Place to Live in', in Russell Walden (ed.), *The Open Hand* (Cambridge, Mass., 1977), 374.

16. Jacques Gubler, *Nationalisme et Internationalisme dans l'Architecture Moderne de la Suisse* (Lausanne, 1975), 145–152.

17. The original members of Team X were: J. B. Bakema, Aldo van Eyck, Sandy van Ginkel and Hovens-Greve from Holland; Alison and Peter Smithson, W. and G. Howell, and John Voelcker from England; Georges Candilis and Shadrach Woods from France; and Rolf Gutmann from Switzerland; see AAGS (Additional Association General Studies) Theory and History Papers 1, 'The Emergence of Team X out of CIAM' (Architectural Association, London, 1982), compiled by Alison Smithson.

18. Alison Smithson (ed.), *Team X Primer* (Cambridge, Mass., 1968), 78.

19. Ibid., 48.

20. This was reminiscent of the dilemma that had faced Wilhelm Dilthey, Georg Simmel, and other proponents of *Lebensphilosophie* (*Philosophy of Life*) in Germany at the turn of the twentieth century; see, for example, Georg Simmel, 'The Conflict of Modern Culture' (1918) in Donald Levine (ed.), *Georg Simmel: On Individuality and Social Forms* (Chicago, 1971), 375–393.

21. Alison Smithson (ed.), *Team X Primer*, 48, 52.

22. For example, Maurice Merleau-Ponty's *Phenomenology of Perception*, 1945 (London, 1962, 1989).

23. For Systems theory references see Further Reading, page 268.

24. Wim van Heuvel, *Structuralism in Dutch Architecture* (Rotterdam, 1992), 15.

25. The structural anthropology of Claude Levi-Strauss, with which the Dutch Structuralists claimed an affinity, shares the holism of Systems theory: both postulate the existence of 'structures' that have an objective existence independent of the subject but, whereas Structuralism sees these as stable, establishing long-term cultural norms, Systems theory sees them as dynamic, driven by function.

26. Fumihiko Maki, *Investigations in Collective Form* (School of Architecture, Washington University, St Louis, 1964).

27. David B. Stewart, *The Making of a Modern Japanese Architecture, 1868 to the Present* (Tokyo and New York, 1987), 179.

28. Ibid., 181.

29. Tange's report on the Tokyo Bay competition is a brilliantly concise statement of the aims of the Metabolist movement as a whole and illustrates the fusion of Utopian and pragmatic elements that is characteristic of the Japanese movement. It is reprinted in Ockman, *Architecture Culture*, 327 ff.

30. Antoine Picon, *La ville territoire des cyborgs* (Paris, 1998), 74.

31. Quoted in Banham, *Megastructure* (London and New York, 1976), 81.

32. Quoted in Banham, ibid., 60.

33. The Situationists were influenced by the writings on the city of the Marxist Sociologist Henri Lefebvre; see Henri Lefebvre, 'The Right to the City', 1967, reprinted in Ockman, *Architecture Culture*, 427 ff.

34. A characteristic feature of Constant's models is that their structure is designed to the scale of the models themselves rather than to that of the architecture which they ostensibly represent, indicating that the models are the work of someone trained as a sculptor and a painter, not as an architect.

35. Gilles Ivain's 'Formulary for a New Urbanism' is reprinted in Ockman, *Architecture Culture*, 167 ff.

Chapter 12. Pax Americana: Architecture in America 1945–65

1. In his later book *The City in History* (1961), Mumford was to revert to something like his previous pessimism.

2. For an account of the relation between American and European progressive legislation between 1890 and 1945, see Daniel T. Rodgers, *Atlantic Crossings: Social Politics in a Progressive Age* (Cambridge, Mass., 1998). The foregoing account is indebted to Rodgers's book.

3. For the Hertfordshire schools programme, see Richard Llewellyn-Davies and John Weeks, 'The Hertfordshire Achievement' in *Architectural Review*, June 1952, 367–72; and D. Ehrenkrantz and John D. Day, 'Flexibility through Standardisation' in *Progressive Architecture*, vol. 38, July 1957, 105–15.

4. The development of suburbia was greatly accelerated by the Interstate Highways Act of 1956, which provided for 41,000 miles of new highway to be built with a 90 per cent federal subsidy. The Act was the result of ten years of intensive lobbying by the American Road Builders' Association (within which General Motors formed the largest group); see Reinhold Martin, *Architecture and Organization: USA c.1956* (PhD dissertation, Princeton University, 1999), chapter 4, 260.

5. For an account of the American house in the 1950s and 1960s, see Mark Jarzombek, 'Good-Life Modernism and Beyond: The American House in the 1950s and 1960s, a Commentary', in *The Cornell Journal of Architecture*, 4, 1991, 76–93.

6. Charles Eames, John Entenza, and Herbert Matter, 'What is a House?', in *Arts and Architecture*, July 1944.

7. 'La Casa 1955 di "Arts and Architecture"', in *Domus*, 320, July 1956, 21, quoted in Reyner Banham, 'Klarheit, Erlichkeit, Einfachkeit . . . and Wit too', in Elizabeth A. T. Smith (ed.), *Blueprints for Modern Living: History and Legacy of the Case Study Houses* (Cambridge, Mass., 1989), 183.

8. For Charles and Ray Eames see John Neuhart, Marilyn Neuhart, and Ray Eames, *Eames Design: the Work of the Office of Charles and Ray Eames* (New York, 1989), and 'An Eames Celebration', in *Architectural Design*, September 1966.

9. William H. Jordy, *American Buildings and their Architects: the Impact of European Modernism in the Mid-Twentieth Century* (Anchor Books, New York, 1976), 232.

10. Henry Russell Hitchcock, 'Introduction', in Skidmore, Owings, and Merrill, *Architecture of Skidmore, Owings, and Merrill, 1950–1962* (New York, 1963).

11. Total modular coordination was in fact never achieved owing to the dimensional inflexibility of the mechanical services industries; verbal information from Robert Heintches.

12. For an account of Eero Saarinen's General Motors Technical Center, see Martin, *Architecture and Organization*, chapter 12. In the long run, GM's policy of styling has proved a near disaster for the American automobile industry.

13. In an informal conversation with students at the

Architectural Association, London, May 1959, Mies said that, though he greatly admired Le Corbusier, he disagreed with his individualistic and monumental approach.

14. For a contemporary English view of American automobile design in the 1950s, see Reyner Banham, 'Vehicles of Desire', in *Art*, September 1955, reprinted in Mary Banham et al. (eds), *A Critic Writes: Essays by Reyner Banham* (Berkeley, 1996).

15. On Georgy Kepes's influential aesthetic philosophy, see Martin, *Architecture and Organization*, chapter 2.

16. Arthur J. Pulos, *The American Design Adventure 1940–1975* (Cambridge, Mass., 1988), 268.

17. In the representation of architecture in the wall frescoes at Pompeii, the columns are elongated and etherealized.

18. See Louis Kahn, 'Monumentality', typed transcript, 14 November 1961, published in Paul Zucker (ed.), *New Architecture and City Planning* (New York, 1944), 577–588. This article shows how close Kahn's views on this subject were to those of Sigfried Giedion (see chapter 11).

19. There was a common interest in classicism among anglophone architects in the early 1950s, partly triggered by the publication of Rudolf Wittkower's *Architectural Principles in the Age of Humanism* in 1949. This interest was shared by Kahn with both the Smithsons and Wittkower's pupil, Colin Rowe. See Henry Millon, 'Rudolf Wittkower's *Architectural Principles in the Age of Humanism* and its Influence on the Development of Modern Architecture', in *Journal of the Society of Architectural Historians*, 31, 1972, 83–9.

20. Ernst Haeckel, *Art Forms in Nature* (New York, 1974), originally published 1899–1904; D'Arcy Wentworth Thompson, *On Growth and Form* (Cambridge, 1961), originally published 1917. Two exhibitions at the Institute of Contemporary Art in London—'On Growth and Form' in 1951

and 'Parallel of Life and Art' in 1953—testify to the popularity of these ideas at the time. D'Arcy Thompson's Pythagorean model, however, only applied at the level of gross biological forms, not at the level of biochemistry; it therefore gave a one-sided picture of the problem of form in biology. See Joseph Needham, 'Biochemical Aspects of Form and Growth', in Lancelot Law Whyte (ed.), *Aspects of Form* (London, 1951).

21. Louis Kahn, quoted in David B. Brownlee and David G. De Long, *Louis I. Kahn: in the Realm of Architecture* (New York, 1992), 58.

22. Louis Kahn, quoted ibid., 58.

23. For an insightful comparison between Kahn's Jewish Community Center and Mies's unbuilt Library and Administration Building, Illinois Institute of Technology, Chicago, see Colin Rowe, '"Neoclassicism" and Modern Architecture II', in *The Mathematics of the Ideal Villa and other Essays* (Cambridge, Mass., 1982). Kahn's Community Center bears a family resemblance to the work of Aldo van Eyck and the Dutch Structuralists. The Dutch architects shared Kahn's interest in Viollet-le-Duc's structural rationalism, transmitted to them through H. P. Berlage. But they also shared his desire to return to the irreducible house-like unit of architecture (see chapter 11). The degree of mutual influence, if any, is not clear.

24. See Jordy, *American Buildings and their Architects*, 407–26; and Reyner Banham, *The Architecture of the Well Tempered Environment* (Chicago, 1969), 246–55.

25. For Kahn's concept of an architecture of public symbolism, see Sarah Williams Ksiazak, 'Architectural Culture in the 1950s: Louis Kahn and the National Assembly at Dhaka', in *Journal of the Society of Architectural Historians*, 52, December 1993, 416–35, and 'Critiques of Liberal Individualism: Louis Kahn's Civic Projects 1947–1957', in *Assemblage*, 31, 1996, 56–79.

Further Reading

This is a starting place for readers who wish to explore various topics in greater detail. A more detailed list of sources can be found on the Oxford History of Art website.

General

Reyner Banham, *Theory and Design in the First Machine Age* (London and New York, 1960).

Sigfried Giedion, *Space, Time and Architecture* (Cambridge, Mass., 1967).

Manfredo Tafuri and Francesco Dal Co, *Modern Architecture* (London, 1980).

Chapter 1. Art Nouveau 1890–1910

General

Donald Drew Egbert, *Social Radicalism and the Arts in Western Europe: a Cultural History from the French Revolution to 1968* (New York, 1970).

Eugènia W. Herbert, *The Artist and Social Reform: France and Belgium, 1885–1898* (New Haven, 1961).

H. Stuart Hughes, *Consciousness and Society: the Reorientation of European Social Thought 1890–1930* (New York, 1961, 1977).

David Lindenfeld, *The Transformation of Positivism: Alexis Meinong and European Thought 1880–1920* (Berkeley and Los Angeles, 1980), chapters 1, 2, 4, and 5.

Carl Schorske, *Fin-de-Siècle Vienna* (New York, 1980).

Theory

Barry Bergdoll (ed.), *The Foundations of Architecture* (New York, 1990) contains an English translation of extracts from Viollet-le-Duc's *Dictionnaire Raisonné d'Architecture*.

Wolfgang Herrmann, *Gottfried Semper: in Search of Architecture* (Cambridge, Mass., 1984).

Nikolaus Pevsner, *Some Architectural Writers of the Nineteenth Century* (Oxford, 1972).

The Art Nouveau movement

Jean-Paul Bouillon, *Art Nouveau 1870–1914* (New York, 1985).

Akos Moravánszky, *Competing Visions: Aesthetic Invention and Social Imagination in Central European Architecture, 1867–1918* (Cambridge, Mass., 1998).

Frank Russell (ed.), *Art Nouveau Architecture* (London, 1979).

T. Schudi Madsen, *Sources of Art Nouveau* (New York, 1955) and *Art Nouveau* (New York, 1967).

Debora L. Silverman, *Art Nouveau in Fin-de-Siècle France: Politics, Psychology and Style* (Berkeley and Los Angeles, 1989).

Nancy Troy, *The Decorative Arts in Fin-de-Siècle France: Art Nouveau to Le Corbusier* (New Haven, 1991).

Otto Wagner, *Modern Architecture* (1896), trans. Harry F. Mallgrave (Los Angeles, 1988).

Individual architects

Alan Crawford, *Charles Rennie Mackintosh* (London, 1995).

David Dernie and Alastair Carew-Cox, *Victor Horta* (London, 1995).

Heinz Garetsegger, *Otto Wagner* (New York, 1979).

Ian Latham, *Joseph Maria Olbrich* (New York, 1988).

Eduard F. Sekler, *Josef Hoffmann: the Architectural Work* (Princeton, 1985).

Klaus-Jürgen Sembach, *Henry van de Velde* (New York, 1989).

Ignasi de Solà-Morales, *Antoni Gaudí* (New York, 1984).

Pieter Singelenberg, *H. P. Berlage* (Utrecht, 1972).

Chapter 2. Organicism versus Classicism: Chicago 1890–1910

Primary sources

Louis Sullivan, *Kindergarten Chats and Other Writings* (New York, 1965).

Louis Sullivan, *The Autobiography of an Idea* (New York, 1956).

Frank Lloyd Wright, *An Autobiography* (New York, 1977).

Frank Lloyd Wright, 'The Art and Craft of the Machine' (catalogue of the 14th Annual Exhibition of the Chicago Architectural Club, 1901), reprinted in Bruce Brooks Pfeiffer (ed.), *Frank Lloyd Wright: Collected Writings*, vol. 1 (New York, 1992).

Frank Lloyd Wright, 'In the Cause of Architecture', *The Architectural Record*, 1908, reprinted in Brooks Pfeiffer (ed.), *Frank Lloyd Wright: Collected Writings*, vol. 1.

General

Donald Drew Egbert, 'The Idea of Organic Expression in American Architecture' in Stow Persons, *Evolutionary Thought in America* (New Haven, 1950).

Fiske Kimball, *American Architecture* (New York, 1928).

Lewis Mumford, *The Brown Decades* (New York, 1931).

Montgomery Schuyler, *American Architecture and Other Writings* (Cambridge, Mass., 1961).

Caroline van Eck, *Organicism in Nineteenth-Century Architecture: an Inquiry into its Theoretical and Philosophical Background* (Amsterdam, 1994).

The Chicago School
Leonard K. Eaton, *American Architecture Comes of Age* (Cambridge, Mass., 1874).
William H. Jordy, *American Buildings and their Architects: Progressive and Academic Ideals at the Turn of the Century* (New York, 1972).
Heinrich Klotz, 'The Chicago Multistorey as a Design Problem', in John Zukovsky (ed.), *Chicago Architecture* (Art Institute of Chicago, 1987).
Mario Manieri-Elia, 'Toward the "Imperial City": Daniel Burnham and the City Beautiful Movement', in Giorgio Ciucci, Francesco Dal Co, Mario Manieri-Elia and Manfredo Tafuri, *The American City: From the Civil War to the New Deal* (Cambridge, Mass., 1979), originally published as *La Città Americana della Guerra Civile al New Deal* (Laterza, 1973).

The home and the Social Reform movement
Gwendolyn Wright, *Building the American Dream: Moralism and the Model Home* (Chicago, 1980).

Frank Lloyd Wright and the Prairie School
H. Allen Brooks, *The Prairie School: Frank Lloyd Wright and his Mid-west Contemporaries* (Toronto, 1972).
Giorgio Ciucci, 'The City in Agrarian Ideology and Frank Lloyd Wright: Origins and Development of Broad Acres', in *The American City* (Cambridge, Mass., 1979).
Leonard K. Eaton, *Two Chicago Architects and their Clients: Frank Lloyd Wright and Howard Van Doren Shaw* (New York, 1969).
Neil Levine, *The Architecture of Frank Lloyd Wright* (Princeton, 1996).
Henry Russell Hitchcock, *In the Nature of Materials* (New York, 1942).
Norris Kelly Smith, *Frank Lloyd Wright: a Study in Architectural Content* (American Life Foundation and Institute, 1979).

Individual architects
Thomas Hines, *Burnham of Chicago: Architect and Planner* (Oxford, 1974).
Mario Manieri-Elia, *Louis Henry Sullivan* (New York, 1996).
Narciso Menocal, *Architecture as Nature: the Transcendentalist Idea of Louis Sullivan* (Madison, 1981).
Robert C. Twombly, *Louis Sullivan: his Life and Work* (New York, 1986).

Chapter 3. Culture and Industry: Germany 1907–14

General
Louis Dumont, *German Ideology: from France to Germany and Back* (Chicago, 1994).
Norbert Elias, *The Civilizing Process* (Oxford, 1993).
Donald I. Levine (ed.), *Georg Simmel on Individuality and Social Forms* (Chicago, 1971).
George L. Mosse, *The Crisis in German Ideology* (New York, 1964, 1998).
Fritz Stern, *The Politics of Cultural Despair* (New York, 1965).

Aesthetics
Harry Francis Mallgrave and Eleftherios Ikonomu, *Empathy,*

Form and Space: Problems of German Aesthetics 1873–1893 (Los Angeles, 1994).
Michael Podro, *The Manifold of Perception: Theories of Art from Kant to Hildebrand* (Oxford, 1972), and *The Critical Historians of Art* (New Haven, 1982).
Mitchell Schwarzer, *German Architectural Theory and the Search for Modern Identity* (Cambridge, 1995).

The Deutscher Werkbund
Joan Campbell, *The German Werkbund: the Politics of Reform in the Applied Arts* (Princeton, 1978).
Francesco Dal Co, *Figures of Architecture and Thought* (New York, 1990).
Marcel Franciscono, *Walter Gropius and the Creation of the Bauhaus in Weimar* (Chicago, 1971).
Mark Jarsombek, 'The Kunstgewerbe, the Werkbund, and the Aesthetics of Culture in the Wilhelmine Period', *Journal of the Society of Architectural Historians*, 53, March 1994, 7–9.
Frederick J. Schwartz, *The Werkbund: Design Theory and Mass Culture before the First World War* (New Haven, 1996).

Style and ideology
Stanford Anderson, *Peter Behrens and a New Architecture for the Twentieth Century* (Cambridge, Mass., 2000).
Stanford Anderson, 'The Legacy of German Neoclassicism and Biedermeier: Tessenow, Behrens, Loos, and Mies', *Assemblage*, 15, 63–87.
Reyner Banham, *A Concrete Atlantis* (Cambridge, Mass., 1986), chapter 3 (for a discussion of Gropius's Fagus Factory).
Tilmann Buddensieg, *Industriekultur: Peter Behrens and the AEG*, trans. Iain Boyd Whyte (Cambridge, Mass., 1984).
Heinrich Tessenow, 'House Building and Such Things', in Richard Burdett and Wilfred Wang (eds), *9H*, no. 8, 1989, 'On Rigour'.

Chapter 4. The Urn and the Chamberpot: Adolf Loos 1900–30

Primary sources
Adolf Loos, *Ins Leere Gesprochen*, trans. *Spoken into the Void* (Cambridge, Mass., 1982).
A few scattered essays from *Trotzdem* have been translated and appear in Münz and Künstler, Safran and Wang, and Rissilada (see below).

General
Carl Schorske, *Fin-de-Siècle Vienna* (New York, 1980), chapters 2, 6, and 7.
Otto Wagner, *Modern Architecture* (1896), trans. Harry F. Mallgrave (Los Angeles, 1988).

The work of Adolf Loos
Massimo Cacciari, *Architecture and Nihilism: on the Philosophy of Modern Architecture* (New Haven, 1993).
Beatriz Colomina, *Privacy and Publicity: Modern Architecture and Mass Media* (Cambridge, Mass., 1994).
Benedetto Gravagnuolo, *Adolf Loos: Theory and Works* (New York, 1982).
Ludwig Münz and Gustav Künstler, *Adolf Loos, Pioneer of*

Modern Architecture (Vienna, 1964; London, 1966).
Max Rissalada (ed.), *Raumplan versus Plan Libre* (New York, 1988).
Burkhardt Rukschcio and Roland Schachel, *La Vie et l'Œuvre de Adolf Loos* (Brussels, 1982).
Yahuda Safran and Wilfred Wang (eds), *The Architecture of Adolf Loos* (The Arts Council of Great Britain, 1985).
Panayotis Tournikiotis, *Adolf Loos* (Princeton, 1994).

Chapter 5. Expressionism and Futurism
Expressionism
Primary sources
Paul Scheerbart, *Glasarchitektur* (Berlin, 1914), trans. *Glass Architecture* (New York, 1972).
Bruno Taut, *Alpine Architektur* (Hagen, 1919), trans. *Alpine Architecture* (New York, 1972).
Bruno Taut, *Frühlicht* (Berlin, 1963).
Bruno Taut, *Die Stadtkronen* (Jena, 1919).
Bruno Taut, *Ein Wohnhaus* (Stuttgart, 1927).

General
Rosemary Haag Bletter, 'The Interpretation of the Glass Dream: Expressionist Architecture and the History of the Crystal Metaphor' in the *Journal of the Society of Architectural Historians*, 40, no. 1, 1981, 20–43.
Marcel Franciscono, *Walter Gropius and the Creation of the Bauhaus in Weimar* (Chicago, 1971).
Donald E. Gordon, *Expressionism: Art and Idea* (New Haven, 1987).
Wolfgang Pehnt, *Expressionist Architecture* (New York, 1973).
Walter H. Sokel, *The Writer in Extremis: Expressionism in 20th Century German Literature* (Stanford University Press, 1954).
Rose-Carol Washton Long (ed.), *German Expressionism: Documents from the End of the Wilhelmine Period to the Rise of National Socialism* (G. K. Hall and Company, 1993).
Joan Weinstein, 'The November Revolution and the Institutionalization of Expressionism in Berlin', in R. Hertz and N. Klein (eds), *Twentieth-Century Art Theory* (New York, 1990).

Individual architects
Iain Boyd Whyte, *Bruno Taut and the Architecture of Activism* (Cambridge, 1982).

Futurism
Primary sources
Umbrio Apollonio (ed.), *Futurist Manifestos* (London, 1973).

General
Adrian Lyttleton, *The Seizure of Power: Fascism in Italy 1919–1929* (Princeton, 1973), chapter 14.
Marjory Perloff, *The Futurist Movement: Avant-Garde, Avant-Guerre and the Language of Rupture* (Chicago, 1986).
Caroline Tisdall and Angelo Bozzella, *Futurism* (Oxford, 1973).

Individual architects
Esther Da Costa Meyer, *The Work of Antonio Sant'Elia: Retreat into the Future* (New Haven, 1995).

Sanford Quinter, 'La Città Nuova, Modernity and Continuity', in *Zone*, 1986, 81–121.

Chapter 6. The Avant-gardes in Holland and Russia
Holland
Primary sources
Theo van Doesburg, *On European Architecture: Complete Essays from Het Bouwbedrijf 1924–1931* (Boston, 1990).

General
Carel Blotkamp (ed.), *De Stijl 1917–1922: the Formative Years* (Cambridge, Mass., 1982).
Yves-Alain Bois, *Painting as Model*, 'The De Stijl Idea' (Cambridge, Mass., 1990).
Warncke Carsten-Peter, *The Ideal as Art: De Stijl 1917–1931* (Cologne, 1994).
H. L. C. Jaffé, *De Stijl 1917–1931: the Dutch Contribution to Art* (Cambridge, Mass., 1986).
Jan Molena, *The New Movement in the Netherlands 1924–1936* (Rotterdam, 1996).
Nancy Troy, *The De Stijl Environment* (Cambridge, Mass., 1983).

Individual architects
Evert van Straaten, *Theo van Doesburg: Painter Architect* (The Hague, 1988).

Russia
Primary sources
Moise Ginsburg, *Style and Epoque* (Cambridge, Mass., 1982).
El Lissitzky, *Russia: an Architecture for World Revolution* (Cambridge, Mass., 1970; original: Vienna, 1930).

General
Stephen Bann, *The Tradition of Constructivism* (London, 1974).
Jean-Louis Cohen, 'Architecture and Modernity in the Soviet Union 1900–1937', in *A+U* (1991, part 1, no. 3, 46–67; part 2, no. 6, 20–41; part 3, no. 8, 13–19; part 4, no. 10, 11–21).
Catherine Cooke, *The Russian Avant-Garde: Theories of Art, Architecture and the City* (London, 1995).
Kenneth Frampton, 'The New Collectivity: Art and Architecture in the Soviet Union, 1918–1932' in Kenneth Frampton, *Modern Architecture: a Critical History* (London, 1982).
Hugh D. Hudson Jr., *Blueprints and Blood: the Stalinization of Soviet Architecture* (Princeton, 1994).
Selim O. Khan-Magomedov, *Pioneers of Soviet Architecture* (New York, 1987).
Anatole Kopp, *Town and Revolution: Soviet Architecture and City Planning 1917–1935* (New York, 1970).
Christina Lodder, *Russian Constructivism* (New Haven, 1983).
Oleg Shvidovsky, *Building in the USSR* (London, 1971).
Manfredo Tafuri and Francesco Dal Co, 'The Avant-Garde, Urbanism and Planning in Soviet Russia', in Manfredo Tafuri and Francesco Dal Co, *Modern Architecture* (Milan, 1972; New York, 1976).

Individual architects
Frederick S. Starr, *Konstantin Melnikov: Solo Architect in a Mass Society* (Princeton, 1978).

Chapter 7. Return to Order: Le Corbusier and Modern Architecture in France 1920–35

Writings by Le Corbusier
Le Corbusier, *Aircraft* (London, 1935).
Le Corbusier, *L'Art Décoratif d'Aujourd'hui* (Paris, 1925), trans. *The Decorative Art of Today* (London, 1987).
Le Corbusier, *Œuvre Complète*, vol. 1 1910–29, vol. 2 1929–34, vol. 3 1934–38 (Zürich).
Le Corbusier, *Précisions sur un Etat Présent de l'Architecture et de l'Urbanisme* (Paris, 1930), trans. *Precisions* (Cambridge, Mass., 1991).
Le Corbusier, *Quand les Cathédrales Etaient Blanches* (Paris, 1937), trans. *When the Cathedrals Were White* (London, 1947).
Le Corbusier, *Urbanisme* (Paris, 1925), trans. *The City of Tomorrow* (London, 1929).
Le Corbusier, *Vers une Architecture* (Paris, 1925), trans. *Towards a New Architecture* (London, 1927).
Le Corbusier, *La Ville Radieuse* (Editions de l'Architecture d'Aujourd'hui, 1933), trans. *The Radiant City* (London, 1964).
Le Corbusier, *Le Voyage d'Orient* (Paris, 1966), trans. Ivan Zaknic and Nicole Pertuiser (eds), *Journey to the East* (Cambridge, Mass., 1987).

Other primary sources
Sigfried Giedion, *Bauen in Frankreich, Bauen in Eisen, Bauen in Eisenbeton* (Leipzig, 1928), trans. *Building in France, Building in Iron, Building in Ferro-concrete* (Los Angeles, 1995).
On Le Corbusier
Timothy Benton, *The Villas of Le Corbusier* (New Haven, 1987).
Brian Brace Taylor, *Le Corbusier; the City of Refuge, Paris, 1929–1933* (Chicago, 1987).
H. Allen Brooks, *Le Corbusier's Formative Years* (Chicago, 1997) is the definitive work on the early career of Le Corbusier.
Jean-Louis Cohen, *Le Corbusier and the Mystique of the USSR* (Princeton, 1992).
Norma Evenson, *Le Corbusier: the Machine and the Grand Design* (New York, 1969).
Robert Fishman, *Urban Utopias* (Cambridge, Mass., 1977), Part III, chapters 18–28.
Nancy Troy, *Modernism and the Decorative Arts in France* (New Haven, 1991), chapters 2, 3, and 4.
Stanislas von Moos, *Le Corbusier: Elements of a Synthesis* (Cambridge, Mass., 1979), first published as *Le Corbusier, Elemente einer Synthese* (Zürich, 1968).

Other individual architects
Brian Brace Taylor, *Pierre Chareau, Designer and Architect* (Cologne, 1992).
Maurice Culot (ed.), *Robert Mallet-Stevens, Architecte* (Brussels, 1977).

Chapter 8. Weimar Germany: the Dialectic of the Modern 1920–33

Primary sources
Adolf Behne, *Der Moderne Zweckbau* (Munich, 1926, though written in 1923), trans. *The Modern Functional Building* (Los Angeles, 1996).
Theo van Doesburg, *On European Architecture: Complete Essays from Bouwbedrijf, 1924–1931* (Basel, 1990), 88 ff.
Both texts describe the controversy over functionalism and rationalism and give an insight into architectural discussions of the time.

General
Manfredo Tafuri, *The Sphere and the Labyrinth: Avant-gardes and Architecture from Piranesi to the 1970s* (Cambridge, Mass., 1987), chapters 4 and 7.
Rose-Carol Washton Long (ed.), *German Expressionism: Documents from the End of the Wilhelmine Period to the Rise of National Socialism* (New York, 1993), part 4.
John Willet, *Art and Politics in the Weimar Period: the New Sobriety 1917–1933* (New York, 1978).

The Bauhaus
Marcel Franciscono, *Walter Gropius and the Creation of the Bauhaus in Weimar* (Chicago, 1971).
Gillian Naylor, *The Bauhaus Reassessed* (London, 1985).

Social housing
Barbara Miller Lane, *Architecture and Politics in Germany, 1918–1945* (Cambridge, Mass., 1968).
Richard Pommer and Christian Otto, *Weissenhof 1927 and the Modern Movement in Architecture* (Chicago, 1991).
See also Tafuri, *The Sphere and the Labyrinth*, chapter 7.

Mies van der Rohe
Robin Evans, 'Mies van der Rohe's Paradoxical Symmetries', *AA Files*, 19, Spring 1990.
Fritz Neumeyer, *The Artless Word: Mies van der Rohe on the Building Art* (Cambridge, Mass., 1991) includes transcriptions of all Mies's writings.
Richard Padovan, 'Mies van der Rohe Reinterpreted', in *UIA: International Architect*, issue 3, 1984, 38–43.
Franz Schulze, *Mies van der Rohe: a Critical Biography* (Chicago, 1985).
Ignasi Sola Morales, 'Mies van der Rohe and Minimalism', in Detlef Mertins (ed.), *The Presence of Mies* (Princeton, 1994).
Wolf Tegethof, *Mies van der Rohe: the Villas and Country Houses* (Museum of Modern Art, New York, 1985).

ABC
Claude Schnaidt, *Hannes Meyer: Buildings, Projects, and Writings*, bilingual German and English edition (Switzerland, 1965).

Other architects
F. R. S. Yorke, *The Modern House* (London, 1934, 1962).

Chapter 9. From Rationalism to Revisionism: Architecture in Italy 1920–65

Dennis Doordan, *Building Modern Italy, Italian Architecture 1914–1936* (Princeton, 1988).
Richard Etlin, *Modernism in Italian Architecture, 1890–1940*

(Cambridge, Mass., 1991) covers both the Novecento and the Rationalist movements.

Vittorio Gregotti, *New Directions in Italian Architecture* (London, 1968).

Adrian Lyttleton, *The Seizure of Power: Fascism in Italy 1919–1929* (Princeton, 1987).

Manfredo Tafuri, *History of Italian Architecture, 1944–1985* (Cambridge, Mass., 1989).

Chapter 10. Neoclassicism, Organicism, and the Welfare State: Architecture in Scandinavia 1910–65

Denmark and Sweden

Scio Paavilainen (ed.), *Nordic Classicism 1910–1930* (Museum of Finnish Architecture, Helsinki, 1992).

Claes Caldenby, Jöran Lindvall, and Wilfred Wang (eds), *Twentieth-Century Architecture, Sweden* (Munich, 1998).

Kim Dirckinck, *Guide to Danish Architecture Vol. II 1960–1995* (Copenhagen, 1995).

Kenneth Frampton, *Studies in Tectonic Culture*, 'Jörn Utzon: Transcultural Form and the Tectonic Metaphor' (Cambridge, Mass., 1995).

Jorgen Sestoft and Jorgen Christiansen, *Guide to Danish Architecture Vol. I, 1800–1960* (Copenhagen, 1995).

Individual architects

Claes Dimling (ed.), *Architect Sigurd Lewerentz* (Stockholm, 1997).

Eva Rudberg, *Sven Markelius, Architect* (Stockholm, 1989).

Felix Salaguren Beascoa de Corral, *Arne Jacobsen Works and Projects* (Barcelona, 1989).

Wilfred Wang et al., *The Architecture of Peter Celsing* (Stockholm, 1996).

Stewart Wrede, *The Architecture of Gunnar Asplund* (Cambridge, Mass., 1980).

Finland

Taisto Makela, 'Architecture and Modern Identity in Finland' in Mariann Aav (ed.), *Finnish Modern Design: Utopian Ideals and Every-Day Reality* (New Haven, 1998).

Kirmo Mikkola, *Architecture in Finland in the 20th Century* (Helsinki, 1981).

Malcolm Quantrill, *Finnish Architecture and the Modernist Tradition* (London, 1995).

Individual architects

Karl Fleig (ed.), *Alvar Aalto*, vols. 1 and 2 (Zürich, 1963, 1978), a collection of the complete works of Aalto.

Paul David Pearson, *Alvar Aalto and the International Style* (New York, 1978).

Goran Schildt, *Alvar Aalto The Early Years, The Decisive Years, and The Mature Years* (New York, 1984–91).

Chapter 11. From Le Corbusier to Megastructures: Urban Visions 1930–65

General

H. Allen Brooks (ed.), *Le Corbusier* (Princeton, 1987).

Le Corbusier, *Œuvre Complète* (Zürich, 1929–70), vols. 2–7.

Stanislas von Moos, *Le Corbusier: Elements of a Synthesis* (Cambridge, Mass., 1979).

The New Monumentality

Christine C. and George R. Collins, 'Monumentality: a Critical Matter in Modern Architecture', in *Harvard Architectural Review*, vol. 4, no. 4, 1985, 15–35.

Sigfried Giedion, Josep Lluis Sert, and Fernand Léger, 'Nine Points on Monumentality', reprinted in Joan Ockman (ed.), *Architecture Culture 1943–1968* (New York, 1993), 29–30.

Chandigarh and Brasilia

Norma Evenson: *Chandigarh* (Berkeley and Los Angeles, 1966) and *Two Brazilian Cities* (New Haven, 1973).

Madhu Sarin, 'Chandigarh as a Place to Live in', in Russell Walden (ed.), *The Open Hand* (Cambridge, Mass., 1977).

James Holston, *The Modernist City: an Anthropological Critique of Brasilia* (Chicago, 1989).

CIAM and Team X

AAGS (Architectural Association General Studies), Theory and History Papers 1, 'The Emergence of Team X out of CIAM' (Architectural Association, London, 1982).

Le Corbusier, *La Charte d'Athènes* (1942), trans. *The Athens Charter* (New York, 1973).

Eric P. Mumford, *The CIAM Discourse of Urbanism, 1928–1959* (Cambridge, Mass., 2000).

Oscar Newman, *CIAM '59 in Otterlo* (Stuttgart, 1961).

Alison Smithson (ed.), *Team X Primer* (Cambridge, Mass., 1968).

Systems Theory

Ludwig von Bertalanffy, *General Systems Theory* (London, 1968).

Jean-François Lyotard, *The Post-Modern Condition* (Minneapolis, 1983).

Norbert Wiener, *The Human Use of Human Beings: Cybernetics and Society* (London and Boston, 1950).

Structuralism and Megastructures

Reyner Banham, *Megastructure* (London and New York, 1976).

Wim van Heuvel, *Structuralism in Dutch Architecture* (Rotterdam, 1992).

Hilde Heynen, 'New Babylon: the Antinomies of Utopia', in *Assemblage*, 29, April 1996, 25–39.

David B. Stewart, *The Making of a Modern Japanese Architecture, 1868 to the Present* (Tokyo and New York, 1987), chapters 7 and 8.

Situationists

Libero Andreotti and Xavier Costa (eds), *Situationists: Art, Politics, Urbanism* (Museu d'Art Contemporani de Barcelona, 1996).

Elisabeth Sussman (ed.), *On the Passage of a Few People Through a Rather Brief Moment in Time: the Situationist International, 1957–1972* (Cambridge, Mass., 1989).

Mark Wigley, *Constant's New Babylon: a Hyper-Architecture of Desire* (Rotterdam, 1998).

Chapter 12. Pax Americana: Architecture in the USA 1945–65

General

Donald Albrecht (ed.), *World War II and the American Dream: How War-time Building Changed a Nation* (Washington, DC, 1995).

William H. Jordy, *American Buildings and their Architects: the Impact of European Modernism in the Mid-Twentieth Century* (New York, 1976).

Joan Ockman, *Architecture Culture 1943–1968* (New York, 1993).

Arthur J. Pulos, *The American Design Adventure 1940–1975* (Cambridge, Mass., 1988).

Political and social background

Herbert Croly, *The Promise of American Life* (Cambridge, Mass., 1965), first published 1909.

C. Wright Mills, *The Power Elite* (Oxford, 1956, 2000).

David Riesman, *The Lonely Crowd* (New Haven, 1950).

Daniel T. Rodgers, *Atlantic Crossings: Social Politics in a Progressive Age* (Cambridge, Mass., 1998).

The Case Study House Program

Charles Eames, John Entenza, and Herbert Matter, 'What is a House?' in *Arts and Architecture*, July 1944.

Elizabeth A. T. Smith (ed.), *Blueprints for Modern Living: History and Legacy of the Case Study Houses* (Cambridge, Mass., 1989).

Charles Eames

John Neuhart, Marilyn Neuhart, and Ray Eames, *Eames Design: the Work of the Office of Charles and Ray Eames* (New York, 1989).

Eero Saarinen

Eero Saarinen, *Eero Saarinen on His Work* (New Haven, 1968).

Skidmore, Owings, and Merrill

Skidmore, Owings, and Merrill, *Architecture of Skidmore, Owings, and Merrill, 1950–1962* (New York, 1963).

Mies van der Rohe

Philip C. Johnson, *Mies van der Rohe* (Museum of Modern Art, New York, 1947).

Detlef Mertins (ed.), *The Presence of Mies* (Princeton, 1994).

Fritz Neumeyer, *The Artless Word* (Cambridge, Mass., 1991).

Louis Kahn

David B. Brownlee and David G. De Long, *Louis I. Kahn: in the Realm of Architecture* (New York, 1992).

Sarah Williams Ksiazak, 'Architectural Culture in the 1950s: Louis Kahn and the National Assembly at Dhaka', in *Journal of the Society of Architectural Historians*, vol. 52, December 1993, 416–35.

'Critiques of Liberal Individualism: Louis Kahn's Civic Projects 1947–1957', in *Assemblage*, 31, 1996, 56–79.

	Art and architecture	**Events**
1890	**1890** W. L. B. Jenney, Fair Store, Chicago Julius Langbehn, *Rembrandt als Erzieher* William Morris, *News from Nowhere*	**1890** Henrik Ibsen, *Hedda Gabler* Sioux Indians massacred at Wounded Knee, South Dakota Forth Bridge near Edinburgh completed Herman Hollerith develops a punch card machine, later founds IBM **1891** Whitcombe Judson invents the zipper
	1891 Antoni Gaudí begins transept façades of Sagrada Familia, Barcelona Daniel Burnham and John Wellborn Root, Monadnock Building, Chicago **1892** Louis Sullivan, Wainwright Building, St. Louis, and 'Ornament in Architecture'	**1892** François Hennebique patents a reinforced-concrete system Rudolph Diesel develops diesel engine Department of Social Sciences and Anthropology founded at the University of Chicago
	1893 Victor Horta, Hôtel Tassel, Brussels August Schmarsow, *The Essence of Architectural Creation* Adolf Hildebrand, *The Problem of Form in the Fine Arts* Alois Riegl, *Questions of Style* Munich Secession founded Edvard Munch, *The Scream*	**1893** World's Columbian Exposition, Chicago Thomas A. Edison invents the movie projector
	1894 Burnham and Co., Reliance Building, Chicago Henry Van de Velde, *The Purification of Art*	**1894** Claude Debussy, *Prelude to the Afternoon of a Faun* Guglielmo Marconi invents wireless telegraphy Jesse W. Reno invents the escalator Dreyfus Affair begins in France Sino-Japanese War begins
	1895 Henry Van de Velde, Bloemenwerf, Uccle, Belgium Siegfried Bing opens L'Art Nouveau gallery, Paris	**1895** Lumière brothers show first motion pictures using film projection Wilhelm Konrad von Roentgen discovers X-rays Joseph Thomson discovers the electron H. G. Wells, *The Time Machine* London School of Economics founded
	1896 Louis Sullivan, 'The Tall Office Building Artistically Considered' Otto Wagner, *Modern Architecture* Henri Bergson, *Matter and Memory* **1897** Alfred Lichtwark forms Art Education Movement in Germany Vereinigten Werkstätten founded in Munich Vienna Secession founded	**1896** Henri Becquerel founds science of radioactivity First modern Olympics held **1897** Emile Durkheim, *Suicide: A Study in Sociology* Jane Addams founds Hull House in Chicago Theodor Herzl calls first Zionist Congress Ivan Pavlov conducts classical conditioning experiments
	1898 Antoni Gaudí begins Chapel of the Colonia Güell, Barcelona Héctor Guimard, Castel Béranger, Paris Otto Wagner, Majolica House, Vienna Dresdner Werkstätten für Handwerkskunst founded	**1898** H. G. Wells, *War of the Worlds* Spanish-American War
	1899 Karl Kraus founds *Die Fackel* in Vienna Thorstein Veblen, *Theory of the Leisure Class* Victor Horta, Maison du Peuple, Brussels Founding of artists' colony, Darmstadt, Germany	**1899** Boxer Rebellion begins in China Boer War begins in South Africa Max Planck proposes quantum theory
1900	**1900** Héctor Guimard, Paris Métro stations	**1900** World's Fair, Paris Sigmund Freud, *Interpretation of Dreams* John Ruskin dies

Art and architecture

1901	Frank Lloyd Wright lecture on 'The Art and Craft of the Machine', Chicago Alois Riegl, *The Late Roman Art Industry*
1902	Ferdinand Avenarius forms the Dürerbund in Germany Benedetto Croce, *Aesthetic as Science of Expression and General Linguistic*
1903	Auguste Perret, apartment house at 25 Rue Franklin, Paris Georg Simmel, 'The Metropolis and Mental Life' Wiener Werkstätte founded H. P. Berlage, Stock Exchange, Amsterdam
1904	Hermann Muthesius, *Das Englische Haus* Bund Heimatschutz formed in Germany
1905	Paul Mebes, *Um 1800* Fauvism emerges at the Salon d'Automne in Paris Expressionists form Die Brücke in Dresden
1906	Alfred Stieglitz and Edward Steichen open Little Gallery of the Photo-Secession in New York Alexandr Bogdanov founds Proletkult in Russia
1907	Deutscher Werkbund founded in Munich Peter Behrens appointed design consultant to AEG Adolf Loos, Kärntner Bar, Vienna Mies van der Rohe, Riehl House, Potsdam, Germany Cubism developed by Pablo Picasso and Georges Braque in Paris
1908	Adolf Loos, 'Ornament and Crime' Ernst Ludwig Kirchner, *Street, Dresden* Wilhelm Worringer, *Abstraction and Empathy*
1909	Daniel Burnham and Edward Bennett, Plan of Chicago Raymond Unwin, *Town Planning in Practice* Sergei Diaghilev founds Ballets Russes in Paris Filippo Tommaso Marinetti, 'The Foundation and Manifesto of Futurism' Peter Behrens, AEG Turbine Factory, Berlin Neue Künstler Vereinegung founded in Munich
1910	Herwarth Walden founds Expressionist *Der Sturm* review in Berlin First of two Wasmuth volumes on Frank Lloyd Wright published in Europe
1911	Walter Gropius lectures on 'Kunst und Industriebau', Germany First Blaue Reiter art exhibition, Munich Futurist exhibition, Milan Adolf Loos, Looshaus, Vienna Wassily Kandinsky, *Concerning the Spiritual in Art*

Events

1901	First transatlantic radio telegraphic transmission Victor Talking Machine Co. formed Queen Victoria of England dies Colonies of Australia united
1902	Willis H. Carrier invents air conditioning Marie and Pierre Curie discover radium
1903	Emmeline Goulden Pankhurst forms Women's Social and Political Union in Britain Orville and Wilbur Wright achieve first powered aircraft flight Ford Motor Company formed in Detroit
1904	Isadora Duncan founds school of modern dance in Berlin Russo-Japanese War begins
1905	First Russian Revolution fails Albert Einstein formulates the special theory of relativity
1906	Upton Sinclair, *The Jungle*
1907	William James, *Pragmatism* Henry Adams, *The Education of Henry Adams*
1908	Georges Sorel, *Reflections on Violence* Young Turk Revolution in Turkey
1909	P. D. Ouspensky, *The Fourth Dimension* First newsreel films Louis Blériot flies across the English Channel
1910	Igor Stravinsky, *The Firebird* Arnold Schönberg formulates an Expressionist atonal music system Boer republics united as South Africa
1911	Frederick Taylor, *The Principles of Scientific Management* Gustav Mahler, *Ninth Symphony* Roald Amundsen reaches South Pole

1910

Art and architecture

1912	Daniel Burnham & Co., Conway Building, Chicago
	Mikhail Larionov and Natalia Goncharova create Rayonism in Russia
	Walter Gropius, Fagus Factory, Alfeld an der Leine, Germany
	Marcel Duchamp, *Nude Descending a Staircase*
1913	Kasimir Malevich founds Suprematist movement in Russia
1914	Antonio Sant'Elia, project for La Città Nuova
	Deutscher Werkbund exhibition, Cologne
	Paul Scheerbart, *Glasarchitektur*
	Giorgio de Chirico, *Mystery and Melancholy of a Street*
	Le Corbusier, Dom-ino frame
1915	Heinrich Wölfflin, *Principles of Art History*
	Alfred Stieglitz, Marcel Duchamp, and Francis Picabia found journal *291* in New York
1916	Hugo Ball founds Cabaret Voltaire in Zurich and begins Dada movement
1917	Henry van de Velde, *Formules de la Beauté Architectonique Moderne*
	De Stijl first published in the Netherlands
	Berlin Dada movement founded
1918	Novembergruppe and Arbeitsrat fur Kunst formed in Germany
	De Stijl Manifesto
1919	Bauhaus established by Walter Gropius in Weimar
	Exhibition for Unknown Architects, Berlin
	Bruno Taut, *Alpine Architektur*
1920	Hans Poelzig, project for Salzburg Festspielhaus
	Vladimir Tatlin, project for a Monument to the Third International
	Bruno Taut founds magazine *Frühlicht*
	Le Corbusier and Amédée Ozenfant found the review *L'Esprit Nouveau* in Paris
	First International Dada Fair, Berlin
1921	Wassili Luckhardt, People's Theatre project
	Theo van Doesburg moves to Weimar
	First Working Group of Constructivists formed in Moscow
1922	Otto Bartning, Sternkirche project, Germany
	Adolf Behne, 'Kunst, Handwerk, Technik'
	Chicago Tribune Tower competition
	Le Corbusier, Ville Contemporaine

Events

1912	The sinking of the Titanic
	African National Congress founded in South Africa
1913	First performance of Igor Stravinsky's *The Rite of Spring*
	Marcel Proust publishes first volume of *Remembrance of Things Past*
	Niels Bohr develops quantum mechanics
	Standard time signal issued worldwide
1914	Wyndham Lewis and Ezra Pound found magazine *BLAST* in London and create Vorticism
	First World War breaks out following assassination of Archduke Franz Ferdinand of Austria in Serbia
	Panama Canal opens
1915	D. W. Griffith, *The Birth of a Nation*
	Albert Einstein publishes *General Theory of Relativity*
1916	M. H. J. Schoenmaeker, *The Principles of Plastic Mathematics*
	Easter Rebellion against British in Ireland
1917	D'Arcy Wentworth Thompson, *On Growth and Form*
	Bolsheviks seize power in Russia
	America enters First World War
1918	Oswald Spengler, *The Decline of the West*
	First World War ends
	Civil War begins in Russia
1919	Robert Wiene, *Cabinet of Dr. Caligari*
	Treaty of Versailles between First World War Allies and Germany
	Spartacus workers' uprising in Berlin
	League of Nations founded
	Ernest Rutherford splits the atom
1920	Britain establishes Jewish state in Palestine
	Irish Civil War
	Suffrage granted to women in the USA
	Vladimir Lenin institutes the New Economic Plan (NEP)
	First commercial radio broadcast
1921	Ludwig Wittgenstein, *Tractatus logico-philosophicus*
	Karel Capek coins term 'robot' in play *R.U.R.*
	British Broadcasting Corporation (BBC) founded
1922	Sigmund Freud, *Beyond the Pleasure Principle*
	F. W. Murnau, *Nosferatu*
	Arnold Schönberg first employs serial system in Op. 25 *Piano Suite*
	T. S. Eliot, *Waste Land*

1920

Art and architecture

1922 Dada–Constructivist meeting, Weimar
Adolf Loos, Rufer House, Vienna
Alexei Gan, Konstruktivizm manifesto
El Lissitzky founds *Veshch* (*Object*) in Berlin
Hans Richter, El Lissitzky, and Werner Gräf found journal *G* in Berlin
László Moholy-Nagy joins Bauhaus
Exhibition of Soviet Art, Berlin
Giovanni Muzio, Ca' Brutto, Milan

1923 'Art and Technology: A New Unity' exhibition, Bauhaus, Weimar
Adolf Behne writes *Der Moderne Zweckbau*, published in 1926
Mies van der Rohe, Lessing House project
Exhibition of work of Theo van Doesburg and Cor van Eesteren in Paris
Nikolai Ladovsky founds Association of New Architects (ASNOVA)

1924 Gerrit Rietveld, Schroeder House, Utrecht, the Netherlands
Robert Mallet-Stevens, Project for a Villa
Swiss journal *ABC* begins publication
Moisei Ginsburg, *Style and Epoch*
André Breton, 'Manifesto of Surrealism'
Erich Mendelsohn, Einstein Tower, Potsdam, Germany

1925 Le Corbusier, *Vers une Architecture*
Exposition des Arts Décoratifs et Industriels, Paris
Bauhaus moves to Dessau
Ernst May appointed city architect for Frankfurt-am-Main
Neue Sachlichkeit exhibition, Mannheim
Union of Contemporary Architects (OSA) formed

1926 Adolf Loos, Tristan Tzara House, Paris
Hannes Meyer and Hans Wittwer, Petersschule, Basel
El Lissitzky, *Proun Room*, Hanover
Grete Schütte-Lihotsky, Frankfurt Kitchen
Paul Schultze-Naumburg, *ABC des Bauens*
Gruppo 7 formed in Milan

1927 Deutscher Werkbund-sponsored exhibition, Weissenhofsiedlung, Stuttgart
Ilya Golosov, Zuyev Workers' Club, Moscow
Ivan Leonidov, Lenin Institute project, Moscow

1928 Sigfried Giedion, *Building in France, Building in Iron, Building in Ferro-concrete*
First meeting of CIAM at La Sarraz, Switzerland
László Moholy-Nagy, *Von Material zu Architektur*
Adolf Loos, Moller House, Vienna
Walter Gropius, Siemensstadt, Berlin
Rudolf Steiner, Goetheanum, Dornach, Switzerland

Events

1922 James Joyce, *Ulysses*
USSR formed
Foreign Minister Walter Rathenau assassinated in Germany
Reform in Turkey led by Ataturk

1923 Ernst Cassirer publishes first of three volumes of *Philosophy of Symbolic Forms*
Georg Lukács, *History and Class-Consciousness*
Leon Trotsky, *Literature and Revolution*
Hyperinflation in Germany
Neon advertising signs introduced
Rainer Maria Rilke, *Duino Elegies*
René Clair inaugurates Surrealist film with *Entr'acte*
Ferdinand Léger and Dudley Murphy, *Ballet mécanique*

1924 Rudolf Steiner founds Anthroposophy Society
Thomas Mann, *The Magic Mountain*

1925 Charlie Chaplin, *The Gold Rush*
Sergei Eisenstein, *Battleship Potemkin*
John Dos Passos, *Manhattan Transfer*
F. Scott Fitzgerald, *The Great Gatsby*
Scopes evolution trial in USA
Alban Berg, *Wozzeck*
Adolf Hitler, *Mein Kampf*

1926 Fritz Lang, *Metropolis*
John Logie Baird, C. F. Jenkins, and D. Mihaly invent the television

1927 Martin Heidegger, *Being and Time*
The Jazz Singer, first motion picture with sound
Joseph Stalin comes to power in USSR
Charles Lindbergh makes first solo transatlantic flight

1928 Bertholt Brecht and Kurt Weill, *Threepenny Opera*
André Breton, *Nadja*
Equal voting rights granted to women in Britain
First Five Year Plan in the USSR
Alexander Fleming discovers penicillin

Art and architecture		Events	
1929	Moisei Ginsburg, Narkomfin apartment block, Moscow Mies van der Rohe, Barcelona Pavilion Museum of Modern Art founded in New York Henry Russell Hitchcock, *Modern Architecture* Johannes Brinkman and Leendert Cornelis van der Vlugt, Van Nelle Factory, Rotterdam	1929	Louis Buñuel and Salvador Dali, *Un Chien Andalou* Dziga Vertov, *The Man with a Movie Camera* Eugène Freysinnet develops prestressed concrete Karl Mannheim, *Ideology and Utopia* Martha Graham founds dance company Hugo Eckener flies around the world Stock market crash on Wall Street marks beginning of Great Depression
1930	Adolf Loos, Müller House, Prague Erik Gunnar Asplund, Stockholm Industrial Arts Exhibition buildings Mies van der Rohe, Tugendhat House, Brno, Czech Republic Ernst May and Hannes Meyer move to the Soviet Union	1930	Ortega y Gasset, *Revolt of the Masses* Luis Buñuel, *L'Age d'or* Gandhi's Salt March, India Robert Maillart, Salginatobel Bridge, Switzerland First World Cup soccer match
1931	Le Corbusier, Villa Savoye, Poissy, France Berlin Building Exposition Salvador Dali, *The Persistence of Memory*	1931	Fritz Lang, *M* George Washington Bridge in New York completed
1932	The Dessau Bauhaus closes 'The International Style: Architecture since 1922' exhibition at MoMA, New York Rockefeller Center opens in New York	1932	Aldous Huxley, *Brave New World* Social Democrats come to power in Sweden BASF and AEG develop magnetic tape recording in Germany
1933	Le Corbusier, Ville Radieuse Le Corbusier, Cité de Refuge, Paris Alvar Aalto, Tuberculosis Sanatorium, Paimio, Finland Emil Kaufmann, *Von Ledoux bis Corbusier* Surrealist review *Minotaure* founded in Paris	1933	Alexander Kojève begins lectures on Hegel in Paris André Malraux, *Man's Fate* Adolf Hitler becomes chancellor of Germany American Congress adopts New Deal social and economic measures
1934	Socialist Realism ordained as official style in USSR John Dewey, *Art as Experience* Henri Focillon, *The Life of Forms in Art* Herbert Read, *Art and Industry*	1934	Cole Porter, *Anything Goes* Lewis Mumford, *Technics and Civilization* Arnold Toynbee, first volume of *The Study of History* Mao Tse-tung begins Long March in China Stalin begins purge of political leaders in the USSR
1935	Mies van der Rohe, Hubbe House project, Magdeburg, Germany J. J. P. Oud, *Nieuwe Bouwkunste in Holland en Europe* Marcello Piacentini, University of Rome	1935	John Maynard Keynes, *General Theory of Employment, Interest and Money* Hoover Dam completed in Colorado, America Leni Riefenstahl, *Triumph of the Will* Charlie Chaplin, *Modern Times* Popular Front comes to power in France
1936	Nikolaus Pevsner, *Pioneers of the Modern Movement* Frank Lloyd Wright, Falling Water, Bear Run, Pennsylvania Giuseppe Terragni, Casa del Fascio, Como, Italy	1936	Spanish Civil War begins BBC inaugurates television service Alan Turing adumbrates a programmable computer
1937	Degenerate Art Exhibition staged by Hitler in Munich Pablo Picasso, *Guernica*	1937	American aviator Amelia Earhart lost over Pacific Jean Renoir, *The Great Illusion*
1938	Alvar Aalto, Villa Mairea, Noormarkku, Finland	1938	Kristallnacht attack on Jews in Germany Munich Pact between Britain, France, Germany and Italy Arthur H. Compton and George Inman invent the fluorescent light

1930

Art and architecture

1939	Clement Greenberg, 'Avant-Garde and Kitsch' Erwin Panofsky, *Studies in Iconology*
1940	Hans Hofmann's *Spring* marks the beginning of Abstract Expressionism in America
1941	Sigfried Giedion, *Space, Time and Architecture*
1942	Espoizione Universale di Roma (EUR) planned but never opened
1943	
1944	Patrick Abercrombie, Greater London Plan
1945	Bruno Zevi, *Towards an Organic Architecture*
1946	Knoll Associates founded Mario Ridolfi, *Manuale dell'architetto*
1947	First Levittown suburban tract development founded on Long Island, New York The New Empiricism movement begins in Sweden László Moholy-Nagy, *Vision in Motion* Jackson Pollock begins drip paintings
1948	Sigfried Giedion, *Mechanization Takes Command* COBRA group of painters founded Hans Sedlmayr, *Art in Crisis: The Lost Center*
1949	Rudolf Wittkower, *Architectural Principles in the Age of Humanism* Alison and Peter Smithson, Hunstanton School, Norfolk, Britain Philip Johnson, Glass House, New Canaan, Connecticut Eames House, Pacific Palisades, California INA Casa created in Italy
1950	Bruno Zevi, *A History of Modern Architecture* Jean Dubuffet's *Le Metafisyx (Corps de Dame)* exemplifies art brut
1951	Festival of Britain, London Le Corbusier and others begin plan of Chandigarh E. H. Gombrich, 'Meditations on a Hobby Horse'
1952	Le Corbusier, Unité d'Habitation, Marseilles Alvar Aalto, Säynätsalo Town Hall, Finland

Events

1939	German invasion of Poland begins Second World War New York World's Fair
1940	Robert M. Page invents radar
1941	Tacoma Narrows Bridge collapses in USA Orson Welles, *Citizen Kane* Japan bombs Pearl Harbor in Hawaii: America enters the war
1942	Enrico Fermi and Manhattan Project create first artificial atomic reaction
1943	Jean Paul Sartre, *Being and Nothingness*
1944	Germany develops V2 rocket Allies stage D-Day invasion of Normandy
1945	John von Neumann theorizes a programmable computer Roberto Rossellini, *Rome, Open City* Germany surrenders, ending Second World War in Europe America drops atomic bombs on Japan
1946	United Nations established New Town Act, Britain ENIAC electronic vacuum tube computer developed
1947	India gains independence, state of Pakistan created General Agreement on Tariffs and Trade (GATT) established in Geneva Chuck Yeager flies at supersonic speed
1948	Vittorio de Sica, *The Bicycle Thieves* Marshall Plan institutes American financial aid to Europe Communists assume power in Czechoslovakia Berlin blockade and airlift Gandhi assassinated Nation of Israel established Scientists at Bell Labs invent transistor Norbert Wiener, *Cybernetics*
1949	Claude Lévi-Strauss, *The Elementary Structures of Kinship* Arthur Miller, *Death of a Salesman* George Orwell, *Nineteen Eighty-Four* North Atlantic Treaty Organization (NATO) founded Eastern Germany becomes an independent state under Communist government Apartheid instituted in South Africa Mao Tse-tung seizes power in China
1950	David Riesman, *The Lonely Crowd* Korean War begins
1951	Akira Kurosawa, *Rashomon* Marshall McLuhan, *The Mechanical Bride* Computers sold commercially
1952	Samuel Beckett, *Waiting for Godot* John Cage, *4'33"* America explodes first hydrogen bomb

1940

1950

Art and architecture		Events	
1952	Independent Group established in London Michel Tapié, *An Other Art*		
1953	Meyer Shapiro, 'Style'	1953	Edmund Hillary and Tenzing Norgay reach the summit of Mount Everest Francis H. C. Crick and James D. Watson discover DNA
1954	Richard Buckminster Fuller, geodesic dome Mario Ridolfi and Ludovico Quaroni, Tiburtino Housing Estate, Rome	1954	Vietnam divided after French defeat Algerian war of independence begins Construction of Disneyland in Anaheim, California begins
1955	Robert Rauschenberg's *The Bed* establishes American Pop Art	1955	Vladimir Nabokov, *Lolita* Jonas Salk announces development of polio vaccine
1956	Lúcio Costa and Oscar Niemeyer begin Brasilia plan Sigurd Lewerentz, St. Mark's Church, Biörkhaven, Sweden Team X challenge to CIAM	1956	Federal Interstate Highway Act passed in America Nikita Khrushchev denounces Stalin in the USSR Hungarian uprising put down by USSR
1957	Jørn Utzon, Sydney Opera House Situationist International formed in Paris Constant begins New Babylon series Carlo Scarpa, Gipsoteca Canoviana, Treviso, Italy	1957	Roland Barthes, *Mythologies* Ingmar Bergman, *The Seventh Seal* Leonard Bernstein, *West Side Story* Jack Kerouac, *On the Road* Sputnik satellite launched by USSR
1958	BPR, Torre Velasca, Milan	1958	European Economic Community (EEC) founded
1959	Alvar Aalto, Vuoksenniska Church, Imatra, Finland Giuseppe Samonà, *Urbanism and the Future of the City* Ludovico Quaroni, plan for Quartiere Cepalle Barene di S. Giuliano in Mestre, Italy	1959	Jean-Luc Godard, *Breathless* François Truffaut, *The 400 Blows* C. P. Snow, *The Two Cultures and the Scientific Revolution* Jack S. Kilby of Texas Instruments invents the integrated circuit Nixon–Khrushchev 'Kitchen Debate' Fidel Castro seizes power in Cuba
1960	Reyner Banham, *Theory and Design in the First Machine Age*	1960	Federico Fellini, *La Dolce Vita* Sharpeville massacre in South Africa
1961	Archigram group formed in Britain Jane Jacobs, *The Death and Life of Great American Cities*	1961	Russian cosmonaut Yuri Gagarin becomes first man to travel in space Berlin Wall erected American invasion of Cuba at the Bay of Pigs Construction begins on the Severn Bridge, Britain
1962	George Kubler, *The Shape of Time* Richard Buckminster Fuller, project for a geodesic dome over midtown Manhattan Andy Warhol, *Marilyn Monroe* Louis Kahn begins work on capital complex at Dhaka	1962	Jorge Luis Borges, *Labyrinthe* Rachel Carson's *Silent Spring* begins a new environmental movement Thomas Kuhn, *The Structure of Scientific Revolutions* Cuban missile crisis
1963	Roy Lichtenstein, *Whaam*	1963	Thomas Kurtz and John Kemeny develop BASIC computer language Betty Friedan, *The Feminine Mystique* President John F. Kennedy assassinated in Dallas Cultural Revolution begins in China
1964	Donald Judd and others exhibit first Minimalist works in New York Bernard Rudofsky, *Architecture without Architects* exhibition, MoMA, New York Giovanni Michelucci, Church of S. Giovanni, Florence	1964	New York World's Fair Gulf of Tonkin Resolution signals America's entry into war in Vietnam
1965	Peter Celsing begins work on Culture House complex, Stockholm Reyner Banham, 'A House is not a Home' Le Corbusier dies	1965	India–Pakistan War American forces sent to Vietnam IBM develops word processing

1960

List of Illustrations

The author and publisher would like to thank the following individuals and institutions who have kindly given permission to reproduce the illustrations listed below.

dance performance, with a set by Adolphe Appia. Photo Institut Jaques-Dalcroze, Geneva. CID.

37. Peter Behrens, AEG Pavilion, Shipbuilding Exposition, 1908, Berlin. © DACS 2002.

38. Peter Behrens. Design for the cover of an AEG prospectus, 1910. © DACS 2002.

39. Peter Behrens. AEG Turbine Factory, 1908–9, Berlin. Photo Achim Bednorz, Cologne. © DACS 2002.

40. Peter Behrens. AEG Turbine Factory, 1908–9, Berlin, detail of rocker. Photo Achim Bednorz, Cologne. © DACS 2002.

41. Peter Behrens. AEG Turbine Factory, 1908–9, Berlin, corner buttress. Photo Achim Bednorz, Cologne. © DACS 2002.

42. Walter Gropius and Adolf Meyer. Fagus Factory, 1911–12, Alfeld an der Leine. AKG London/photo Erik Bohr.

43. Walter Gropius and Adolf Meyer. Fagus Factory, 1911–12, Alfeld an Leine, entrance lobby. Photo Achim Bednorz, Cologne.

44. Adolf Loos. Kärntner Bar, 1907, Vienna. AKG London/photo Erich Lessing. © DACS 2002.

45. Adolf Loos. The Looshaus, 1909–11, Michaelerplatz, Vienna. Adolf Loos Archiv, Grafische Sammlung Albertina, Vienna. © DACS 2002.

46. Adolf Loos. Chest of drawers, c.1900. Courtesy Board of Trustees of the Victoria & Albert Museum, London. © DACS 2002.

47. Adolf Loos. Scheu House, 1912, Vienna. Adolf Loos Archiv, Grafische Sammlung Albertina, Vienna. © DACS 2002.

48. Adolf Loos. Müller House, 1929–30, Prague. Drawing from M. Risselada (ed.), *Raumplan versus Plan Libre* (Delft University Press, 1987), p. 79. © DACS 2002.

49. Adolf Loos. Moller House, 1927–8, Vienna, plan and section from M. Risselada (ed.) *Raumplan versus Plan Libre* (Delft University Press, 1987), p. 35, fig. 25. © DACS 2002.

50. Adolf Loos. Rufer House, 1922, diagrammatic elevations, from P. Tournikiotis, *Adolf Loos* (Princeton Architectural Press, 1994; original edition Editions Macula, Paris), p. 68, fig. 49a. © DACS 2002.

51. Adolf Loos. Scheu House, 1912, Vienna. Adolf Loos Archiv, Grafische Sammlung Albertina, Vienna. © DACS 2002.

52. Adolf Loos. Müller House, 1929–30, Prague. Adolf Loos Archiv, Grafische Sammlung Albertina, Vienna. © DACS 2002.

53. Antonio Sant'Elia. Power Station, 1914. Consuelo Accetti Collection, Milan.

54. Oskar Kokoschka. Murderer, Hope of Women, 1909. Poster. © DACS 2002.

55. Bruno Taut. Haus des Himmels, 1919, from *Frühlicht*. RIBA Library, London. 56 Bruno Taut. Snow, Ice, Glass, from *Alpine Architektur* (1919). RIBA Library, London.

57. Bruno Taut. Glass Pavilion, Werkbund Exhibition, 1914, Cologne. Werkbundarchiv, Museum der Dinge, Berlin.

58. Hans Poelzig. Grosses Schausspielhaus, 1919, Berlin (demolished c.1980). Bildarchiv Foto Marburg.

59. Wassili Luckhardt. Project for a People's Theatre, 1921, external view, plan and section. Stiftung Archiv der Akademie der Künste, Sammlung Baukunst, Berlin.

60. Otto Bartning. Sternkirche, 1922. Technisches Universität Darmstadt.

61. Rudolf Steiner. Goetheanum, 1924–8, Dornach. Photo Achim Bednorz, Cologne. © DACS 2002.

62. Hermann Finsterlin. Traum aus Glas, 1920. Watercolour, 19 × 29 cm. Graphische Sammlung (inv. GL1277), Staatsgalerie, Stuttgart.

63. Wenzel Hablik. Exhibition Building, 1920. Watercolour. Wenzel Hablik Museum, Itzehoe.

64. Jefim Golyscheff. Little Houses with Illuminated Roofs, 1920.

65. Umberto Boccioni. Dynamism of a Speeding Horse + Houses. 1914–15. Gouache and oil on wood and cardboard, with collage, copper and iron sheet, tin coating 112.9 × 115 cm. The Solomon R. Guggenheim Foundation, Peggy Guggenheim Collection, Venice/photo David Heald.

66. Antonio Sant'Elia. Modern Building, 1913. Museo Civico, Como.

67. Jože Plečnik. A page from the Rome sketchbook: a monument to Victor Emmanuel, 1899. Architectural Museum, Ljubljana.

68. Antonio Sant'Elia. La Città Nuova, 1914. Museo Civico, Como.

69. Otto Wagner. Project from the Ferdinandsbrücke, 1905, Vienna.

70. Emil Hoppe. Sketch for a tower, 1902.

71. Umberto Boccioni. Table+Bottle+Houses, 1912. Axonometric drawing. Private Collection.

72. Piet Mondrian. Composition I with Red, Yellow and Blue, 1921. 103 × 100 cm. Gemeentemuseum, The Hague/© 2002 Mondrian/Holtzman Trust c/o Beeldrecht, Amsterdam, Holland and DACS, London.

73. Vilmos Huszar. Spatial Colour Composition for a Stairwell, 1918. From *Levende Kunst*, 2 (1919), p. 60. © DACS 2002.

74. Jan Wils. De Dubbele Sleutel, 1918. Wils Archive (inv. 1711), Netherlands Architecture Institute, Rotterdam.

75. Theo van Doesburg and Hans Vogel. Studies for Purely Architectural Sculpture Resulting from Ground Plan, 1921. Netherlands Institute for Cultural Heritage, Rijswijk (Amsterdam)/photo Kim Koster. © DACS 2002.

76. Theo van Doesburg and Cornelis Van Eesteren. Axonometric drawing of Hôtel Particulier, 1923. Collection Van Eesteren-Fluck en Van Lohuizen-Foundation, The Hague/photo Netherlands Architecture Institute, Rotterdam. © DACS 2002.

77. Theo van Doesburg. Counter-construction (Construction in Space-Time II), 1923. Gouache, ink and pencil on paper, 46 × 39.7 cm © Museo Thyssen-Bornemisza (inv. 527), Madrid. © DACS 2002.

78. J. J. P. Oud. Social Housing, 1924–7, Hook of Holland. RIBA Photographs Collection, London. © DACS 2002.

79. Johannes Brinkman and Leendert Cornelis van der Vlugt. Sonneveld House, 1928. Netherlands Photo Archive (Collection Jan Kamman)/Netherlands Architecture Institute, Rotterdam.

80. Nikolai Ladovsky. Design for a Commune, 1920.

81. Kasimir Malevich. Arkhitekton, 1924.

82. Vladimir Tatlin. Monument to the Third International, 1919–20. Society for Co-operation in Russian and Soviet Studies, London.

83. Alexander Rodchenko. Drawing of a chess table, 1925. Rodchenko Archiv, Moscow. © DACS 2002.

84. Lyubov Popova. Set for Meyerhold's Bio-mechanical Theatre, 1922.

85. Alexander and Viktor Vesnin. Competition Design for the Moscow Headquarters of the Leningrad Pravda, 1924. © DACS 2002.

86. Moisei Ginsburg. Narkomfin Housing, 1928–9, Moscow.

87. Konstantin Melnikov. The USSR Pavilion, Exposition des Arts Décoratifs, 1925, Paris.

88. Ivan Leonidov. The Lenin Institute of Librarianship, 1927. From A. Kopp, *Architecture et Urbanism Sovietiques des Années Vingt. Ville et Révolution* (Paris: Editions Anthropos, 1967), p. 199.

89. Boris Iofan. Palace of the Soviets, 1931–3. Photo Novosti (London).

90. Jeanneret/Le Corbusier. Still Life, 1919. © Fondation Le Corbusier (FLC 304), Paris. © FLC/ADAGP, Paris and DACS, London 2002.

91. Le Corbusier and Pierre Jeanneret. Pavillon de L'Esprit Nouveau at the Exposition des Arts Décoratifs, 1925, Paris. © Fondation Le Corbusier, Paris. © FLC/ADAGP, Paris and DACS, London 2002.

92. Auguste Perret. Musée des Travaux Publics, 1936–46, Paris. L'Institut Français d'Architecture, Paris.

93. Le Corbusier. Dom-ino Frame, 1914. © Fondation Le Corbusier (FLC 19209), Paris. © FLC/ADAGP, Paris and DACS, London 2002.

94. Le Corbusier. Citrohan House, 1925–7, Weissenhofsiedlung, Stuttgart. © Fondation Le Corbusier (L1(2)40), Paris. © FLC/ADAGP, Paris and DACS, London 2002.

95. Rob Mallet-Stevens. Project for a Villa, 1924. © ADAGP, Paris and DACS, London 2002.

96. Le Corbusier. Housing, 1928. Pessac. © FLC/ADAGP, Paris and DACS, London 2002.

97. Le Corbusier. Four House Types, 1929. © Fondation Le Corbusier, Paris. © FLC/ADAGP, Paris and DACS, London 2002.

98. Le Corbusier. Villa Savoye, 1929–31, Poissy. Photo Jaime Ardiles-Arce, New York/ *Architectural Digest*, New York and Los Angeles. © FLC/ADAGP, Paris and DACS, London 2002.

99. Le Corbusier. Villa Savoye, 1929–31, Poissy. First floor. © Fondation Le Corbusier (L2(17)35), Paris. © FLC/ADAGP, Paris and DACS, London 2002.

100. Le Corbusier. Villa Savoye, 1929–31, Poissy. Plans. © Fondation Le Corbusier, Paris. © FLC/ADAGP, Paris and DACS, London 2002.

101. Le Corbusier. Ville Contemporaine, 1922. Fondation Le Corbusier (29711), Paris. DACS. © FLC/ADAGP, Paris and DACS, London 2002.

102. Le Corbusier. Cité de Refuge, 1929–33, Paris. Fondation Le Corbusier (10907), Paris. © FLC/ADAGP, Paris and DACS, London 2002.

103. Le Corbusier. Cité de Refuge, 1929–33, Paris. Fondation Le Corbusier (10910), Paris. © FLC/ADAGP, Paris and DACS, London 2002.

104. Le Corbusier. Villa de Mandrot, 1931, Pradet. Fondation Le Corbusier (L2(19)16), Paris. © FLC/ADAGP, Paris and DACS, London 2002.

105. Le Corbusier. Radiant Village Coopératif, 1934–8. © Fondation Le Corbusier (L3(20)61), Paris. © FLC/ADAGP, Paris and DACS, London 2002.

106. Mies van der Rohe. German Pavilion, International Exposition, 1929, Barcelona (demolished, rebuilt 1992). Photo Eloi Bonjoch, Barcelona. © DACS 2002.

107. Lyonel Feininger. Cover of the 'Bauhaus Manifesto', 1919. Woodcut, black ink on green wove paper, 30.2 × 18.6 cm. Courtesy of the Busch-Reisinger Museum, Harvard University Art Museums, Gift of Mrs Lyonel Feininger/photo Rick Stafford © Harvard University. © DACS 2002.

108. Marianne Brandt. Ceiling light, 1927. Bauhaus Archiv, Museum für Gestaltung, Berlin. © VG Bild Kunst, Bonn.

109. and 110 Walter Gropius. Bauhaus Building, 1926, Dessau. Photo AKG (London).

111. Otto Haesler and Walter Gropius. Dammerstock Estate, 1927–8, Karlsruhe, plan.

112. Walter Gropius. Apartment Block, 1928, Siemensstadt, Berlin. Photo Achim Bednorz, Cologne.

113. Housing, 1925–7, Düsseldorf. Photo Ullstein Bild, Berlin/Photo Hedda Walther, 1937.

114 and 115. Hans Scharoun. Schminke House, 1933, Löbau. Photos Achim Bednorz, Cologne.

116. Mies van der Rohe. Riehl House, 1907, Berlin (Neubabelsberg, Potsdam). Photograph Courtesy The Mies van der Rohe Archive, The Museum of Modern Art, New York. © DACS 2002.

117. Mies van der Rohe. Plans, Brick Country House, 1924, Concrete Country House, 1923, and Lessing House, 1923. Drawings by Alan Colquhoun. © DACS 2002.

118. Mies van der Rohe. Wolf House, 1925–7, Guben (demolished). Photograph courtesy The Mies van der Rohe Archive, the Museum of Modern Art, New York. ©.

119. Mies van der Rohe. Tugendhat House, 1928–30, Brno, Czech Republic. Bildarchiv Foto Marburg.

120. Mies van der Rohe. Tugendhat House, 1928–30, Brno, Czech Republic. RIBA Photographs Collection, London. © DACS 2002.

121. Mies van der Rohe. Upper and lower-floor plans, Tugendhat House, 1928–30, Brno, Czech Republic. Both ink on illustration board, 76.5 × 102 cm. The Mies van der Rohe Archive, The Museum of Modern Art, New York. Gift of the Architect. © 2001 The Museum of Modern Art, New York. © DACS 2002.

122. Mies van der Rohe. Site and floor plan, German Pavilion, International Exposition, 1929, Barcelona (demolished, rebuilt 1992). From I. de Solà-Morales, C. Cirici, and F. Ramos, *Mies van der Rohe, Barcelona Pavilion* (Barcelona: Editorial Gustavo Gili, 1993), p. 29, fig. 53.

123. Mies van der Rohe. Hubbe House, 1935, Magdeburg. Perspective of living room and terrace with Elbe River. Pencil on illustration board, 49.2 × 67.4 cm. The Mies van der Rohe Archive, The Museum of Modern Art, New York. Gift of the architect. © 2001 The Museum of Modern Art, New York. © DACS 2002.

124. Mies van der Rohe. Hubbe House, 1935, Magdeburg. Plan with furniture placement. Pencil on illustration board, 48 × 67.3 cm. The Mies van der Rohe Archive, The Museum of Modern Art, New York. Gift of the architect. © 2001 The Museum of Modern Art, New York. © DACS 2002.

125. Mart Stam. Reinterpretation of Mies van der Rohe's Concrete Office Building of 1922.

126. Carlo Scarpa. Gipsoteca Canoviana, 1956–7, Possagno, Treviso. Arcaid, London/photo Richard Bryant.

127. Giuseppe Terragni. Casa del Fascio, 1932–6, Como. Photo Tim Benton, Cambridge.

128. Mario Ridolfi and Ludovico Quaroni. Tiburtino Housing Estate, 1944–54, Rome. Photo Andrea Jemolo, Rome.

129. Ernesto Rogers, Lodovico Belgiojoso and Enrico Peressutti (BPR) Office Building, 1958–69, Piazza Meda, Milan. Photo Archivio Electa, Milan.

130. Giovanni Michelucci. church of S. Giovanni, 1962, Autostrada del Sole, Florence. Photo AKG (London).

131. Ludovico Quaroni. Model, Quartiere Cepalle Barene di Giuliano, 1959, Mestre. Fondo Quaroni, Archivicio Storico Olivetti, Ivrea.

132. Erik Gunnar Asplund. Entrance Pavilion, Industrial Arts Exhibition, 1930, Stockholm. Arkitekturmuseet, Stockholm/photo Okänd.

133. Sven Backström and Lief Reinius. rosta Housing Estate, 1946, Orebro. Arkitekturmuseet, Stockholm/photo Max Plunger.

134. Peter Celsing. Cultural Centre, Culture House, 1965–76, Stockholm. Arkitekturmuseet, Stockholm/photo Thomas Hjertén.

135. Sigurd Lewerentz. St. Mark's Church, 1956–60, Björkhaven. Arkitekturmuseet, Stockholm/photo Max Plunger.

136. Alva Aalto. Tuberculosis Sanatorium, 1929–33, Paimio. Alvar Aalto Foundation/ Alvar Aalto Museum, Jyväskylä/photo G. Welin.

137. Alvar Aalto. Site plan, Tuberculosis Sanatorium, 1929–33, Paimio. Alvar Aalto Foundation/Alvar Aalto Museum, Jyväskylä.

138. Alvar Aalto. Villa Mairea, 1937–9, Noormarkku. Alvar Aalto Foundation/Alvar Aalto Museum, Jyväskylä/photo E. Mäkinen.

139. Alvar Aalto. Villa Mairea, 1937–9, Noormarkku. Ground-floor plan. Alvar Aalto Foundation/Alvar Aalto Museum, Jyväskylä.

140. Alvar Aalto. Town Hall, 1949–52, Säynätsalo. Alvar Aalto Foundation/Alvar Aalto Museum, Jyväskylä/Photo M. Kapanen.

141. Alvar Aalto. Vuoksenniska church, 1957–9, Imatra. Aalvar Aalto Foundation/ Alvar Aalto Museum, Jyväskylä/photo M. Kapanen.

142. Pekka Pitkänen. Funeral Chapel, 1967, Turku. Museum of Finnish Architecture, Helsinki/photo Arvo Salminen.

143. Constant. New Babylon: Group of Sectors, 1959. Collotype and ink, 57 × 68 cm. Gemeentemuseum, The Hague/Beeldrecht Amstelveen/© DACS 2002.

144. Le Corbusier. Model, Obus A. Project for Algiers, 1933. © Fondation Le Corbusier (LI(1)63), Paris. © FLC/ADAGP, Paris and DACS, London 2002.

145. Le Corbusier. Obus A Project for Algiers, 1933. © Fondation Le Corbusier (14345), Paris. © FLC/ADAGP, Paris and DACS, London 2002.

146. Le Corbusier. Obus E Project for Algiers, 1939. © Fondation Le Corbusier (14594) Paris. © FLC/ADAGP, Paris and DACS, London 2002.

147. Le Corbusier. Capitol, 1956, Chandigarh. © Fondation Le Corbusier (5162), Paris. © FLC/ADAGP, Paris and DACS, London 2002.

148. Le Corbusier. The Secretariat, 1951–63, with the State Assembly Building in the foreground, Chandigarh. Photo Alan Colquhoun.

149. Lúcio Costa, Oscar Niemeyer, and others; consultant Le Corbusier. Ministry of Education and Public Health, 1936–45, Rio de Janeiro. RIBA Photographs Collection, London.

150. Lúcio Costa. Brasilia Masterplan, 1957. From N. Evenson, *Two Brazilian Capitals* (Yale University Press, 1972), fig. 154.

151. Alison and Peter Smithson. Urban Reidentification, 1959.

152. Georges Candilis, Alexis Josic and Shadrach Woods. Free University, 1964–79, Berlin.

153. Aldo van Eyck. Burgerweeshuis Orphanage, 1957–60, Amsterdam.

154. Piet Blom and Joop van Stigt. Village of Children, 1962.

155. Kenzo Tange. Tokyo Bay Project, 1960. Kenzo Tange Associates, Tokyo.

156. Arata Isozaki. Joint Core Stem system, 1960. Arato Isozaki & Associates, Tokyo.

157. Archigram. Plug-in City, 1964.

158. Yona Friedman. L'Urbanisme Spatiale, 1960–2.

159. Constant. New Babylon (1959–): view of New Babylonian Sectors, 1971. Watercolour and pencil on photomontage, 135 × 223 cm. Gemeentemuseum, The Hague/Beeldrecht Amstelveen/© DACS 2002.

160. Mies van der Rohe. Seagram Building, 1954–8, New York. Photo © Angelo Hornack Library, London.

161. Pierre Koenig. Case Study House 21, 1958, Los Angeles. Photo © Julius Shulman, Los Angeles.

162. Charles and Ray Eames. Case Study House 8, 1945–9, Pacific Palisades. Photo © Julius Shulman, Los Angeles.

163. Skidmore, Owings, and Merrill. Lever House, 1951–2, New York. Photo © Angelo Hornack Library, London.

164. Skidmore, Owings, and Merrill. US Air Force Academy, 1954–62, Colorado Springs. Chicago Historical Society/photo Hedrich-Blessing.

165. Skidmore, Owings, and Merrill. Union Carbide Building, 1957–60, New York. © Esto, Mamaroneck, NY/photo Ezra Stoller.

166. Eero Saarinen. General Motors Technical Center, 1948–56, Warren, Michigan. © Esto, Mamaroneck, New York/photo Ezra Stoller.

167. Mies van der Rohe. Preliminary scheme, Illinois Institute of Technology, 1939, Chicago. Aerial perspective. Pencil, conte crayon on illustration board, 101.5 × 129.5 cm. The Mies van der Rohe Archive, The Museum of Modern Art, New York. Gift of the Architect. © 2001 The Museum of Modern Art, New York. © DACS 2002.

168. Mies van der Rohe. Alumni Hall, Illinois Institute of

Technology, 1945–6. Chicago Historical Society/photo Hedrich-Blessing.

169. Mies van der Rohe. Seagram Building, 1954–8, New York. Photo © Angelo Hornack Library, London.

170. Mies van der Rohe. Seagram Building, 1954–8, New York. I-beam mullions from J. Joedicke, *Office Buildings* (London: Crosby Lockwood & Sons, 1962; R/1968 Penguin Books), fig. 268.

171. Eero Saarinen. TWA Terminal, JFK Airport, 1956–62, New York. © Esto, Mamaroneck, NY/photo Ezra Stoller.

172. Edward Durrell Stone. US Embassy, 1954, New Delhi, India. Photo Alan Colquhoun.

173. Louis Kahn. Adler House, 1954–5, Philadelphia. Plan. © 1977 Louis I. Kahn Collection, University of Pennsylvania and the Pennsylvania Historical and Museum Commission.

174. Louis Kahn. Jewish Community Center, 1954–9, Trenton. Plan. © 1977 Louis I. Kahn Collection, University of Pennsylvania and the Pennsylvania Historical and Museum Commission.

175. Louis Kahn. Richards Medical Research Laboratories, University of Pennsylvania, 1957–65, Philadelphia. Photo Grant Mudford, Los Angeles.

176. Louis Kahn. Plan, First Unitarian church, 1961, Rochester, New York. © 1977 Louis I. Kahn Collection, University of Pennsylvania and the Pennsylvania Historical and Museum Commission.

177. Louis Kahn. National Assembly Building, 1962–83, Dhaka. The Aga Khan Trust for Culture, Geneva/photo Reha Gunay.

178. Louis Kahn. National Assembly Building, 1962–83, Dhaka. © 1977 Louis I. Kahn Collection, University of Pennsylvania and the Pennsylvania Historical and Museum Commission.

The publisher and author apologize for any errors or omissions in the above list. If contacted they will be pleased to rectify these at the earliest opportunity.

Index